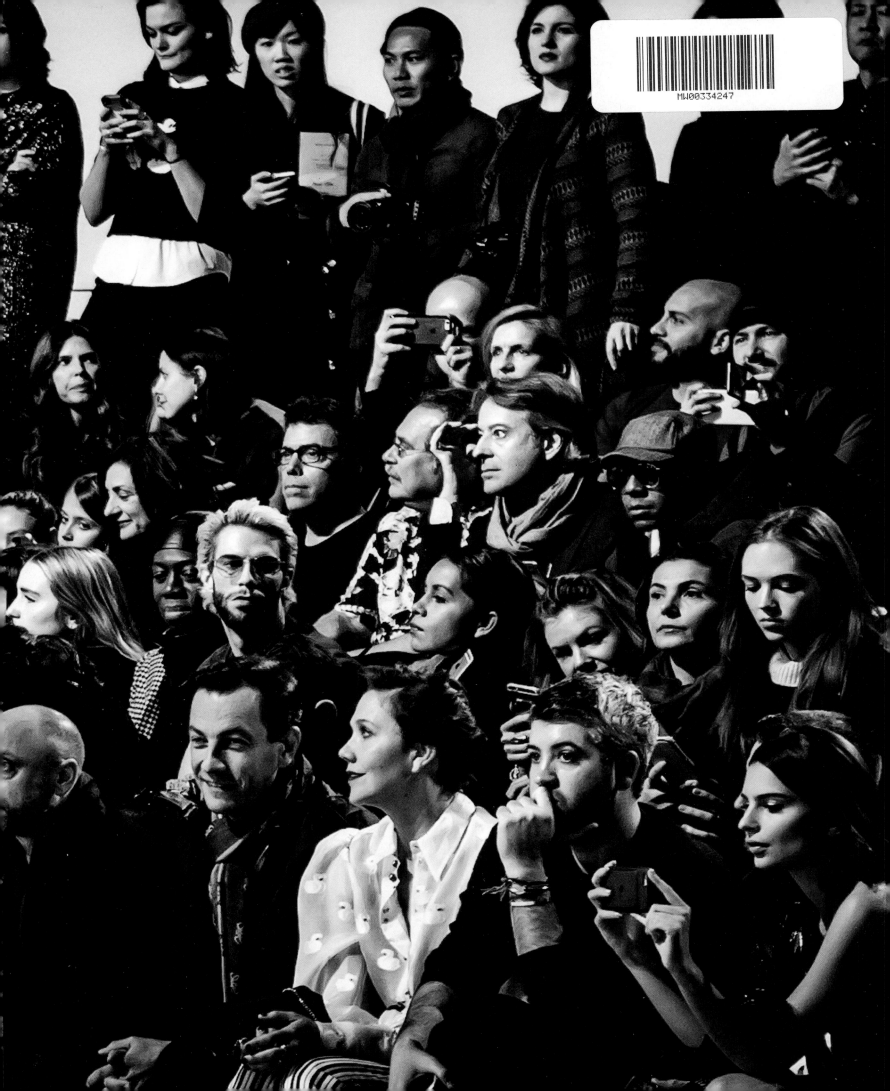

THE COUNCIL OF FASHION DESIGNERS OF AMERICA PRESENTS

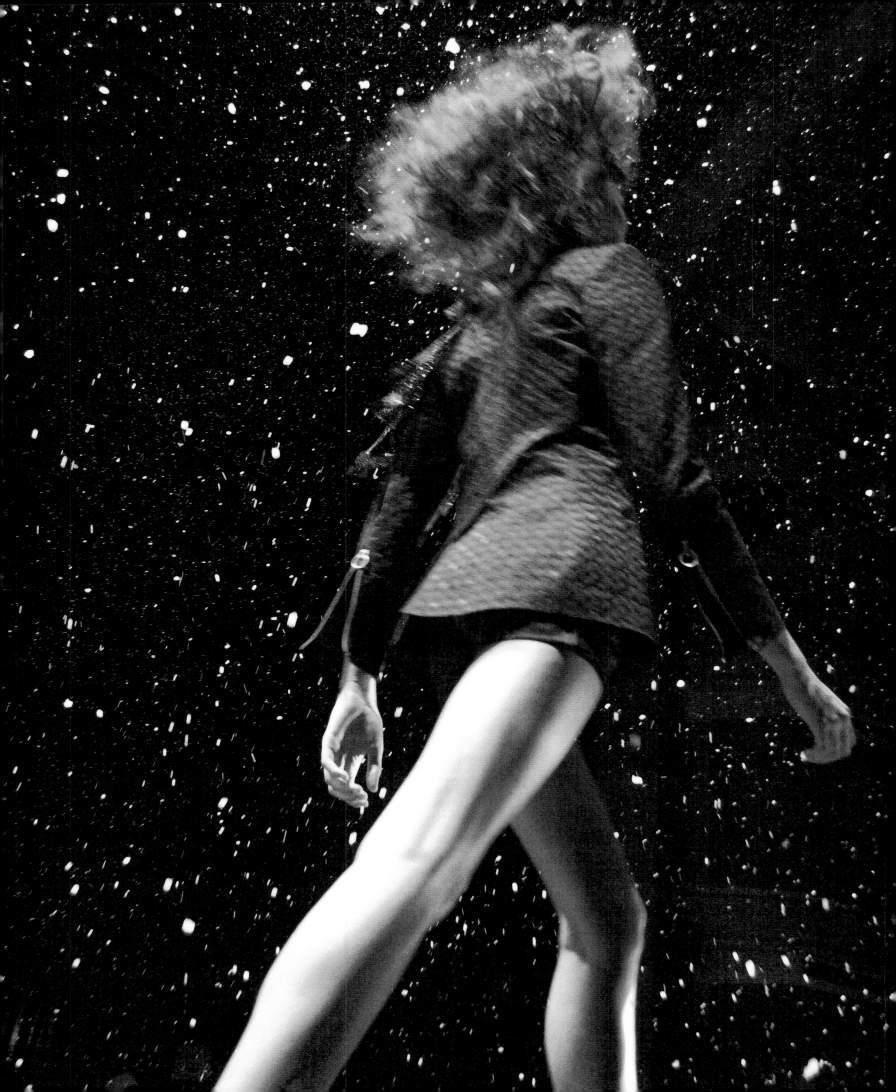

AMERICAN RUNWAY

75 YEARS OF FASHION AND THE FRONT ROW

BOOTH MOORE

AND THE COUNCIL OF FASHION DESIGNERS OF AMERICA

Foreword by Diane von Furstenberg

ABRAMS, NEW YORK

Opposite: New York Fashion Week, September 2004. Following spread: Carolina Herrera Fall 2008 show, February 2008.
Pages 2–5: New York Fashion Week, February 2005.

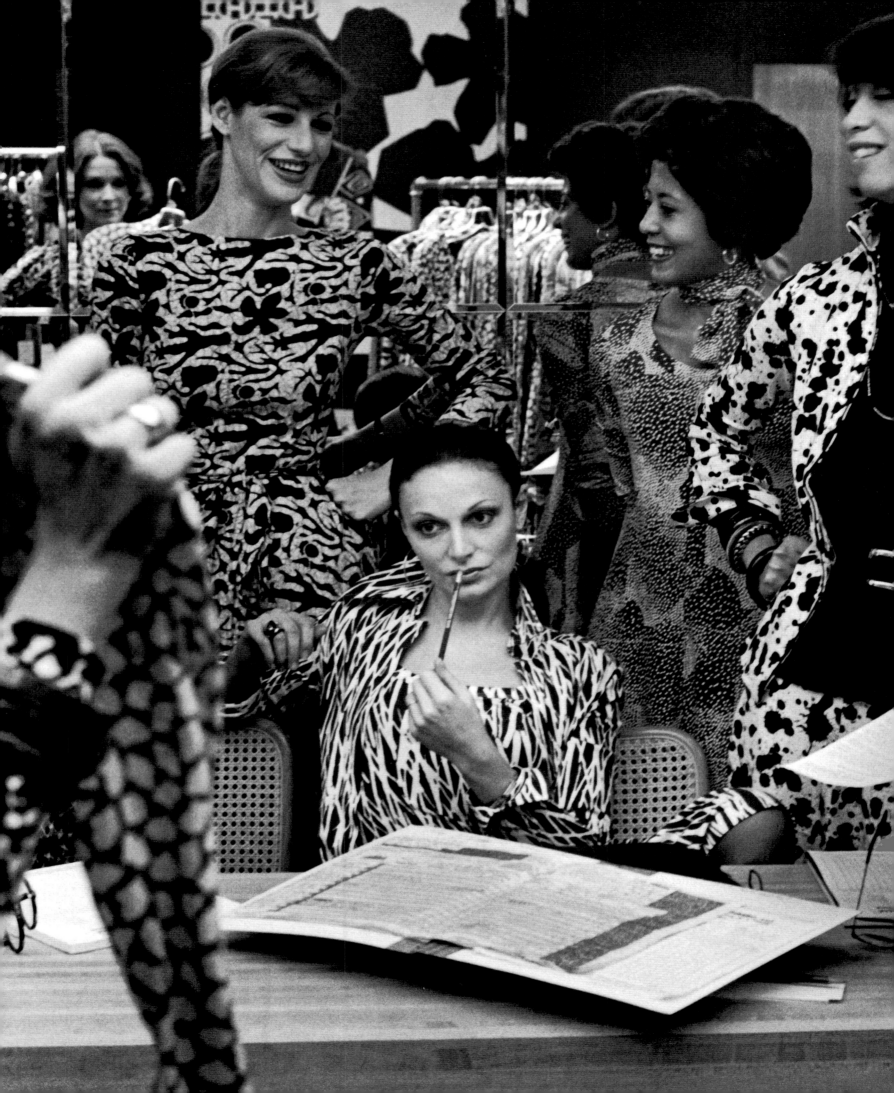

FOREWORD

by Diane von Furstenberg, Chairwoman of the CFDA

The American runway is like a mosaic—colorful, diverse, democratic, exciting, and always evolving.

It wasn't until seventy-five years ago that Eleanor Lambert, who was a publicist and later became the founder of the Council of Fashion Designers of America, decided that it was time to promote the talented American designers who had, until that point, been hidden in the back of very successful Seventh Avenue fashion companies.

Once Lambert launched Press Week in 1943, the era of the American designer started. The American fashion show was born, and Norman Norell, James Galanos, Bill Blass, and Adolfo became celebrities.

Fashion shows were very different then. They happened twice a year—spring and fall—and were mostly for trade, taking place in showrooms and hotel ballrooms. Unlike anywhere else in the world, America had thousands of department stores at the time. Buyers from the all over the country and regional newspaper editors from the *Boston Globe*, the *San Francisco Chronicle,* and the *Dallas Morning News* came to New York to cover the new collections. *Women's Wear Daily*, the fashion trade bible, could make or break your career, and editor-in-chief John Fairchild was the most-feared person in the industry.

By the early '70s, the American runway had distinguished itself through the designers' modern sportswear vision. Paris remained the home of haute couture, with the exception of Yves Saint Laurent, whose Rive Gauche ready-to-wear was slowly beginning to change that.

When I did my first fashion show, it was still very intimate.

We did shows for stores, buyers, buying offices, and press, and listed them on the Fashion Calendar.

In 1970, I introduced dresses at a small, fairly low-key fashion show in the banquet room of the Gotham Hotel. I remember showing the wrap dress in animal prints on Jerry Hall and Apollonia van Ravenstein at the Pierre Hotel's Cotillion Room in 1974.

As models like Jerry, Apollonia, Pat Cleveland, Iman, and Janice Dickinson became famous, fashion shows turned into bigger and bigger press events, and celebrities wanted to attend. By the time of supermodels Naomi Campbell, Christy Turlington, and Linda Evangelista, the shows were big entertainment productions created by the designers with event producers, set designers, and some of the best hair stylists and makeup artists. Designers will agree with me that fashion shows became geared more toward publicity than buyers.

More recently, the intent of fashion shows has shifted again. With the digital revolution came social media and a new group of influencers. These game-changers disseminate the newest trends to the world with a simple click on their smartphone once the models step onto the runway. The fashion industry is still grappling with the concept of immediacy and adjusting to this new reality in different ways. We are collectively riding the tsunami and figuring out what the fashion show of the future should be.

We are in the era of disruption, but no matter where the American runway is headed, it will always be colorful, diverse, democratic, and exciting, just like the mosaic that is American fashion.

Opposite: Diane von Furstenberg, 1976.

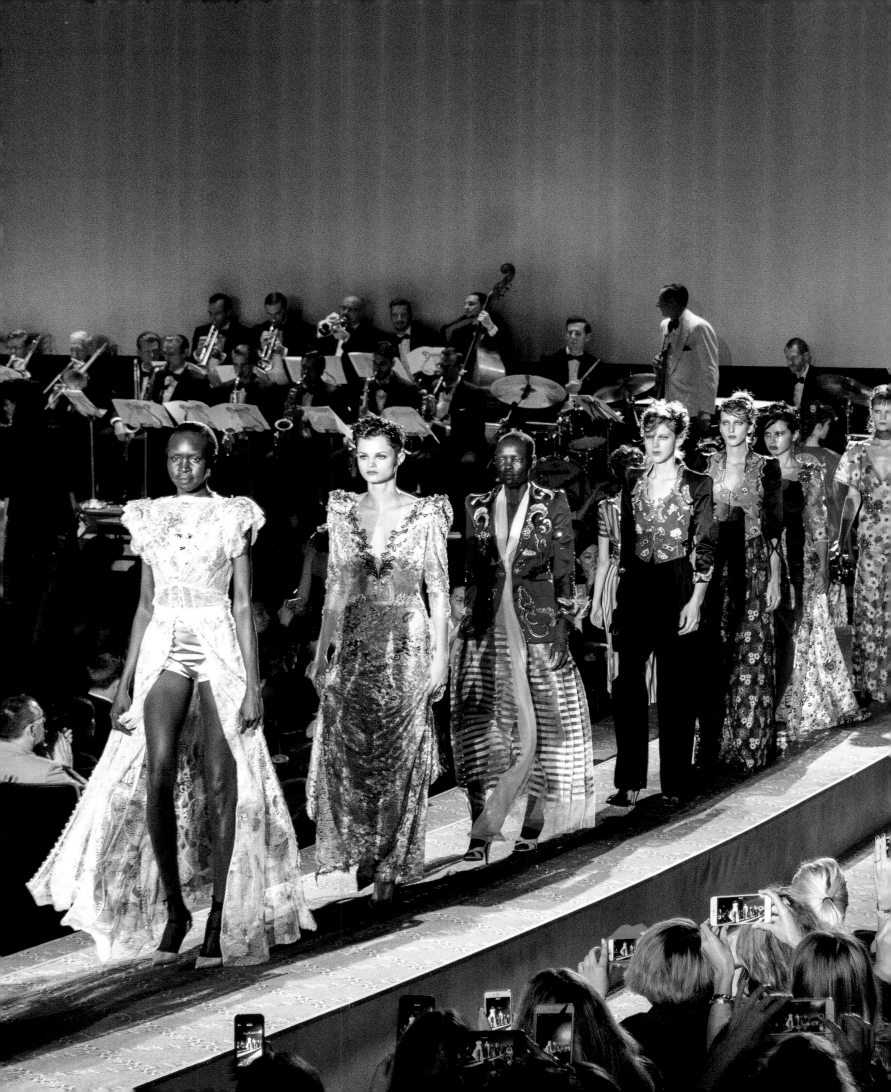

AMERICAN RUNWAY: AN INTRODUCTION

by Booth Moore

"Marc Jacobs: One Night Only!" read the marquee outside New York City's Ziegfeld Theatre on September 17, 2015. Jacobs was staging a fashion show tribute to American cinema in one of the last great movie palaces. The show started on the sidewalk, where an all-star cast of models and celebrities walked the red carpet, including Kendall Jenner, Bella Hadid, Debbie Harry, Bette Midler, and Beth Ditto, their images simultaneously broadcast on the movie screen inside the theater for the fashion industry audience, outside on a screen for the public lining the streets, and via Internet for viewers around the world. Inside, old-fashioned cigarette girls passed out Marc Jacobs–themed *Playbill*s, popcorn, and snacks. The event was the pinnacle of fashion as theater—proof that the runway show has surpassed its role as promotional linchpin for the multibillion-dollar fashion industry and taken a place in the pop-culture pantheon.

Fashion Week belongs to New York like the Oscars belongs to Hollywood. Thanks to the Internet and social media, the twice-yearly designer runway shows are not just for fashion insiders anymore; they're also for fans around the world to watch and be part of in real time, even if they are sitting at home instead of in a coveted front-row seat.

Viewers tune in to live streams and TV, read print coverage, and click on social-media photos to see the latest high-fashion designs that will trickle down to every closet, and to experience fashion spectaculars with as much production value as Broadway musicals. They also tune in to soak up the scene surrounding the shows, which can be just as colorful—the preening editrixes, celebrities, pro athletes, models, street-style stars, and other front-row fixtures, such as Anna Wintour, Carine Roitfeld, Nina Garcia, Bryanboy, Aimee Song, and Susie Bubble, all dressed to peacockish perfection. But how did we get here?

Before there was a New York Fashion Week, there was PR maven Eleanor Lambert. For much of the early twentieth century, she was a driving force in putting American fashion on the map by positioning it to challenge the longstanding trend of copying French designs for the American market. She lobbied to bring American designers out of the back rooms and into the spotlight by coordinating the first semi-annual Fashion Press Week beginning July 19, 1943. Fifty-three editors of magazines and newspapers attended what was the first New York Fashion Week, and they carried the message of American creativity and the names of a slate of new American designers home with them.

Lambert's ingenuity helped American fashion reach a wider audience, but the runway shows themselves were still very insular throughout the 1950s and early '60s. Journalists and store buyers occupied the seats, and the shows were low-key events. The Youthquake of the 1960s changed all that, thanks to celebrity magnets such as Halston and downtown talents like Stephen Burrows and Betsey Johnson, who staged runway shows that were akin to happenings, with contemporary music, models, and starry front rows.

With the rise of American sportswear in the 1970s, the runway became a branding tool to communicate an image that reverberated through licensed product categories. Seventh Avenue titans Ralph Lauren, Calvin Klein, Bill Blass, and Perry Ellis weren't only selling the clothing coming down their runways, they were using that image to sell entire lifestyles of affordable, attainable products like perfume, jeans, and underwear to the mass market. The runway became a place to tell a story.

But the business of Fashion Week hadn't really begun. Throughout the 1970s and '80s, designers held shows all over

Opposite: Marc Jacobs Spring 2016 show at the Ziegfeld Theatre, September 2015.

the city in lofts, studios, and showrooms with harrowing staircases or rickety elevators that could malfunction when overloaded. These venues weren't designed for public events, and they didn't showcase the burgeoning American fashion scene in the best light. The final straw was actually a piece of plaster that came loose from the ceiling during a Michael Kors show in 1991, falling onto the models and the front row.

Finally, the Council of Fashion Designers of America (CFDA) took up the cause to create a professional New York Fashion Week in a venue where all the shows could be held in the same space. Tents went up in midtown's Bryant Park, and on October 31, 1993, New York Fashion Week had a modern, centralized home for the first time. The tents created a grand stage for an industry that had come of age, and the shows became the new nightclubs, drawing actors, artists, musicians, and politicians, who came to be part of the scene and see what came down the runway.

Daily coverage on cable TV brought New York Fashion Week into people's homes, followed in the late '90s and early 2000s by national coverage on the cable networks E! and Style. The runway's reach extended way beyond the Bryant Park tents and off-site venues. Entertainment, celebrity, and fashion were converging on the runway in an exciting new way, and it proved to be a valuable commodity.

As the star power in the seats and coverage of the shows increased, New York Fashion Week became unwieldy to manage. So in February 2001, the CFDA entered into an agreement to sell the runway show production division to international sports and entertainment marketing and events conglomerate IMG (now WME/IMG). The synergistic possibilities were immense, especially with the rise of celebrity designers using the runway as an entertainment vehicle. You only had to look at the one-million-dollar production of hip-hop mogul Sean "Diddy" Combs's Fall 2001 menswear show to know that; it was broadcast live from the tents in a special two-hour program.

Along with synergy came sponsorship opportunities. New York Fashion Week entered a new, more commercial phase that culminated with its move to Lincoln Center in 2010. The Upper West Side location was farther from the heart of New York's Garment District, but it put American fashion in the context of the city's other major cultural institutions, including the home stages of the New York City Ballet, the New York Philharmonic, and the Metropolitan Opera.

As recently as 2008, seeing a camera phone in the front row of a fashion show was rare. But now, the public can follow along in real time, and runway shows have become a participatory sport. The rise of social media at New York Fashion Week has made fashion even more accessible, popular, and immediate, but it's also disrupted the way the industry does business, blurring any idea of seasonality and forcing a discussion about the future of the runway.

American Runway is a primer on the nuts and bolts of the fashion industry. In this book, industry insiders—such as designers Marc Jacobs, Michael Kors, Tory Burch, Tommy Hilfiger, Rebecca Minkoff, and Thom Browne; show producer Alex de Betak; set designer Stefan Beckman; and makeup artist Pat McGrath—share behind-the-scenes stories about what goes into staging a runway show, from casting and scripting to the music and front-of-house planning. And supermodels Cindy Crawford, Karlie Kloss, and more take us through what it's like to walk in a show from a model's point of view.

This book highlights the most over-the-top American runway shows of all time, the most buzzy designers, the familiar front-row faces and street-style stars, and looks at the business of Fashion Week—how designers have used the runway as a platform for philanthropy and activism and how shows have evolved from insider-only affairs into branding spectaculars directed at consumers as much as the store buyers and editors sitting in the seats.

New York Fashion Week has evolved since the 1940s, with designers looking toward the future. They continue to find creative, new ways to show their collections—whether on the runway, through online presentations, or at in-season and open-to-the-public events. What will the next seventy-five years look like?

Opposite: Geoffrey Beene presentation, June 1968. Following spread: Model Carolyn Scott gets ready to dive into a large dress for a presentation, October 1950.

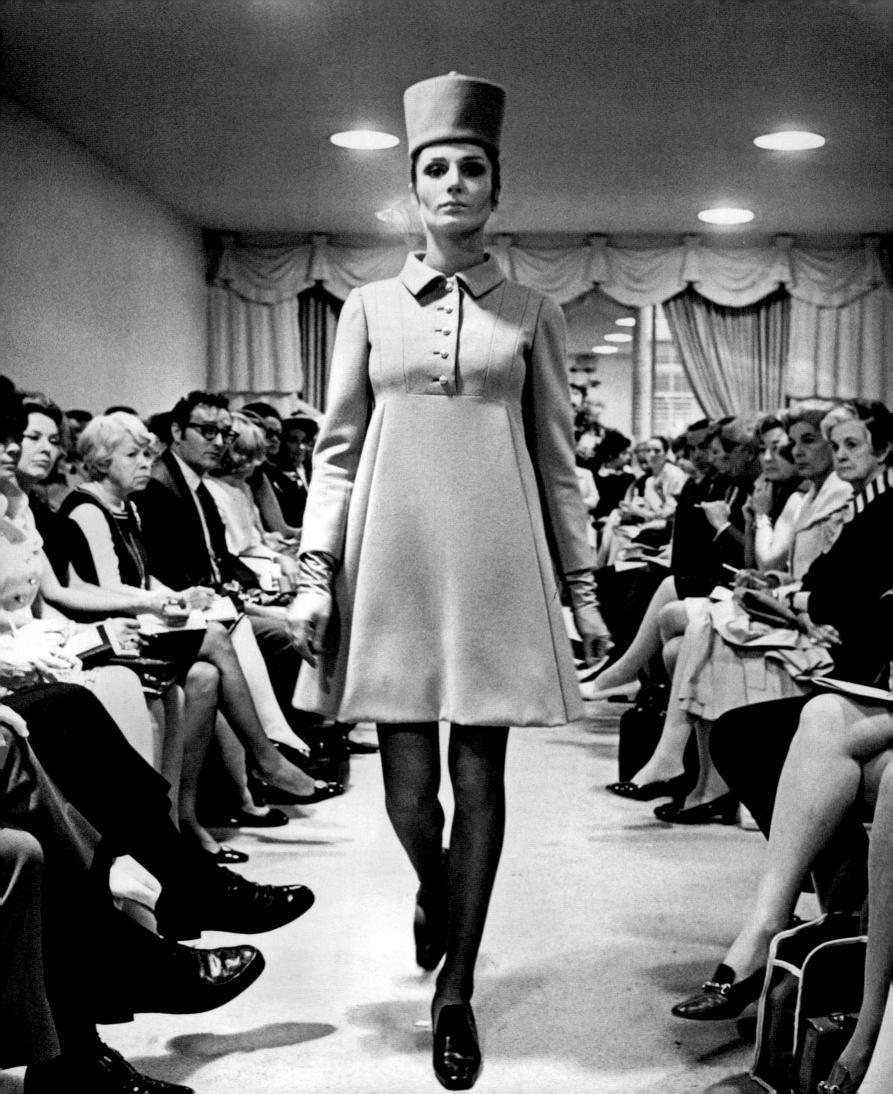

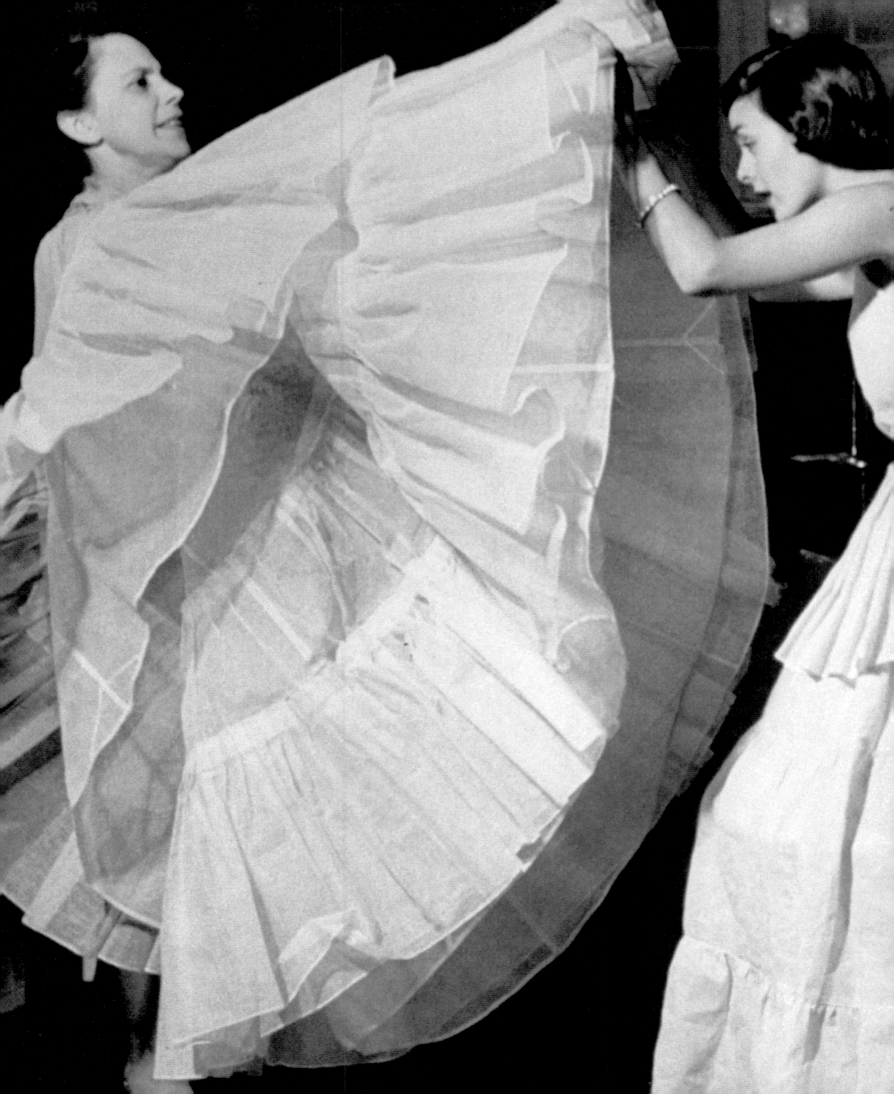

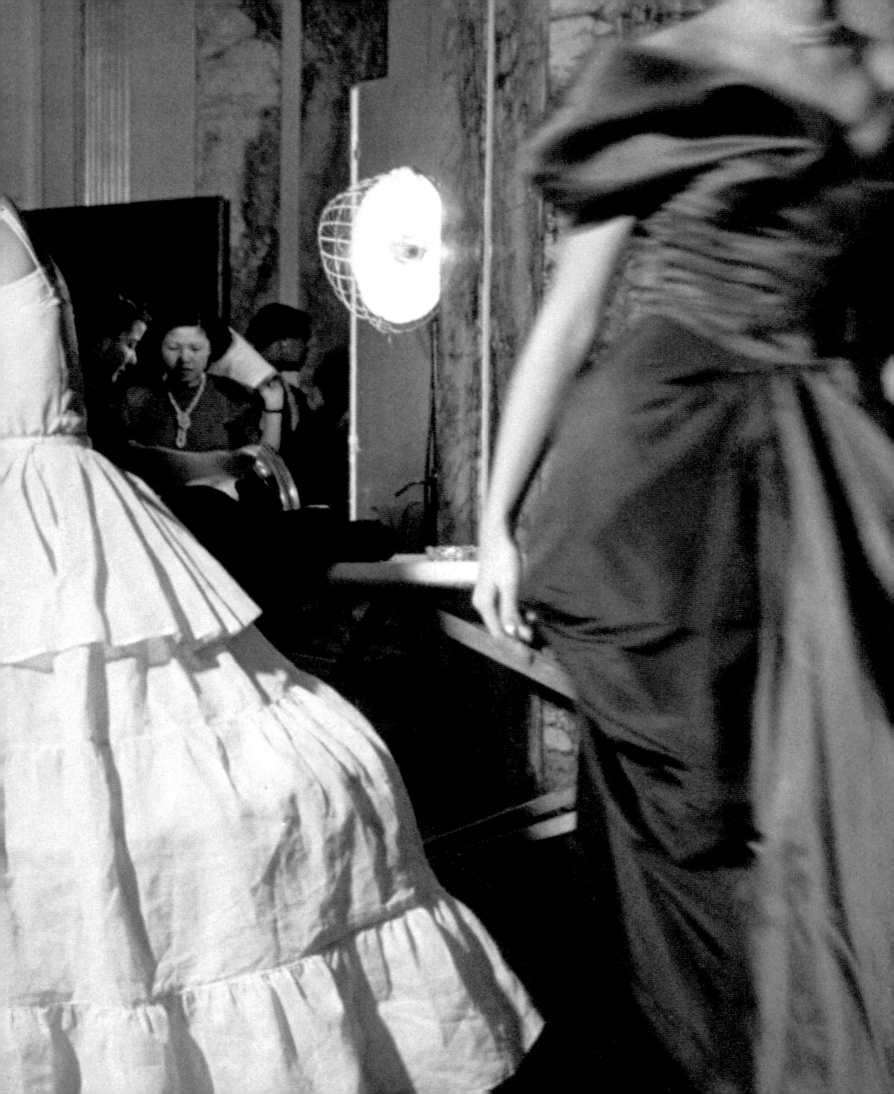

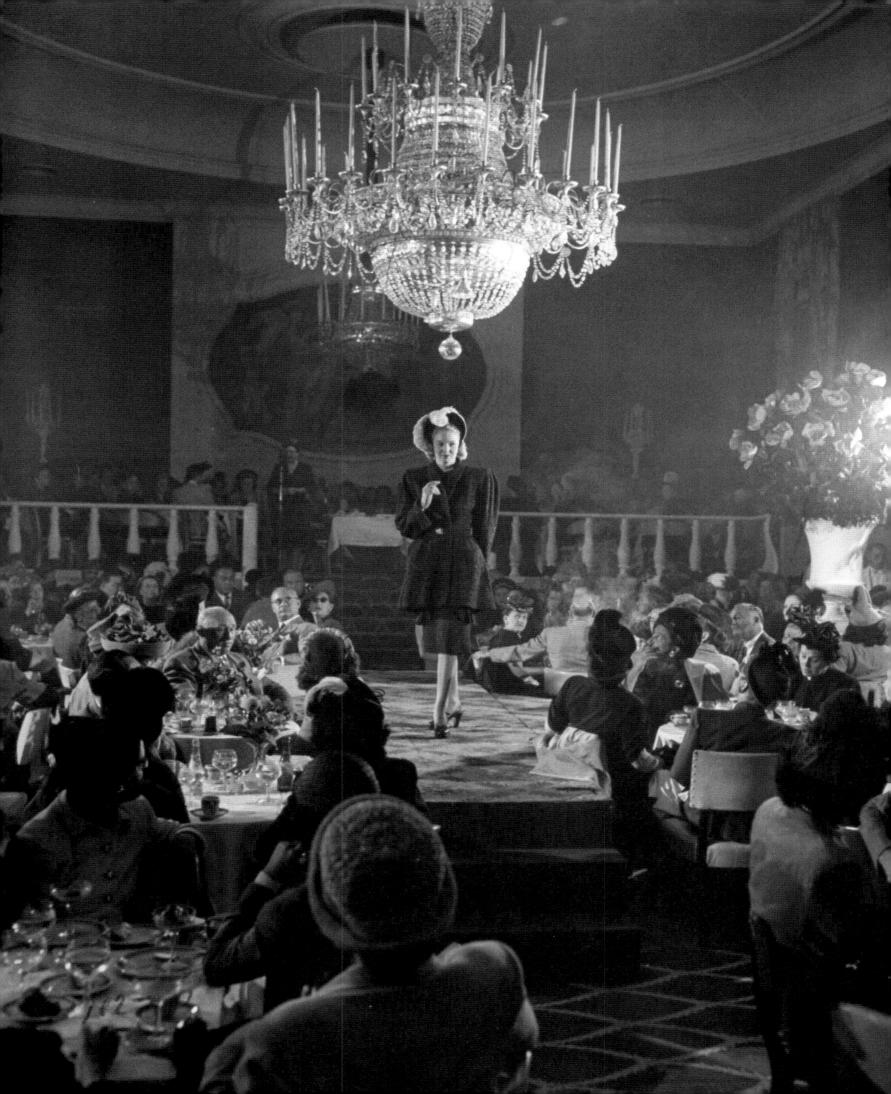

1

PUTTING AMERICAN FASHION ON THE MAP

What's in a name? If asked to list prominent American fashion designers, most of us could come up with a few: Ralph Lauren, Calvin Klein, Marc Jacobs, Tory Burch, and Tommy Hilfiger, perhaps. But that wasn't always the case.

The earliest designers with recognizable names were based in Europe. Rose Bertin, dressmaker to Marie Antoinette and a powerful member of the court of Versailles, opened her first store on the Rue Saint-Honoré in Paris in 1770. Her creations were highly sought after throughout Europe and helped establish France as the birthplace of modern fashion. In the 1860s, an Englishman in Paris, Charles Frederick Worth, pioneered the role of the modern fashion designer when he started making clothes not according to a client's specifications, the way a traditional dressmaker would, but according to his own taste. He created a distinct Charles Worth style and sewed his name into his labels so everyone would know it. Instead of going to royals' and celebrity clients' homes, he hosted women such as Empress Eugenie and Sarah Bernhardt in his Paris salon, or *maison*, selling his made-to-measure creations with the help of live models—called *mannequins*—including his own wife, Marie Vernet. Known as the father of haute couture, he established the Chambre Syndicale de la Couture Parisienne in 1868 to regulate the industry in France, promote its designers, and protect their designs from copying.

American Fashion Before World War II
The story of the American fashion industry begins in the port city of New York, which, from the early nineteenth century, was the destination for the finest imported fabrics

and trimmings and the most skilled workers. By the early twentieth century, manufacturers were king and the garment industry was New York's biggest business, with the highest concentration of clothing stores. While American garment workers excelled at mass production, they lacked creativity, at least according to some of the wealthiest customers who traveled to Paris to have their wardrobes made.

American buyers traveled to Paris, too, and by the early 1900s, their trips were being mentioned in American newspapers. Fashion shows were pioneered by the houses with the biggest number of exports, such as Paquin, Poiret, Patou, and Lucile, the latter of whom was the first to use an elevated stage for modeling.[1] The French shows mimicked elite social events, with calligraphed invitations, live music, and tea service. By 1918, there was such an appetite for French fashion, and so many foreign buyers traveling to Europe to see the latest styles, that couture fashion houses started to show their collections on fixed dates, two times a year, forming the basis for the first Fashion Weeks.

In America, women admired the latest Paris creations displayed in New York store windows, presented at daily in-store fashion parades (according to William Leach's 1993 book *Land of Desire*, America's first fashion show was likely held in 1903, at a New York City specialty store called Ehrich Brothers) or published as sketches or sewing patterns in magazines and newspapers. But what was available to buy was in most cases not the real thing, but rather an adaptation, sewed by an American seamstress, dressmaker, or ready-to-wear

Opposite: A millinery fashion show at the Hotel Pierre, September 1946.

manufacturer, based on a pattern purchased (or occasionally stolen) from a couture designer and modified for American tastes and budgets. The clothes had the names of the dress manufacturers that made them or the stores where they were sold on their labels, not the names of individual designers or seamstresses.

So who dictated style in America? The lines between manufacturer, retailer, and designer were muddled. Hattie Carnegie, regarded as the mother of American high fashion and one of the industry's first great success stories, was not a trained dressmaker. She actually got her start as a hat maker and a retailer. In 1919, Carnegie started traveling to Paris to buy original dresses that she would either sell in her boutique or give to her design team for inspiration. (Norman Norell, Travis Banton, Claire McCardell, Jean Louis, and James Galanos are among the illustrious names to have passed through her workroom over the years.) Advertisements for her store in New York offered "foreign creations and Hattie Carnegie adaptations"—you could buy a Chanel, or her workroom's interpretation of a Chanel, and by the late 1930s, you could buy her ready-to-wear sportswear collection.

Other American designers in the 1920s, such as Jessie Franklin Turner, Valentina, and Elizabeth Hawes, were more independent spirits, rejecting the dominance of France by selling their original designs under their own names. Hawes's first job had been to knock off couture dresses for a manufacturer in Paris; she quickly grew disgusted by the process, which required her to memorize a dress during a fashion show and sketch it afterward. "We were basically stealing their designs," she wrote in her 1938 book, *Fashion Is Spinach*.[2]

In 1928, Hawes returned to New York, intent on proving "beautiful clothes could and should be designed in the United States."[3] She opened her own couture house, and without going to France to copy, sold her own made-to-order clothing to a high-end clientele. But the road to recognition was difficult—many New York newspapers did not print the names of designers because they worried about inciting jealousies among advertisers, Hawes wrote. In 1931, she took her American-made clothes to show in Paris, an experience

she describes as difficult. When, on July 4, "the models paraded to music provided by an American orchestra, the applause was not generous and there were even some hisses," she told the *New York Times*.[4]

Several associations sprang up in New York to promote and dignify American fashion, including the Fashion Group, formed in 1928 by *Vogue* editor-in-chief Edna Woolman Chase with an advisory board of impressive women—editors, dressmakers, retailers, and beauty entrepreneurs. The group included trailblazing dermatologists-turned-cosmetics-titans Elizabeth Arden and Helena Rubinstein; magazine editors Margaret Case, Carmel Snow, and Julia Coburn; retailer Nan Duskin; film costume designer Edith Head; interior designer Eleanor LeMaire; *New York Times* fashion editor Virginia Pope; fashion merchandising consultant and columnist Tobé Coller Davis; and budding designers Lilly Daché, Adele Simpson, Clare Potter, and Claire McCardell—as well as Eleanor Roosevelt, whose husband was running for New York State Governor at the time.

Another founding member was the visionary retailer Dorothy Shaver. Then vice president of Lord & Taylor—founded in 1826, it is America's oldest department store—she played a critical role in promoting American design. Following the groundbreaking 1925 Exposition Internationale des Arts Décoratifs et Industriels Modernes in Paris, which established the popularity of Art Deco, Shaver mounted a spin-off show at Lord & Taylor that showcased the latest furnishings and household accessories made by French companies in the new style. Delighted with the success of the exhibition, Shaver decided to try her approach using a new American aesthetic.[5] In 1929, she hired several trendsetting artists, including two members of the group of celebrated artists and writers the Algonquin Round Table, Dorothy Parker pal Neysa McMein and Katherine Sturges, to create fabrics with American themes that women could buy and use to sew dresses at home. That, too, was a success, and Shaver was promoted to Lord & Taylor's vice president in charge of style, publicity, and advertising. In 1932, she piloted a broader initiative known as The American Look to showcase the work of new American designers in special collections tailored for American

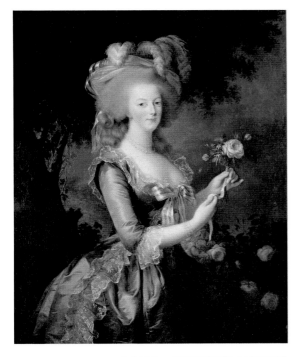

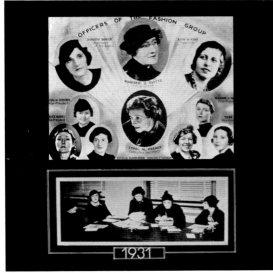

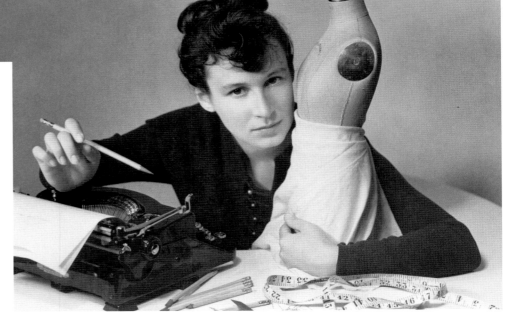
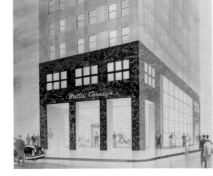

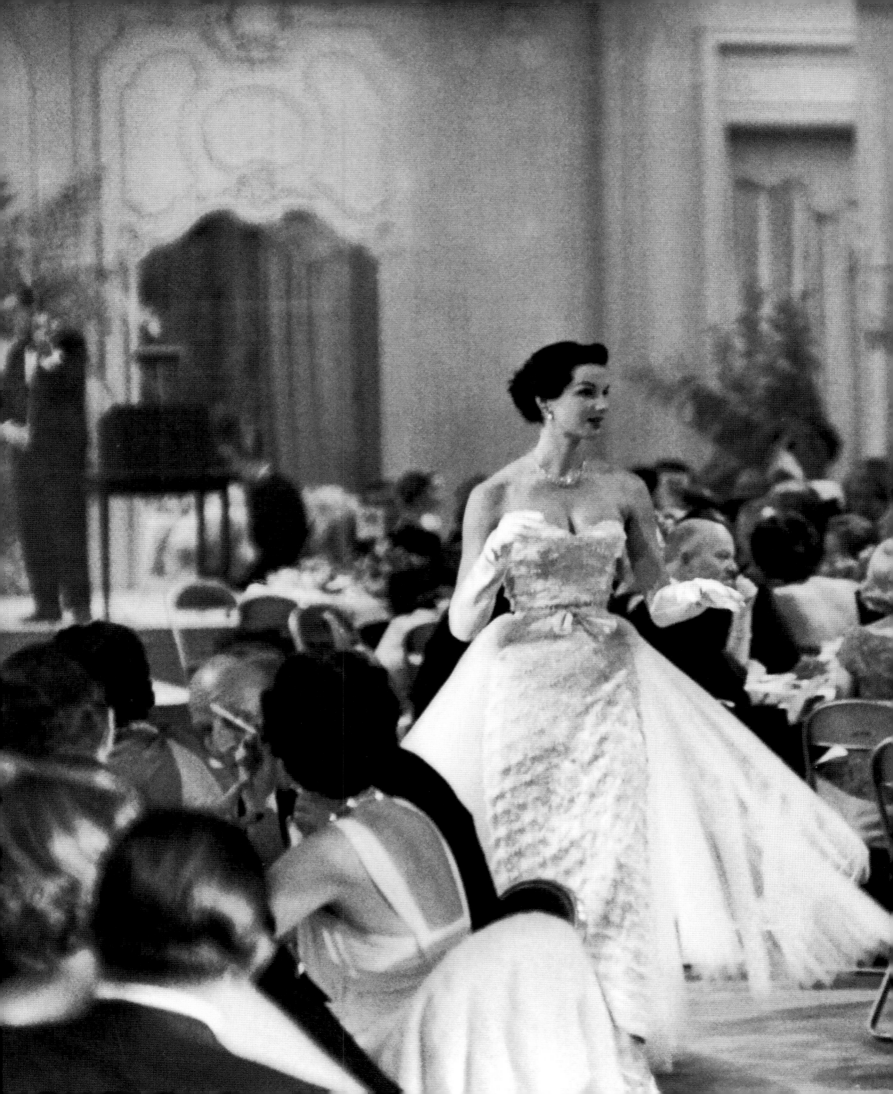

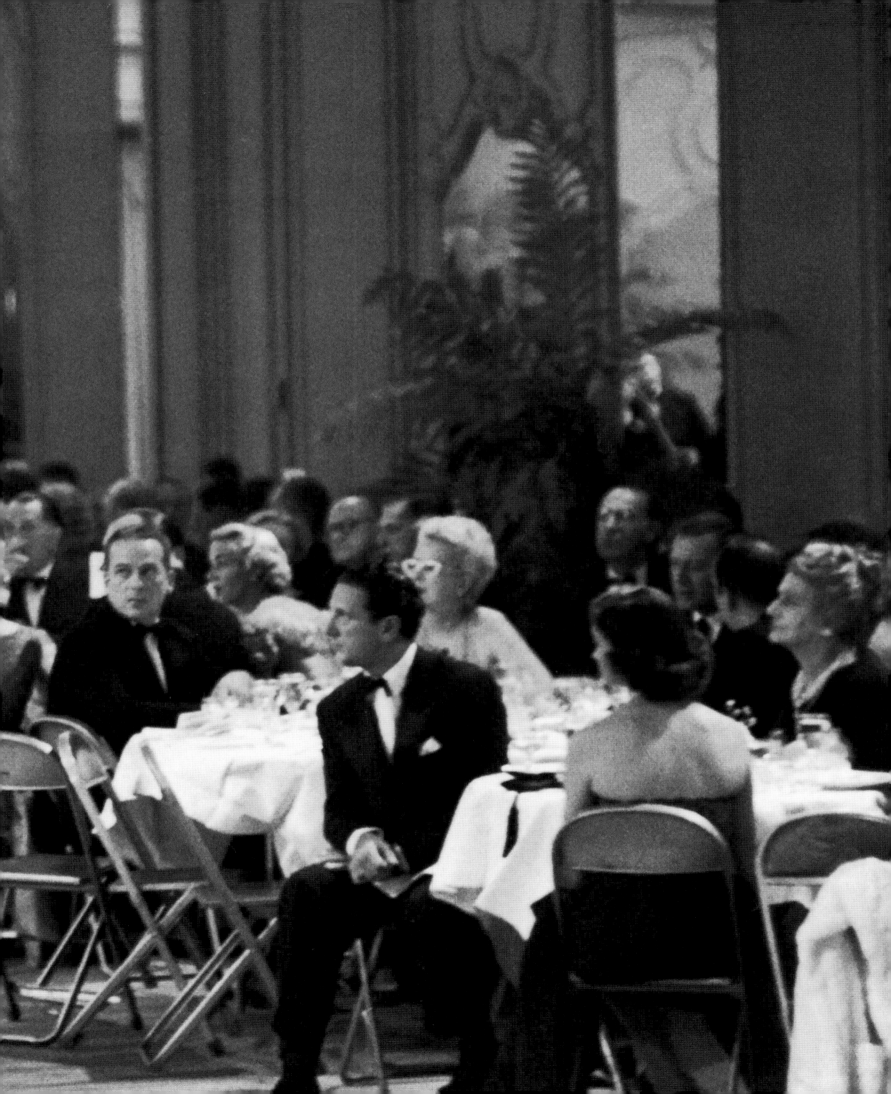

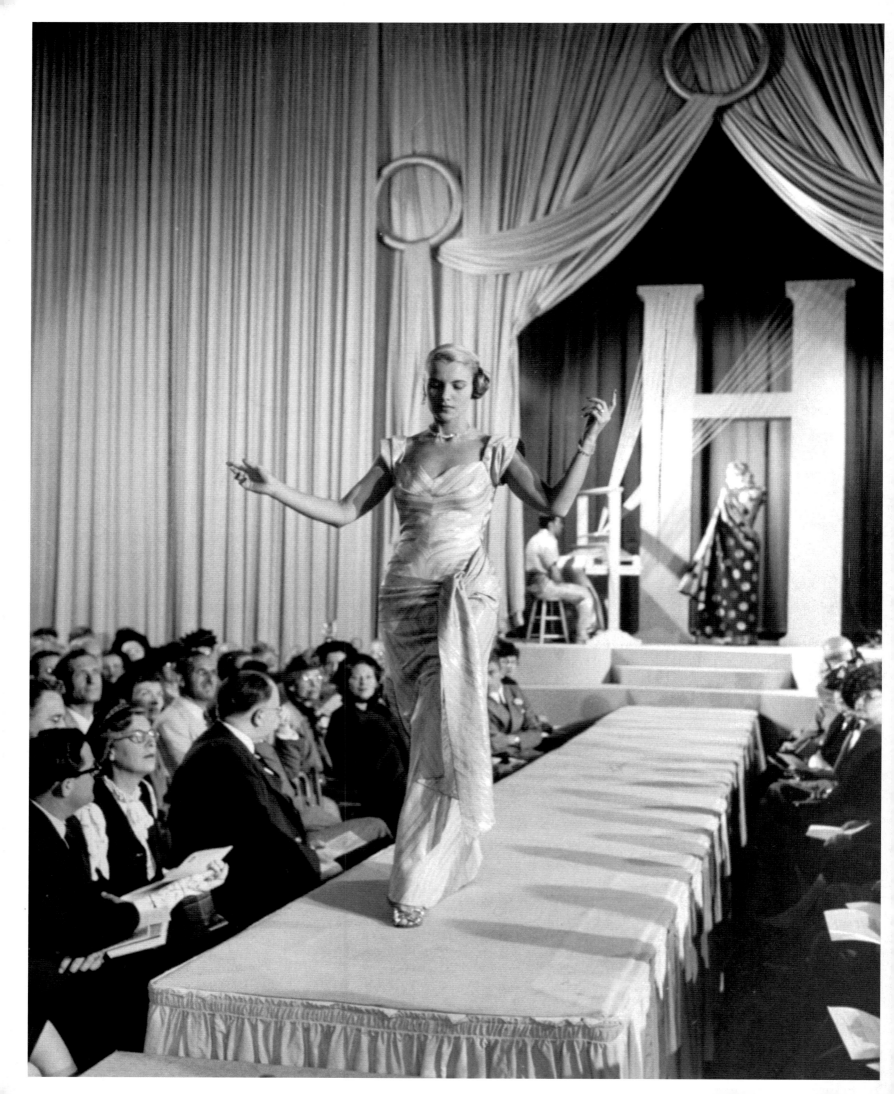

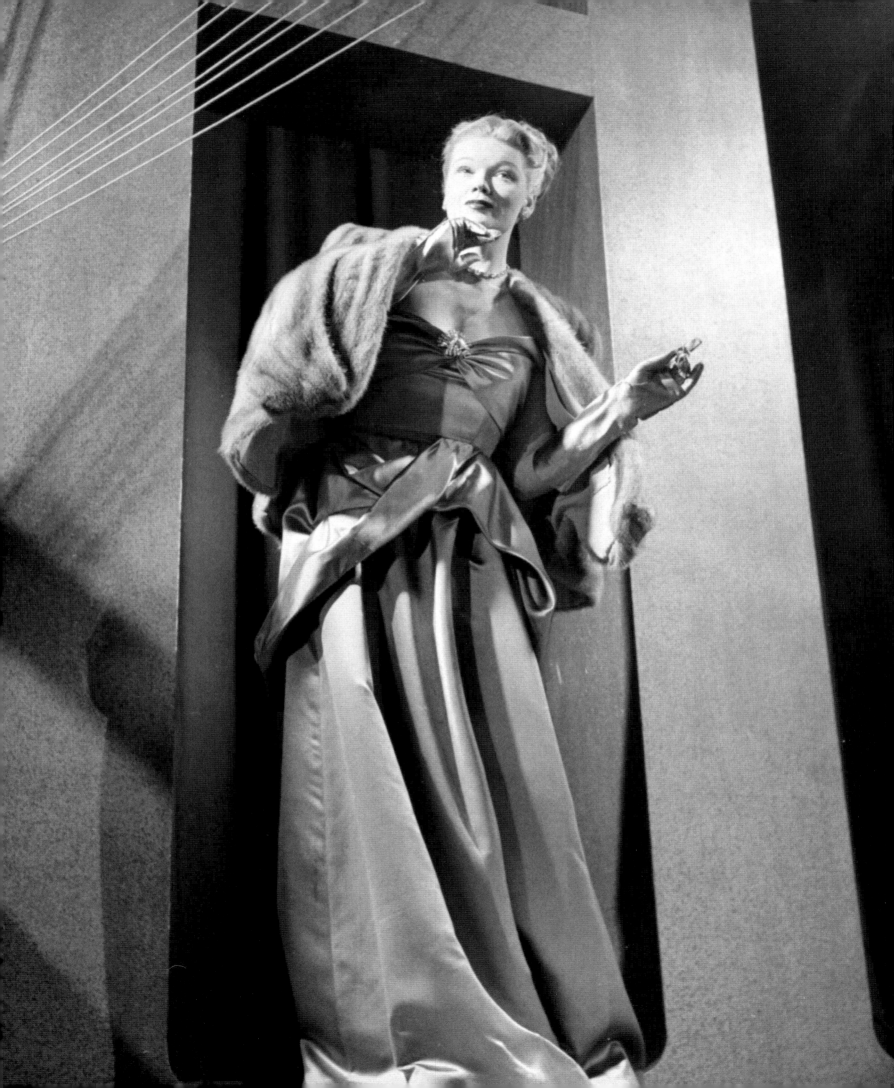

consumers: moderately priced, well-constructed, and suitable for casual living. Essentially, she invited them to knock off their high-end creations for a wider audience, an early example of the democratization of fashion.

The first three designers in The American Look were Hawes; Potter, who was a favorite of Roosevelt; and Muriel King, who went on to design wardrobes for Ginger Rogers and Katharine Hepburn. In King's case, Lord & Taylor sold her higher priced collection, with dresses at $149 (or roughly $2,500 in today's dollars), and her lower priced one, too, with dresses from $29 to $49 (or $475 to $810). Their photographs were displayed along with their designs in the store's Fifth Avenue windows. "American designers are best equipped by tradition, background, and feeling to understand the needs and demands for American women in sports clothes," Shaver wrote.[6] Between 1932 and 1939, The American Look introduced sixty young designers, including Vera Maxwell, maker of Rosie the Riveter's coveralls, Hollywood costume designer Adrian, sportswear innovator McCardell, and dressmaker Nettie Rosenstein who would dress future first lady Mamie Eisenhower for the 1953 inaugural ball. In 1945, Shaver became the first woman in history to head a major US retail establishment when she was named president of Lord & Taylor.

But even as some American creators were gaining notice for their high-end creations and ready-made sports clothes, Paris was still the first and last word in luxury and taste. "To go to a showing at one of the great Paris houses is as thrilling as attending a first night at a New York theater," wrote *New York Times* Fashion Editor Pope in 1935. "There is no such fanfare of trumpets when designers such as Nettie Rosenstein, Jo Copeland, and Germaine Monteil show a collection; there are no invited guests; only the buyers may penetrate their showrooms. . . . It is all very businesslike. And for a reason: so quickly do electric knives cut into material and machines sew up seams, so quickly does the word of a new trend circulate, that the American designer must guard herself against the fashion 'pirate' who is always lurking around the corner."[7]

Although New York newspapers had started reporting on the

UNION LABEL
INT'L LADIES' GARMENT WORKERS UNION
UNION MADE
A.F. of L.
OF THE I.L.G.W.U.

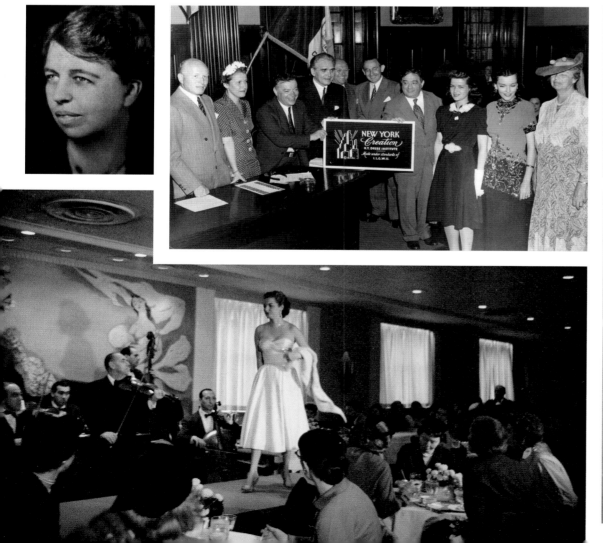

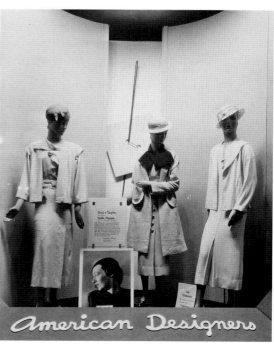

American Designers

collections from the showrooms and salons of Potter, King, Hawes, and others in the 1930s, mentioning them by name in print, most of the newspapers outside of New York only wrote about fashion when it landed in stores, and then it was about the style, not who made it. "We never were conscious of designers.... I probably knew of big French names like Lanvin and Chanel and maybe Schiaparelli.... But there was no such thing as a designer dress that the average person could afford,"[8] recalled Eleanor Lambert, the legendary New York publicist who would play a monumental role in changing the perception of American fashion.

Establishing New York as the Fashion Center

War was a catalyst for change. When the Nazis invaded France in 1940, many Paris couture houses shut down, and the American garment industry was cut off from the stream of ideas that had been flowing to its market. New York City's powerful unions and manufacturers were afraid women would stop buying dresses and their industry would collapse—along with their profits—so they took matters in their own hands and joined forces.

On March 9, 1941, Julius Hochman's Waist and Dressmakers Joint Board of the International Ladies Garment Workers Union (ILGWU) wrote a contract with dress manufacturers that required them to pay a royalty to the union on every unit produced. Those royalties were to be used to fund the New York Dress Institute, a new organization created to promote locally made dresses and prop up New York as a fashion center. Well aware that the garment industry was the city's largest employer with more than 85,000 workers, and that a wartime recession could be looming, City Hall joined in the effort. "On July 7, 1941, Mayor Fiorello La Guardia proclaimed New York the fashion center of the entire world—not by accident, not by default on account of the war in Europe, but by right of creative talent, skilled mechanics, and the best-dressed women in the world,"[9] according to the New York Times. He spoke at a City Hall ceremony that introduced a "New York Creation" clothing label that was to be sewn into every dress.

At the event, First Lady Eleanor Roosevelt passed out 14-karat-gold needles[10] used by union workers to ceremoniously sew the first labels, setting a precedent for cooperation between the White House and the fashion industry that would continue for years to come. Twenty models showed dress styles ranging in cost from $1.95 to $295 (about $33 to $5,050 in today's dollars). "When I was young, we used to think of Paris and Vienna as the fashion centers of the world, but we have the right to think now of New York," Roosevelt said in her remarks.[11]

In the fall, the New York Dress Institute kicked off a million-dollar promotion campaign encouraging women to buy American-made dresses.

Restrictions Breed Creativity

By December 1941, the United States had entered WWII after the bombing of Pearl Harbor. Manufacturers worked within the dictates of the new War Production Board order L-85, which restricted use of certain fabrics and materials so they could be reserved for the war effort. Again, there was panic that the garment industry would suffer losses. The media played its part in cheerleading for American fashion.

In April 1942, the New York Times quoted designer Potter, Vogue editor Chase, Harper's Bazaar editor Snow, and others, saying the WPA restrictions would not compromise American fashion but stimulate it. "In the past, we took orders from Paris; now it is Uncle Sam who is the arbiter," Pope wrote.[12] Vogue magazine's first cover after the US entry into the war spoke of the new normal for American women, proclaiming, "New designs for our double-duty lives." In September 1942, the magazine featured a cover line teasing American collections. Other magazines such as Glamour, Harper's Bazaar, and Mademoiselle also featured patriotic styles and stories.

In 1942, the New York Times got in on the promotional act, launching its first Fashions of the Times show, presenting "the democracy of fashion,"[13] from evening gowns by Norell to war-plant uniforms. The event attracted out-of-town buyers, press, and the public alike. The Fashions of the Times revues were held from 1942 to 1955, developing into Ziegfeld-like spectacles, with twelve to fourteen tableaux on a three-tiered stage, including a musical score, creative lighting, and settings reflecting the life in which the clothes would be worn.

Opposite, from top row, left to right: Eleanor Roosevelt, 1931; New York City Mayor Fiorello La Guardia (fourth from right) and Eleanor Roosevelt (far right) at the ceremony introducing the "New York Creation" label, 1941; ILGWU union label, which was introduced in 1958; Lord & Taylor fashion show, 1940; Lord & Taylor window display, 1933. Following spread: Fashion shows at the Waldorf Astoria Hotel, 1944 (left) and 1945 (top); Guests attend a fashion show held during a ball at the Plaza Hotel, 1956 (bottom). Pages 30–31: Buyers attend a fashion presentation at a Seventh Avenue showroom, 1955.

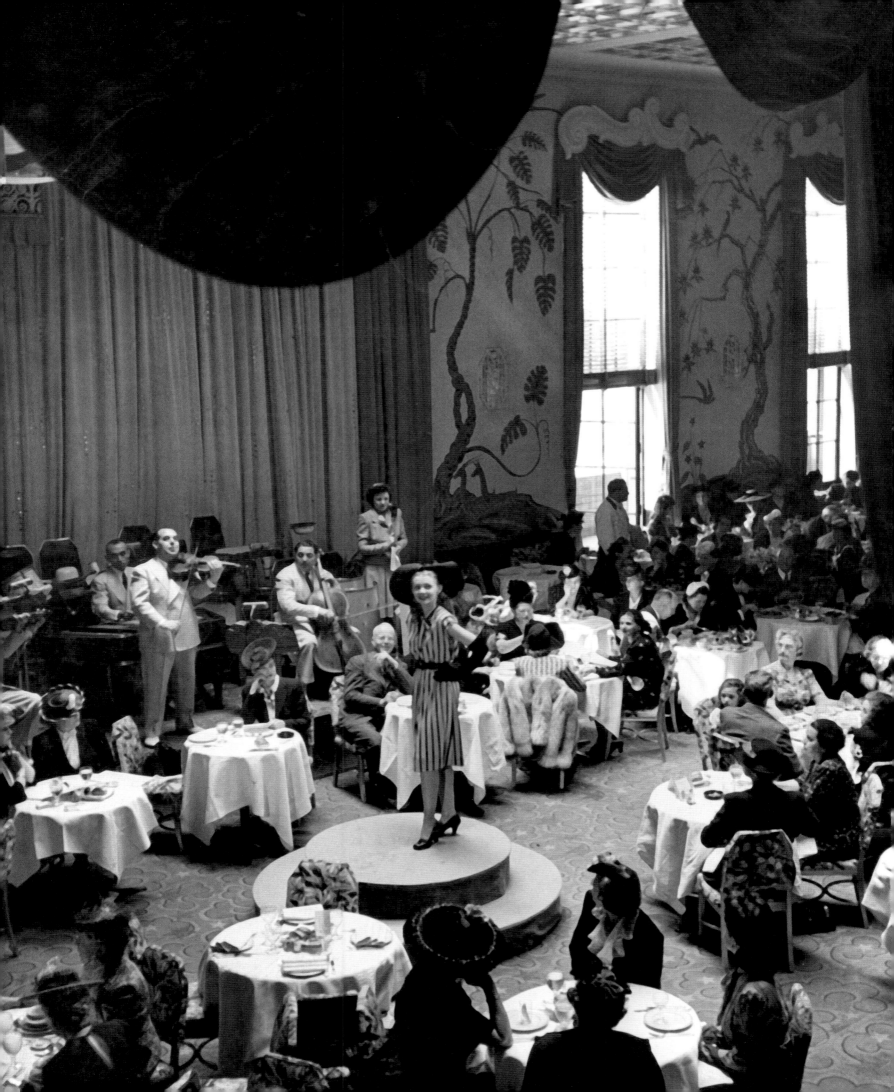

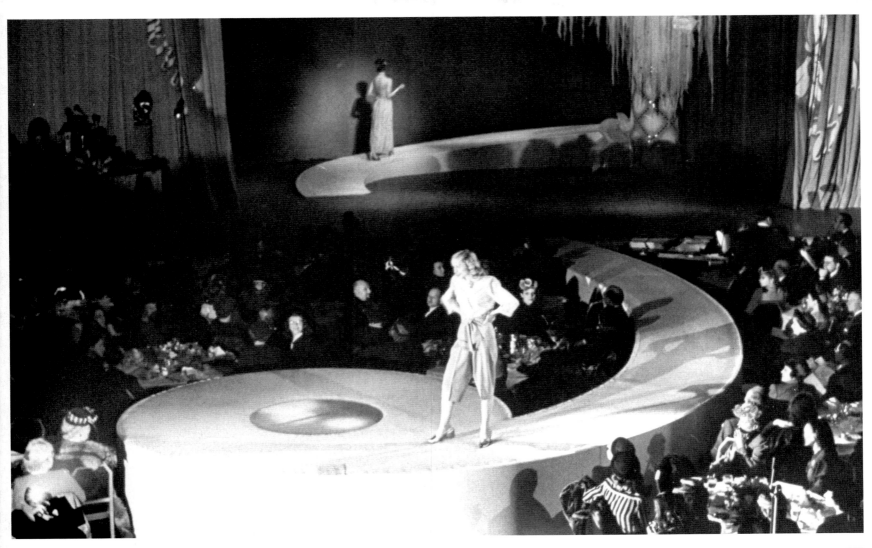
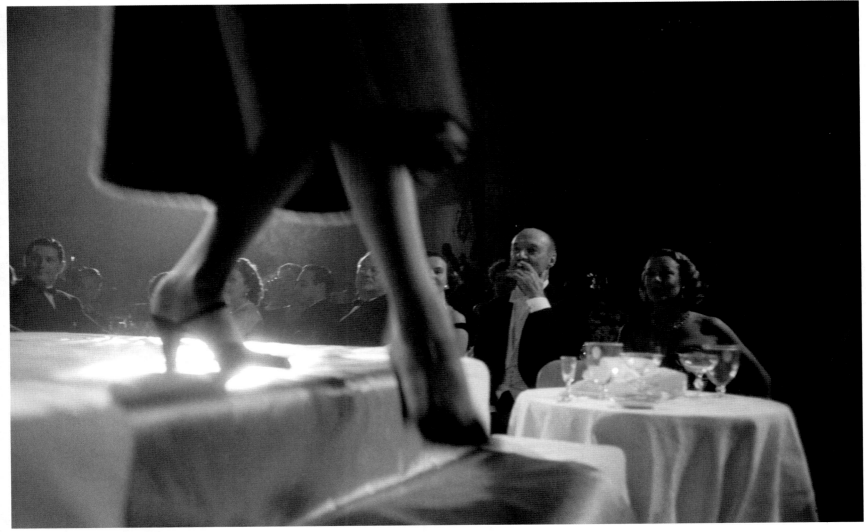

But while the New York Dress Institute's wartime New York Creation effort may have served manufacturers and unions, it didn't prop up American designers. In order for American fashion to rival French fashion, the industry had to cultivate its own leadership and promote it by name. Eleanor Lambert, American fashion's first publicist and impresario, knew that.

Lambert arrived in New York City from Crawfordville, Indiana, in the 1920s with dreams of being an artist, and she often mingled with the city's literati at the Algonquin Hotel. During one drunken night with author Dorothy Parker, Lambert got a star tattoo on her ankle.[14] Realizing she lacked sufficient talent herself, she started representing fine artists instead, picking up several clients by canvassing galleries on 57th Street and offering to write their press releases for $10 to $100 each. She worked with Salvador Dalí, Jackson Pollock, and Isamu Noguchi, and she was the first press director for the Whitney Museum of American Art in the 1930s.

She segued into fashion in 1932, signing Annette Simpson as her first designer client. In 1941, Lambert was named publicist for the New York Dress Institute. She was charged with promoting American design but found it difficult. "I tried to do a general campaign on fashion, but it was almost impossible without identifiable clothes," Lambert said.[15] Because of her experience in the art world, Lambert understood the importance of a signed original. It was the designers, not the manufacturers, who needed to be the face of fashion. "She considered fashion one of the arts," says her grandson Moses Berkson. "And she understood the designers in the back room had talent."

Lambert made a case for introducing the personalities behind the labels. "Just forget the whole thing unless we can use designer names, and you yourselves must pick your leaders, the people who are the most creative," she told her Dress Institute bosses.[16] They did, in 1941, designating Simpson, Nettie Rosenstein, Jo Copeland, Maurice Rentner, Ben Reig, and several others the first members of an elite group called the Couture Group. In 1942 she created the Coty American Fashion Critics' Awards to recognize industry excellence, and she established a biannual press event for designers to show their collections to out-of-town newspaper editors.

The First Press Weeks

The First Annual Fashion Press Week took place the week of July 19, 1943, with a slate of designer collections by Copeland, McCardell, Potter, Norell, Carnegie, and others emphasizing how stylish the new slim silhouette imposed by order L-85 could be.[17] Far from the Fashions of the Times spectaculars, these were less shows than showings, which lasted up to forty-five minutes each. Designers presented their collections in showrooms with little fanfare. Models paraded with numbers in their hands, and the designers explained each look.

Rather than showing their collections six months (a whole season) before they were to land in stores, as is common practice now, designers previewed them a few weeks before the clothes were available in stores. In essence, at the start, it was close to today's vision of "see now, buy now." Store buyers had already seen the collections and placed their orders months before, and the shows were geared to the press, and by extension the newspaper-reading public who would soon be shopping for new clothes.

In an effort to secure favorable press coverage, The Couture Group offered to cover the expenses of editors to travel to New York. More than fifty editors made the trip from Los Angeles, Memphis, Dallas, Detroit, and Hartford. From the start, there was a social swirl and sense of camaraderie to the week. *Vogue* editor Chase held a cocktail party at the Cosmopolitan Club to welcome the group of women's pages editors. They visited showrooms, museums, and shops, and the activities culminated in a lunch at the Pierre Hotel, where fifty manufacturing houses collaborated on a style show with the theme "100 Ways to Save Fabric." The guest of honor, Mayor La Guardia, didn't miss an opportunity to promote New York fashion.[18]

How did the editors cover the collections in their stories, filed by typewriter from a makeshift pressroom at 1450 Broadway? *Women's Wear Daily* summed it up: "Enthusiasm flavors all the reports, enthusiasm for the job New York designers have done

Opposite, clockwise from top left: Norman Norell and model, September 1951; Eleanor Lambert, 1963; The January 15, 1942, cover of *Vogue*; The *New York Times* Fashion of the Times show, 1944; New York Dress Institute advertisement, 1944. Following spread: The *New York Times* Fashion of the Times show, 1944.

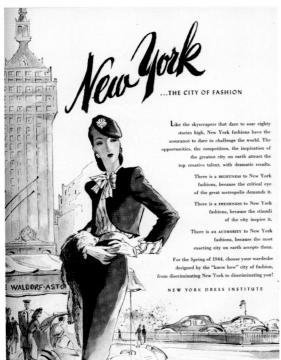

New York

...THE CITY OF FASHION

Like the skyscrapers that dare to soar eighty stories high, New York fashions have the assurance to dare to challenge the world. The opportunities, the competition, the inspiration of the greatest city on earth attract the top creative talent, with dramatic results.

There is a RIGHTNESS to New York fashions, because the critical eye of the great metropolis demands it.

There is a FRESHNESS to New York fashions, because the stimuli of the city inspire it.

There is an AUTHORITY to New York fashions, because the most exacting city on earth accepts them.

For the Spring of 1944, choose your wardrobe designed by the "know how" city of fashion, from discriminating New York to discriminating you!

NEW YORK DRESS INSTITUTE

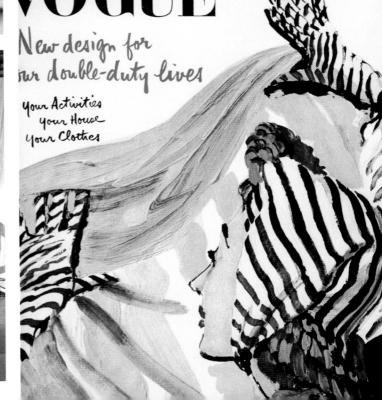

VOGUE

New design for our double-duty lives

your Activities
your House
your Clothes

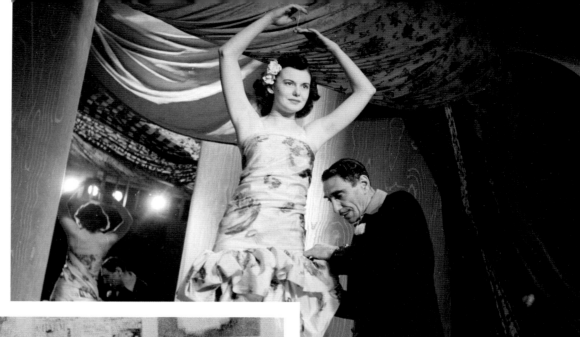

FASHION CALENDAR

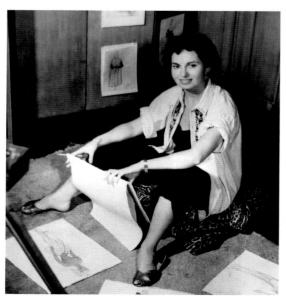

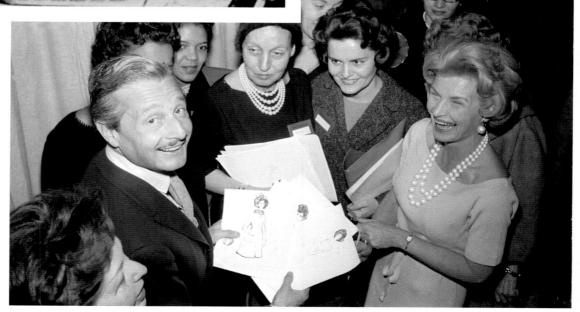

in meeting the challenge of WPA restrictions, and praise for the results. Glamour crops up in every other headline; fashion writers admit to being dazzled to the point of blindness by the many sequins; the slim silhouette gets scrupulous attention and more than one editor warns readers of the women's page that they'll have to pare off excess poundage before they can wear the clothes come October."[19] Copeland's glitter tweeds, Carnegie's Russian-inspired dinner sheaths, Norell's chemise dresses, and Potter's hug-me-tight jackets were among the standout styles. And yet, there was a divide over at least one trend—sequins, with one out-of-town editor confiding anonymously in *WWD*, "Looking at these gaudy clothes, you'd never know there was a war on. Where would you wear them?"[20]

A second Press Week was held in January 1944 and a third in July 1944; the number of editors attending swelled, and so did the number of designers showing, overloading the schedule and making it difficult to file daily stories even then. Ruth Finley, a cub newspaper reporter at the time, came up with an idea to further organize the industry after hearing two colleagues complain about conflicting fashion shows, and established the subscription-based Fashion Calendar in 1945. "There were a lot of shows but no time to travel in between," she says, noting that fashion writers sometimes had to choose between showings at the same time. Over the course of fifty-plus years running the calendar, Finley became the master planner for Fashion Week and a key figure in legitimizing emerging talent.

Press Week continued through the late 1950s, featuring the work of Lambert's clients, including Bill Blass, Oscar de la Renta, and Pauline Trigère. In many ways, the regional press that came to New York twice a year *made* American fashion, by translating news about changing hemlines and silhouettes, and the names of the designers, to female consumers. "In 1954, I was working at the *Des Moines Register*, and my editor sent me to New York for Press Week," remembers fashion journalist Marylou Luther. "It was at the Pierre Hotel, and it was all Lambert's clients. We sat there at a table, with whatever you needed to drink, and each designer would show their collection or parts thereof. The funniest speaker was Oleg Cassini, because he would give stories about Hollywood."

Eventually, the press decided it wanted to see the collections at the same time as the buyers. So reporters, including Luther, by then at the *Chicago Tribune*, started showing up to Anne Klein, Bonnie Cashin, and other designer showrooms six weeks earlier. Some designers let them in and some didn't, but it was the beginning of the end of Press Week, as the showings became the responsibility of individual designers rather than a coordinated industry effort of America.

Lambert's Legacy

Lambert also worked to establish fashion on a national platform. She wanted to have it included as an art, alongside painting and dance, in the National Council on the Arts. However, she was told that such a move would require the involvement of a nonprofit rather than a purely business entity. So in 1962, she rallied a group of designers to form the nonprofit Council of Fashion Designers of America, which eventually became the governing body of American fashion. "I've always said that getting people together as a community helps further their identity as a whole," she told *Women's Wear Daily* at the time.[21]

To bring American fashion to a wider audience, she organized a televised fashion show at the 1964 World's Fair featuring CFDA designers and produced the first fashion show at the White House with Lady Bird Johnson in 1968, titled "Discover America." Held in the state dining room over a lunch for wives of visiting governors, the show highlighted summer styles by Galanos, Blass, and Donald Brooks, among others.[22]

"She was very patriotic," says Berkson of Lambert. "She recognized these people were more than just hired hands to copy what was coming out of Paris. She represented people early on who set the standard for what was to become American sportswear. That was a truly American idea, and she recognized it."

But when it comes to securing New York's place as a major fashion capital, one show succeeded above all the others. In 1973, Lambert was tapped to help raise funds for the restoration of the Palace of Versailles in France by producing a Franco-American fashion show. What she did instead was stage a palace coup.

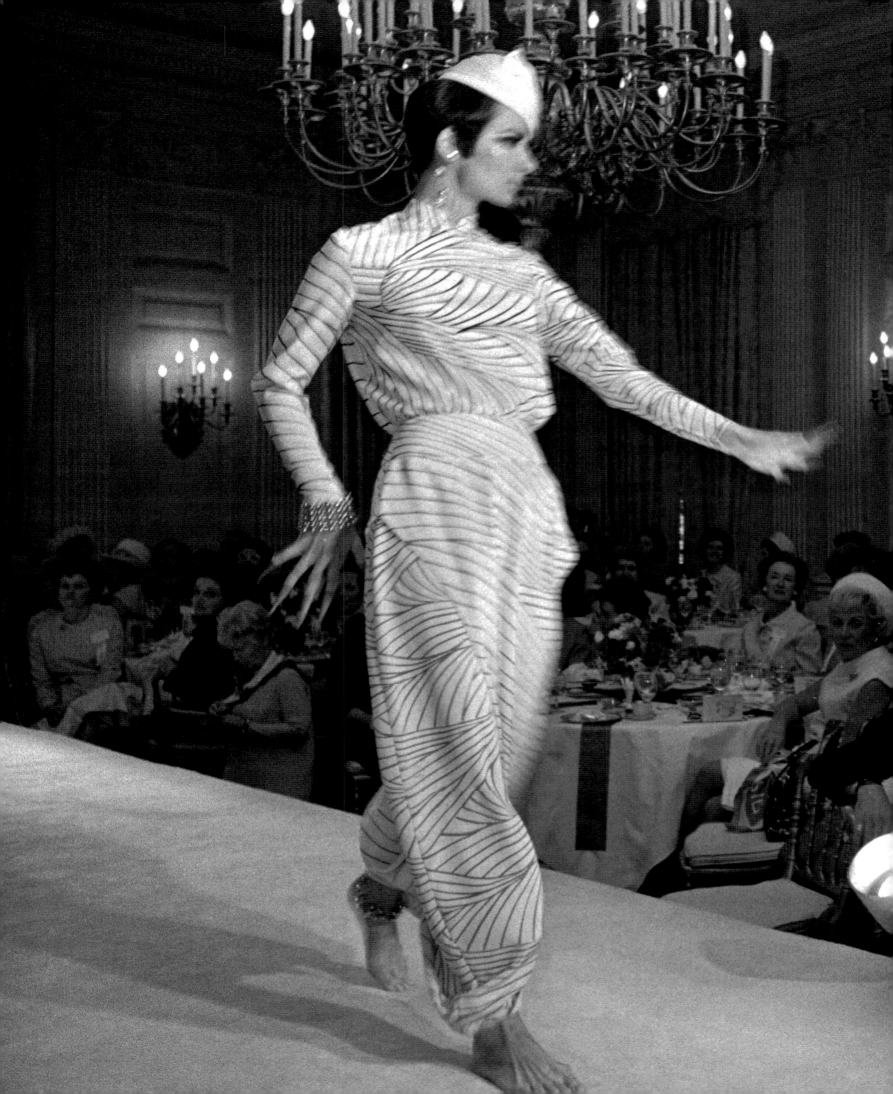

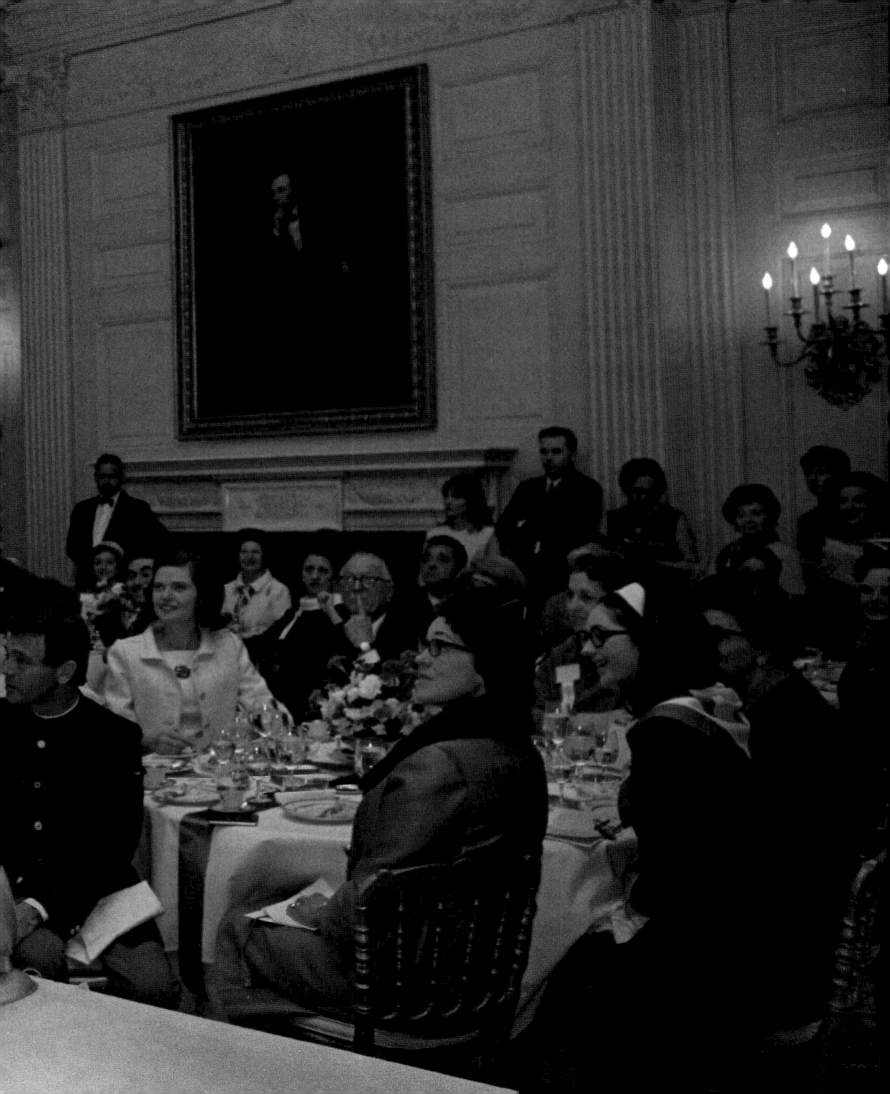

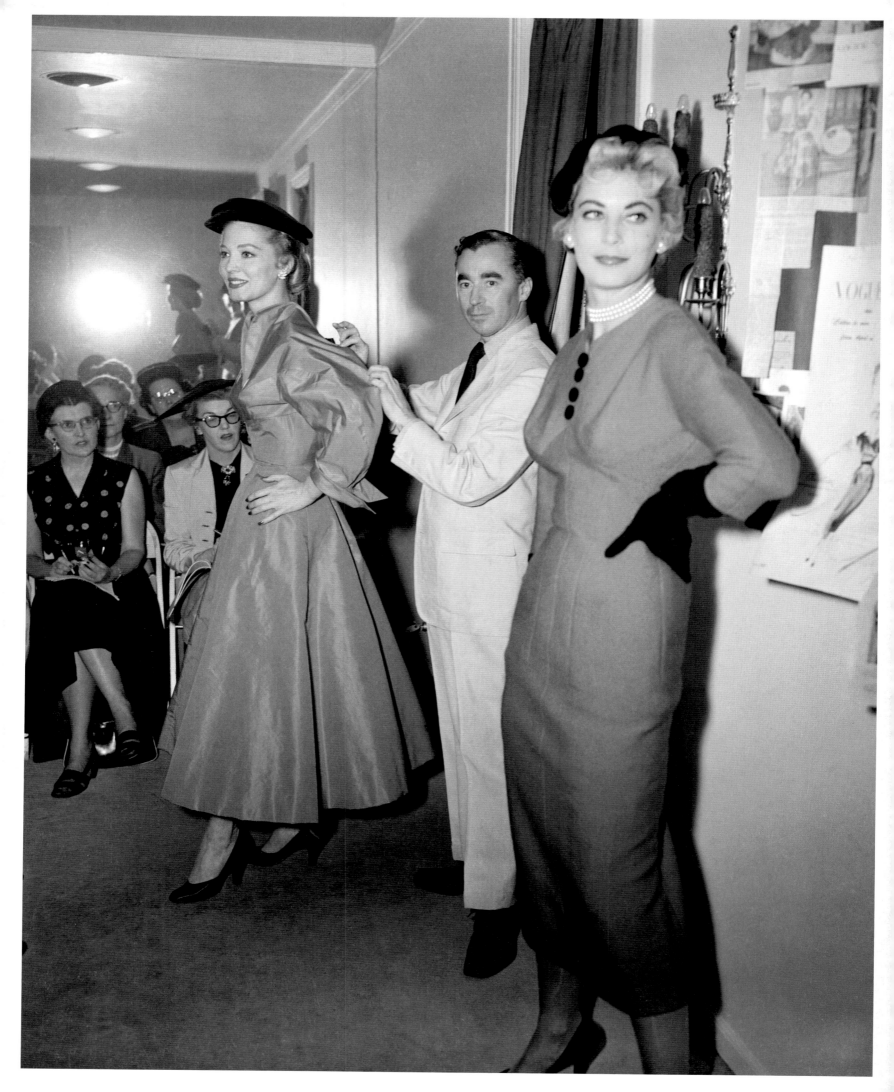

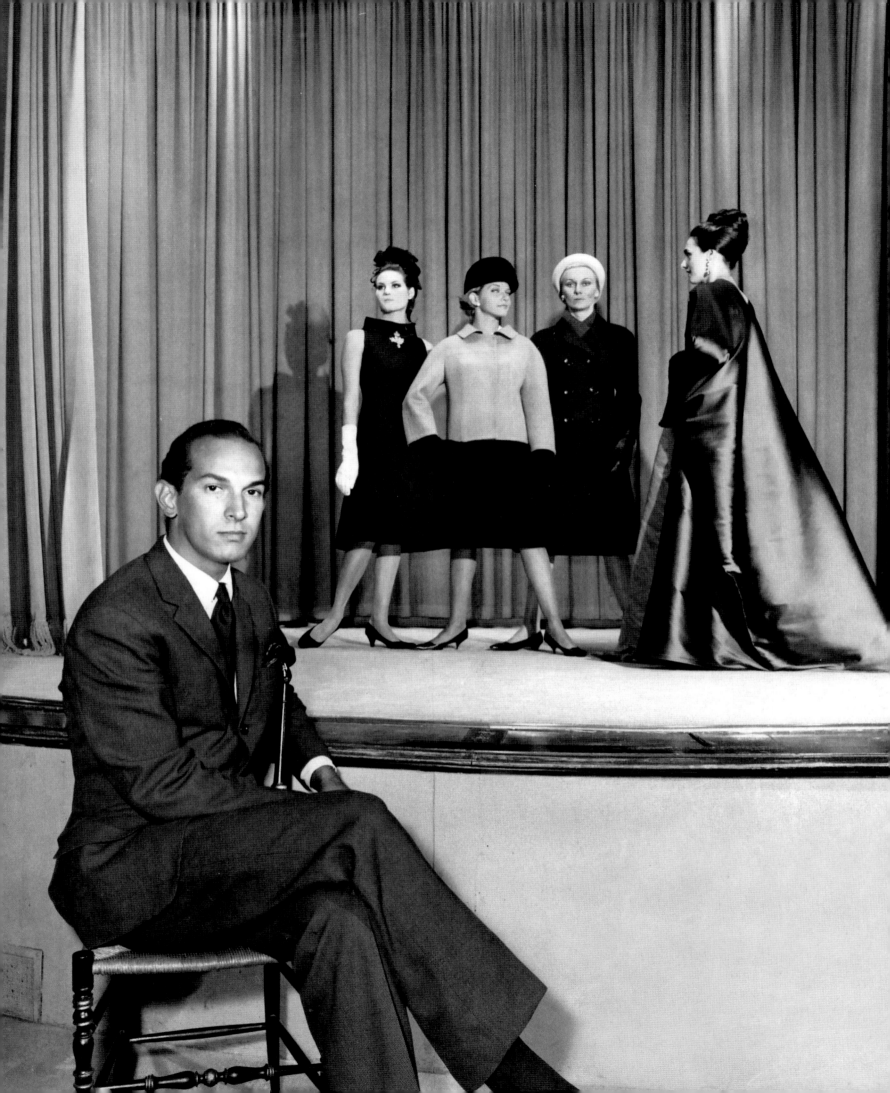

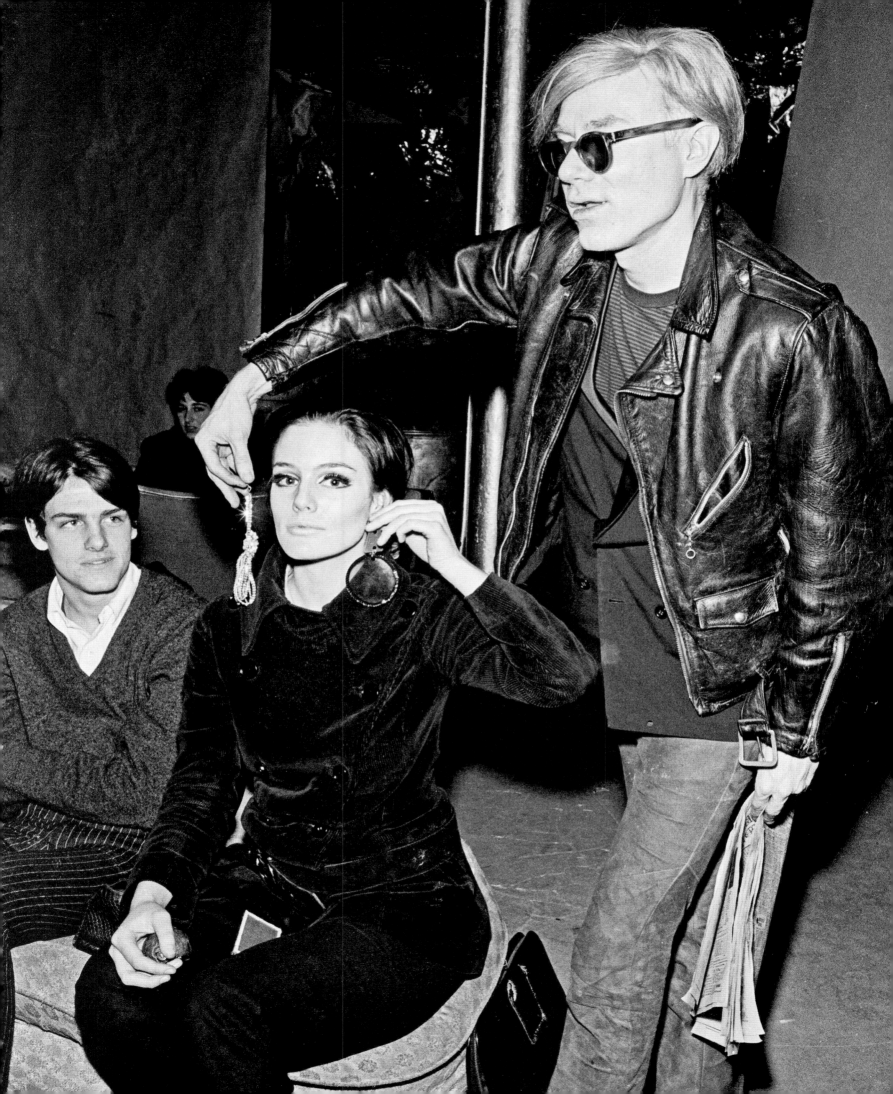

2

THE RISE OF
AMERICAN SPORTSWEAR

Youth. It was the single most important force in 1960s America, as a generation of Baby Boomers came of age under the modern glamour of the Kennedy White House in the early years, and the colorful counterculture at the end of the decade.

In 1961, when Jacqueline Kennedy became first lady at just thirty-one, she set a new standard for fashion in the United States. The clean lines and simple chic of her European- and American-made wardrobe were widely imitated, including styles by Givenchy, Balenciaga, Chez Ninon, and Oleg Cassini. "She not only disabused the French of some of their cherished misconceptions about American style backwardness, but she infused the national consciousness with a Gallic appreciation of fashion," Marylin Bender wrote in her 1967 book, *The Beautiful People*.[23]

And yet, designer fashion remained the provenance of the elite. Most serious designers presented their collections to the press in their showrooms, including Claire McCardell, Bonnie Cashin, Geoffrey Beene, Oscar de la Renta, Donald Brooks, and Norman Norell. Norell's openings were unique in that they were held in the evening, required everyone to wear black tie, and often attracted glittery society fixtures. "You would sit in the showroom, your legs would be on the floor, your hands would be in your lap with your gloves on," remembers journalist Marylou Luther. "It was all very civilized, and it was all about the clothes."

At the same time, there were new forces bubbling up. If Jacqueline Kennedy was America's royalty, Andy Warhol was its cultural revolutionary. From his beginnings in commer-

cial illustration and store-window dressing to his launch of *Interview* magazine and *Andy Warhol's TV*, he was deeply invested in style and fashion. His studio, The Factory, was the center of art and performance, with stylish It girls Edie Sedgwick, Baby Jane Holzer, and Nico as his muses. Glamour influenced his work and his lifestyle, from the fashion-model subjects of his early *Screen Tests* and his penchant for filming trendy boutiques and happenings in the 1960s, to his focus on Diana Vreeland, Carolina Herrera, Perry Ellis, and other fashion-world figures on his cable TV show in the early 1980s. Eventually the man who was always so self-conscious about his looks became a fashion runway model himself, represented by the Zoli and Ford agencies.[24]

The Swinging '60s' Effect on Fashion

In Europe, designers such as Mary Quant and André Courrèges were changing the look and feel of fashion shows by speeding up the pace, using props and live music, and having models smile, kick, and dance. And New York experienced its own fashion Youthquake, originating in the hip—and niche—boutiques that started sprouting across the city, including Fred Leighton for Mexican wedding dresses, Naked Grape for slogan T-shirts, Different Drummer for bell-bottom jeans, Teeny Weeny for futuristic plastic fashion, and Paraphernalia, whose opening was hosted by Warhol in 1965 (and where Betsey Johnson was the in-house designer).[25]

"In 1966, we had a cutting table, a runway, and a rock 'n' roll band," says Johnson of the Paraphernalia shows. "We just did these fun little parties, very innocently and unknowingly."

Opposite: Andy Warhol with model and actress Susan Bottomly, January 1967.

Magazines such as *Mademoiselle* and *Glamour* catered to the new youth market and spread the honors around for young American designers. "Until then, young women dressed like their mothers," says fashion journalist Luther. "In the '60s, the mothers started wanting to dress like their daughters."

Out of this rock 'n' roll, Pop Art swirl arose American fashion's first showmen and -women, who helped transform fashion shows from staid trade events into something more akin to 1960s happenings by mixing elements of art, music, and dance. As seasonal fashion shows became entertaining, celebrity-studded performances, and fashion became bigger business, the runway started to play a role for individual designers in creating a distinct brand image that reached the greater public.

The Runway Show as Pop-Culture Moment
Before he was America's first celebrity designer, Roy Halston Frowick, known as Halston, was a milliner. He rose to international fame in 1961 when Jacqueline Kennedy purchased his pillbox hat and wore it to her husband's presidential inauguration. His designs began to be featured in magazines, and in 1965, Barbra Streisand chose his salon in Bergdorf Goodman as a setting for her first TV special, *My Name Is Barbra*.

On June 28, 1966, his first runway show for his in-house ready-to-wear line at Bergdorf Goodman was a revelation to both those who were there and those who read about it afterward. Instead of quietly walking through a showroom holding numbered placards, as was tradition, Halston's models "seemed to swing down the runway as if they were having fun," wrote Stephen Gaines in his biography *Simply Halston*.[26] The designer's niece Lesley Frowick, who in 2014 curated the exhibition "Halston and Warhol: Silver and Suede" at the Warhol Museum, says, "He was one of the first designers to remove the number from in front of the stiff marching mannequins. He encouraged his models to do their own thing, so they all projected their own personalities, while they paid homage to the personality of what they were wearing."

The next morning, *Women's Wear Daily* columnist Carol Bjorkman raved, "Every once in a while, the fashion pendulum swings a certain way and out comes a star."[27] Other reviewers

weren't so sure, but Halston and his sleek, unfussy designs got the publicity they neeed.

His next shows, in October and January 1967, were covered by CBS TV,[28] and by 1968, when he opened his fabled mirrored East 68th Street showroom filled with exotic décor, walls covered in Indian batik, and pots of white orchids on every table, he had amassed a reputation as one to watch. "The shows were small, more like a party than a show. Everyone knew each other—and the Champagne was flowing," said Halston regular and legendary African American model Pat Cleveland.[29]

Halston was one of the first designers to feature a plus-size model on his runway, in the form of entertainer Pat Ast. "Each collection was a different performance," says Frowick. "Sometimes she'd be fanning herself all the way down the runway, sometimes she'd roll down the runway, sometimes she would flirt with people in the audience. Theatrics were a huge part of his collections from the beginning."

The same can be said of Stephen Burrows, the African American designer whose dynamic matte jersey clothes were inspired by the color and swirl of the nightlife and streets of New York City. It was Burrows who helped Cleveland develop her signature exaggerated runway walk, which was really a lyrical dance. In 1968, after attending the Fashion Institute of Technology, Burrows and his business advisor Roz Rubenstein opened O Boutique, across the street from the trendy nightclub Max's Kansas City on 18th and Park Avenue. He quickly became a designer to the arty downtown crowd that hung out at Max's, including Warhol and Joel Schumacher, who later gained fame as a filmmaker.[30] Schumacher introduced him to Geraldine Stutz, president of upscale Fifth Avenue retailer Henri Bendel, who persuaded Burrows to move his atelier to the midtown store and work as its designer-in-residence, bringing downtown cool uptown.

Cleveland walked in Burrows's first show at Henri Bendel in August 1970, held in Stephen's World, his third-floor in-store boutique resembling a swanky nightclub. "The show was such a hot ticket that the helpers had to keep extending the show space out into the hallways, bringing out folding chairs

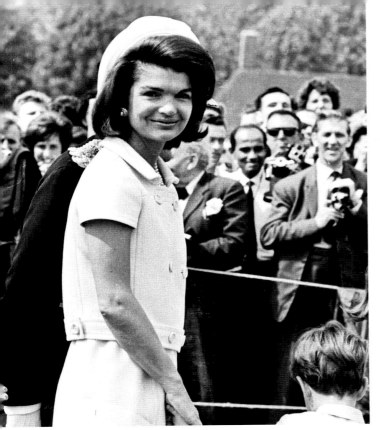
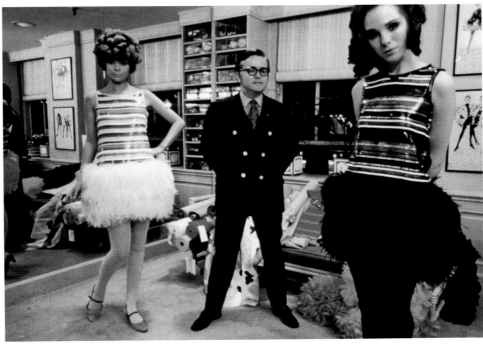
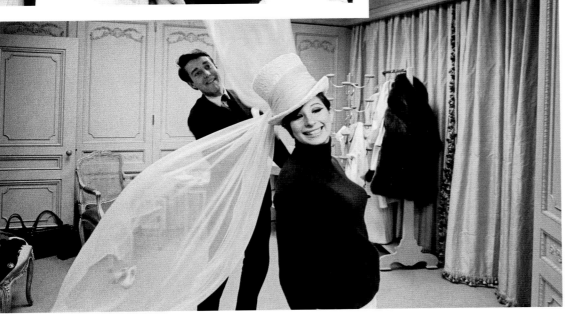

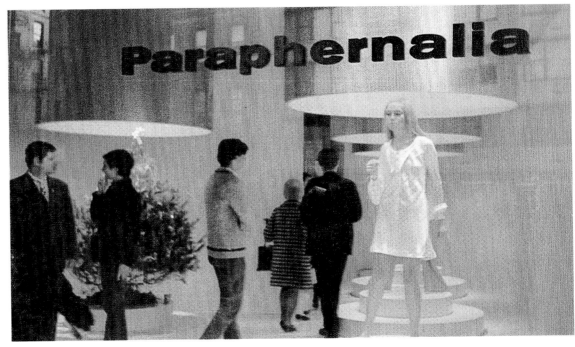

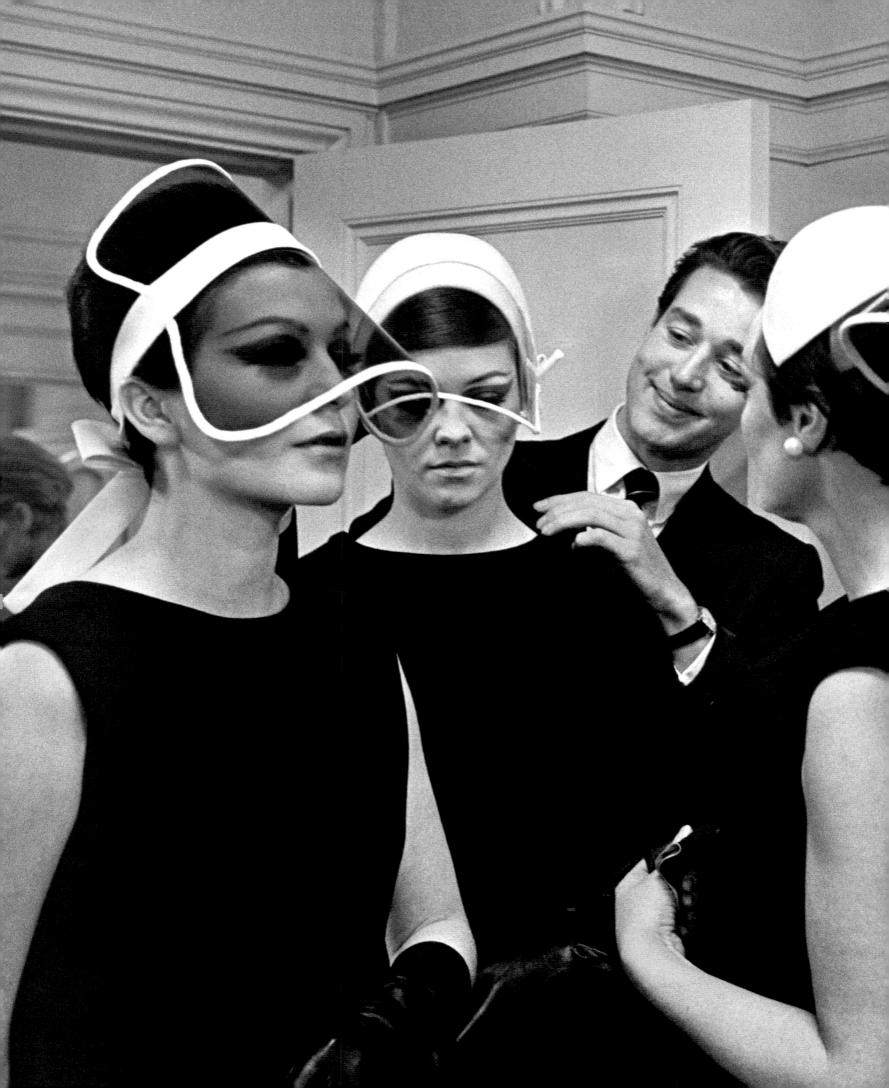

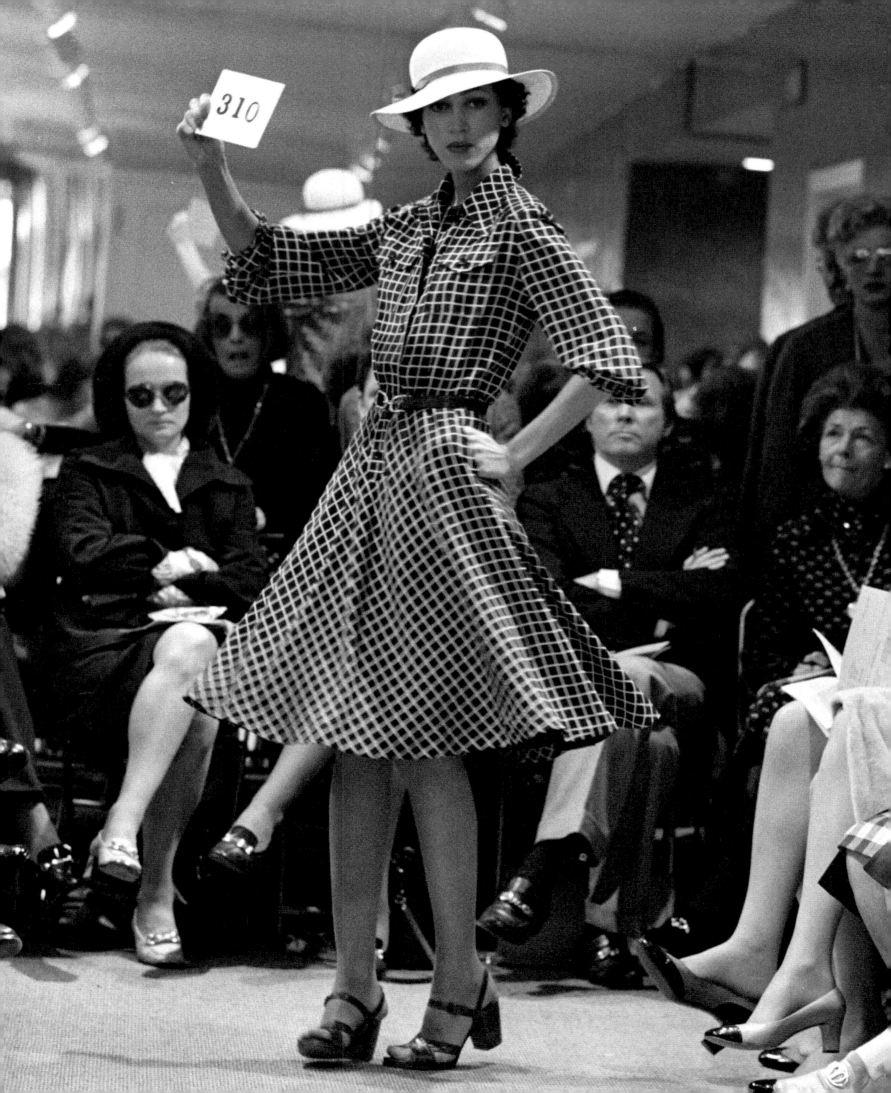

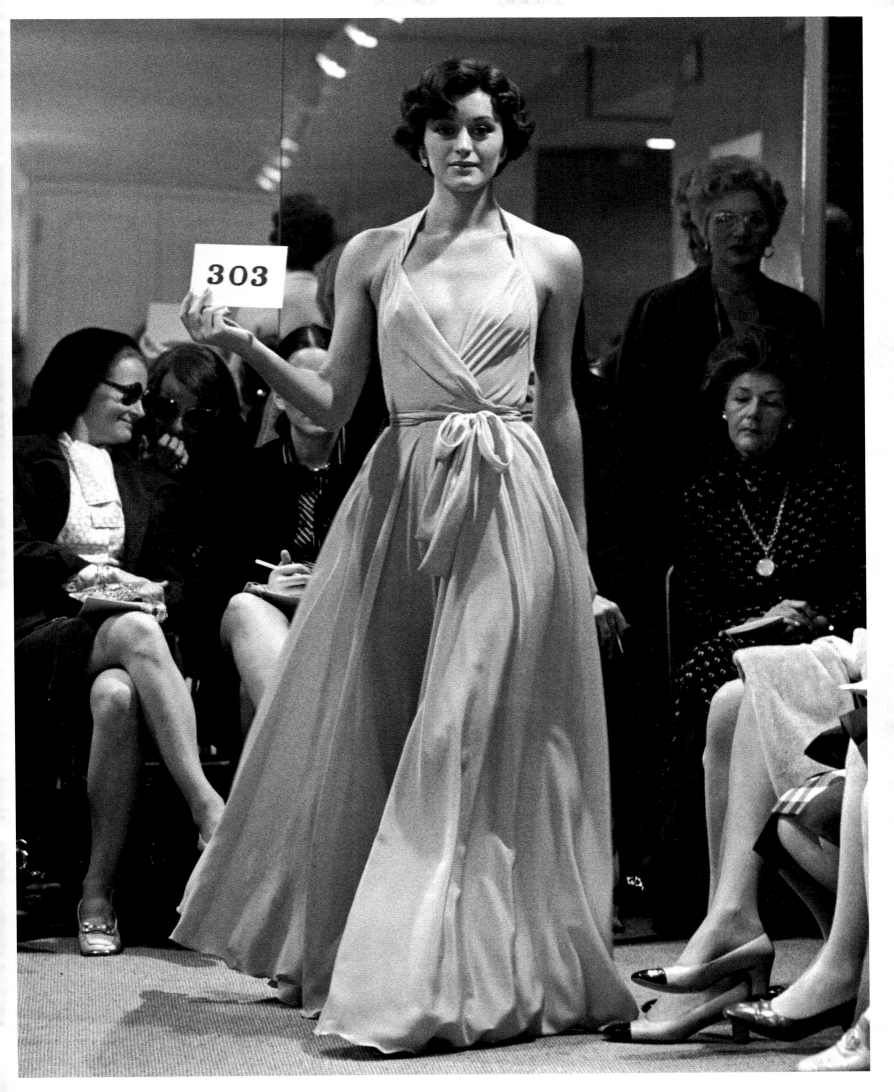

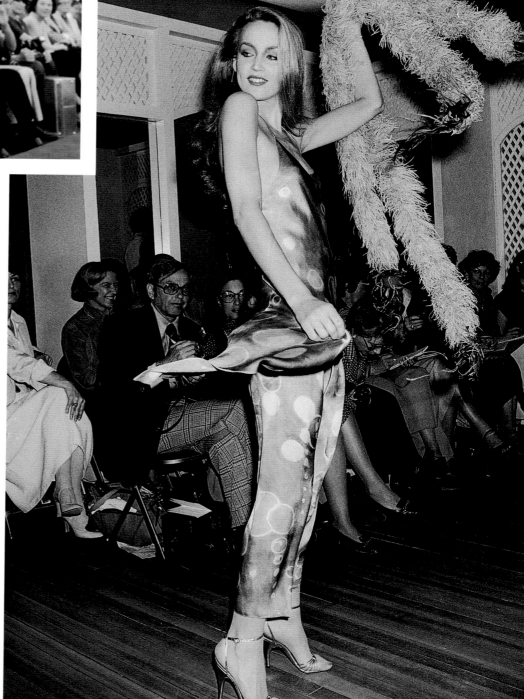

for the extra people until seats reached all the way to the elevators," she remembered. "Some editors arriving late found themselves as they got off the elevator walking along with the models.[31]

Selling Fantasy—and Reality—in the 1970s

Over the years, Halston cultivated a cadre of famous fans to sit in his front row, including Liza Minelli, Elizabeth Taylor, Bianca Jagger, Martha Graham, and Warhol, who called Halston's fashion shows "the art form of the 1970s."[32] Halston's association with Warhol hit a new level on October 19, 1972, at the Coty American Fashion Critics Award, when Halston was one of eight designers to win a Winnie, the Oscar of the fashion world. During the runway component, all the other designers gave traditional shows except Halston, who produced "An Onstage Happening by Andy Warhol." The happening involved blaring music, Warhol actress Donna Jordan tap dancing, a Halston-clad model juggling, fashion editor China Machado playing bongos, and then for a finale, socialite Nan Kempner cooking bacon on an electric stove onstage. "It was a very kooky event where each model was asked to do whatever she wanted to do, while wearing Halston clothing," explains Frowick.[33] The tony audience was less than thrilled, but Halston said, "It was fun and camp. God, I hate pretentions! If it shook people up, goody."[34]

Halston was ahead of his time, paving the way for the shape of fashion to come. It's debatable whether we would be watching designers on *Project Runway* or shopping for affordable versions of their clothes at Target and H&M if it weren't for Halston, a TV natural who once appeared on *The Love Boat*. He was the first American designer to try licensing on a large scale to the mass market, an exercise in fashion democracy that failed miserably then but is the norm now. He succeeded in bringing fashion to a wider audience. And perhaps he had to amp up his shows, in part, because his designs were so simple. He was also one of the first to employ a videographer to document his shows, Frowick says.

At the same time, Burrows was pushing the envelope with his showings. Music and a happy-minded disposition were the tools to selling a collection, Burrows says. "I saw the clothes,

in my mind, as all about showing off the human body through movement . . . the highest form of an idealized body in colorful, fun, toyful, second-skin clothes."

The models were key, too, and in the '60s and '70s they started to be known as personalities. Burrows loved the diversity, and says, "it was like dressing the everywoman." They became celebrities in their own right, which helped glamourize the industry for the outside world. "Fashion was no longer in a small showroom . . . it was a whole different thing," says former model Bethann Hardison, who was one of Burrows's muses and walked in the American portion of the 1973 Versailles show. "People expressed themselves, and it ties into what was happening at the time, the evolution and the revolution culturally, economically, and socially; that's what pulsated through what we were doing."

One of Burrows's more memorable shows was held in 1973, both in the lobby and directly outside of the just-constructed Solow building at 9 West 57th Street. "It was Geraldine [Stutz] who suggested that we try to get it as the venue for my show and to have the models enter the lobby through the huge revolving door from the street," says Burrows. "We used a vacant spot next to the lobby as the dressing room, and the girls literally stopped traffic, of course. I had live, in-house DJ Finlay playing new, unheard, R&B tracks. It was a big extravaganza and a great success."

Stan Herman, whose Mr. Mort collection was the height of fashion in the late 1960s and early 1970s, had his fair share of revolutionary shows at the time, too, including a presentation in 1972 during which he showed faux fur among the real animals at the Central Park Zoo. He remembers being blown away by the Burrows extravaganza. "They weren't just sitting there with their legs crossed; they were dancing to clothes," Herman says. "Stephen was very much the person who did that."

Versailles 1973

When it comes to securing New York's place as a major fashion capital, one show succeeded above all the others. In 1973, Eleanor Lambert was tapped to help raise funds for the

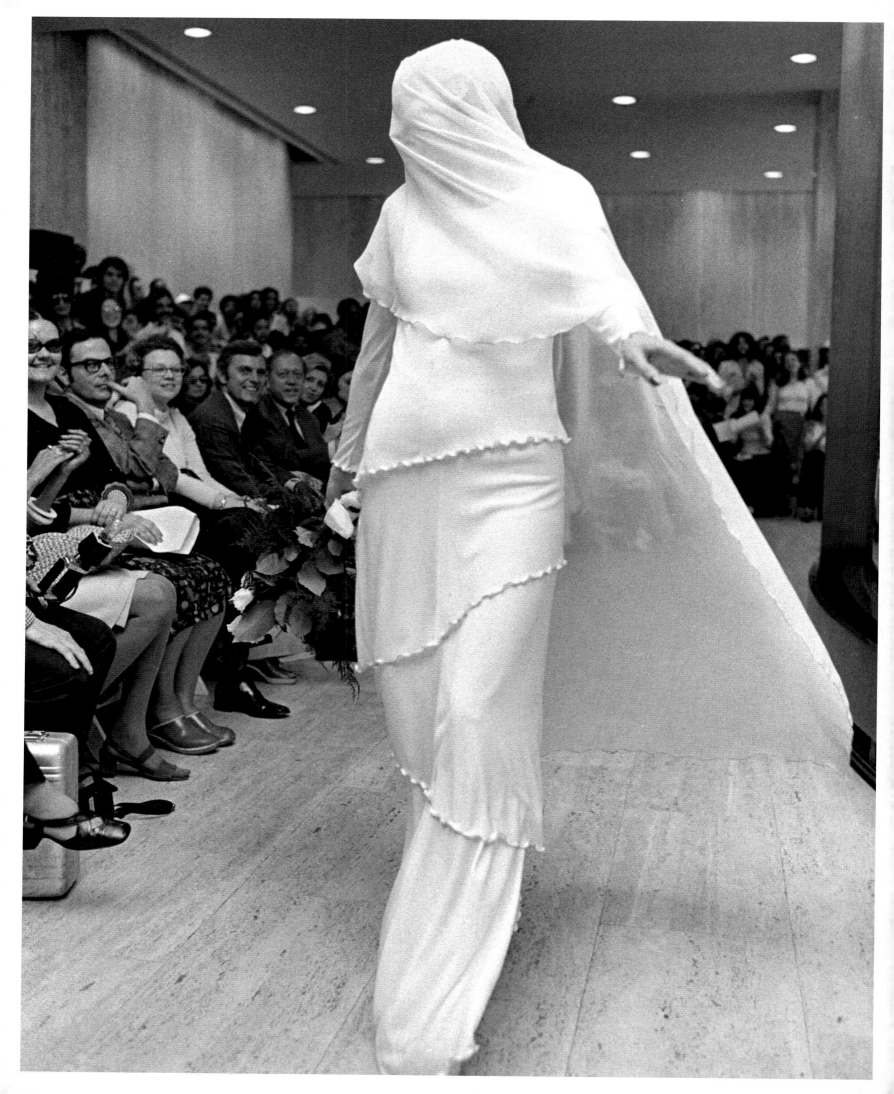

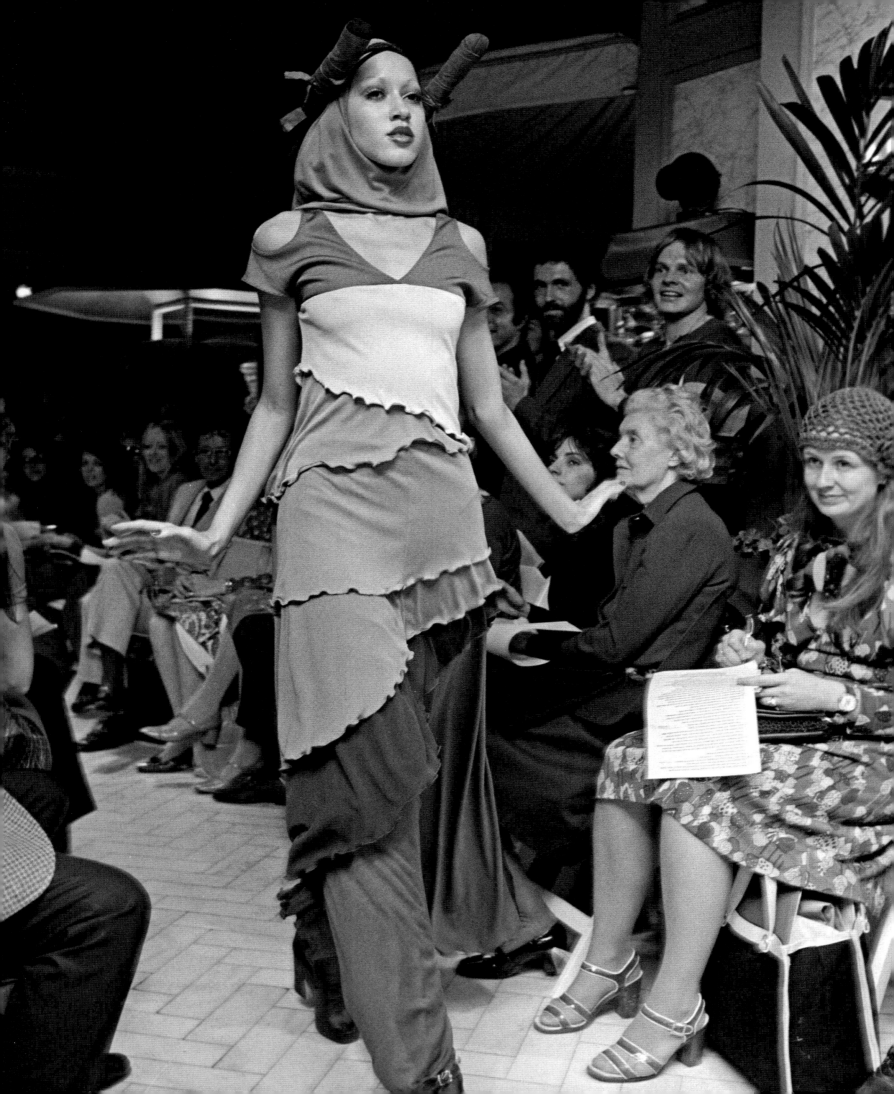

restoration of the Palace of Versailles in France by producing a Franco-American fashion show.

At the politically and culturally charged event, Lambert's American designers were society-minded Bill Blass and de la Renta, modern minimalist Halston, youth culture representative Burrows, and sportswear star Anne Klein (who brought assistant Donna Karan), and they went toe-to-toe with French masters Yves Saint Laurent, Pierre Cardin, Hubert de Givenchy, Emanuel Ungaro, and Marc Bohan for Christian Dior. Although it was not billed as a battle between New York and Paris, it essentially was, with ready-to-wear—the wave of the future—up against French couture—a vestige of the past.

"The French were impossible," remembers Karan, who was pregnant with daughter Gabby at the time. "They took all day to do all their prep, and we had to go at night. We had a black curtain that didn't fit the floor because they must have measured it in inches instead of centimeters. It was a disaster."

The French designers spared no expense for their lavish show, which featured a forty-five-piece orchestra, a pumpkin coach, nearly naked Le Crazy Horse Saloon showgirls, ballet dancing by Rudolph Nureyev, and American expat chanteuse Josephine Baker dressed in an ermine cape, singing "J'ai Deux Amours."[35] While the crowd of seven hundred (a who's who of society, including Princess Grace, C. Z. Guest, and the Baroness de Rothschild) drank Champagne during intermission, the American designers panicked backstage.

To open the American portion, Minelli, fresh from winning an Oscar for *Cabaret*, came out singing "Bonjour Paris" against a bare-bones set of the Eiffel Tower by fashion illustrator Joe Eula. Of the cast of thirty-six American models, the ten African Americans made the most unforgettable impression, including Cleveland, Hardison, and Billie Blair. They danced and moved to the music, allowing the easy American sportswear to shine.

"The minute Anne [Klein's] collection came out, because she showed first, the audience was blown away," says Karan. "Everyone was used to stiff [models] walking out with the numbers, and we had the first group of black models. The way we showed versus the way they showed—it was unbelievable. For us, it was about clothes and energy. The French said, 'What do you mean no zippers, no hooks and eyes? You don't need somebody to dress you? What is this American style? They had never seen sportswear."

"The performance was the beater," says Burrows. "The American segment was clean, fresh, and fast—our show was thirty minutes long and the French went on for two and a half long, boring hours."

The American presentation, choreographed by Kay Thompson, an actress, singer, and the author of the *Eloise* children's books, felt natural and new, from Klein's revealing styles for the beach, to Burrows's swirling color dresses, to Halston's sensual sequins and chiffons, some barely covering the breasts. "They showed clothes you could wear, and that was important," says the Fashion Calendar's Ruth Finley, who four decades later still lists Versailles 1973 as the best fashion show she's ever seen. Cleveland spun and twirled, Hardison strutted with steely determination, and Blair danced in a performance that carried with it the winds of cultural change. The audience threw their programs on the stage in stunning approval. It was the championing of the new over the old.

"Sportswear made us different from Europe," says Herman, who credits Klein with creating American fashion as we know it today by understanding that women wanted to dress more casually. "We saw European glamour and that way of life as unattainable to most people. But Anne knew women were going to wear sportswear. She was right. And they started to take us seriously over there."

By leveraging their fresh approach and easygoing lifestyles, and making them cornerstones of their brands, Anne Klein, Halston, and Burrows paved the way for the great American sportswear giants: Calvin Klein, Ralph Lauren, and Perry Ellis.

American Fashion Comes of Age

Born Ralph Lifschitz in the Bronx, Lauren began in the tie department of WASP bastion Brooks Brothers before he started designing and selling his own neckties in 1967. Soon,

Opposite: The "Battle of Versailles" fashion show, Versailles, France, November 1973. From top row, left to right: Bill Blass with models during a rehearsal; Yves Saint Laurent and guest (top); Marisa Berenson, Halston, and Liza Minnelli (bottom); Pat Cleveland backstage at the show; Paloma Picasso (left) with Andy Warhol; the audience at Versailles; Stephen Burrows and guest; A model on the runway. Following spread: Models during the "Battle of Versailles" show.

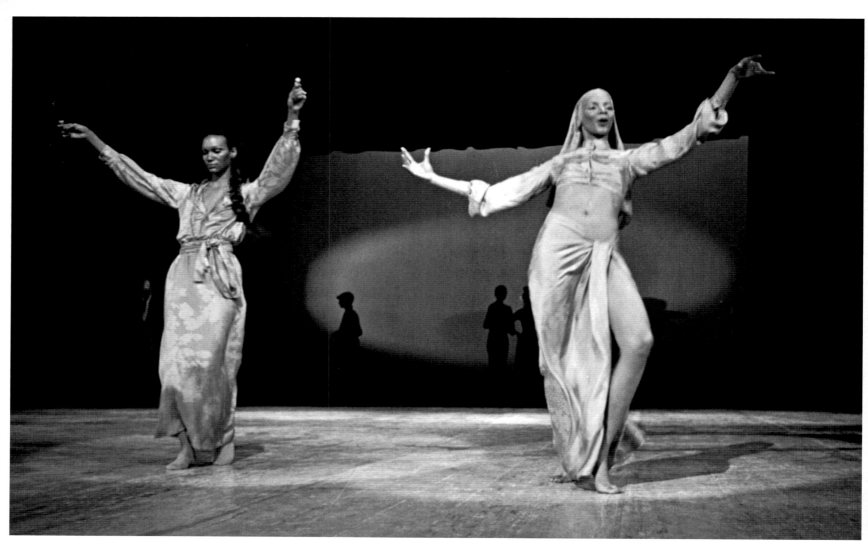
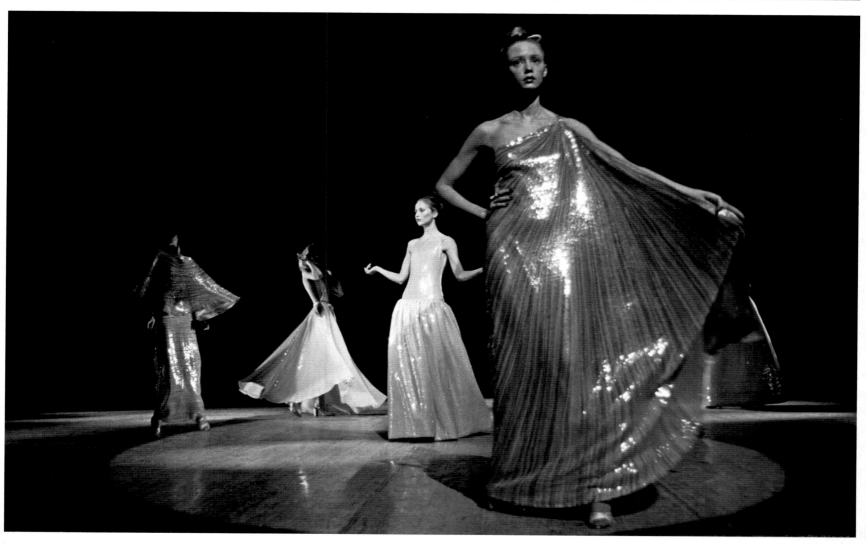

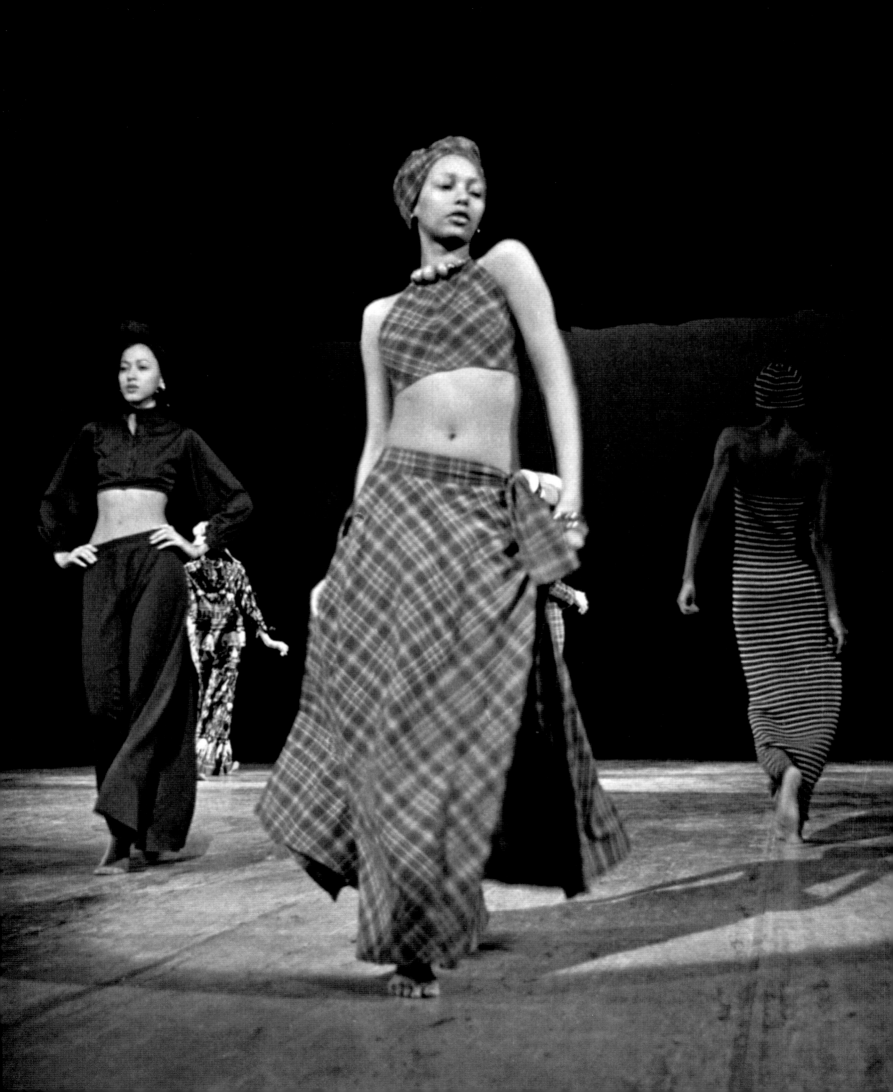

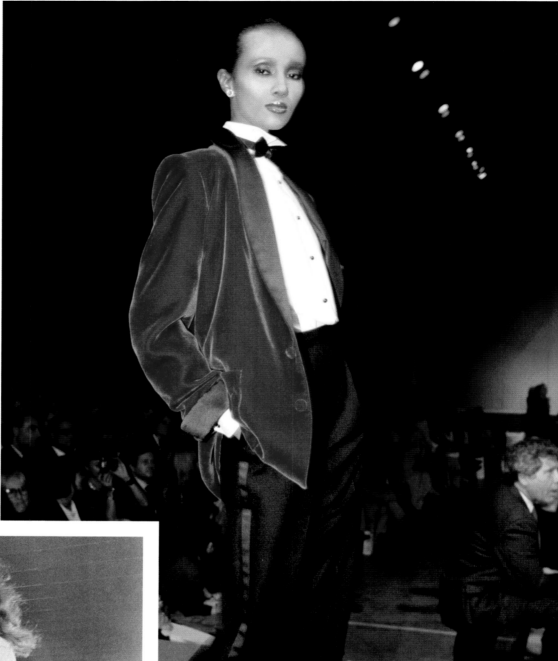

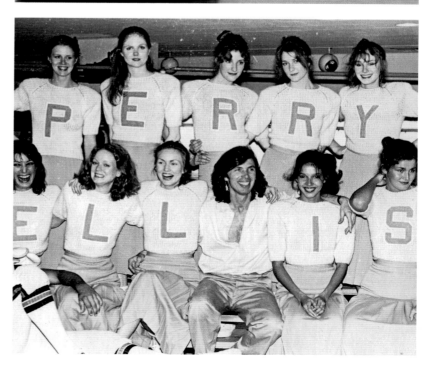

he was expanding into oxford and polo shirts for men, emblazoned with an instantly recognizable polo pony on the front, and then a whole range of men's and women's wear. Using the storyline of heritage and wealth, he spun lavish ad campaigns and fashion shows to sell the Ralph Lauren lifestyle.

"The first women's collection I showed to the press was Fall 1972," says Lauren. "We set up chairs in my office at 40 West 55th Street. There were only ten or fifteen editors and about ten models. They strolled in one at a time, and I talked about the clothes. Looking back, I loved that intimacy."

Ellis rose from a job as a sportswear buyer at the Miller & Rhoads store in Richmond, Virginia, in the late 1960s to founding his own label in New York in 1975, backed by the manufacturing house Manhattan Industries. He burst onto the scene with a new, fresh-faced ideal. Ellis was anti-establishment, anti-pretentiousness—and he understood the power of a good presentation.

His Fall 1978 runway show is the stuff of legend: The designer staged a pep rally, complete with cheerleaders and a Princeton quarterback to create excitement around his signature "slouch look" geared to the collegiate crowd. Models laughed and smiled as they walked down the runway, and the editors had a ball. The show proved that fashion could be lighthearted and fun and that showmanship could help tell the story of a fashion brand. Ellis helped redefine the runway. It's no wonder he would become an inspiration to one of fashion's most famous showmen of today, Marc Jacobs. "I think fashion dies when it is taken too seriously," Ellis said.[36] "There is more to life than buying a new bag or a new dress. I really try to put clothes in the proper perspective."

Like Halston, Ellis developed a cult of personality that made buyers greet his creations at runway shows as if they were seeing their favorite rock stars. His shows "were anticipated because they were bigger and brighter and more star-studded than your average Seventh Avenue show," says Isaac Mizrahi, who worked for Ellis early in his career. "He was also one of the first designers to book print models like Kim Alexis, Esmé [Marshall], and Janice Dickinson. It was really Perry who decided to use those girls in the show. I remember people saying, 'They are so stiff, they don't know how to walk.' But they were great in photos, and it was very titillating and exciting for editors and the audience to see print stars on the runway."

An even bigger success story was Calvin Klein, who like Lauren also hailed from the Bronx. He rose from a job as copy boy at *Women's Wear Daily* to a Seventh Avenue titan, selling billions of dollars' worth of licensed product by the late 1970s based on design, yes, but also on shrewd marketing and a brand image built on sex.

Klein launched his label in May 1968 with just six coats and three dresses, winning attention almost immediately from buyers and press for his clean lines and simple shapes. In 1974, he won his second Coty Award and chose to show his fall and resort collections, which included models wearing cardigans paired only with bikini bottoms, at the award ceremony. "The night of the show, we told them to unbutton it. . . . Of course, these bare breasts were flashed, and it brought the house down," said Jeffrey Banks, a former design assistant to Klein.[37] Klein used the power of sex and celebrity to sell designer denim (in 1980, a thirteen-year-old Brooke Shields famously said, "You want to know what comes between me and my Calvins? Nothing."), underwear, and numerous fragrances, from Obsession to CK.

"When designers started holding hands with the beauty industry, it made a big difference. The runway show became a bigger part of selling everything," says Herman.

More than a single piece, designers had to sell a look and a lifestyle, so they could make even more money on affordable, attainable products like perfume, jeans, underwear, and activewear. For sportswear powerhouses like Calvin Klein and Ralph Lauren, the runway would become part of spinning this fantasy, especially as women's wardrobes became more casual.

By 1979, it seemed that American fashion had finally achieved equal footing with European fashion, as the *New York Times*

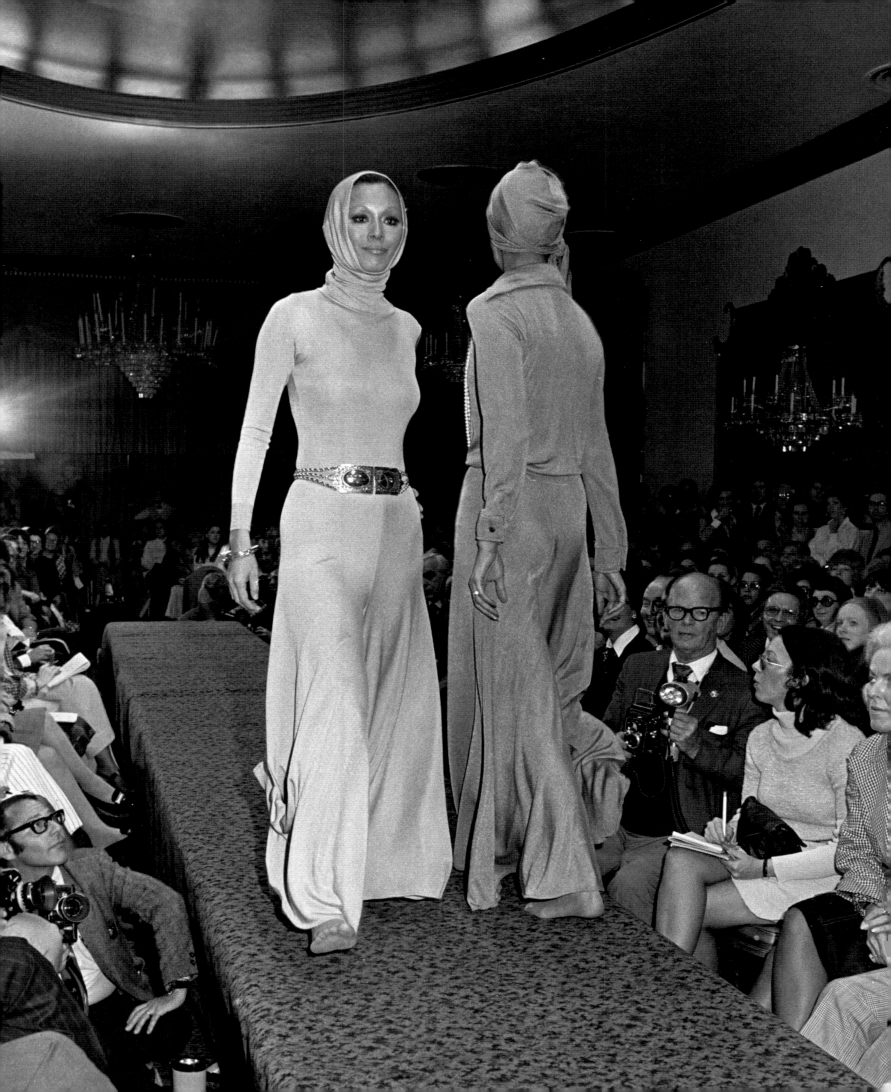

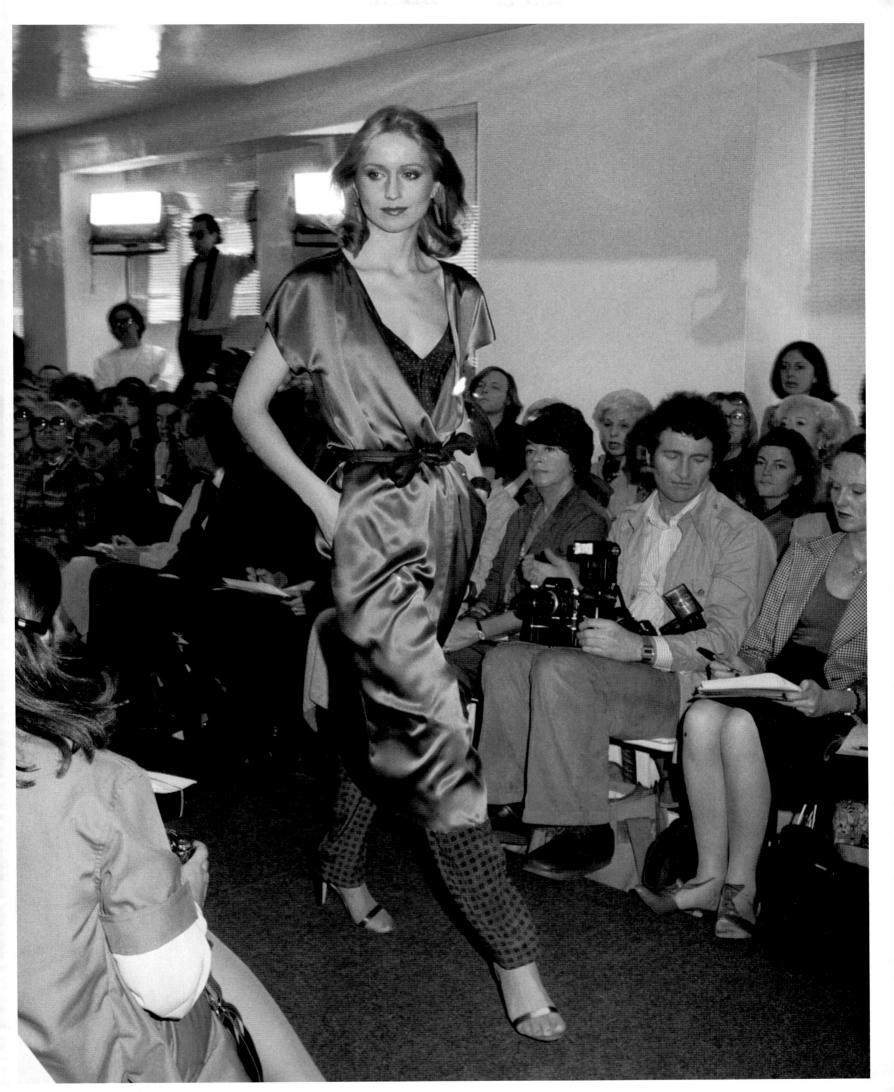

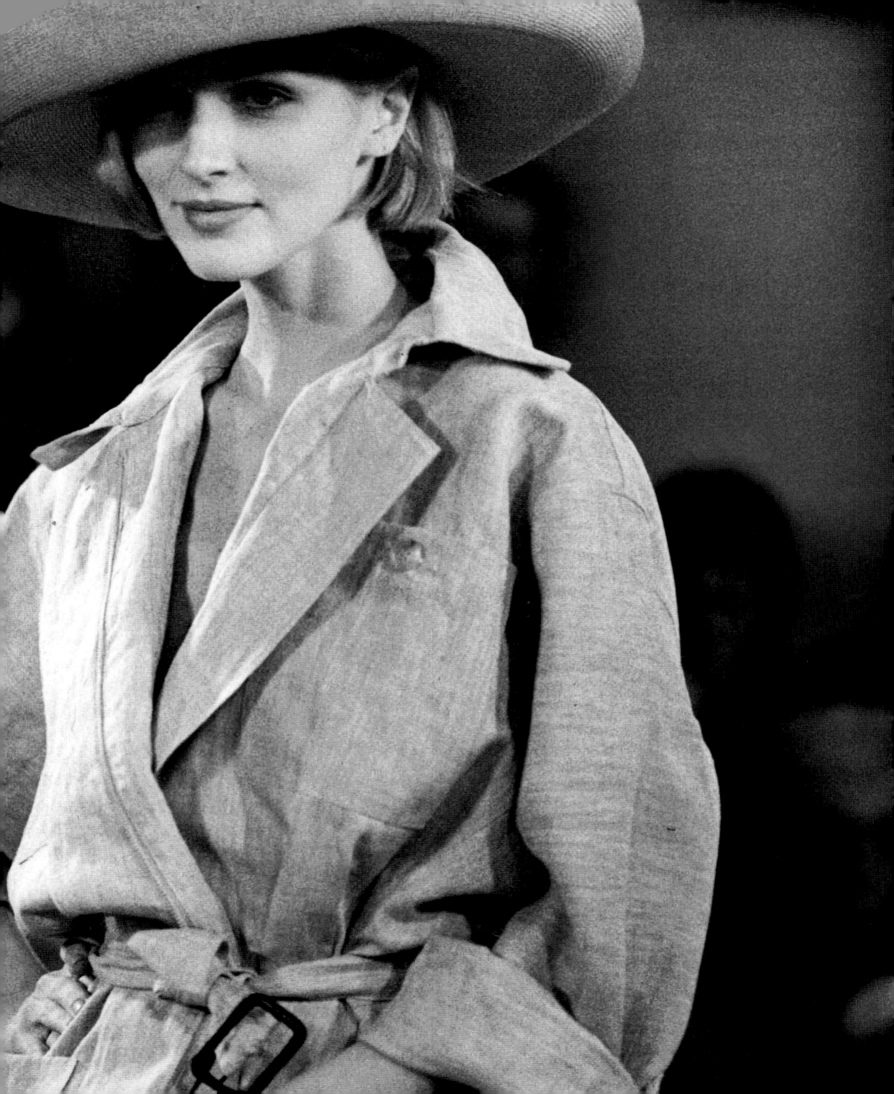

proclaimed that the names of Perry Ellis, Calvin Klein, Geoffrey Beene, and others were as well-known as Karl Lagerfeld, Thierry Mugler, and Yves Saint Laurent. Parisian clothes were considered by many to be out of touch compared to America's more accessible styles. As Carrie Donovan wrote in the *New York Times*, American designers had "come of age."[38] And even though many designers were not selling their clothes internationally yet, it was common to see European editors at New York presentations.

Fashion became less about dictating trends and more about women cultivating an individual look, and Americans excelled at giving them the tools for lifestyle dressing. Designer denim became a thing, Diane von Furstenberg designed the legendary wrap dress, and Betsey Johnson presented Spandex at her downtown shows, including one held at a roller rink with a Blondie soundtrack. "We wanted it like Frank Sinatra, 'My Way,'" says Johnson of first showing her namesake label in 1978. "There was nothing else around. There were no tents. There was the Mudd Club and downtown survival. You created by air and went with the flow."

And yet, Europe was ahead of the United States in organizing fashion weeks as we know them now. The first recognized Paris Fashion Week, held in 1973, organized haute couture, ready-to-wear, and men's fashion under one umbrella, the Fédération Française de la Couture. The French held shows outdoors in tents, first at Centre Georges Pompidou, and later in Les Halles, where the 1979 "Super Bowl of Style" boasted twenty presentations.[39]

Not everyone thought it was a good thing though, including Donovan. "This is not the way things should be, of course. But the extravaganza, whetting the appetite of both creator and viewer, is a fact of life that promises to remain."[40]

Worlds Colliding, the Democratization of Style

The '80s brought on themes that would shape the next thirty years of American fashion: mass vs. class, downtown vs. uptown, celebrity vs. socialite, democratic vs. exclusive, the street vs. the runway. The public appetite for and awareness of fashion grew throughout the decade, when there were plenty of high-wattage fashion events, cable TV coverage, and designers with showbiz personalities but little consistency.

Downtown, "there were a lot of people making things, super arty kids, this girl Carmel who had a storefront, someone named Animal X, she was wild. . . . It was a very rough, sewing it themselves, showing it in clubs kind of thing," says *Paper* magazine cofounder Kim Hastreiter. In the late '70s, the downtown fashion world revolved around Betsey Johnson and Andre Walker, she says. "Andre was in high school when I met him, and we became really good friends. He did fashion shows wherever he could get free space, and they were so outrageous. He was such an artist and had the craziest makeup and wigs. One show, he had the girls walking with those invisible dog leashes. Keith Haring, Jean-Michel Basquiat, and Andy Warhol started coming to see what he was doing."

There was one show that would make Hastreiter go above 14th Street: Geoffrey Beene, with whom she was a friend for life. "He always was a rebel, and I met him through Andre [Walker]. Geoffrey put us in the front row at his show and we died—all the gowns!"

Meanwhile, department stores and brands tried to outdo one another with elaborate promotional runway shows, such as Bergdorf Goodman's US debut show for Jean Paul Gaultier in Battery Park,[41] and one Dawn Mello organized for Azzedine Alaïa at the club Palladium, hosted by nightlife impresarios Steve Rubell and Ian Schrager.[42]

And in June 1983, Halston debuted his mass-market J.C. Penney collection with an extravaganza at the American Museum of National History set under the giant blue whale, and attended by his old pal Warhol. The show then traveled to twenty cities across the country and was viewed by a total of six thousand people. "What I always wanted to do was dress America," Halston said.[43] The move to do cheap chic destroyed Halston's brand name, because his top retailers dropped him, but it did a lot for the American runway by predicting the kind of public-facing events that would become the way of the future.

Opposite, clockwise from top left: Models in the Calvin Klein Spring 1974 collection, November 1973; Klein uses a model to measure out a pattern, October 1967; Klein, seated in his workroom, with actress Elizabeth Ashley (left), model Sara Kapp (center), and photographer Berry Berenson Perkins (right) wearing his designs, 1975; Klein, Brooke Shields, and Steve Rubell at Studio 54, September 1981; Calvin Klein Fall 1973 show, May 1973.

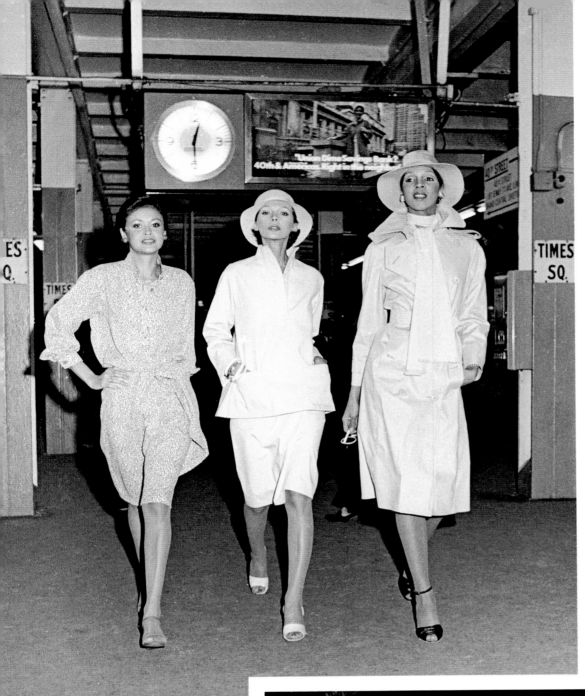

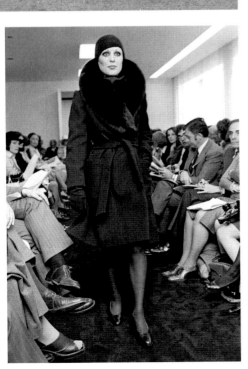

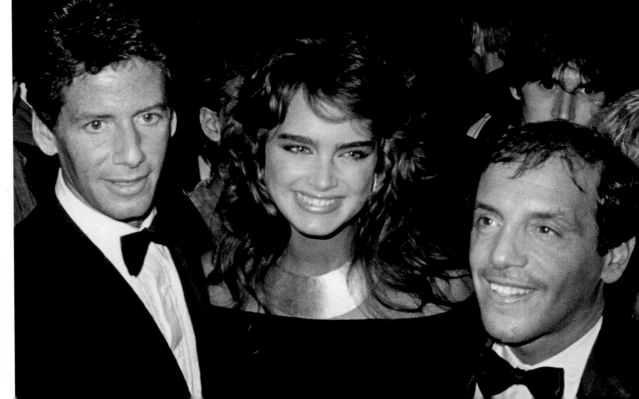

3

GETTING ORGANIZED

By the 1980s, Seventh Avenue was booming; already having conquered the men's, women's, denim, and fragrance markets, Calvin Klein was launching underwear and the lower-priced CK line. Ralph Lauren was spinning off Polo Sport, opening stores internationally, and positioning itself for a public offering in the next decade. And in 1985, after years at Anne Klein, Donna Karan was striking out on her own, launching her "Seven Easy Pieces" collection of separates, starting with the bodysuit, which *International Vogue* editor Suzy Menkes calls "the beginning of fashion feminism," and the lower-priced label DKNY in 1988. Meanwhile, Arnold Scaasi, James Galanos, and Bill Blass continued to dazzle the society set with glamorous evening clothes and daytime suits.

As the industry grew and designers began expanding into licensed products, fragrances, home furnishings, and secondary lines, so did the ranks of the fashion press, buyers, and industry bigwigs at the twice-annual shows scattered throughout April and November, and organized by the Fashion Calendar. There was an increased pressure on designers to have bigger presentations in more professional venues. The runway was becoming a key part of fashion branding and an expression of a designer's vision that could be sold across multiple categories. "I had been in the business for eleven years," Anna Sui said, "yet people didn't consider me a player until I did a fashion show. It gives the press and retailers a clue as to how to define you."[44]

Designers were having shows all over New York City, from Fifth Avenue hotel ballrooms to downtown lofts. "My favorite show of all time was my first one in 1981," says Carolina Herrera. "It was at the Metropolitan Club, and I had Iman and all the other great models, and a little band playing Cole Porter songs. It was a mix of press, society, friends, important buyers, and presidents of stores. When Steve Rubell arrived at the club, he wasn't wearing a tie, and there was a dress code, so he went to the Bergdorf Goodman men's department and bought a tie and came back to the show! Maybe I loved it because I didn't know where I was going or what I was doing."

In April 1983, Ralph Lauren rented the Park Avenue Armory to allow ample space to show the breadth of his aristocratic lifestyle collection for men, women, and children, including ski clothes, tailored coats, and slip dresses, by then nearly a billion dollar business, "but you couldn't reach out and touch the clothes or even tell for sure what they were made of," sniffed Bernadine Morris in the *New York Times*.[45] Meanwhile, Calvin Klein and Karan stayed close to home in their showrooms, sometimes having two or three shows in a row to accommodate all the guests. "It was a small, brand-new company," Karan says, "and I wanted that intimacy, so people could understand what the clothes were all about."

Uptown vs. Downtown

In the late '80s and early '90s, Scaasi, Herrera, Oscar de la Renta, Carolyne Roehm, and others held their shows at the Plaza Hotel after Ivana Trump began offering lower rates than surrounding hotels. At the time, she was married to then–real estate developer Donald Trump, who had bought the Plaza in 1988, and she was the hotel's president. "During

Opposite: Arnold Scaasi Fall 1989 show at The Plaza Hotel, April 1989.

the fashion shows, she held a front-row seat at every event," reported Gannett News Service in 1989. "Photographers, eager for candid photos of Ivana and her husband, who accompanied her to many of the shows, snapped away and, at the de la Renta showing, had to be asked to sit down so the show could begin."[46]

The excitement wasn't limited to who was in the front row. In 1989, at the Scaasi show, look No. 8928 was a replica of First Lady Barbara Bush's satin and velvet inaugural-night ball-gown.[47] The next year, the designer had Dalmatians on the runway to match his black-and-white clothes, and Ivana Trump organized a fashion show as part of the Easter parade down Fifth Avenue, enlisting twenty designers, including Lauren, Klein, and Karan, to create Easter looks, raising money for Equity Fights AIDS at an after-show brunch.[48]

Designer and society fixture Blass showed nearby in the Pierre Hotel ballroom, spending up to half a million dollars per season and repeating the presentations three times to accommodate well-heeled clients like Nan Kempner, Lynn Wyatt, and Betsy Bloomingdale, as well as his business associates responsible for licensing his name and putting it on everything from bed linens to Lincoln Continental cars. "It impresses the hell out of the licensees," he said in 1989,[49] explaining the rationale behind his expensive runway presentations. "As obsolete as the fashion show may be, there's no other way we can generate the same excitement."

Ever the showman, Todd Oldham packed standing-room-only crowds into Soho lofts, including front-rowers David Byrne, Spike Lee, and Susan Sarandon, to see his kitschy, themed shows and bewigged models, ranging from transvestites to pop stars Queen Latifah and Kate Pierson from the B-52s. "It's the only fair chance for me to show what I do the way I see it. Once it gets to the retailers, it's their way," Oldham said.[50]

Other downtown designers were feeling the squeeze. After several seasons of crowding guests into her tiny showroom on Seventh Avenue, Betsey Johnson moved to the Parsons School of Art and Design auditorium for her 1987 "Betsey's Backyard Fashion Follies" collection. *Our Gang* and the Little

Rascals were the inspiration behind the clothing, and during the show, Johnson stayed onstage, "strumming a guitar and proffering Champagne."[51] "I never wanted to have just a regular show," says the designer, whose runway cartwheel and splits, done instead of a bow, may be one of the American runway's most recognizable designer moves. "I have always been inspired by my dance recitals from when I was a kid, and by happenings. I spoke to my downtown people, the Max's Kansas City crowd, or whatever time period I was in."

Meanwhile, younger designers struggled to show at all, with the high costs of renting a venue, invitations, lighting, sound, hair, makeup, and $350/hour models adding up to $15,000 at a minimum. "Every season I'd look for wonderful spaces that hadn't been discovered," says Isaac Mizrahi, whose first show in 1988 was at a Soho loft. "One was at the Hammerstein Ballroom, where literally the walls were crumbling; one was at Cipriani downtown before they built the lobby, and it was just a huge fabulous marble bank space. We had a show at the Pace Gallery, and one at this crazy Brazilian restaurant. I always wanted it to be topical, interesting."

If there were fifty designers showing during a season, there were fifty venues. Some weren't designed for big events and were difficult for the press to get in and out of, and others were downright dangerous.

The final straw was actually a piece of plaster that came loose from the ceiling during a Michael Kors show held at a Chelsea loft on a very hot, humid April day in 1991. "We had this pounding disco music. 'Shake Your Body Down' was the first song, and we were at look number 6 or 7, and I heard an explosion; that was my first thought," Kors recalls. "Naomi Campbell came backstage and said the ceiling had caved in. I think what happened was that from the heat expanding and the intense bass in the music, the plaster just crumbled and we hit [then *International Herald Tribune* fashion editor] Suzy Menkes square in the head, and Carrie Donovan from the *New York Times* had plaster all over her."

"It almost killed [model] Anna Bayle by an inch," remembers then-*Elle* magazine editor Joe Zee. "But she did a twirl and

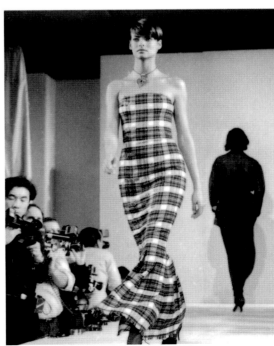

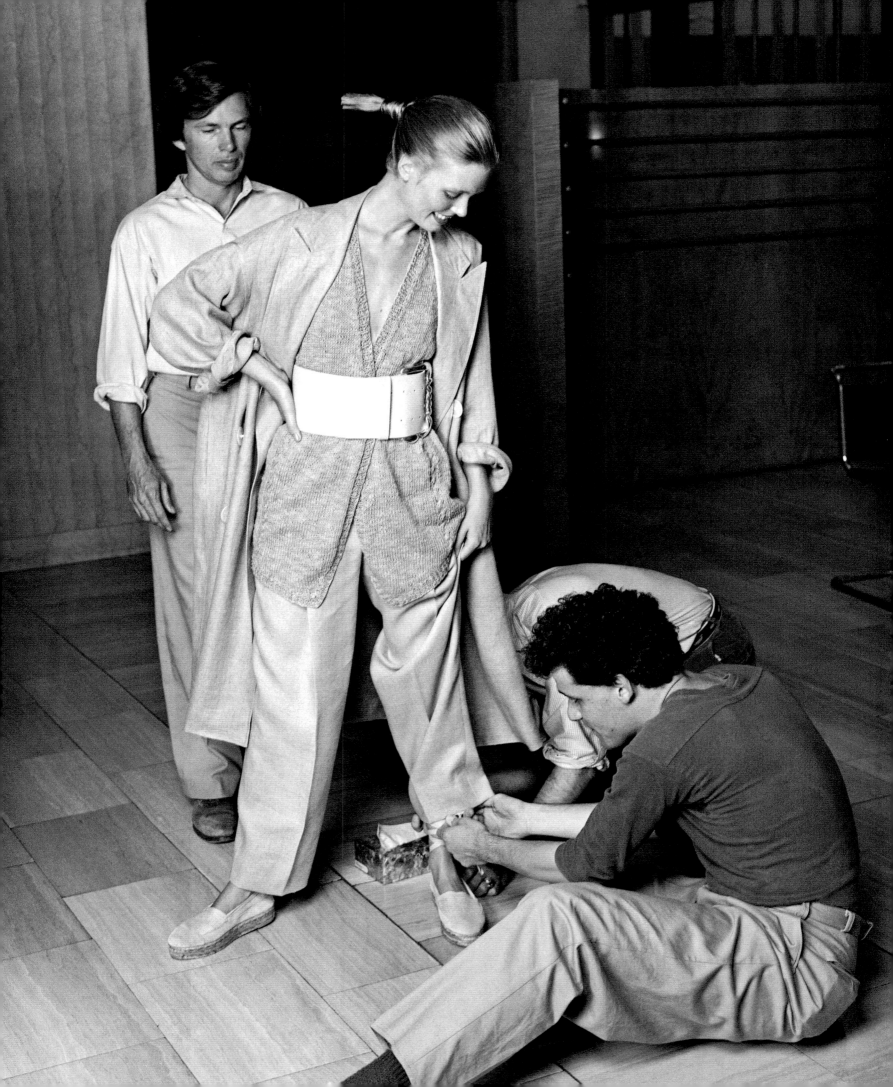

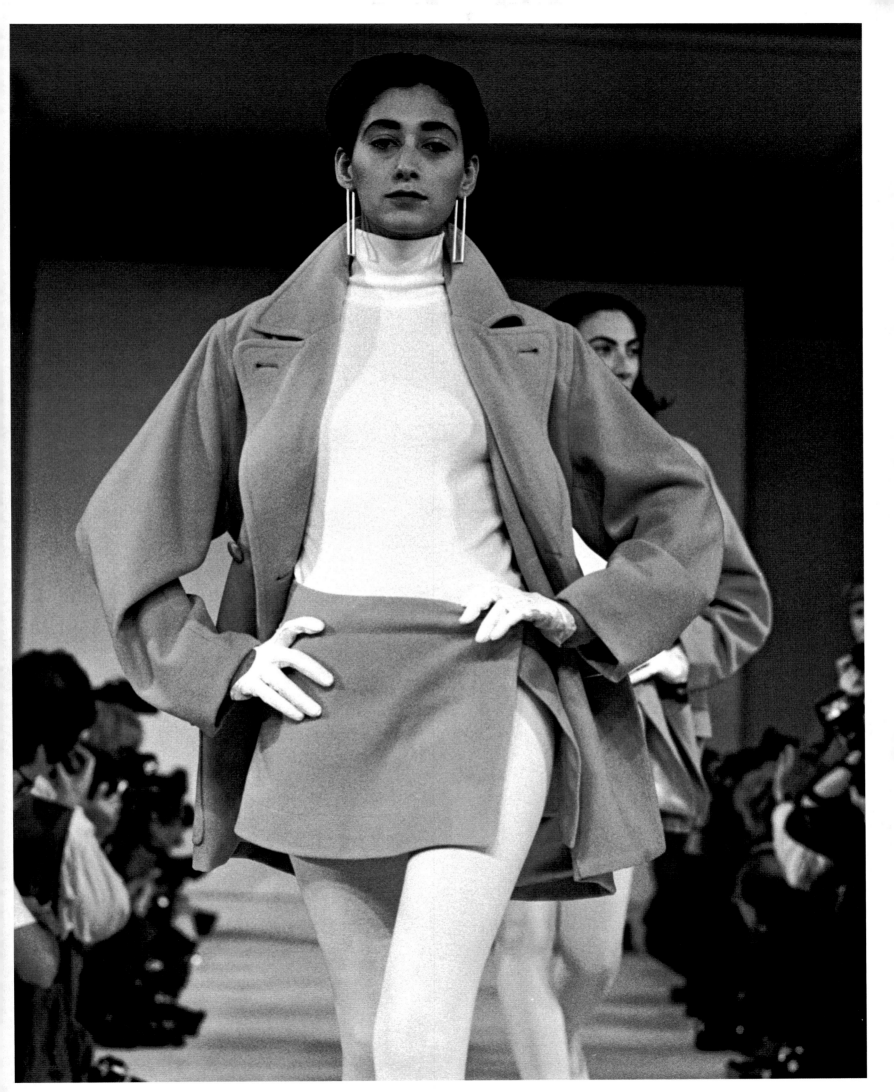

kept on walking." After determining no one had been hurt, Kors announced that people could leave if they liked. The mess was swept up, and the show went on. "Fashion people are troopers, and no one left," he says.

"I have been in many rickety places for shows over the years. But that was a moment when people started saying that this was below standards expected from such a great city and its ebullient fashion," says Menkes, who had a bruise on her head for the remainder of the week of shows. Kors echoes this, saying, "We were showing in spaces that didn't have the polish or professionalism that the collections merited."

Later the same year, a Mizrahi show left the audience in the dark. "On outfit No. 67 (of 111), the lights went out. Pitch black. The models stood motionless, and the hundreds of oglers packed into the steamy SoHo loft mumbled about the misfortune," wrote the *Palm Beach Post*. "Several guys with video cameras shined their lights on the runway, but that did little good. Finally, a shaken Mizrahi appeared on the runway, ciga-

rette in hand. 'Thank you for your patience,' he said to applause. 'We're trying to get to the bottom of this.' "[52]

The show resumed fifteen minutes later. "All I remember is Isaac on the runway in the dark, taking drags off his lit cigarette and crying," says *Paper* magazine's Kim Hastreiter.

"When I read headlines in *WWD* and the *Times* that said, 'We live for fashion, we don't want to die for it,' " says Fern Mallis, who in 1991 became executive director of the CFDA, "I realized that my job description had just changed."

The CFDA Takes Charge
The CFDA took up the cause to create a professional New York Fashion Week. The goal was to have one venue where all the shows could be held, with room for guests and press and easy access to hair and makeup. Mallis took a research trip to Milan, where most designers showed at the Fiera Milano, an exhibition venue often used for conventions and trade fairs, and to Paris, where, by then, runway shows were being held at the Louvre Museum.

After her trip, she spent the next year scouting locations in New York. "Anywhere I was, I'd be looking at an empty lobby, parking garage, or pier," Mallis says. "Harry Macklowe, who was a big developer, saw articles in the press about the fashion industry looking for a place to put on fashion shows, and he called and offered his hotel." The Macklowe, which was located on West 44th Street just east of Broadway, had space for seven hundred guests and was next to the Hudson Theatre, a potential additional venue. Kors was the first designer to sign on, followed by Mary McFadden, Steven Stolman, Bob Mackie, Arnold Scaasi, Eleanor Brenner, and Liza Bruce.[53]

There was a press room set up with typewriters and fax machines for the first presentations held at the hotel in November 1991, with Scaasi showing twirly ballet dresses, McFadden presenting embroidered frocks, and Kors offering rompers and leather bustiers. But it was Mackie, an established Hollywood costume designer for Cher and Carol Burnett, who left the most lasting impression, with a spectacular show that rivaled any you would see down the street on the Broadway stage.

Mackie took inspiration from twentieth-century originals including Lucille Ball, Mary Martin, Martha Graham, Betty Boop, Diana Vreeland, Rita Hayworth, Billie Holiday, and Grace Kelly. He cast models as impersonators wearing clothes that could have been in these icons' wardrobes, including '50s-style shirt dresses for Lucy and flower-trimmed frocks for Billie Holiday. "Few runway shows can bring today's fashion critics to tears of joy, but designer Bob Mackie had even the crusty reaching for linen hankies and clapping like seals," wrote the *Houston Chronicle*.[54] Mackie had become the hottest ticket on the American runway. "I always thought, 'It's a fashion show, give them a little of the show,'" the designer says.

Fittingly, the Macklowe shows were broadcast live on the Jumbotron in Times Square, bringing the runway to the street in a new, high-tech way. "We sent people out to watch it and take pictures of people watching it," says Kors of his country club chic collection. "It really was the precursor of the live streaming of shows today on the Internet."

Of course, there was already grousing that the shows had become too showbiz, and there was a desire by some designers for more low-key presentations. In 1992, Geoffrey Beene rejected his Pierre Hotel runway show in favor of a presentation at the School of American Ballet at Lincoln Center. Ballerinas served as ushers while dressed in Beene jumpsuits, "a tribute to the mobility of designs so functional they can be worn with toe shoes," wrote the *Times Picayune*.[55]

In April 1993, Carolina Herrera decided to skip the runway presentation altogether. "I thought there were too many shows too closely spaced this time," Herrera told the *New York Times*.[56] "And the shows themselves were turning into entertainments, not an opportunity to review the styles. So there had to be a break. But who knows? Maybe next season we'll have a mega show in Madison Square Garden."

But the CFDA still saw opportunity for a bigger, better venue and event, particularly after the Democratic National Convention fashion show took over Central Park on July 14, 1992, with more than one thousand delegates and guests gathered on the Great Lawn to see the latest offerings from Seventh Avenue. Mallis had helped envision that show, sitting on the DNC host committee alongside others who were representing key industries in New York City and planning events to entertain delegates. Under a tent erected on the lawn near the Delacorte Theater, fourteen designers (including Karan, Calvin Klein, Michael Kors, Oscar de la Renta, Byron Lars, Isaac Mizrahi, Todd Oldham, and Anna Sui) sent five looks each from their fall collections down a curving catwalk described as "the longest runway in the world."

Introduced by Mayor David Dinkins, the event was billed "NY Is Fashion," and it gave designers a taste of what it could be like to collaborate. "Fern looked at me and said, 'We could do this,'" remembers designer Stan Herman, who was president of the CFDA at the time. "It took us a year, but we did."

Creating Fashion's Backyard

Herman, who has occupied an office overlooking midtown's Bryant Park since 1975, sat on the board of the Bryant Park Restoration Corporation and was able to negotiate a deal that

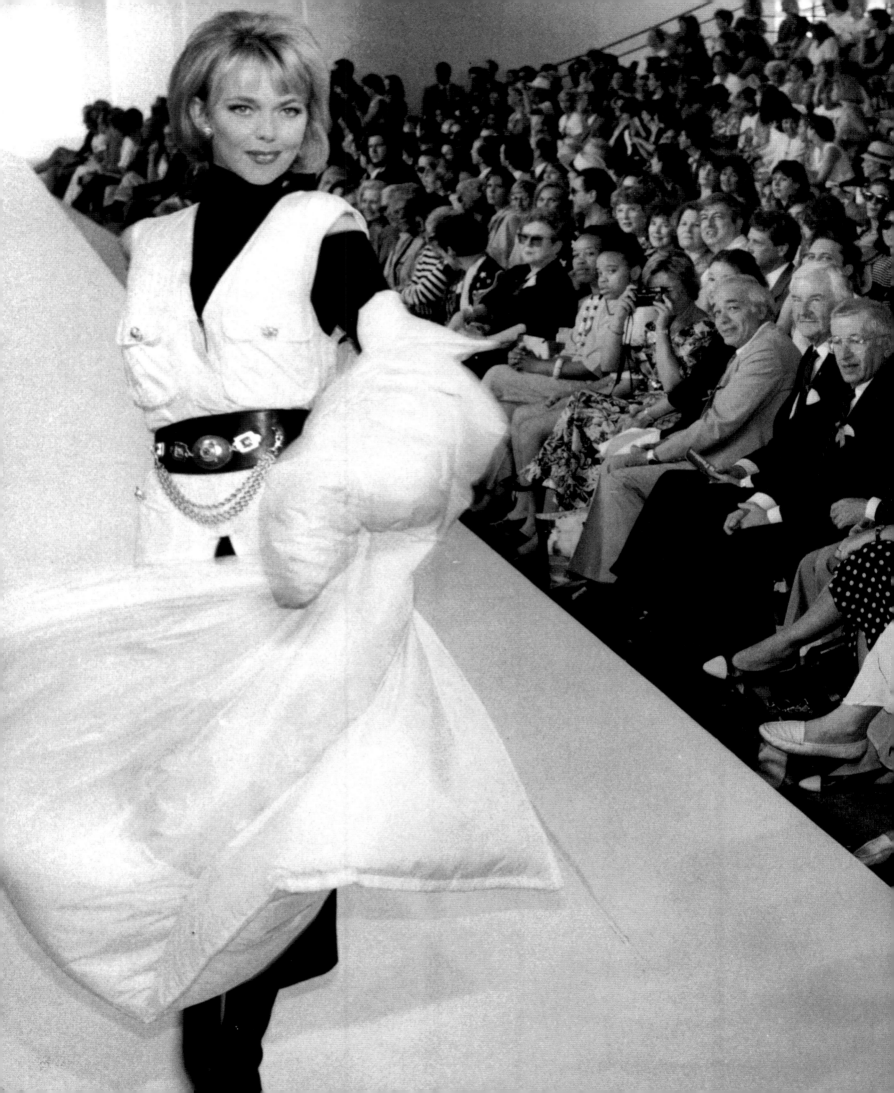

allowed the CFDA to put temporary tents for shows on the lawn, located between 5th and 6th Avenues and 40th and 42nd Streets, otherwise known as Bryant Park.

Mallis set out to raise money, working the phones. Evian gave her $100,000. She got similar commitments from *Vogue*, *Harper's Bazaar*, *Elle*, *Town & Country*, the *New York Times*, Prescriptives cosmetics, Godiva Liqueur, Pantone, and Clairol. Then, she cold-called the president of General Motors and got Cadillac on board as the eleventh corporate sponsor. "The pulling together was very easy," says Herman. "Every magazine joined in, *Harper's [Bazaar]* gave money at the same time *Vogue* and *Elle* gave money; they all joined hands together, something that never will happen again."

The CFDA created 7th on Sixth, a separate production company for the shows, formalized a schedule in conjunction with the Fashion Calendar's Ruth Finley, compiled a press list, and planned the event. Two tents were erected on the sides of the lawn. Security, lighting, and sound were provided. "All the designers had to do was bring the clothes," Mallis said.

On October 31, 1993, New York Fashion Week as we know it began, with forty-two shows, including the industry's biggest names: Ralph Lauren, Donna Karan, Calvin Klein, Oscar de la Renta, Todd Oldham, Isaac Mizrahi, Betsey Johnson, and Anna Sui. The American runways were organized, centralized, and modernized with an eye toward generating even more exposure and business for American fashion.

Fashion Week, Day One

Bryant Park was fashion's new backyard. The tents, which Herman and Mallis named Gertrude (a reference to Bryant Park's statue of Gertrude Stein) and Josephine (after the fountain named for philanthropist Josephine Shaw Lovell), joined Celeste Bartos Forum, a stunning hall with a glass dome ceiling in the nearby New York Public Library, to create three show venues in one location. When Donna Karan cut the ribbon across the entrance, she cut it on the bias—and it wasn't a red ribbon but a rust-gold one, "fitting for fall," wrote Amy Spindler of the *New York Times* in one of the most detailed accounts of opening day.[57]

Across the street, there was a press office full of pastries and flowing Champagne, phones and fax machines; free make-overs were offered by Clairol and Prescriptives to show attendees. Networks like CNN, CBS, NBC, BBC, VH-1, and MTV, as well as major print outlets from around the globe, covered the shows. "The season normally starts with a whimper: a showroom collection under fluorescent lights or a handful of models treading the floral carpet of a hotel. DKNY started the season with a bang, and CK ended the day with a second resounding one," Spindler wrote.[58]

The DKNY show began with the sound of a rattling subway car, the flickering of the underground lights, and a siren. Fifty men in blue power suits stormed the runway. "Ah, but leading the pack? A woman, in a DKNY blue suit of her own. A man's world? Not the one Ms. Karan rules," Spindler wrote of the show, which also included a performance from the New York City Church of Christ gospel choir. Karan used the runway opportunity to launch her DKNY activewear label, which included oversized anoraks, sweatshirts, and skirts with racing stripes.

The first day, there were four shows, ending with Calvin Klein's lower-priced CK line, which had some theatrics of its own. Once buyers, fashion reporters, and New York luminaries like Bianca Jagger, Roy Lichtenstein, Jaye Davidson, and Fran Leibowitz were seated, Klein opened with a video history of his titillating advertising, then followed with a lesson in personal style, featuring real people on street corners and at gyms wearing cropped tees, untucked shirts, cutoffs, suit vests, simple CK underwear, and black bathing suits. "The parade was a riveting forty-five-minute display of how good everyone, anyone (young and shapely, mind you) can look wearing CK," Spindler wrote.[59]

Fashion Week, Take One

That first season brought the fashion industry together under the tents. The downtown crowd came to Oldham's show, which was as in demand as a rock concert, featuring Cindy Crawford on the runway in flame-patterned jeans and Kate Moss, Linda Evangelista, and Naomi Campbell in saucy crop tops and mini-skirts. And the uptown crowd, including Nancy Kissinger,

Opposite, clockwise from top left: Backstage at the CK by Calvin Klein Spring 1994 show, October 1993; Anna Wintour, Carolyne Roehm, and Donna Karan during the "7th On Sale" to benefit AIDS research, November 1990; "7th on Sixth" signage inside the tents, 1993; DKNY Spring 1994 show, October 1993; Karan, Suzy Menkes, and Fern Mallis during the Fall 1992 season, February 1992; Mallis outside the tents, 1994; The Gertrude Pavilion in Bryant Park, October 1993. Following spread, from left: Meaghan Douglas, Christy Turlington, Kate Moss, and Naomi Campbell at the Isaac Mizrahi Spring 1994 show, November 1993; Marky Mark in the Calvin Klein Fall 1995 show at the "Race to Erase MS" benefit in Beverly Hills, California, September 1995.

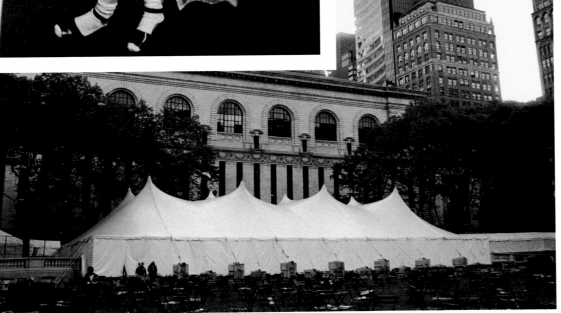
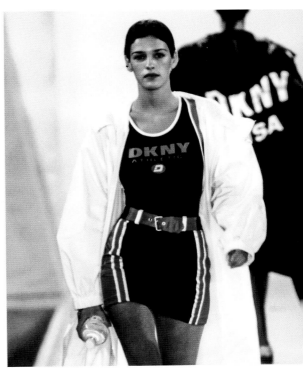

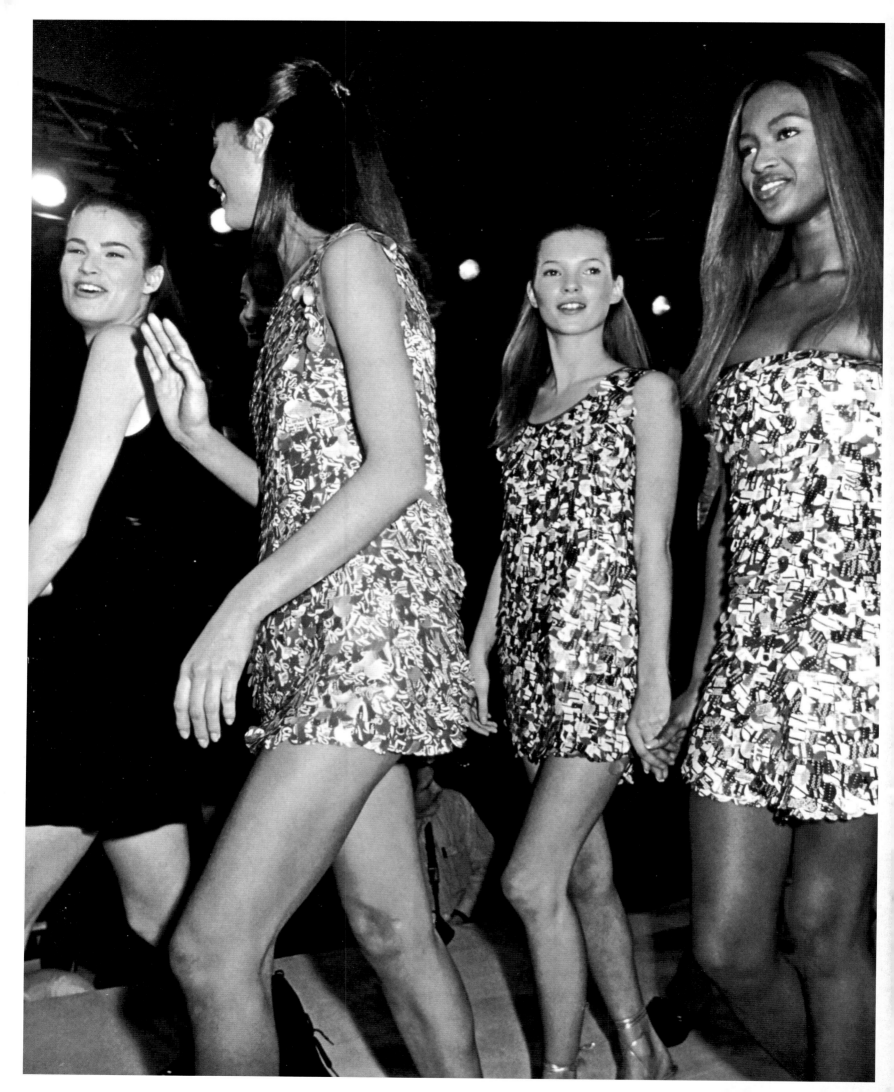

Barbara Walters, and Nan Kempner, came to see Oscar de la Renta's resort-ready palazzo pants and wide-brimmed hats.

Byron Lars opened his "Super Women" show with a clip from the '60s TV series *The Avengers*, featuring fictional spy Emma Peel. "This show had it all," the *L.A. Times* reported.[60] "Lacquered bouffants, bullet belts plied with lipsticks, drug-busting cops with mint-green pistols, black-belt masters who swung their long braids like lethal weapons. . . . The clothes lived up to the antics."

At Bryant Park, people didn't just come for the show on the runway; they came for the show off the runway, too. "It was the new meeting place for sports, politics, and entertainment," says Mallis. "Everyone wanted to be there."

The week closed with Karan's main line, featuring a light effect achieved by placing one thousand flashlights and miner's headlamps, purchased by the designer, on each seat. Inside the darkened tent, guests trained their lights on the runway to reveal the designer's glow-in-the-dark clothes, made from reflective fiberglass fabric.[61] But some key editors, including Suzy Menkes and Carrie Donovan, were left outside after Fernando Sanchez's show ran late next door at the Public Library, only to find their seats taken shortly after Barbra Streisand arrived. "At the end, [Karan] led her models off the runway and into the foyer for a gala wrap party," wrote the *Cleveland Plain Dealer*.[62] "White-gloved waiters were waiting with trays of Champagne and hors d'oeuvres. But Karan stopped in horror when she saw who was sitting in front of the TV sets. . . . She was close to tears when she discovered who had been shut out and offered to start the show all over again, but the models had already dispersed. Not to mention that workers had already started to strike the tent and tear down the runway."

Still, the first season at Bryant Park was deemed a success, even by Karan. "We can't go back to the showrooms again," she vowed. "We have to move on."[63]

The appeal of the American shows, and clothes, was that they were reality-based, just like designers had demonstrated

back in 1973 at Versailles. Designers showed T-shirts under slip dresses, active wear with office wear, bodysuits and wrap-around skirts, models with tattoos and navel rings. Although the Internet as we now know it wasn't around yet, New York Fashion Week garnered enough press (with TV coverage via Elsa Klensch on CNN and Judy Licht and Robert Verdi on Metro TV) and interest to ensure a second season.

Inside in the seats, there were celebrities, buyers, and fashion editors. But outside, even those who didn't have tickets came to join in the excitement and gawk at the famous faces walking through the doors. A whole new category of paparazzi photography arose around the tents to document the celebrities and style personalities coming in and out. For the first time, the entire city was aware of what the fashion industry was up to.

Future of American Fashion, Secured

By October 1994, a year after the shows at Bryant Park began, the *New York Times* was labeling New York Fashion Week a "social juggernaut" and calling fashion shows "the new nightclubs," where "the siren call of paparazzi will cause V.I.P.s, both rising and fading, to elbow their way to the front rows, and designers will be shameless about planting celebrities in the seats."[64] The next year, 30 percent more foreign media registered to attend the shows, bringing the ranks to 1,500, including four hundred photographers,[65] and proving true the old adage, "if you build it, they will come."

Designers heralded the business gains, and thanks to the ample coverage on cable TV, the concept of fashion-as-entertainment was born. "The tents gave designers more freedom," says Kors. "The audience got bigger, celebrities became more important in the front row, we were able to invite more clients. You had the space to do something different."

"Seventh on Sixth took a ragtag bunch of designers and put us in the same corral," said Bud Konheim, owner of the Nicole Miller fashion label. "Before then, people did not recognize New York as a fashion capital, and they really get the credit for that."[66]

And yet, if fashion is known for anything, it's rule breaking.

Opposite, clockwise from top left: Todd Oldham with Cindy Crawford at his Fall 1994 show, April 1994; Kate Moss during the CK by Calvin Klein Spring 1994 show, October 1993; Donna Karan backstage, 2000; Michael Kors Spring 1992 show, November 1991; Judy Licht and Robert Verdi, September 2002. Following page: Linda Evangelista during the Anna Sui Fall 1993 show, March 1993; Page 83, clockwise from top left: Shalom Harlow during the Todd Oldham Spring 1995 show, October 1994; Naomi Campbell at the Todd Oldham Spring 1996 show, October 1995; Crawford and Campbell, 1992. Pages 84–85: Christy Turlington and Evangelista backstage, 1990.

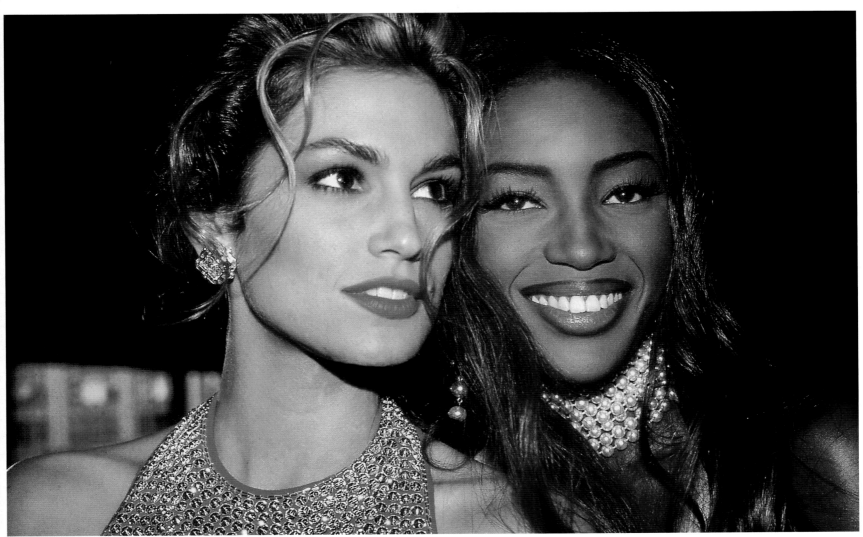

4

STRENGTHENING
THE AMERICAN POSITION

Just as soon as there was a centralized location for Fashion Week at Bryant Park, there were those who wanted to show elsewhere. As the event grew larger, corporate sponsorships took on more prominence, with Mercedes-Benz, General Motors, Olympus, Delta, and even the high-end kitchen and bathroom maker Kohler competing with designers for attention.

With the tents earning the reputation of being the establishment, there was also an anti-establishment—those designers who did not identify with Seventh Avenue, many of whom eschewed the $4,900 to $50,000 rental fees for a runway in the tent to show on the street, in nightclubs or lofts, or even in a porn theater. "For many designers who were more artistic, the tents were too cookie cutter and too expensive," said Kim Hastreiter, cofounder of *Paper* magazine, which has been documenting the alternative fashion scene since 1983.

With New York home to several design schools, including Parsons School of Art and Design and the Fashion Institute of Technology, freshly graduated fashion students also looked to the runway for exposure and press coverage. They hit the scene with attention-grabbing names (such as "Little Girls with Big Ideas"), hoping that having a show would lead to sales. Indie events cropped up around town, some organized and with sponsors and some not; these offbeat shows brought their own flavor to the American runway.

Then, some of fashion's biggest players started leaving the tents, too, all in the name of creative freedom. But even in the midst of it all, New York fashion attracted more attention than ever, thanks to some of the industry's brightest talents and most strident rule changers.

Alternatives

A year after the tents first went up in Bryant Park, another Fashion Week came together downtown. In November 1994, the first Alternative Fashion Week was held at Webster Hall, a nightclub in the East Village, with seven designers showing, including boutique owner and later *Sex and the City* costume designer Patricia Field. She told *Women's Wear Daily* she was showing "for fun and entertainment as opposed to being sales oriented."[67]

At Kanae & Onyx's show, guests were escorted to their seats by drag queens. The look was shiny, short, sheer, and skintight. Clubwear designer Kitty Boots showed a collection that featured "XXX" T-shirts and vinyl skirts. "Anything over $300 is out of my range," she told the *L.A. Times* of her venue choice, also noting that the 40,000-square-foot club was "where the first anarchist balls were held in the early 1900s."[68] Boots's models were personal friends, as was her music engineer. "I think the concept of having the shows all in one place is good," she said, "but if they're going to charge such a high fee, it rules out a lot of designers." Her entire line cost less than $4,000 to produce. "I'd much rather put the money into filling orders," she said.[69]

In 1995, Alternative Fashion Week moved to the Palladium, nabbed Absolut Vodka as a sponsor, and attracted Debbie Harry and NYPD-cop-turned-*Playboy*-model Carol Shaya.

Opposite: Models backstage at the Anna Sui Spring 1993 show, November 1992.

More than eighty designers showed cyber-chic, fetish, and other edgy looks, and the public was admitted on a first-come, first-served basis. "Fashion shows have never been accessible to the general public," Alternative Fashion Week spokesman Greg DiStefano told *Newsday*. "But we thought it would be much more exciting to invite everyone instead of just the staid media crowd."[70]

Elsewhere, designers made statements of individuality with their venue choices. Nigerian designer Lola Faturoti attracted six hundred people to her Fall 1994 show of African Victoriana at the Museum for African Art in SoHo and followed that show with a Spring 1995 collection at ABC Carpet & Home, a home-furnishings store. "I'm not a big fan of the tents," said Faturoti, who hoped the opulent rugs at ABC would complement her Indian-inspired Spring collection. "Having a show in a setting that helps your clothes makes you different. And I like to be different."[71] Christian Blanken, formerly a designer for Zoran and Michael Kors, debuted at the Jonathan Morr Gallery and Coffee House in SoHo. And at the opposite end of the spectrum, Basco designer Lance Karesh took over the Times Square Howard Johnson's, enticing editors with the promise of the chain's famous fried clams and ice cream. "If you don't do such things, you don't get the buzz," he said.[72]

Tracy Feith showed at the city's biggest porn palace, Show World Center, with models strutting down a mirrored runway and clinging to poles. "A few models walked out just after they arrived—apparently nonplussed by the idea of pole-dancing in pasties and satin panties with chastity belts," reported the *Dallas Morning News*. "But people in the audience seemed to enjoy themselves, spotlighting the models with cheap plastic flashlights as they danced provocatively on a small runway. Among the collection's highlights: slinky jersey and satin wrap dresses in nude (the color); Western-cut jackets with flared, hip-hugging pants; slinky sheer shirts; a python print pantsuit; and black or white satin suits."[73]

Some designers used guerilla tactics to show, piggybacking on other, higher profile presentations. X-Girl, a collection backed by the Beastie Boys and designed by Sonic Youth's Kim Gordon and stylist Daisy von Furth, took to the streets of SoHo to catch the attention of editors and buyers leaving the Fall 1994 Marc Jacobs show.[74]

It wasn't only plucky young rebels who were showing outside the tents. Design icon Geoffrey Beene never showed at Bryant Park and avoided runway shows altogether for many years, preferring instead to show his clothing on dancers or dress forms. Asked by magazine editor Grace Mirabella why he avoided the tents, Beene quipped, "I told her I thought animals perform best under tents."[75]

By the time the Fall 1996 shows rolled around, two Seventh Avenue stalwarts, Donna Karan and Ralph Lauren, had dropped out of the tents in favor of hosting more intimate presentations at their own venues. "There are many things I don't like about the tents. I do not want the photographer's pit. I have a problem with how overblown runway shows have become. There's too much media coverage," Karan told *WWD* of her choice to present her main line at her showroom instead.[76]

Some felt that the shows at Bryant Park became less about what was going on on the runway and more about what was going on off of it, from brand sponsors to celebrity front rows to peacockish hangers-on. Others disagreed. Calvin Klein told *WWD* at the time that he thought designers should have their heads examined for leaving Bryant Park. But by the next season, he himself had left for the Chelsea art gallery Dia Center of the Arts.

"The tents were a great message for people to unify; the problem is you had a two-hour load in, so if you wanted to build a set, you couldn't. It cut the fingers off producers and designers," says casting director James Scully. "If you were in the tents, you were in the tents, and in the end, it became a big white box. All you could do was put up a backdrop. That's why people went back to finding their own locations."

Through it all, 7th on Sixth tried to balance designers' need for individuality with the needs of store buyers and press for convenience. "Every time someone left the tents it was a huge scandal, and when they came back it was a big story," Fern

Opposite, top left and middle row: Tracy Feith Fall 1994 collection at Show World, a strip club in Times Square, April 1994. Top row, right: The Kanae & Onyx presentation at Webster Hall during Alternative Fashion Week, October 1996. Bottom row: X-Girl Spring 1995 show in SoHo, September 1994. The show was produced by Sofia Coppola (right) and Spike Jonze. Following spread, from left: Calvin Klein Spring 1997 show, November 1996; Kate Moss backstage during the Calvin Klein Fall 1996 show, April 1996.

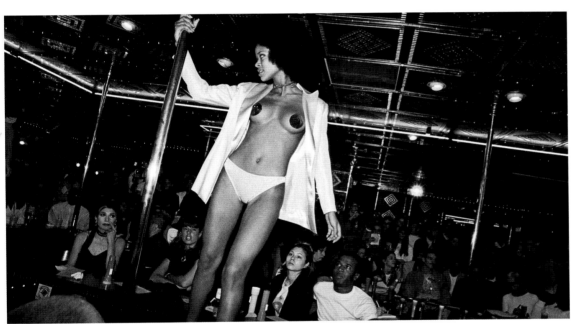

Mallis says. "It bothered me to a degree, the ones who didn't want to be in tents, but I was respectful."

Mallis tried to make it easy for designers to still be part of the official Fashion Week calendar even if they didn't show at the tents by organizing shuttles to take guests between Bryant Park and off-site venues. But Fashion Week began to spread out once again. The debate over a centralized location reached a crescendo in the summer of 1997 when 7th on Sixth announced that due to new venue restrictions in Bryant Park, it was packing up the tents and moving to Chelsea Piers for the next round of shows. The new centralized location did not find favor with buyers and press, and by December, the shows announced they were heading back to Bryant Park.

Coming Down to Earth

Another mid-'90s development that forever changed the course of the runway was when the catwalk was lowered. For decades, shows put models on a pedestal, walking on a platform a few feet above the ground, as photographers on either side jostled to shoot photos and the audience watched from below. The new flat runway trend, which most agree started in Europe with minimalist designers Jil Sander and Miuccia Prada, and was soon adopted in New York by Klein and Helmut Lang, among others, put models at the same level as the audience, moving the frenetic energy of the photographers into a pit at the end of the runway.

A flat runway "was more minimal and modern," says show producer Alex de Betak, who started working on runway shows in New York in 1993. It also led to a more "practical and technical revolution" with the photographers all being located in the front. "It created a completely different look. . . . Instead of having the light coming from above the runway, we started . . . putting all the front lights in the front and the back [lights] in the back, which was much more flattering to be shot from long lenses. To compare the photos from the end of the '80s to the mid-'90s, they were completely different." The photos became much cleaner.

The Ellis Island of Fashion

Fashion was becoming increasingly global, and designers wanted access to the lucrative US market, especially for their secondary lines, so they took their shows on the road. Miuccia Prada's Miu Miu collection made its debut at Bryant Park in 1993. Gianfranco Ferré, Giorgio Armani, Wolfgang Joop, and Yohji Yamamoto also showed collections during New York Fashion Week in the mid-'90s.

But one of the most memorable moments was when brother and sister Gianni and Donatella Versace brought their print-tastic lower-priced Versus collection to Bryant Park in October 1995. Every seat had a cushion emblazoned with the distinctive Versace Medusa logo, and Woody Allen, Mike Tyson, Lisa Marie Presley, Will Smith, Jada Pinkett, Leonardo DiCaprio, Courtney Love, Lou Reed, Cyndi Lauper, and Prince rubbed elbows with fashion editors in the front row. (How's that for celebrity range?) "I remember getting a lot of flak for letting an Italian open New York Fashion Week," Mallis recalls. "But the tents were the Ellis Island of fashion, and having Gianni here just added to the aura and prestige of being here. Plus, he brought a planeload of Italian editors who wouldn't otherwise be here, [and] who were going to be in New York for several days. Everyone benefited from that."

The next season, another out-of-towner created a different kind of frenzy: bad-boy British designer Alexander McQueen showed the collection he'd presented in London in an abandoned synagogue on the Lower East Side. There was such a scrum to get in to see the designer, who'd shown his famous bumster pants a season before, that *Vogue* editor Anna Wintour was "virtually lifted off the ground and passed inside."[77] He told *WWD*, "We already did all our selling in Milan and Paris, so this show is more to promote the label and maybe scare a few people—though hopefully, they won't cancel their orders."[78] But New York was developing its own homegrown runway impresarios, too.

Showmen in the Making

Two of the key designers who helped bring international attention to American fashion and its runways to new audiences in the early 1990s were Marc Jacobs and Isaac Mizrahi, Parsons School of Art and Design schoolmates who were both acolytes of Perry Ellis.

Opposite, clockwise from top left: Kate Moss with Brenda A. Go-Go at the Versus Spring 1996 after-party, October 1995; Carolyn Murphy during the Versus Spring 1996 show, October 1995; Lisa Marie Presley at the Versus Spring 2000 show, September 1999; Runway photographers, 2008; Miuccia Prada at the Miu Miu show held at Bryant Park, April 1994; Jon Bon Jovi and Woody Allen at the Versus Spring 1997 show, October 1996; KD Lang and Deborah Harry at the Versus Fall 1996 show, March 1996. Following spread, from left: Alexander McQueen Fall 1996 show, March 1996; Naomi Campbell in the Versus Spring 1996 show, October 1995.

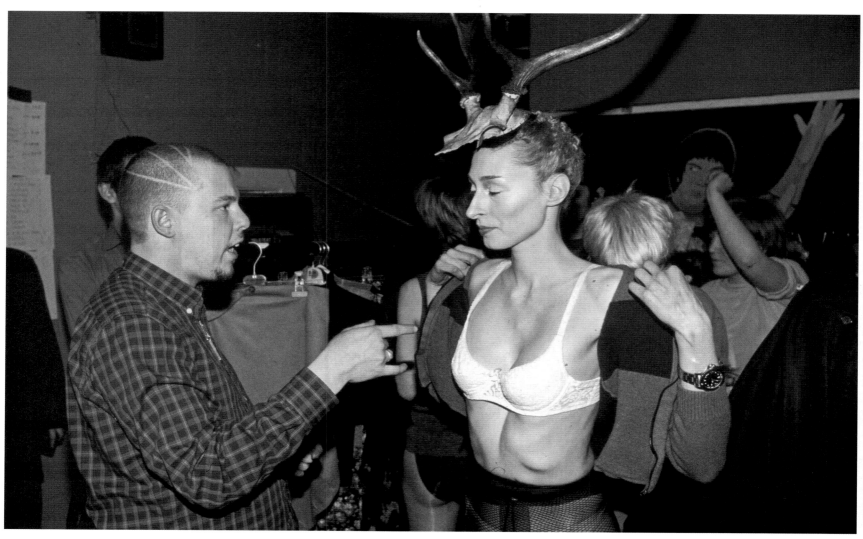

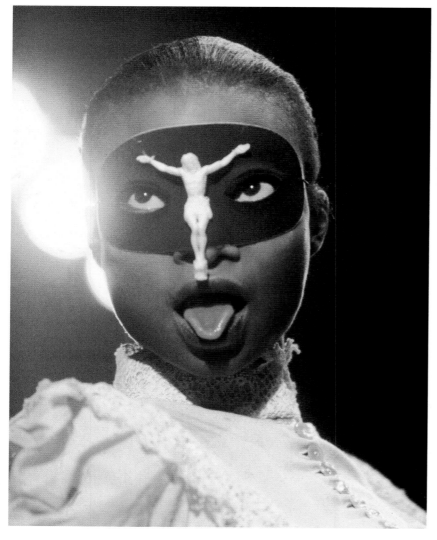

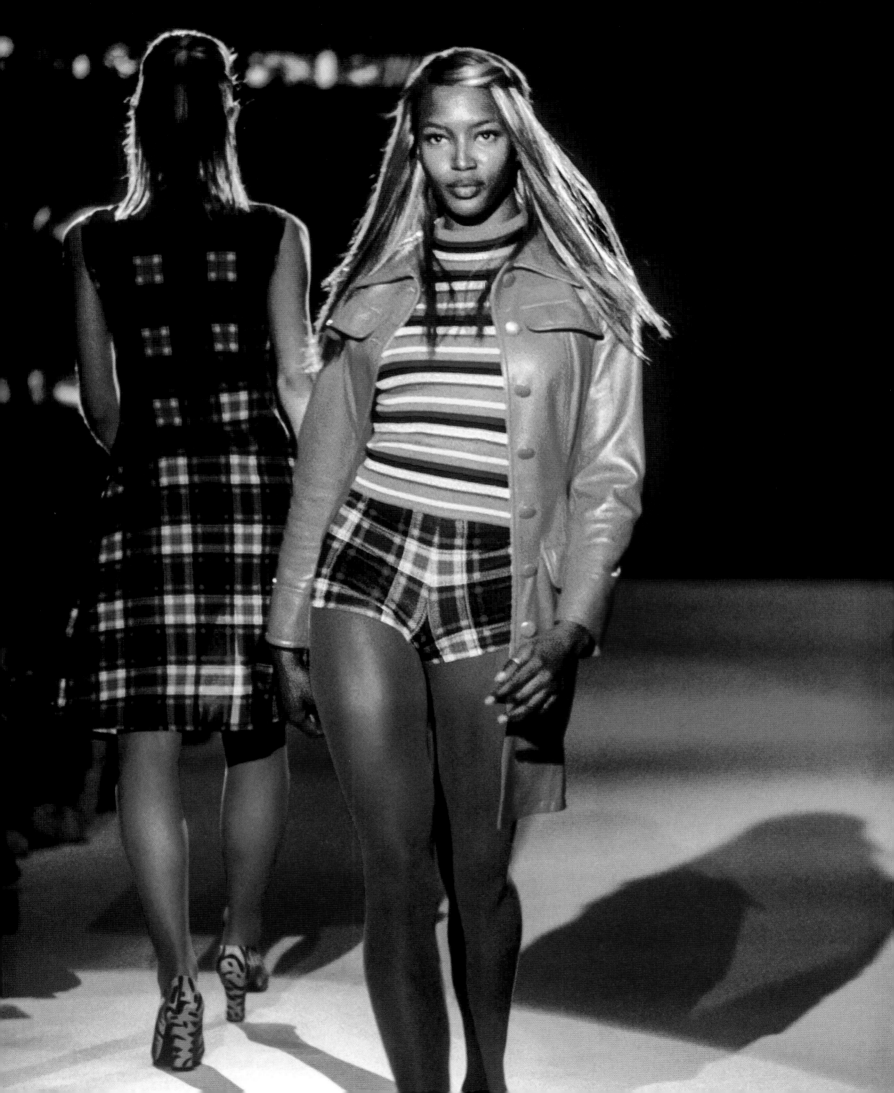

After working at the avant-garde New York boutique Charivari, Jacobs designed his first collection under his name in 1986. A year after the death of its founder in 1986, Perry Ellis scooped up Jacobs. But it was his famous grunge collection, shown for the Ellis label in November 1992, that changed fashion and his career.

Grunge had already gone mainstream—from the chart-topping albums of Pearl Jam and Nirvana to Cameron Crowe's film *Singles* to Courtney Love's ascending celebrity to the flannel shirts flooding Urban Outfitters. But to Seventh Avenue, it was still edgy. "I didn't set out to be some hellion or heretic or rebel," Jacobs told Maureen Callahan for her 2014 book, *Champagne Supernovas*. "It was one of the things I felt I did with such a kind of pure, divine integrity. . . . [I] wanted to celebrate what I loved, and what I loved was seeing things that were imperfect to other people."[79]

Coincidentally, a few weeks before the collection was set to debut, he got a call from the indie, proto-grunge band Sonic Youth asking if they could shoot a video in his show-room. Jacobs said yes, even though he didn't know lead singer Kim Gordon (she has since become a friend and collaborator). The video featured eighteen-year-old Chloë Sevigny as a model.

On the runway during New York Fashion Week, Jacobs showed an elevated take on the anti-fashion fashion trend—plaid silk crop tops, shrunken striped jackets, baseball T-shirt dresses, green army pants, ombréd chiffon, pastel leather, knit beanies, satin Converse sneakers, and rhinestone-buckled Birkenstocks, all worn by Kate Moss, Christy Turlington, and Helena Christensen. "I was an intern at Perry Ellis at that time, and I will always remember that day," says *Project Runway* judge and *Marie Claire* creative director Nina Garcia. "That was such a seminal moment in fashion; here was this collection inspired by the music scene in Seattle. [Jacobs] always makes a statement about pop culture." Fashion editor Joe Zee remembers the show, too: "I was a student at the time and snuck in with someone else's business card. I stood at the back and was swept away by the super-models and the spectacle."

"We're no longer living in a disconnected world," Jacobs told *WWD*. "It's called crossover, sampling all the references in music, art, and fashion."[80]

Anna Sui and Christian Francis Roth showed their own takes on the anti-status grunge look that same season, but it was Jacobs at Perry Ellis who was skewered by much of the press, accused by *New York* magazine of killing grunge. He was publicly fired from the label. "Grunge is anathema to fashion," wrote the influential fashion critic Cathy Horyn in the *Washington Post*, "and for a major Seventh Avenue fashion house to put out that kind of statement at that kind of price point is ridiculous."

It was prescient, of course—another example of an American designer showing real-world style, in Jacobs's case, filtered up from the streets. Many retailer buyers, including Neiman Marcus' Joan Kaner and Bloomingdale's Kal Ruttenstein, gave Jacobs's grunge collection high marks, as did *WWD*, who proclaimed the designer "the guru of grunge" and gave the collection a two-page spread. Jacobs would go on to become one of American fashion's greatest showmen and most astute cultural commentators, making the runway show an art form all its own.

A consummate outsider, Jacobs never showed as part of the official Fashion Week at Bryant Park, always preferring his own venues, including the Plaza Hotel, the Puck Building, and the 69th Regiment Armory at 26th and Lexington, with sets and concepts that became ever more elaborate as the years went by.

Meanwhile, Mizrahi, another pop culture commentator (but from a preppy mold), was inspired as much by Mary Tyler Moore as Jackie O. In 1987, he showed his first collection at a trunk show at Bergdorf Goodman and won over customers and the press with his colorful, silly-serious designs, including taffeta evening gowns with matching baby carriers, extreme kilts, and leather twin-sets.

He was a natural-born performer whose self-deprecating personality was perfect for Hollywood, but when he and then-boyfriend Douglas Keeve tried to pitch a documentary

Opposite: The Marc Jacobs for Perry Ellis Spring 1993 show brought grunge into the fashion world, November 1992. Clockwise from top left: Kate Moss and Kristen McNemany; Christy Turlington and Carla Bruni backstage; Tyra Banks; Jacobs fitting Yasmin Le Bon. Following spread, from left: Anna Sui Spring 1993 show, November 1992; Banks during the Marc Jacobs for Perry Ellis Spring 1993 show, November 1992.

about the making of his fall 1994 "Nanook of the North" collection, they couldn't find any takers. So they made the film themselves for $500,000 and sold *Unzipped* at the Sundance Film Festival. The film took viewers into Mizrahi's process, from fabric shopping to fittings to playing the piano to confiding in his mother, with plenty of moments of hilarity ("All I want is to do fur pants!") and angst (Mizrahi weeps when *WWD* puts rival designer Jean Paul Gaultier's "Eskimo Chic" on its cover before his own show is set to launch).

The runway show was groundbreaking, too, featuring a clear scrim so viewers could see the supermodels backstage, including faces like Cindy Crawford, Linda Evangelista, and future French first lady Carla Bruni. Viewers watched as the glamour of the runway came to life, including hairdressers spritzing and Mizrahi doing last-minute primping to the clothes. Out front, Robert De Niro sat on one side of the runway, Richard Gere on the other. His supermodel spouse, Crawford, did her most perfect turns in front of him. The clothes were elegant, sporty, and fresh—cropped sweatshirts and down jackets worn with taffeta ball skirts, shearling

chubbies over skater dresses, and acres of faux furs in funky colors, including faux-fur boots that would make Nanook proud.

"Fashion is no longer about creating a look, it's about creating a show," Mizrahi said at the time.[81] Elaborating on the concept for bringing the backstage to the foreground, Mizrahi says he was terrified of the grunge era. "I didn't like tattoos and dirty jeans; it just wasn't me. I thought my clothes might feel a little fancy for the times, and the only way to make them interesting was to bring the audience into the process. I wanted them to see a woman dressing, then to see her in a magnificent finished state, from vulnerable girl to fabulous woman."

When the film came out in the summer of 1995, it was glowingly received, with star-studded screenings on both coasts. "You don't have to care a snitch—or a stitch—about fashion or clothes in any form to get on the wavelength of *Unzipped*," wrote the *Washington Times*.[82] "A reality check against the fantasy of the fashion world," declared the *Daily News of Los Angeles*.[83]

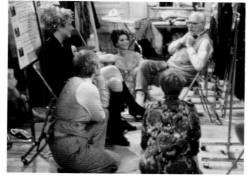

Combined with the 1994 release of Robert Altman's satirical send-up of the industry, *Pret-a-Porter*, fashion went from niche to mainstream entertainment. In the wake of Mizrahi's publicity blitz for the film, he launched his more-affordable secondary label, ISAAC, with its trademarked tagline, "American Star Quality." It's not hard to trace a line from Mizrahi's star turn on the big screen to his groundbreaking deals years later to sell "cheap chic" at Target stores, and later on QVC.

"Marc brought art to the runway, Isaac exposed it," says Stan Herman. "That movie of his changed a lot. That movie of his made fashion accessible."

Rule Changers

By the end of the 1990s, American fashion was held in such high esteem globally that several American designers had been tapped to head European houses, including Tom Ford at Gucci and Yves Saint Laurent (which by now was owned by Gucci), Narciso Rodriguez at Loewe, Michael Kors at Céline, and Marc Jacobs at Louis Vuitton.

But from an outsider's perspective, fashion being produced and shown in America still suffered from a copycat reputation. That started to change in 1998. Few had as much of a profound impact on the future of the American runway as Helmut Lang, the Austrian designer who had led fashion away from the excess of the 1980s and into the sporty minimalism in the 1990s, pioneering innovations we now take for granted, such as the use of techno and stretch fabrics, and raw edges.

He was a runway star in Paris, where he showed from 1986 to 1997. Then, following the opening of his SoHo store, Lang announced he was going to move his headquarters and start showing his men's and women's collections in New York, becoming the first major international designer to do so. (Prior to this, international designers presented their secondary collections in New York.) "We believe in the potential of this city," Lang told *WWD* at the time. "There is no reason why New York should not be the strongest fashion capital in the world. It is the capital in so many other fields. I believe it has the capacity. It is the most urban place."[84]

Lang challenged the show system immediately during his first season, canceling his April 1998 runway presentation and hosting a virtual show instead, where he uploaded his collection to the newly popular Internet. The next season, he decided he wanted to show ahead of the European fashion weeks, spurring a shift in the entire show schedule that put New York shows ahead of London, Paris, and Milan for the first time. The shows would happen in February instead of April, and September instead of November.

"I do think timing is important—when everybody is ready and eager to see what's new," Lang said. "That's why I'm doing this—because I feel New York is so right for today. One thing I don't understand is why New York wants to be last [in fashion], when it wants to be first in everything else."[85]

"When Helmut Lang decided to move, that was the worst couple weeks of my life," says Mallis, who had already organized New York Fashion Week for Bryant Park for November 1998. "We knew he had that crowd and that the foreign press would come to see whatever he was doing. And the first person who called me was Calvin. He said, 'I'm going to show when Helmut shows.' We saw the writing on the wall."

Donna Karan also joined the September crew, and that season, there were two New York fashion weeks—one in September and one in November. "Then it was back to the drawing board," Mallis says. "Everyone had to change production schedules to put America first."

Lang's show that year was one of *Vogue* executive fashion editor Phyllis Posnick's favorites of all time, saying, "As with all of his collections, I wanted to wear every one of his elegant, minimal, sometimes austere looks. For his first New York show, he live streamed it before anyone knew what that was."[86]

Ultimately, the shift, ironically led by a foreign designer in New York, strengthened the position of American designers on the global stage, and soon, their influence was being felt far and wide. The whole world was wearing spare and sporty looks.

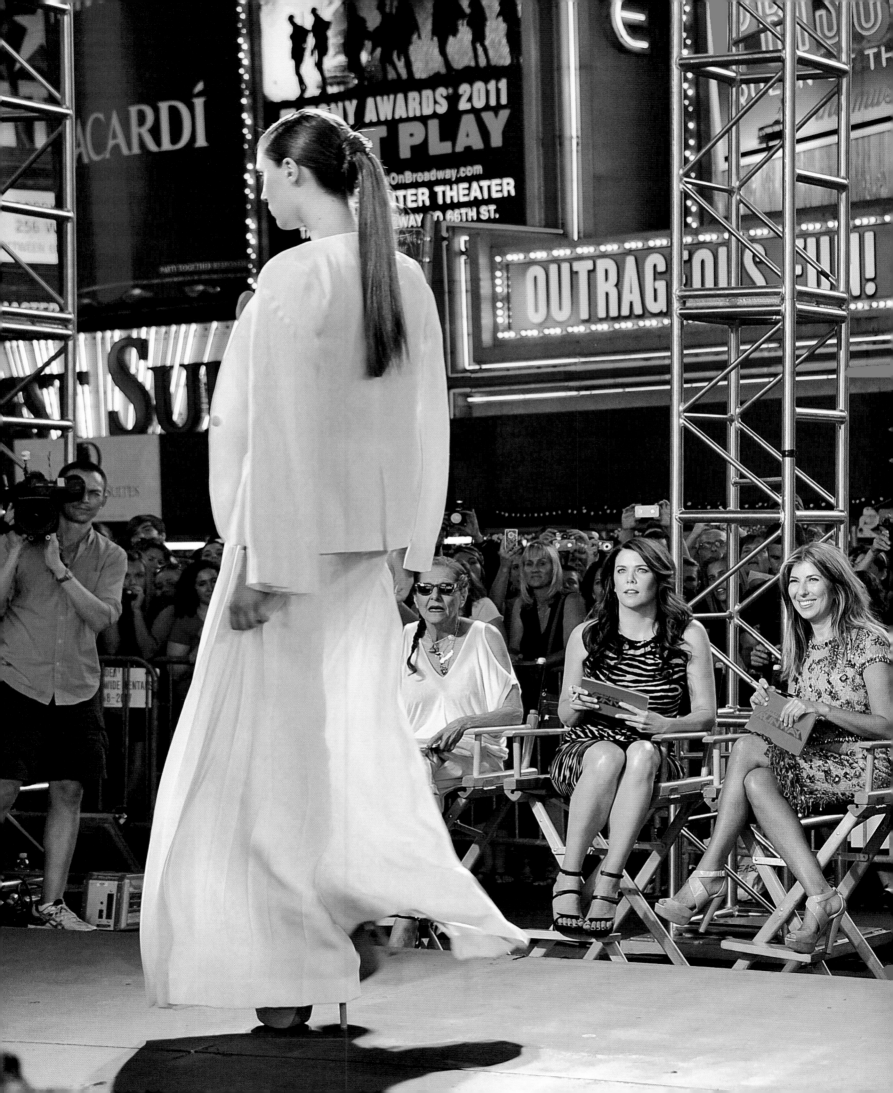

5

THE SHOW BUSINESS OF FASHION WEEK

By the late 1990s, the runway's reach was way beyond the Bryant Park tents and off-site venues. All the world was gaining access to the runways because of exposure on cable and network TV, in film and on the Internet—and fashion emerged as another pillar of pop culture.

In 1999, American designers agreed to make the move and show their collections ahead of the Europeans. Thanks to sportswear giants Ralph Lauren, Tommy Hilfiger, Donna Karan, and Calvin Klein, as well as New York newcomer Helmut Lang, American fashion was international business. Fashion Week entered a new, highly commercial phase that mirrored the globalization and corporatization of the industry. And just as changing venues affected the size and scope of runway shows, so did new media formats.

"It was also the beginning of more theatrical and narrative shows," says show producer Alex de Betak. "You needed more media worthiness; the shows had to be photogenic. There was wider, more global, interest, so the shows had to be more TV-genic, too. Then came the Internet, and we started live-streaming shows."

American fashion designers became household names, lending their talents and faces to commercials, TV hosting gigs, reality shows, and even Band-Aid boxes, and some celebrities became so enamored of fashion that they traded on their fame to become designers. The Internet and social media gave designers the power to create their own content around the runway, and the action backstage started to rival what was happening on the runway and in the front row. Increased exposure to the runway drama laid the groundwork for an even bigger leveling of the playing field, when everybody, not just those in the industry, would gain a front-row seat.

All of these factors made Fashion Week such a valuable commodity that eventually the CFDA sold 7th on Sixth to IMG, a sports and entertainment marketing firm that could better leverage its synergistic opportunities. But first, a snapshot of the runway's starring role.

Fashiontainment

Fashion and television were strangers before Elsa Klensch. A print journalist first, with stints at *Harper's Bazaar*, *Women's Wear Daily*, and *Vogue*, Klensch made her television debut the day CNN first aired in 1980 with *Style with Elsa Klensch*. For twenty-one years, every Saturday morning, she and her signature glossy black bob brought fashion into people's living rooms in 142 countries and made the video camera a fixture on the runway. Klensch logged tens of thousands of miles covering shows around the world and helped turn designers into media darlings, introducing them to global markets. It's no wonder two of the guests on her very first show were the original American designer-celebrities, Halston and his pal Andy Warhol.

In the early 1980s, runway photos were not readily available; in fact, the only place you could find them was in trade publications like *Women's Wear Daily*, in newspapers, and,

Opposite: Costume and fashion designer Patricia Field, actress Lauren Graham, and judge Nina Garcia at the *Project Runway* 10th Anniversary Kick-off in Times Square, June 2012.

months later, in magazines. Klensch's TV show was a window into the rarified fashion world, including the shows at New York Fashion Week, offering snippets of backstage chatter, designer interviews, and images from the catwalks themselves.

"Retired Air Force colonels watch. A lot of entertainment-industry people watch. There's a very wide range of people who are interested in what is happening in fashion," Klensch said of fashion's expanding fan club in 1993. In America alone, 2.5 million households were tuning into her program every week, making it CNN's highest-rated weekend feature-news program. "I think fashion designers became the movie stars in the '80s," she said.[87]

Klensch kicked off a media love affair with fashion that changed the way designers conceived of shows. "[She] was the only TV reporter at my first runway show," says Michael Kors of his 1981 debut. "But as time went on, we started to see huge interest in shows and fashion. By the time I showed at the tents, there would be a whole wall of TV cameras, and I had to think, 'This is going to be a moving image, not just a still picture anymore.' When I started to do fittings, I wanted to make sure the clothes moved in a certain way, not just for the audience watching live, but for the audience watching at home."

Then, along came MTV's *House of Style*. Launched in 1989, it was downtown's answer to uptown's Elsa. Created at the height of the supermodel era, the show was conceived for the MTV audience: cut like a music video, with music, fashion, and lifestyle segments from celebrity and supermodel angles. Cindy Crawford was approached to host. "My modeling agency said, 'why would you do this, you're not really getting paid,' but at that time I said, 'why not?' I got an opportunity to talk and do something different," says the supermodel, who hosted the show until 1995. The first episode featured Salt-n-Pepa and Spinderella modeling summer styles by Betsey Johnson, Bryan Early, and other edgy designers. In his regular "Todd Time" segments, designer Todd Oldham taught viewers how to DIY runway styles. The show documented the emerging streetwear and celebrity designer scene growing up outside of the Seventh Avenue establishment, too, covering Sonic Youth singer Kim Gordon's X-Girl guerilla fashion show on Lafayette Street in 1994, just after the Marc Jacobs show, and Sofia Coppola's Milkfed presentation the same season.

"At the time, MTV was still trying to figure out what it was, and the only fashion I was seeing on TV was Elsa Klensch," Crawford says. "Our show bridged the gap between the women going to Paris and buying couture and girls like me who went to The Limited. It was about how both can be inspired by each other; how Chanel is inspired by street fashion, and at the same time, about how girls who love fashion but could never afford Chanel still want to follow it."

House of Style demystified the world of fashion and made it more accessible to everyday Americans. Viewers saw Naomi Campbell with zit cream on her face and heard Crawford talking about holding in her stomach while shooting a swimsuit campaign. "A two-dimensional image in a magazine is perfect and untouchable, but we showed that there are real people behind those images, and that those images are one split second in time with the perfect hair, lighting, and makeup," she says. "As a result, people started to become interested in what happened up until that perfect moment and right after it, too."

In December 1995, VH1 got in on the act, hosting the first VH1 Fashion Awards, which were broadcast live on TV, with a mix of music performances by the likes of Prince and Madonna and runway shows featuring designs by Oldham, Isaac Mizrahi, Calvin Klein, Dolce & Gabbana, Karl Lagerfeld, and more. The event was held annually through 2002 at various venues, including the 69th Regiment Armory and the Hammerstein Ballroom, attracting a glittery mix of designers, models, rock stars, and celebrities for a night of fashion, music, and awards in ten categories ranging from "celebrity style" to "visionary video" to "most stylish band." A committee of top fashion editors, journalists, stylists, designers, photographers, and models assembled by VH1 (and later *Vogue* when it put its stamp on the event starting in 1999) determined nominees and winners. Some of the more memorable moments were Sean "Diddy" Combs presenting an award

Opposite, clockwise from left: MTV's *House of Style* host Cindy Crawford, 1994; Donatella Versace and Lenny Kravitz present the Versace Award at the VH1/Vogue Fashion Awards, October 2000; *Project Runway* judges Nina Garcia, Michael Kors, and Heidi Klum, 2004; Elsa Klensch, host of CNN's *Style with Elsa Klensch*. Following spread: Emmy Rossum, Nina Garcia, Zac Posen, Heidi Klum, and Desiree Gruber at the *Project Runway* fashion show, September 2014.

onstage while wearing a full-length chinchilla coat, Ben Stiller shooting scenes during commercial breaks for his film *Zoolander*, and Donatella Versace and Maya Rudolph's meeting of the plunging necklines.

Victoria's Secret pioneered the use of the runway as spectacle aimed squarely at consumers, webcasting its fashion show in February 1999 to a million online viewers who learned of it during a Super Bowl Half Time commercial, and in subsequent years televising the show. In September of that same year, Mayor Rudy Giuliani hosted the millennium-themed NYC2000 runway show featuring the work of ninety designers in an open-to-the-public runway show held in Times Square that attracted 18,000 spectators.[88]

The concept of "fashiontainment" reached a new level in 2004 with the launch of *Project Runway*, a competition TV show that pitted budding designers against each other in creative design challenges, culminating in a runway show at the end of each episode judged by a panel that included then–*Elle* editorial director Nina Garcia, designer Michael

Kors, and model/host Heidi Klum. The show was a hard sell at first.

"When I first talked to Harvey [Weinstein], he didn't understand the excitement of bringing an idea from a designer's brain to sketch, to fabrication onto a model's body, to the runway," says producer Desiree Gruber. "But what makes good TV is creative characters solving a problem."

Kors was not too keen on the initial concept, either, and he thought reality TV and fashion should not be mixed. "Finally the people from *Runway* said, 'We're not going to have you live on a desert island, we're not going to eat insects. We're doing [this] to show the creative process. We're going to have you say what you think the way you would [have] when you were a critic at Parsons.' But even when I thought of it that way, it didn't convince me that the general public would care. I underestimated the interest in fashion and how people are intrigued by the alchemy of something. . . . I knew the show was going to be a big success when I found out that [fashion photographer] Steven Meisel was glued, and then Rashida

Jones told me her parents were watching the show. When I found out Quincy Jones watched *Project Runway*, I said, 'I think we've got something.'"

The first season finale was held at Bryant Park, where the top finalists showed their collections on the runway. "Michael and I were very adamant that it had to be a show during New York Fashion Week; it had to be part of the tents," says Garcia. "That's what was going to give it the blessing. It had to have the blessing of the industry."

Project Runway peeled back the curtain just like Isaac Mizrahi's *Unzipped* documentary had a decade before. "The show educated people about the importance of the designer. It gave the industry credibility, and all of a sudden, everyone wanted a piece of it—publications, design houses, even applications for fashion schools went up," says Garcia. "All of a sudden fashion was in fashion, and we were at the crux of it."

Designers as Celebrities, Celebrities as Designers

The Bryant Park tents were another natural stage where entertainment, celebrity, and fashion were converging in a new way. Once reserved for retailers, magazine editors, and socialites, the front rows started to attract serious star wattage in the early '90s, driving non-fashion media to cover the runways. It first started with friends of designers— Susan Sarandon at Todd Oldham, Sandra Bernhard at Isaac Mizrahi, Barbra Streisand at Donna Karan, for example— but soon, celebrities started coming just to join in the fun (or, perhaps, score a well-placed media photo), even to the shows of designers they'd never even met. (Randy Quaid at Todd Oldham?)

"The E! channel came on board early, then spun off the Style channel because of Fashion Week," says Fern Mallis of the network founded in 1998 as a twenty-four-hour home for fashion-related programming. "They saw there was enough going on that they could create a whole channel around it." By the mid '90s, entertainment news crews from *Access Hollywood*, *Extra*, and *Entertainment Tonight* were also covering the runway shows, both backstage and front row.

"We help bring the celebrity association of the designer to the public. It starts with the celebrity connection and the curiosity about what they're wearing," said Linda Bell Blue, executive producer of *Entertainment Tonight*, in 1996, when the show hired its first fashion producer. "We just did a piece on Sharon Stone and Vera Wang. It would never occur to many people to be interested in Vera Wang without the celebrity association, but she's a very interesting person. She's become a celebrity herself because so many people are wearing her clothes."[89]

Celebrities moved from the seats to the runways, too, including Gina Gershon and Rebecca Gayheart sashaying for Nicole Miller in 1994, and a sixteen-year-old Ivanka Trump walking for Marc Bouwer in March 1998. "I did it just to add fresh faces, but the actresses really added a human element. They aren't perfect, they don't walk perfectly, and it's less intimidating to real women," said Miller. "And boy did the press snowball."[90] It wasn't long until Hollywood was infiltrating fashion and beauty ads, with the newest face appearing on the runway as part of the package deal.

Other designers craved the Hollywood spotlight, and news and talk shows started to devote more time to fashion programming. In 1996, Tommy Hilfiger signed on to do regular segments on *Good Morning America*, while Oscar de la Renta, Cynthia Rowley, and Donna Karan started to make appearances on *The Oprah Winfrey Show*, *Live with Regis and Kathie Lee*, *The Tonight Show*, and more. "Cunningly, fashion designers have parlayed style and glamour into a level of celebrity that arguably surpasses some of their Hollywood brethren," proclaimed *WWD* in 1998.[91]

At the epicenter of Hollywood, music, and fashion, Hilfiger was able to turn his men's sportswear business, founded in 1985, into a global fashion empire, in part because of its celebrity associations—from Sean "Diddy" Combs and Coolio modeling on his runway in 1996 to Sugar Ray and Bush performing live at his shows, one of which was held at Madison Square Garden in 1999, years before Kanye West did it. "I always thought it was pretty boring just watching models walk up and down the runway wearing different outfits," says

Opposite, clockwise from top left: Ivanka Trump during the Marc Bouwer Fall 1998 show, March 1998; Sandra Bernhard and Isaac Mizrahi, May 1990; Sharon Stone and Vera Wang, October 2002; *Project Runway* fashion show, September 2016; Todd Oldham and Susan Sarandon at his Spring 1997 show, October 1996; Donna Karan and Barbra Streisand at the 12th Annual Council of Fashion Designers of America Awards, February 1993. Following spread: Emma Stone and Rooney Mara on the front row at the Calvin Klein Fall 2012 show, February 2012.

Hilfiger, who in 1997 became one of the first designers to sign with a Hollywood talent agency. "I've tried to do something a bit different, a bit inspirational and aspirational, either with the infusion of music or celebrity or stage sets. I've always wanted to create a real show rather than just a presentation."

The entertainment factor changed the flavor of the runway shows. With the increased media attention, designers saw an opportunity to have celebrities who were on brand model their clothes for the paparazzi photographers and TV cameras. And celebrities were happy to oblige, eager to hit the runway shows and meet influential fashion power brokers and editors who could help them score lucrative brand advertising and endorsement deals.

"I'll never forget going to a Versus show in 2000 and Madonna was there with Lourdes, who was really young still," remembers fashion editor Joe Zee. "We all swarmed backstage to congratulate Donatella Versace, and all the paparazzi were going crazy. Lourdes said, 'Mommy they are taking more pictures of me than you.'"

In 2001, Sofia Vergara wasn't yet famous in the United States, "but the buxom twenty-eight-year-old Colombian actress headed for Manhattan to become a gossip-column item. Her ticket? A front-row seat at the hottest runway shows during New York's Fashion Week."[92] Her escort was Phillip Bloch, one of a new breed of celebrity stylists paid to connect stars with high-profile designers. "We have a saying in my office," Bloch said. "No front row, we don't go."[93]

The front row started to reflect a who's who of film, music, and television as designers discovered how valuable it could be to have celebrities and stylists at their shows. Some even wooed Hollywood to the runway by offering paid flights to New York, hotel stays, and wardrobes, while others bemoaned that their clothes were being overshadowed in press coverage. "More and more, people are consuming fashion through the lens of celebrity," said Janice Min, then the editor of celebrity tabloid US Weekly. "You can ask any woman who is sixteen or twenty-six or forty what the trends are right now, and she will probably define those trends through what celebrities are wearing. By seeing who's going to these shows, you can see what designers are hot, and who they might be dressing during awards season."[94]

Celebrity diva behavior replaced editrix diva behavior as reality show stars joined the front-row fray. Where magazine editors such as Nina Garcia, Anna Wintour, and André Leon Talley were once the only demanding characters, arriving with their own cars and drivers, and in Wintour's case, bodyguards, now they had competition. "One time, we had all our models lined up and ready to go, and we got a call that Paris Hilton was coming," remembers designer Nanette Lepore. "My husband had to run out to the sidewalk to get her, and bring her and her little dog in through the backstage."

Some celebrities such as Combs launched their own labels and showed them at Bryant Park, creating Hollywood-level spectaculars and bringing new eyeballs to the runway. In 2001, the hip-hop mogul's $1 million fall "Revolution" menswear show, which included fur-cuffed jeans, ostrich-leather pants, camel suits, and slouchy sweaters, was broadcast live from the tents on both E! and Style in a special two-hour program. Channing Tatum, a model before he was an actor, walked the runway for the rapper in 2003.

In 2000, Russell Simmons merged hip-hop and high fashion, creating the Baby Phat label designed by then-wife Kimora Lee Simmons. The shows at Bryant Park always had a scrum at the door, started late, and attracted a mix of the political and celebrity set, including in 2003 Al Sharpton, Hillary Clinton, Paris Hilton, and Tyra Banks. "Baby Phat was over the top," recalls Paper magazine's Mickey Boardman. "There were crowds of fashion addicts freaking out, living and loving Kimora Lee Simmons."

Changing Ownership, Venues

As the star power in the seats and on the runways increased, New York Fashion Week became an even more valuable commodity. Mallis and 7th on Sixth were spending so much time throughout the year lining up sponsors and planning the logistics for Fashion Week, that the CFDA was struggling to fulfill its other duties. "They didn't realize how difficult it

Opposite, clockwise from top left: Madonna and daughter Lourdes at the Versus Spring 2000 show, September 1999; Designer Kimora Lee Simmons with her daughter at the Baby Phat Fall 2002 show, February 2002; Paris Hilton at the Nanette Lepore Fall 2005 show, February 2005; André Leon Talley, Anna Wintour, and Sandra Bullock at the Calvin Klein Spring 2003 show, September 2002; Sofia Vergara arrives for the Sean John Fall 2001 show, February 2001; Sean "Diddy" Combs and model Tyson Beckford on the runway at the Sean John Fall 2008 show, February 2008. Following spread: Calvin Klein Fall 1999 show, February 1999.

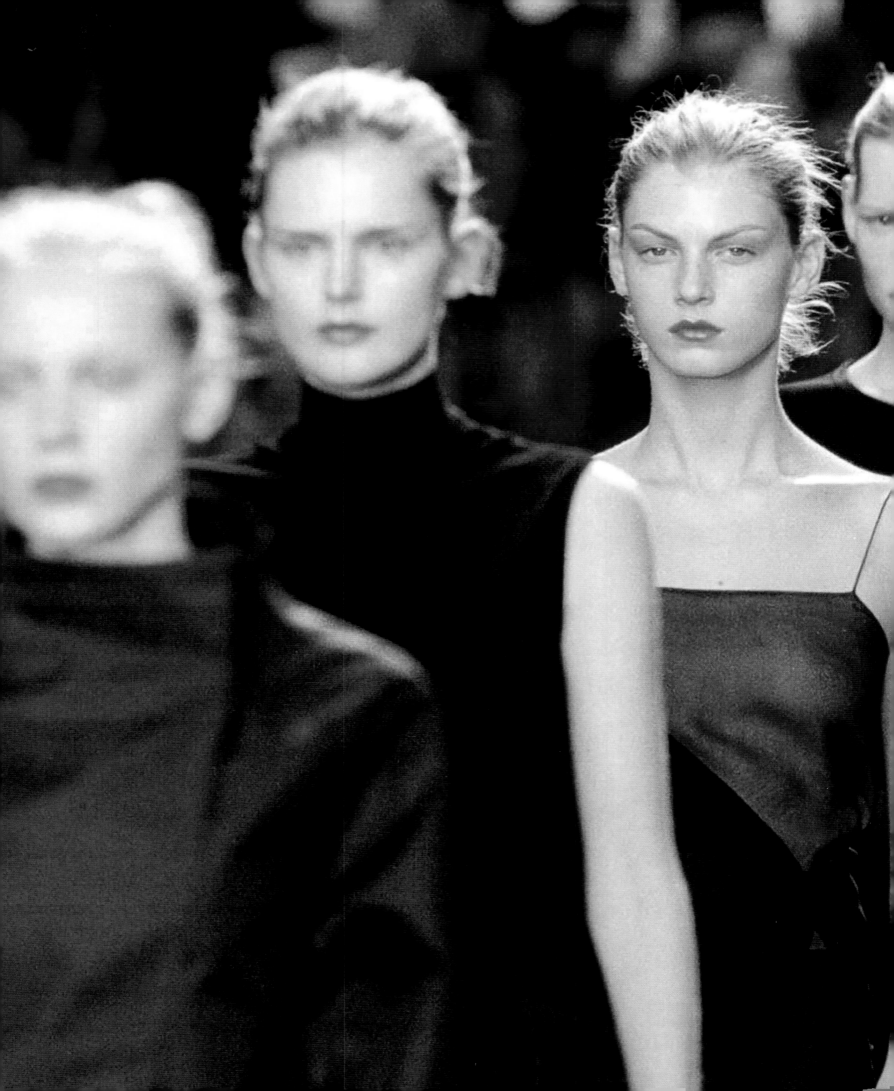

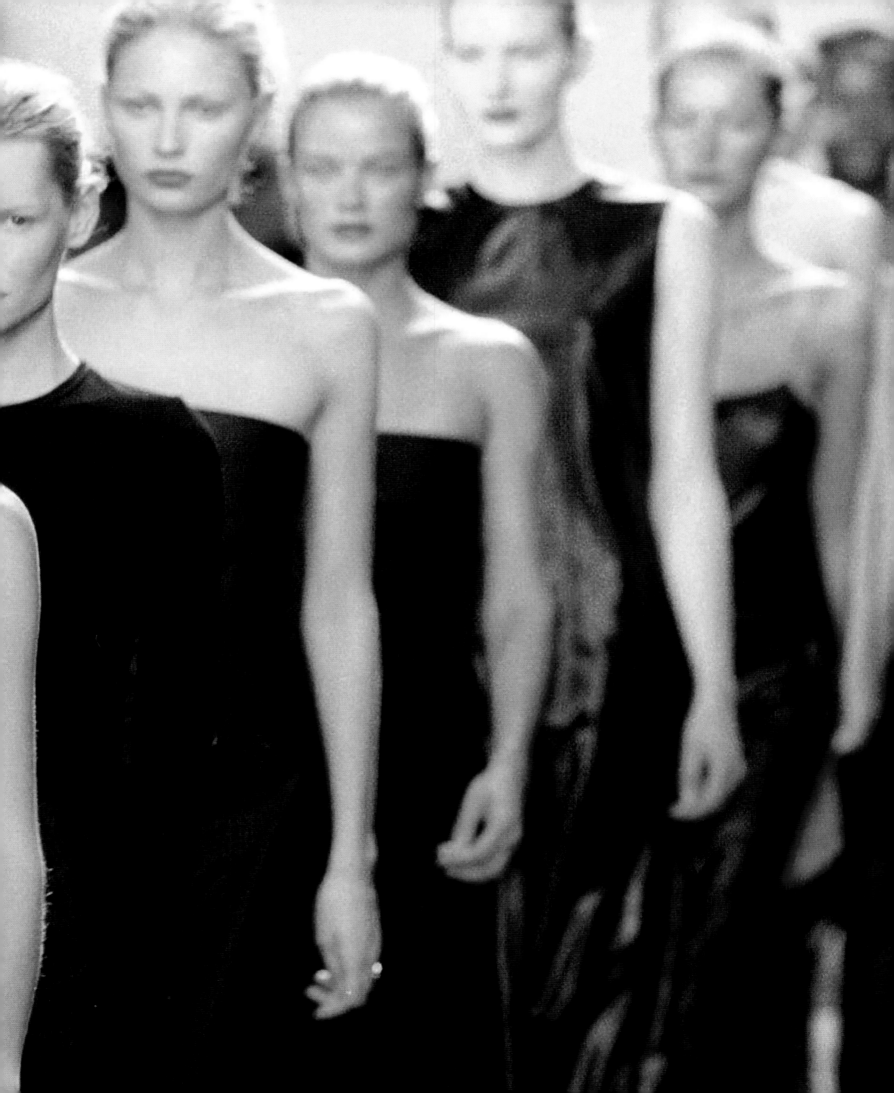

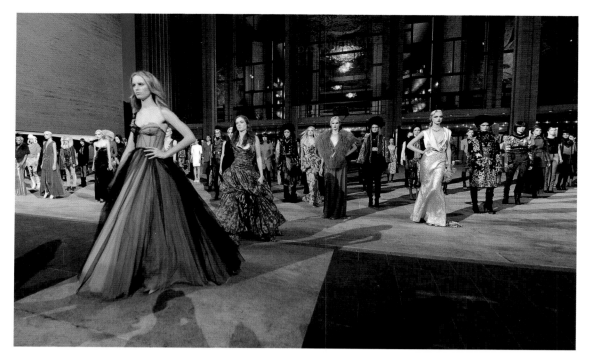

was to run a commercial endeavor," says then-CFDA president Herman, who spearheaded the sale of the runway show production division to sports and entertainment marketing and events conglomerate IMG in February 2001.

"It was totally a financial decision," says Mallis. "The CFDA was getting a little exasperated with how much attention was being spent on Fashion Week. I defend that. When I was running the CFDA, we were doing Fashion Week twice a year, [and] had added men's shows twice a year. We were doing Fashion Targets Breast Cancer and the CFDA Awards. We were doing it all successfully, but with the sponsorships, we were robbing Peter to pay Paul."

IMG had been helping the CFDA for a couple of years to sell sponsorships and get the shows on TV. "They took what we sold and turned it into a bigger package, charging more money and giving more benefits," Mallis explains. Except that for every sponsorship IMG secured, the CFDA owed a commission on it. "We didn't pay, and the commissions added up to a lot of money," Mallis admits. Eventually, they decided that selling to IMG would be easier than paying them back.

"It was bittersweet, because it meant I would be leaving," says Mallis, who resigned from the CFDA to join IMG. "But the choice was to stay at the CFDA or go to IMG. I felt like I needed to make sure [Fashion Week] grew the right way and didn't become over-commercialized. For me, it was moving to a big company, with all these other opportunities and synergies with media, TV, and sports, and it became much more global. IMG put resources to bear . . . so we did shows in L.A., Miami, Berlin, Australia, and India. It was a great opportunity to travel and create Fashion Weeks all over the world."

Donna Karan and other designers agreed that the deal would help transform the shows from "the industry talking to the industry" to "the straightest path from designers to consumers."[95]

Along with synergy came sponsorship opportunities; Mercedes-Benz, Olympus, and Lexus were among the blue-chip brands that signed on as title sponsors for New York

Fashion Week in the following years. Still, not everyone was pleased with the increased commercialization and IMG's plans to turn the runways into more of an entertainment spectacle. So, as New York Fashion Week continued to grow, it spread out once again. Only 20 percent of the September 2001 season's 350 fashion shows were produced by IMG at Bryant Park; 20 percent were produced by MADE, a new entity producing shows in and around Milk Studios in the Meatpacking District, and the rest were produced by designers at independent venues across the city.

At that point, the CFDA started working closely with the Fashion Calendar to help coordinate events, along with the task of grappling how Fashion Week should evolve as access to the runway became more democratic. In 2010, following a series of logistical challenges with Bryant Park, IMG/Mercedes-Benz Fashion Week New York left midtown for good, relocating to Lincoln Center to better accommodate the 500,000-plus attendees. The new Upper West Side location was a different kind of stage for American fashion, putting it in the same realm as such cultural institutions as the New York City Ballet, the New York Philharmonic, and the Metropolitan Opera, further blurring the lines between the runway and entertainment. The new tents were inaugurated in Lincoln Center's Damrosch Park September 2010, with guests entering through a branded façade located between the Opera House and the David H. Koch Theater. The shows opened September 7 with a public fashion show with two hundred models and 1,500 paying guests as part of the industry-wide initiative Fashion's Night Out to get people shopping during the recession. (Tickets were $25 and proceeds went to the New York City AIDS Fund.)

But not before Tommy Hilfiger had the very last show at Bryant Park, presenting a Katharine Hepburn–inspired collection with Taylor Swift in the audience. "I remember the last song was Alicia Keys's 'Empire State of Mind,' and Tommy talked to the crowd after and said, 'onward and upward,'" says former AP fashion editor Samantha Critchell. "I got teary eyed—and I'm pretty sure I wasn't the only one feeling like Fashion Week was changing."

Opposite: To celebrate IMG/Mercedes-Benz Fashion Week's move to Lincoln Center, the Spring 2011 shows kicked off with Fashion's Night Out: The Show on September 7, 2010. The event featured two hundred models, including Gisele Bündchen and Adriana Lima, and had 1,500 paying guests.
Following spread: Lacoste Fall 2013 show at Lincoln Center, February 2013.

6

BEHIND THE SCENES

The runway show has evolved dramatically over the last seventy-five years. What was once a mundane sales tool, hastily arranged when a designer's collection was nearly complete, has grown into its own kind of creative art form for certain designers and a multimedia branding tools for others. Today's big brands such as Marc Jacobs, Michael Kors, and Tory Burch are in show-planning mode all year long, and designers start brainstorming next season's location, concept, and sets before their collections have even been made. Where shows were once presented in showrooms for small audiences of industry-insiders, now they can be massive productions with up to three thousand seated guests and many more watching online through live streams and social-media posts. They require multiple teams specializing in production, styling, public relations, photography, and social media, who operate with budgets comparable to those of some small Hollywood films, from $300,000 for a small show, $600,000 for a medium show, and anywhere from $2 to $4 million for a big-brand blockbuster. All for eight to twelve minutes of live theater and pure fashion bliss.

Here are behind-the-scenes looks into what goes into putting together a runway show, in each insider's own words.

Thom Browne
Designer Thom Browne started his label in 2001 with the idea of bringing back an appreciation for fine tailoring, and his high-water, hemmed trousers moved the needle on menswear. In 2011, he expanded into womenswear, famously designing the silk jacquard coat and dress Michelle Obama wore for her husband's second inauguration, in 2013. One of American fashion's finest storytellers, Browne creates runway shows as immersive experiences—clocking in at twenty to thirty minutes long—presenting everything from an Amish barn-raising to a funeral. Over the years, he's made plenty of over-the-top show pieces, including three-legged trousers worn by two models and a feathered bird cape and mask.

If I couldn't do my shows, I wouldn't want to be in fashion. I look at shows as my responsibility in the world of design to move design forward. I think they are such an amazing way of giving a more interesting context to fashion.

There are so many collections people see; I want people to remember mine. For my Fall 2017 show, [my partner, and the head curator of the Metropolitan Museum of Art Costume Institute] Andrew Bolton had been doing some research and came across the German term for all-encompassing art, *Gesamtkunstwerk*. It's an amazing term, and when I heard it, [I realized that] it's also how I've approached shows from the beginning. The collections are important, but the way people see them and the stories surrounding them are equally important.

Every collection is different. Sometimes I design the collection first and then I design the story around it; sometimes the story and idea I want to put in front of people is first, then I design the collection. It's almost two jobs in one: The concepts and shows are one whole body of work, then the collections are another, and I make sure they tie into each other.

Opposite: Thom Browne backstage before his Fall 2014 show, February 2014.

There is maybe 10 percent [of my collection] that is made up of true showpieces made only for the runway, but they are equally as important and importantly made as the rest of the collection. As conceptual as the show is for me, I want the showpieces to be made in the same way as a classic jacket and trousers. Because there's nothing worse than putting a concept in front of people if quality is compromised.

Most shows are eight to twelve minutes, which I think is a joke. There is so much work that goes into these shows that I could care less if somebody thinks it's too long. I want them to sit and enjoy the things that people have worked so hard on for the last six months.

There's a script, but it's all in my head, and I don't do show notes. I like people to have their own interpretations and create their own story within my story—for people to experience it their own way, instead of me dictating. The idea is to make people think. Even that simple notion scares people sometimes. It's really making them see things differently, showing things they haven't seen before. I love the idea of being a little bit nervous myself, because then it means you are putting something in front of people that will make them think, and that's kinda what we're supposed to do.

Nanette Lepore

Designer Nanette Lepore launched her ultra-feminine women's collection in 1992, selling out of her small boutique in the East Village. It has since grown into a full lifestyle brand sold at department stores around the world. Each one of her designs is handcrafted in New York.

Fashion shows are truly the glamorous side of fashion. I was in business for ten years before I took the leap into producing a fashion show. I was dying to prove myself as a serious designer and put on a show of my own, but I was terrified. Once I got into the routine of shows, I used to wonder if it would ever be easy.

The answer is no! Putting on a fashion show twice a year is crazy, it's suicide, it's illogical, and yet, it's the most rewarding feeling in the world. Your adrenaline pumps, you hyperventilate, and you make yourself and an entire army of helpers work ungodly hours, all for fifteen minutes on the runway. I've had established Hollywood directors marvel at the concept. It's utter madness... maybe that's the magic—maybe it's in the spontaneity and the mystery.

There's nothing like watching a fashion show; you can feel the electricity in the air. The music, the models, the clothing, the lighting, the makeup all come together to transport you.

Morning of the show: models, a team of thirty on hair and makeup, dozens of PR people. Photographers push their way through and snap anything that interests them. Television crews push in with their boom mics and cameras; everyone is in awe of the spectacle of fashion. The funny thing is that the excitement of a live runway show was kind of a secret that only the press and buyers were privy to, a cadre of people who traveled from New York to Paris, London, and Milan, until the Internet and *Project Runway* exposed all of us to the world. The secret was out and everyone wanted in.

Moments before the show: I'm in the front of the line with the guy on the headset, he's on the right of the model line and I'm on the left. My stylist and I have one eye on the monitor and one eye on my opening model. There are butterflies in my stomach; I'm panicked yet bursting with excitement. The lights go down, my heart races as the guys in suits who work the venue ceremoniously pull away the plastic cover on the runway. The music shifts, it's the opening song, the lights slowly come back up! The opening girl is looking straight ahead; she's got this! The guy in the headset puts his arm down, signaling her to go, and she's off.

She looks amazing; I get goosebumps. I can't help but stare at the monitor, feeling a little bit selfish that my team isn't able to see what's going on, but I'm relishing this moment. Twelve minutes and twenty-eight looks later, the models are all back in formation awaiting the final parade. The parade is my favorite part. It's the crescendo of the show, a living, breathing painting. Now it's my turn to take a stroll on the runway. The guy in the headset says, "GO!"

Opposite, clockwise from top left: Thom Browne Fall 2016 show, February 2016; Thom Browne Fall 2015 show, February 2015; Thom Browne Spring 2015 show, September 2014; Backstage at the Thom Browne Spring 2014 show, September 2013; Thom Browne Fall 2017 show, February 2017; Nanette Lepore backstage at her Spring 2014 show, September 2013; Lepore and models walk the runway at her Spring 2015 show, September 2014; Preparations backstage at the Thom Browne Spring 2015 show, September 2014. Following spread: Backstage at the Proenza Schouler Fall 2008 show, February 2008. Pages 130–31: New York Fashion Week, September 2004. Pages 132–33: Scenes from backstage at (clockwise, from top left) Tadashi Shoji Fall 2017, New York Fashion Week, February 2005, 2008, and Calvin Klein Collection Fall 2011, February 2011. Pages 134–35: Thom Browne Spring 2016 show, September 2015.

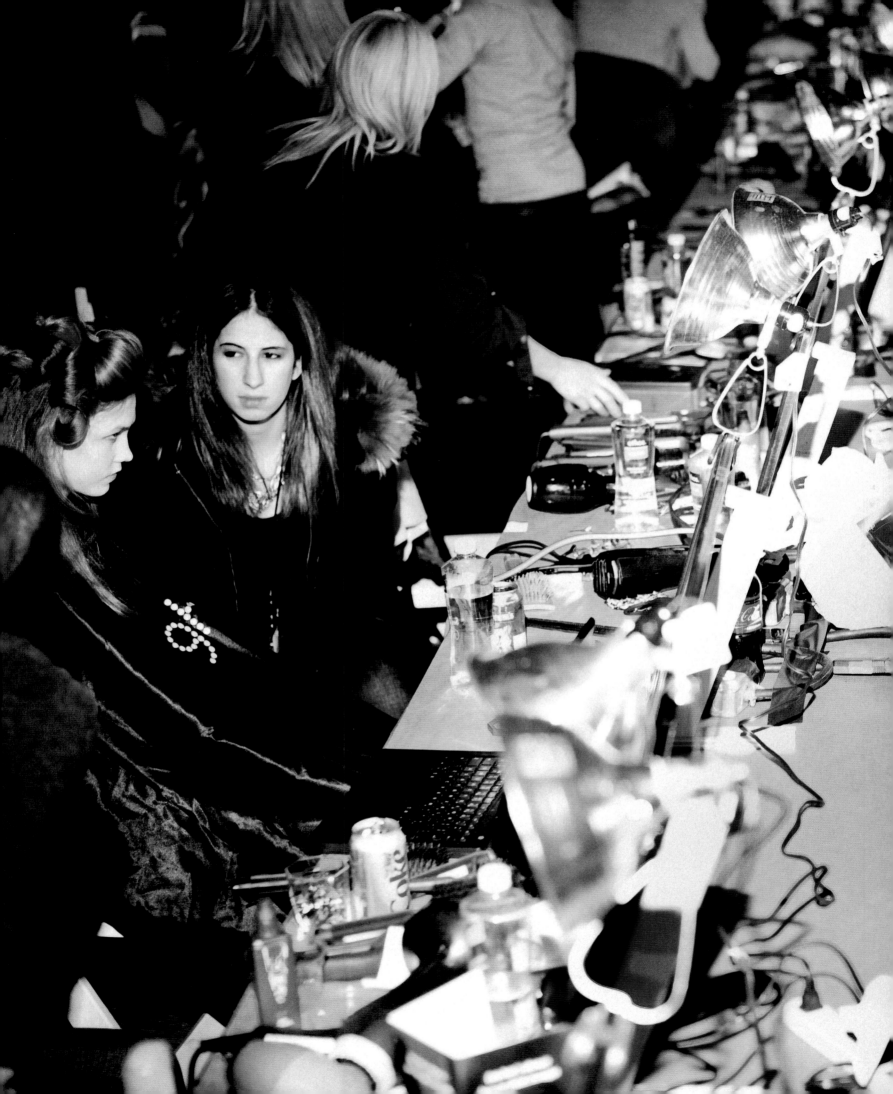

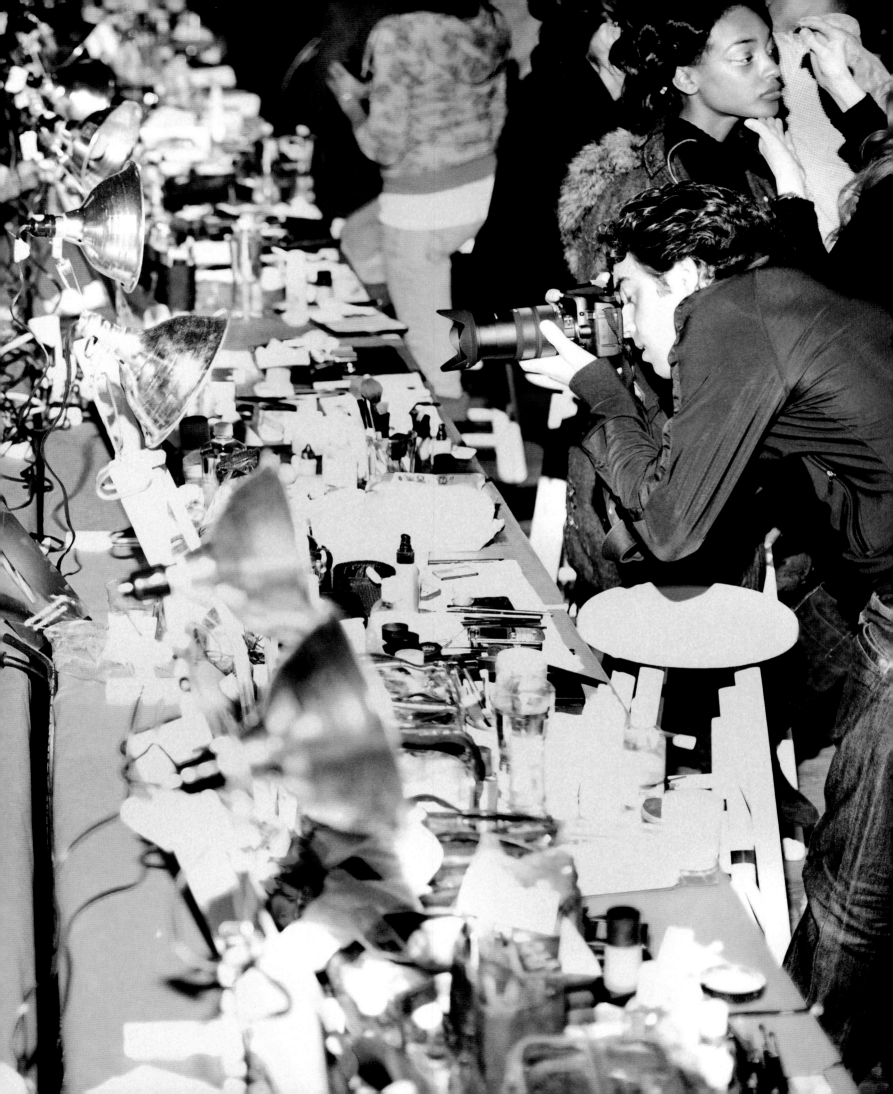

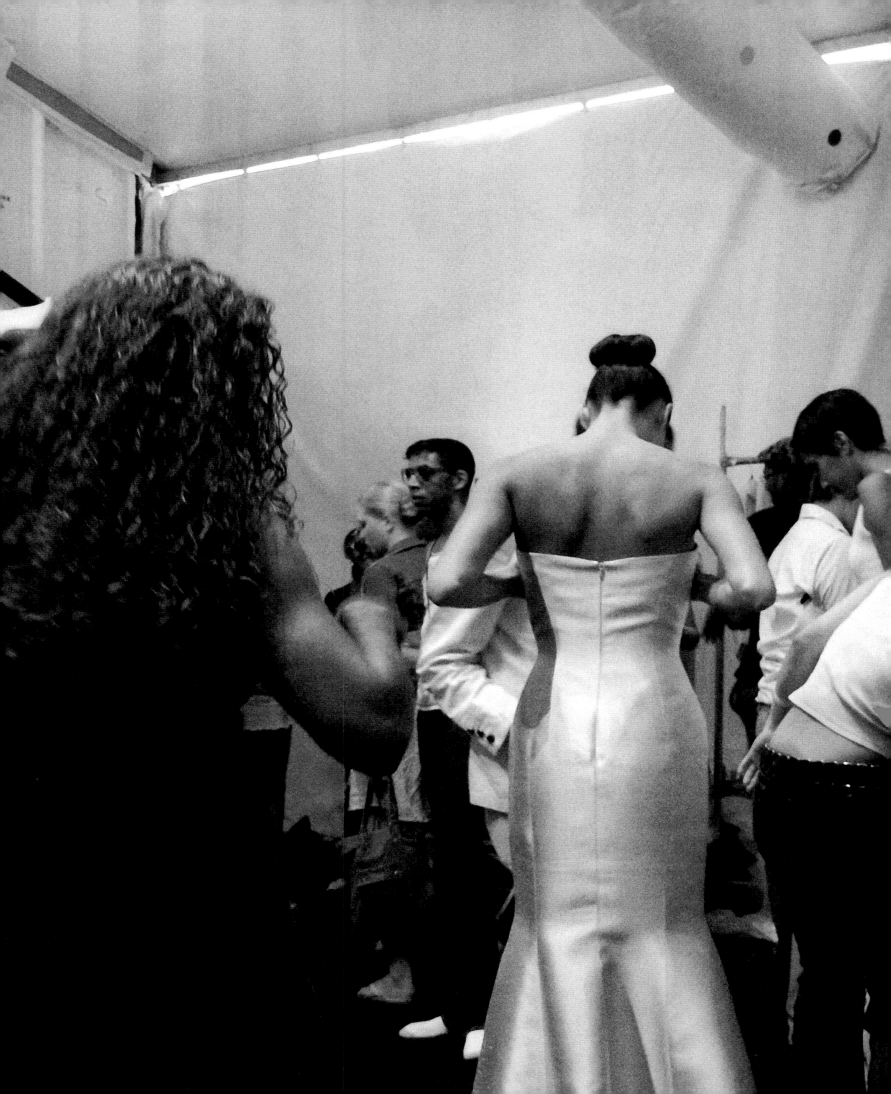

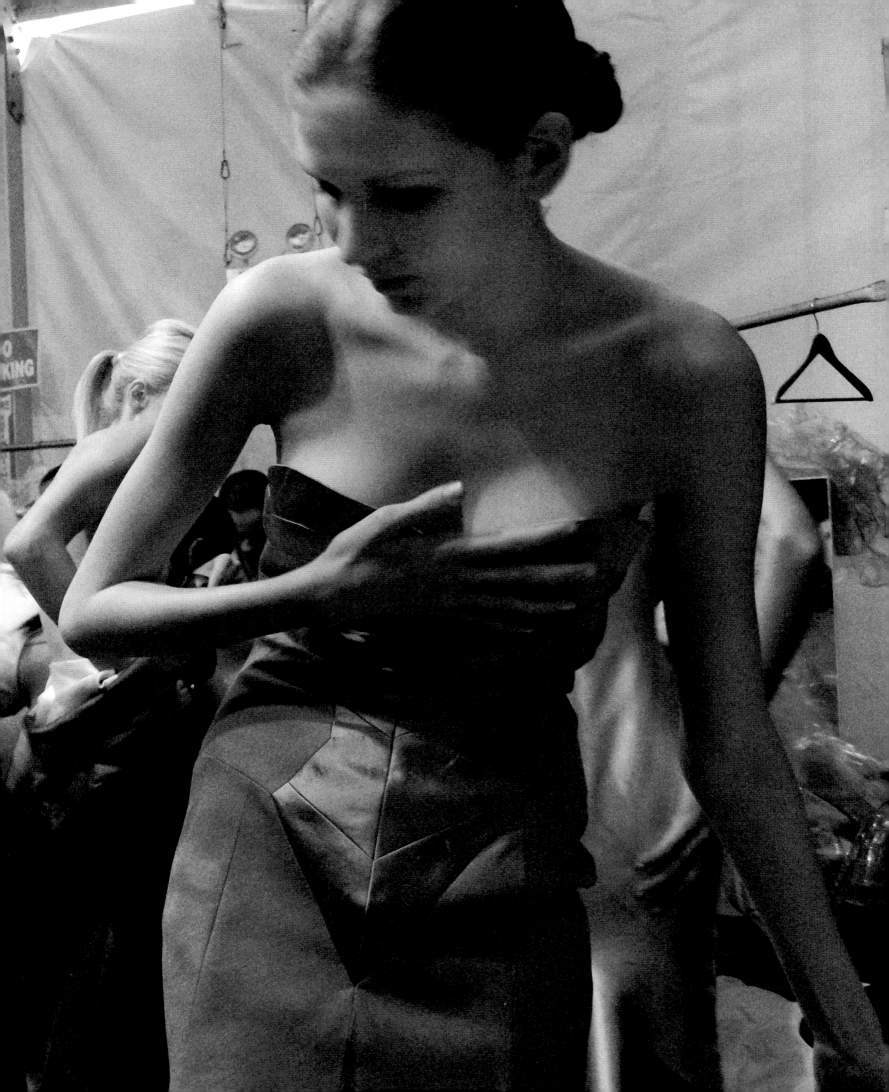

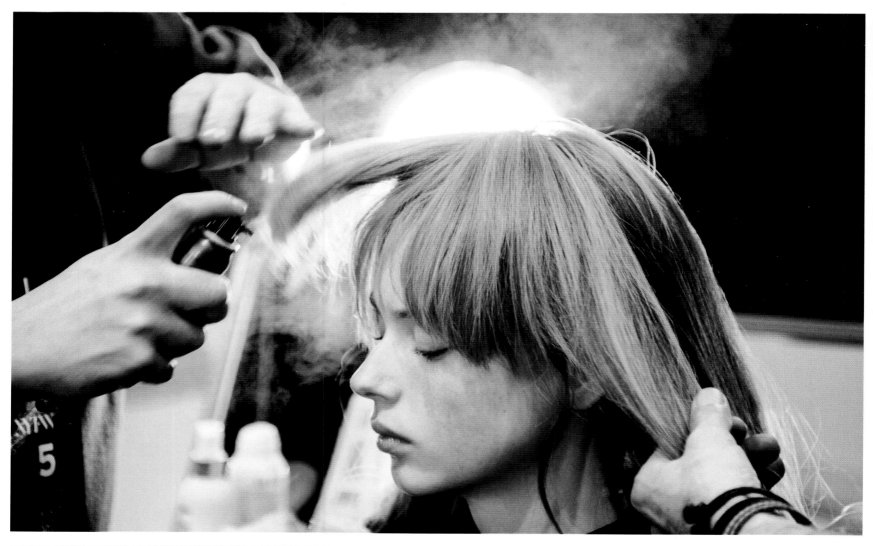
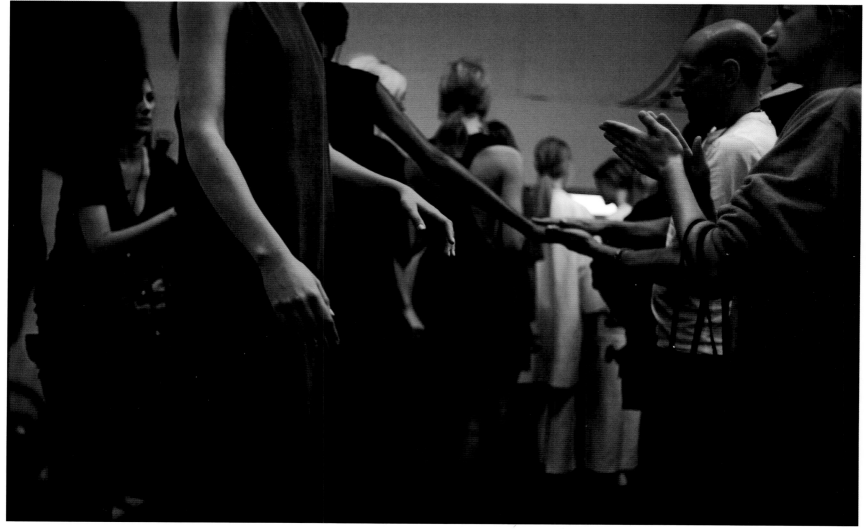

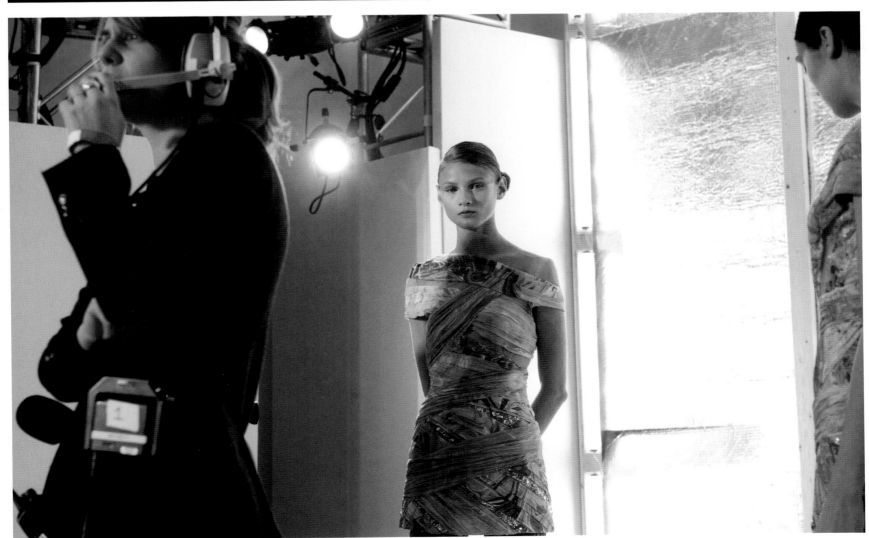

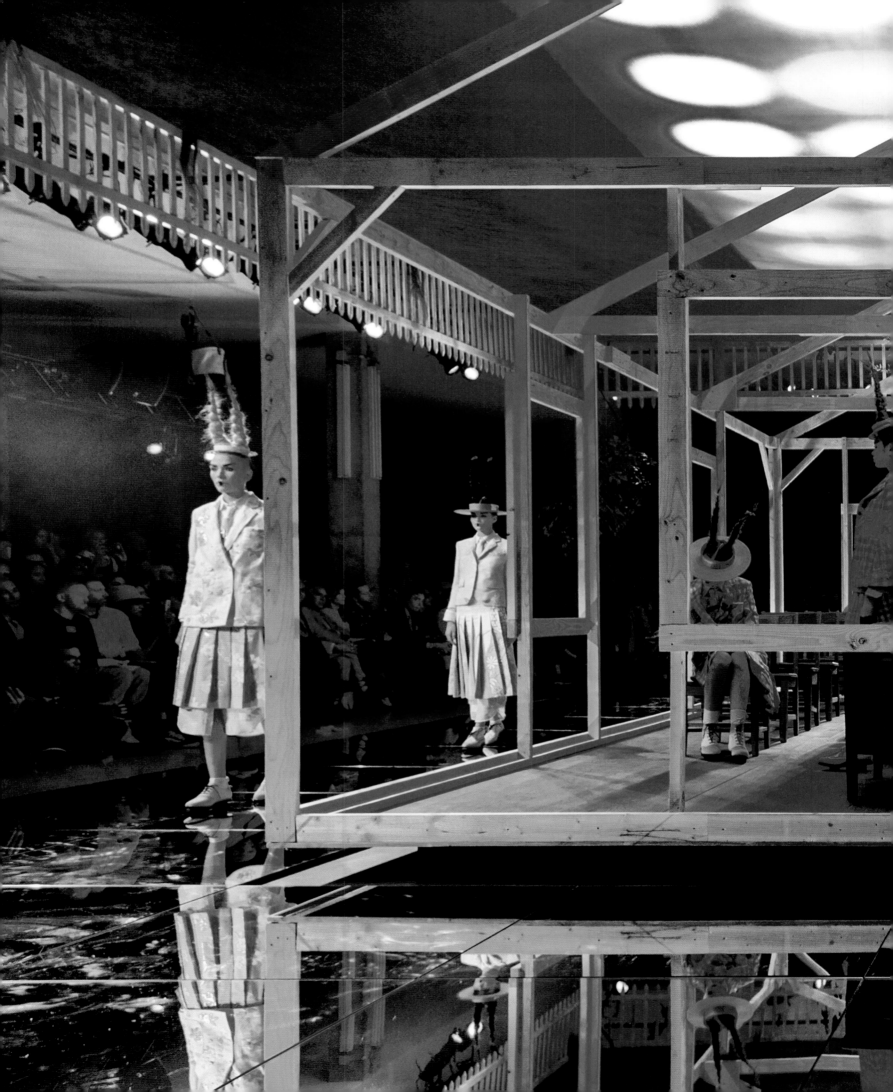

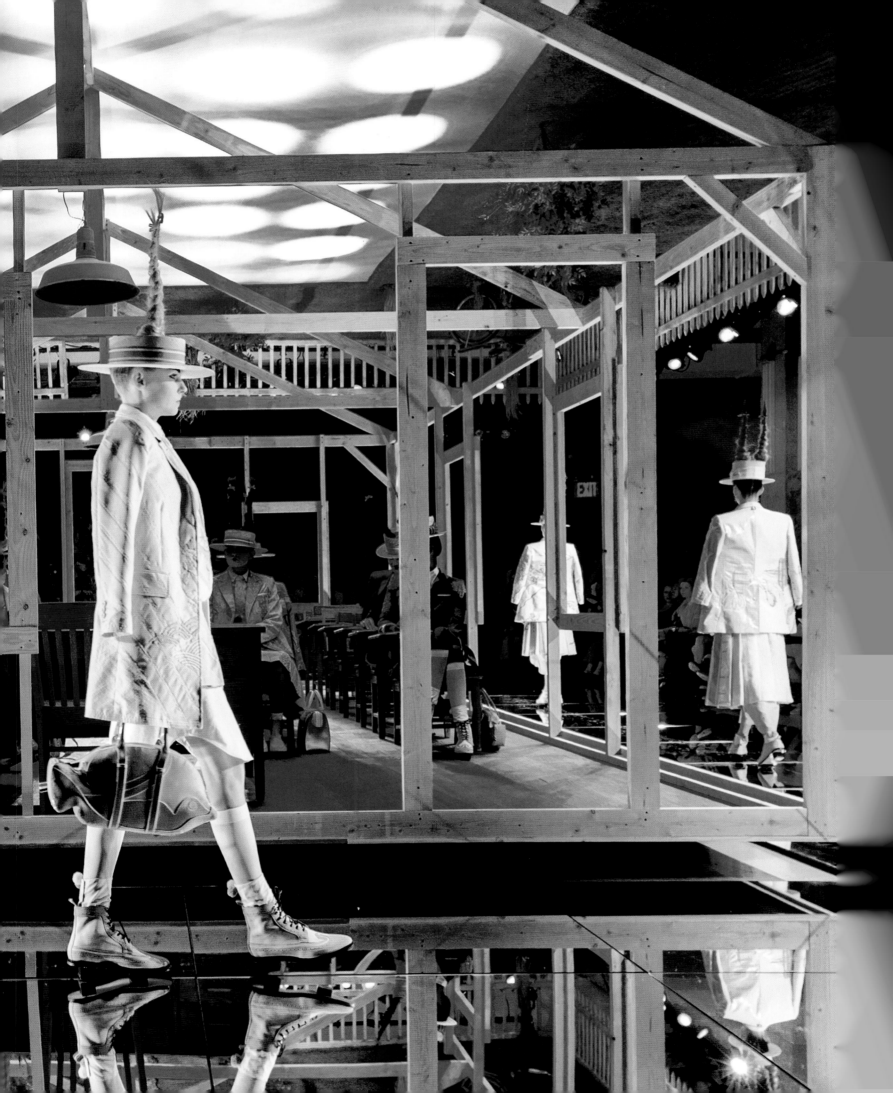

The day after the show: Mila, my shoe designer, is in my office asking for directives for the next season. Heels, bases, platforms all have been decided this weekend. My head is pounding; I'm tired. The show that walked the runway less than twenty-four hours before isn't even costed or merchandised yet, and Mila wants me to think about shoes for the next show. It's an endless cycle. What a glamorous life!

Tabitha Simmons

Tabitha Simmons has been styling runway shows since the early '90s, working with designers such as Tory Burch, Calvin Klein, Dolce & Gabbana, and Alexander McQueen. She also designs her own eponymous footwear collection and is a contributing editor to Vogue.

With Tory Burch, I come on in the beginning of the season and look at concepts of what the next show will be, and then we'll work on the silhouette of the clothing, and the shoes and the bags and jewelry and some knitwear. . . . And then you come back and you criticize, and come back again when everything has been put into work, about a week before the show. You have the whole collection there, and you put it together. And then once you've styled it, and obviously you work very closely with the designer, making sure you're really executing their vision, you help pick the models [with] a big casting for all the girls. Once that's taken place, you're putting together the runway looks. The model stands there, you take a picture of her, and it goes on a big board. You could do two hundred looks for a show of forty.

When it comes to impact on the runway, you always have to be slightly exaggerated, so something a little bit more than you would wear in the street. There's no formula. You respond to what's new. Maybe something that's matchy-matchy goes away for a long time, then you think that looks really good again. There was a time where everything would be a platform shoe. Now you don't see hardly any, and there are tons of sneakers, sandals, and flats. So it really changes. You're working with the instinct of what you see and what you want to see next.

On the day of show, I'm backstage with Tory checking every girl before she walks out. Sometimes when you style shows you see

a watered-down version of a look in the street, which is great because it means you've inspired [someone]. When I was a student, I'd look at shows, and when I couldn't afford that designer piece, I'd try to make it or re-create it. Shows should take you somewhere, at least take you out of reality for a second.

James Scully
Casting director James Scully has worked with thousands of models in his thirty years in the business, casting shows for Tom Ford, Todd Oldham, Brandon Maxwell, and more.

The mechanics of a show don't change. The only things that change are location, collection, and where we are in the modeling world. My process comes together pretty fast. For a show in September, I will do meetings in July about the theme, what the set looks like, and how many people are going to attend. The most important parts happen once the collection is done, three to ten days before the show.

Throughout the year, modeling agencies are sending me books of girls to bookmark. Then ten days before the shows, the agencies send out composites of all the girls who are going to be in New York that season. For the castings, I have a small studio, and I will see one agency at each time rather than having a big cattle call. There are never more than ten or fifteen people in the room, and I'm very quick. I look at you. If I don't know you, I ask where you are from, have you walk back and forth; you are shot on camera and video. It used to be Polaroids, but now it's all digital. It takes less than a minute and you're done. I don't want to waste time; I know sometimes models have twenty castings a day. I offer water and food. It's my goal to make it as casual and easy as possible and not intimidating. There's no science to it. I just know who I'm working for, and the minute I meet a girl I know if she's right for [one designer] or everyone, or if she's on my radar but she needs a season or two to come into her own.

After the castings, I put boards together. Brandon Maxwell is different from Derek Lam who is different from Tom Ford, so I'll think, "This girl can do everything or is only right for one person." Most people will have 60 percent of last season's cast back, and we search for 40 percent new.

Then I propose the models to the designer, and the designer does a final casting. That all happens in ten days. On the day of the show, if a girl doesn't show up, you have to figure out who is going to take her place. For the first part of the morning, I'm checking in girls until everyone is there. Then you call first outfits. Before everyone goes out, you see them lined up for the first time. I find that moment more exciting than anything else. You see all your work right there.

Julie Mannion
As cochairwoman of fashion-branding agency KCD and head of the firm's production services division, Julie Mannion works on thirty to forty runway shows a season, including Marc Jacobs, Tory Burch, and Tommy Hilfiger.

The rhythm of the year is nonstop. You start working immediately after the show on the next [season]. Right away, you're looking at locations and trying to confirm timeslots. Then you meet with the designer and say, "What is your vibe, what are you thinking, what is your mood board?" That first discussion is about a month after the previous show, when they are planning fabrics and what's inspiring them. For Fall 2017, for example, Marc Jacobs said he knew he wanted to be street inspired and he wanted to go spare. He said, "I want to do a non-show. I want no music, no lights, no anything." Tommy Hilfiger may say, "I am L.A. inspired," and one season, Tory Burch was inspired by *The Philadelphia Story*.

Productions are very team oriented—you have the design team, set team, styling team, casting team, and hair and makeup teams. For the bigger designers, those teams are already built, and it's just an evolution and refinement. As shows have become more about storytelling, the stylist, set designer, and casting director have become more important roles.

Once you land on a location, the designer goes away and works on the collection. For us, for a September show, it starts ramping up again in June. From a production standpoint, you need to land on everything by early to mid-July. That's when you are showing final materials, and then a designer will go into full production in August.

At KCD, we have two divisions, the technical production team, which is everything from location to staging, sound, lighting, logistics, and permitting, and the fashion services side, which deals with the design team putting together a calendar for the five to eight days before the show. They are working on when the shoes and accessories arrive, what dates designers are holding stylists, what dates they are doing hair and makeup tests, what the casting dates are, when the models are going to be in town, and what the other shows are that you need to schedule around.

Choreography can look simplistic, but it's not; very early on we'll look at a location, how big it is, what's the floor plan, what's the path, how many models will be out at a time, how many will be in the show, is it one look per model or rotations. We have to look at when to send them out; every eight seconds is the fastest you can go for photography purposes so you don't miss something, and it can go up to twelve or thirteen seconds. We do a stand-in rehearsal anywhere from three to four weeks before the show. We tape it all out and get stand-ins to do pacing and find what works and what doesn't.

The day of the show we try to build in an hour to do a rehearsal with real models. For us, hair and makeup and model time ranges from three to five hours ahead of show time. We do rehearsal in the shoes they are walking in, they will go back into hair and makeup for final touch-ups, and then it's getting them dressed. With everyone wanting content, everything going on backstage is so much more complex than it used to be. There are full look books, sometimes even full ad campaigns, that are being shot. There could be video and print media shooting.

I call shows from front of house. I like to see [the show] as the models are coming out so I can react to it that way. I will stand in photography position or in the tech booth area or near the audience, some inconspicuous spot where I have a good vantage point. Typically you have lighting, sound, and video all on a headset talking to each other. Sometimes you have stage managers, too. At a minimum it's five to six people, but we've had as many as twenty.

Alex de Betak

Founder of Bureau Betak, Alex de Betak has been producing runway shows since 1993, working with brands such as Rodarte, Jason Wu, Michael Kors, and Dior.

When I start a collaboration with a designer, my role is to determine a language for that designer through the fashion shows, and a lot of the elements, some of which will be recurring, that help define the brand. Sometimes we will propose a venue or negotiate an exclusive contract that will last for a few seasons or years, and the first season we will address the space in a certain way, and the next season we will address it differently.

The fashion show is one of the main communication elements designers have; from when they are very small and not very rich and it's all they have, to when they are very big and they do advertising and stores—it's still a large tool. It's also the very first communication of the season—before editorial and advertising and clothes in store. You see the show and it sets the mood for the entire season to come.

For Rodarte, once we agreed on working together, I conceived a language for them, which started at the Dia Center of the Arts on 22nd Street years ago. I first proposed using the fluorescent tubes for the set, which was partially inspired by the Dan Flavin installation in the staircase of that building. I also wanted to contrast the softness and femininity of their dresses with something strong, architectural, and modern. We've made [the sets] evolve season after season for ten years now, but when you see a picture or clip on Instagram, you immediately know where you are.

To put together a concept for the season, we sketch, then we do 3-D renderings of the show. That all happens in the months leading up; we start very early and finish all the concepts a few months before so we can put them into production and source materials in weird places, sometimes for budget reasons.

We have a team called the collection coordination team; they help coordinate all the castings and fittings at every show. For the day of, everything is scripted; we compile what's called a show conductor. We make them very precisely, with live cues,

Opposite, clockwise from left: Rodarte Spring 2009 show, September 2008; Edward Enninful, Diane von Furstenberg, Alex de Betak, and model Karlie Kloss at the Diane von Furstenberg Spring 2014 rehearsal, September 2013; Marc Jacobs Spring 2017 show, September 2016; Guido Palau backstage at the Marc Jacobs Spring 2010 show, September 2009. Following page, from top: Backstage at the Rodarte Fall 2007 show, February 2007; Rodarte Fall 2015 show, February 2015. Page 143: Donna Karan Fall 2013 show, February 2013.

music cues, model cues, special effects cues, and they are printed out. We also draw and print large plans for choreography of the models. We started it twenty years ago, writing storytelling instructions to put the girls in the mood. When we set up at the location, we look at all the angles, because now everyone shoots photos from everywhere, so it's important. Before the show, I brief models by the door from which they come out on the runway, where we have the monitors. I stand there and brief them one last time.

Guido Palau
Hairstylist Guido Palau has tamed tresses for the best of the best, including models walking for Alexander Wang, Tory Burch, and Marc Jacobs, where he created show-stopping rainbow rave 'dos in 2016.

I meet with a designer as little as three days before a show or as much as six weeks depending on the concept. Someone like Marc Jacobs, often we'll have conversations six weeks before the show if it requires a lot of preparation or is a very complex idea or if we have to order wigs.

They tell you their inspiration, show you their mood boards, some clothing; they might put it on a model or a couple of models and discuss any ideas they have about the hair. Then I go off to a separate design studio with a model or two and make a pass at it. Then you bring it back to the designer, there's another discussion, and perhaps some modifications.

The number of models we do for a show can range from forty-five to much more; for a Dolce & Gabbana show, I once had 126 models, and there is generally only a three-hour call time, so you can have up to sixty assistants working on a show. Sometimes I will have to look over every girl's hair and tweak it, and sometimes the assistants can do it and I just oversee it; it all depends on the hairstyle. The more technical the hairstyle, the easier it is for assistants to understand. The more natural and individual the more, funnily enough, it can go awry, so I have to be more hands-on. There are lots of factors that can change things on the day—humidity, cold. Girls might come from another show with hair clogged with hairspray and gel, and it has to be washed. Girls sometimes fall asleep on their hair. . . . You try to control things as much as possible. At the end of the

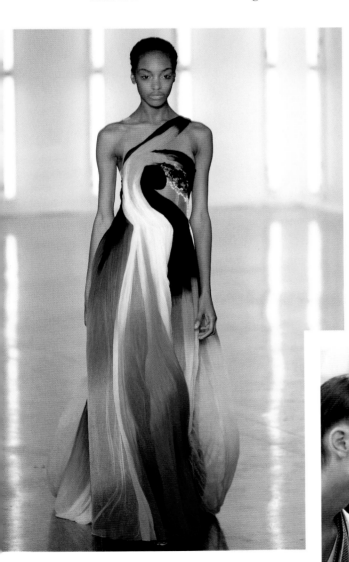

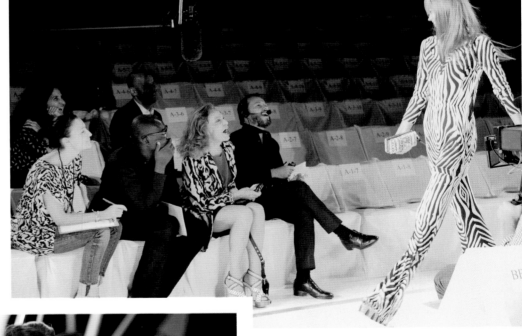

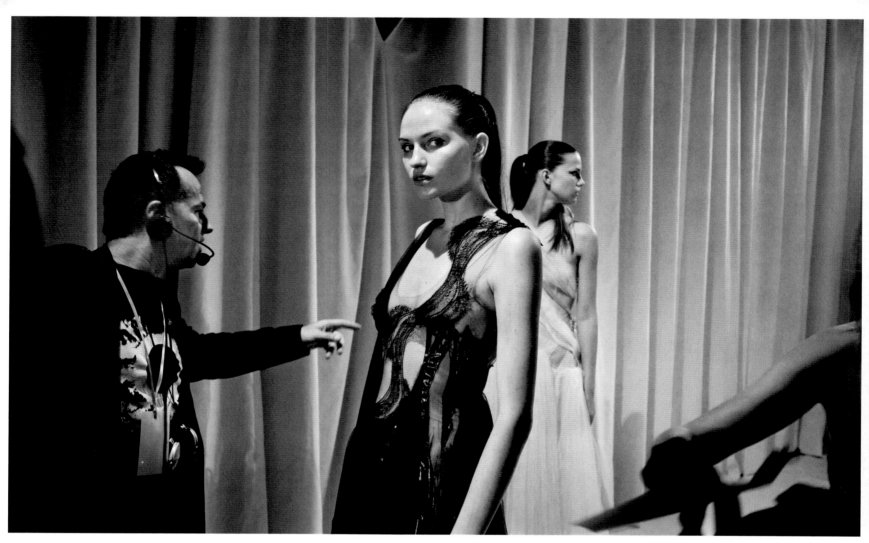
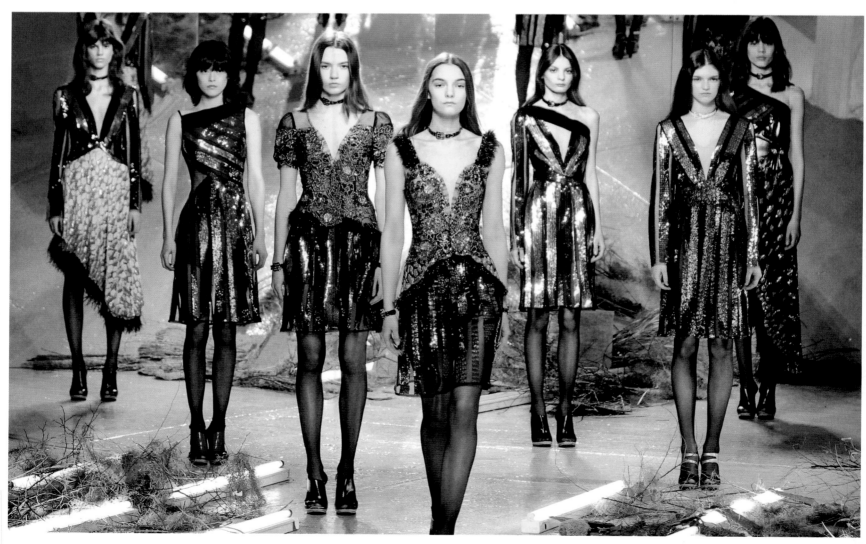

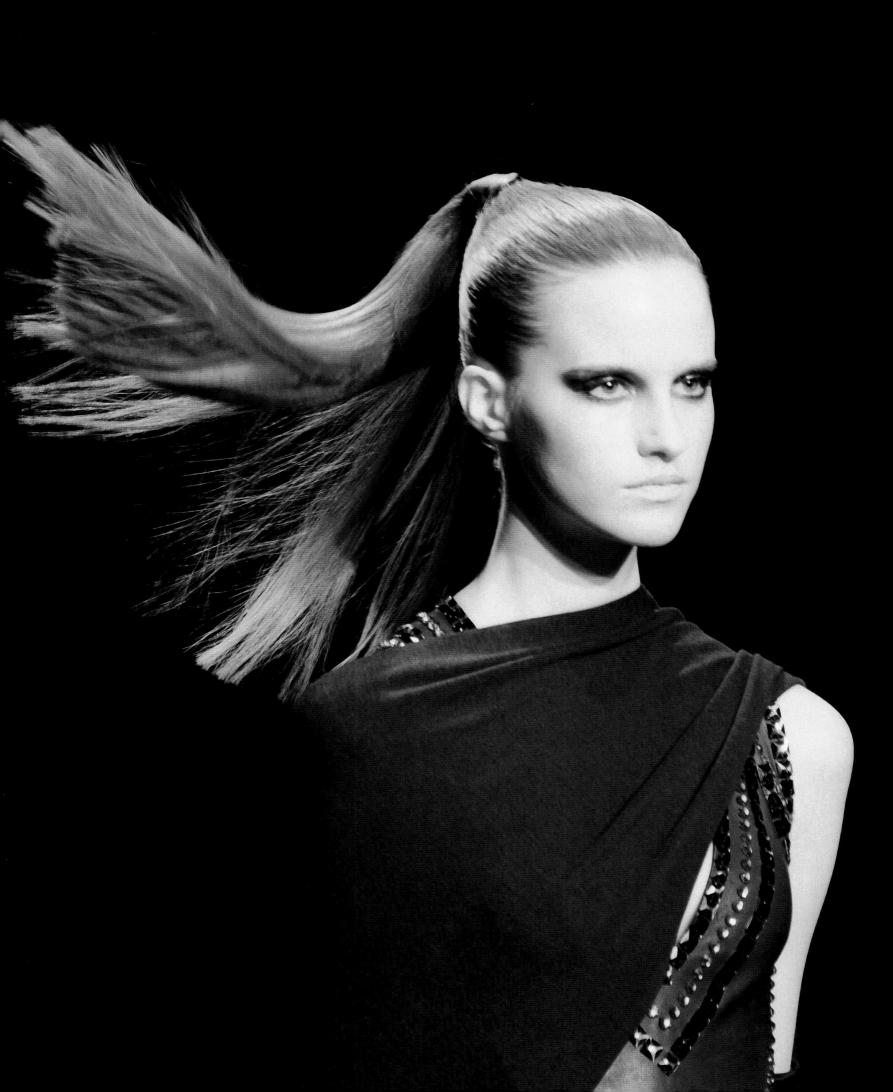

day, it's my responsibility to make sure all the girls go out the way the designer understood they were going to go out.

Pat McGrath

Pat McGrath is one of the most influential and sought-after makeup artists in the world. During her career, she has concepted, launched, and developed a number of luxury cosmetic brands (including her own, Pat McGrath Labs), and creative directed makeup for countless designer runway shows, advertising campaigns, and editorial spreads.

For more than twenty-five years, I've been creating looks for approximately forty shows a season, including about six for each NYFW. I continuously ask my team to push their creative boundaries, challenge my eye with newness, and infuse each presentation with an individual, *sui generis* imprimatur. From concept to the designer's final bow, runway is a juggling act of the most extraordinary kind.

Each designer I collaborate with is unique in their own way. Some like to brief very early—weeks before the show. Some are more last minute, working through a concept until the night before. The method of communicating the concept, and whether the hairstylist or others are present, varies. Designers can show drawings, walk me through toiles, show me bits of embroidery or mood boards.

When we have a week's lead time, I feel fortunate. With some brands, we can study everything from the designers' mood boards to the garments themselves. With others, we may rely on filmic references or brief phrases that we must translate to the visual realm. Although my job is to push the designer's vision via makeup, our vocation is to take it beyond anything they've ever imagined. While they're challenging me, I'm pushing my team to expand their creative boundaries and provoke my eyes with freshness.

When Raf Simons was making his debut at Calvin Klein in February 2017, he focused on a diverse exploration of Americana. After working several days and nights with him, previewing the collection, talking about the show's themes, and seeing the mood boards, we arrived at a stripped-down

look that let the male and female models shine, occasionally punctured with a hint of Pat McGrath Labs' Silver 005 on the inner corner of the eye along with the CyberClear Eye Gloss from Dark Star 006. At Anna Sui's Fall 2017 collection, it was all about color. She'd heard of Pat McGrath Labs' then-forthcoming Dark Star 006, specifically the scintillating UltraViolet Blue pigment, through a mutual friend. The moment I stepped into her studio, she asked for Elsa Schiaparelli, Elsie de Wolfe, and Countess Dorothy di Frasso with a touch of Noel Coward's *Blithe Spirit*, rendered in a new, modern way with a bold, blue eye.

Once I've synthesized the totality of the designer's inspirations, I begin creating looks that I edit and refine until there's a beauty narrative that feels instinctively right. Even then, I continue perfecting the look until the moment the models walk the runway.

Each show varies depending on the complexity of the vision. Stripped-down, bare, "no-makeup makeup" looks usually require two to three hours of preparation and our ten "essential trunks" of product—foundations, concealers, pigments, powders, nude lips, etc. A more complex look, like something for John Galliano at Maison Margiela, can mean up to sixty trunks, five to six hours prep, and sixty to seventy artists.

I creative direct every aspect of the makeup—from the first touch of primer to the last whisk of powder before the runway. But I firmly believe—and my two-and-a-half decades in the industry have borne out—that no one does an entire face perfectly. Some artists are exceptional at eyebrows while others create the most sublime skin. Depending on the look and the time allotted, I conceptualize a customized approach for each show that I disseminate to my team accordingly.

Fashion shows are all about timing. Timing is literally of the essence, and military precision is mandatory. Shows are frequently delayed, schedules are always packed, and models are often late. Sometimes, it demands five makeup artists on one face to achieve a runway look in seconds; but, no matter what, it's all possible with a finely tuned team.

What I love about the runway is that anything can happen. I thrive on the buzz, the energy of the diverse teams—design, styling, hair, production, nails, and more—engaged in the shared pursuit of striving for the impossible: perfection. The runway brings together so many creative people who've inspired me for decades, and affords me the opportunity to work with legendary makeup artists, new talents from social media, and of course all the models—both iconic and newcomers—who lend their ineffable presences to each and every show. Above all, I thrive on the possibility of breaking the rules, of creating new dimensions in the world of beauty, and then translating that spirit into products that create inspiration, obsession, and addiction at Pat McGrath Labs.

Ed Filipowski

As cochairman of fashion agency KCD, Ed Filipowski presides over the public relations strategies, event management, and show production for some of the industry's biggest brands, including Tommy Hilfiger, Tory Burch, and Marc Jacobs. He's a familiar face to showgoers in the front of house, when they arrive to see a runway show, as the unofficial greeter, seater, and de facto school principal, making sure an event is a seamless experience.

We serve the needs of both the designer and the guests in attendance, which is a complex transaction because you have so many parameters that go into that balancing act. You have the journalists, the retailers, the business affiliates of the designers, the friends of the designers, the celebrities. Then you have restrictions on the size of the space, occupancy, the format of the runway, sightlines, what people can see from different rows, who needs to see from the front row, who needs to see accessories and the hierarchy of the industry . . .

There is an art to seating a show. Ours is both digital and manual. About twenty years ago, we started pre-seating shows, where everyone got a seat on their ticket when they got it. This is because if you are inviting them assuming they are going to come, as an agency, you do the work to find out who is coming.

In terms of attendance, the first change was the influx of international press, which started with the Bryant Park tents.

Opposite, clockwise from left: Pat McGrath does Kendall Jenner's makeup at the Givenchy September 11th tribute show, September 2015; Ed Filipowski, 2015; Backstage at the Jenny Packham Spring 2017 show, September 2016.

That's when celebs picked up, too, then you had digital starting to creep in. Then we saw the shift in regional editors, who were no longer coming, and the rise of digital influencers and bloggers. That's what happens. New tribes come along, they are over-accommodated, and then the industry learns how to curate and pull back to what is really needed.

The truth about anyone trying to get into a show is that it's at the invitation of the designer. This is the designer's show; they are paying for it. This is not our PR show to accommodate people we think should be in there. If you are on the on the list, approved by the designer, we will let you in. Otherwise we respect our clients and will not make an exception. Our firmness comes from honesty, not drama or accusing people of trying something; we just say the truth—that's the best way to be.

You can tell if someone doesn't belong in the front row. If you are good at what you do, you know the faces of who are supposed to be there, every retailer and press person. Even though the world now sees runway shows instantaneously, the front row still matters a lot. That's where you get your first opinions that create the lead story for the season, your collection stories, and your feature stories. In my thirty years, it's more professional now than ever. It's less diva and ego, and more focused on the work.

When you can work with production to create a format for the seating that creates energy in the room that reflects the collection and the designer, that's the ultimate goal. That's when you hit a home run. If you are doing it to the most creative degree, you've created an immersive experience. The clothes are the heroes, but they are enveloped by the environment.

Billy Farrell
Famed event and front-row photographer Billy Farrell cofounded his agency, BFA, in 2010, but has been working runways and fashion parties since 2001, photographing everyone from Anna Wintour to Joe Jonas runway-side.

Fashion Week has always been a moving target. Even though you have a schedule, things still change a lot. I know the game,

who to look out for, that anyone who comes through the door is worthy of shooting, and that certain people need to be combos with the designer after the show or before the show. If the PR company is doing its job, we'll have a shot list forty-eight hours before. Sometimes though, we don't get a shot list until an hour before an event. We like to do due diligence, and do our research before, so that's not ideal . . .

What gives me the most joy [at shows] is seeing people who are happy to be there and happy to be seen and have an understanding of what I do and are not being on guard and self-conscious. And I know it sometimes depends on time of day. If you are a shooting a morning show, sometimes you have to give them their space.

You have to have a connection before you start shooting. I love it when it feels like community, when people are open and talkative. I hate it when people are jaded or too cool. Surprisingly, most people are open. People think fashion is like *Zoolander*, but it's really not. It's a community, and it's one of the more embracing communities.

Dan Lecca
Photographer Dan Lecca has been called the king of the runway. With a Harper's Bazaar *contract, and deals to shoot in-house photos for Marc Jacobs, Calvin Klein, Jonathan Simkhai, and many more, he and his wife, Corina, photograph seventy shows per season at New York Fashion Week, and even more in Europe.*

I started out shooting in the pit in the 1990s. [At that time,] more and more photographers were shooting around the runway, and they realized that rather than looking up with a wider lens at the model walking by you, it would be better to look straight on as the model walks toward you. I was one of the first to move from the pit to the podium in back. But a lot of photographers took between three to seven years to [move]. Eventually there was no more pit.

On the podium, it became more important to have the central position so you could look at the model straight on. And as the model turns, they come on the left and turn on

Opposite, from top: Dan Lecca at the Kenneth Cole Fall 2004 show, February 2004; Alexander Wang Fall 2016 show, February 2016.
Following spread: Crew members prepare for the Marc Jacobs Fall 2011 show, February 2011.

146

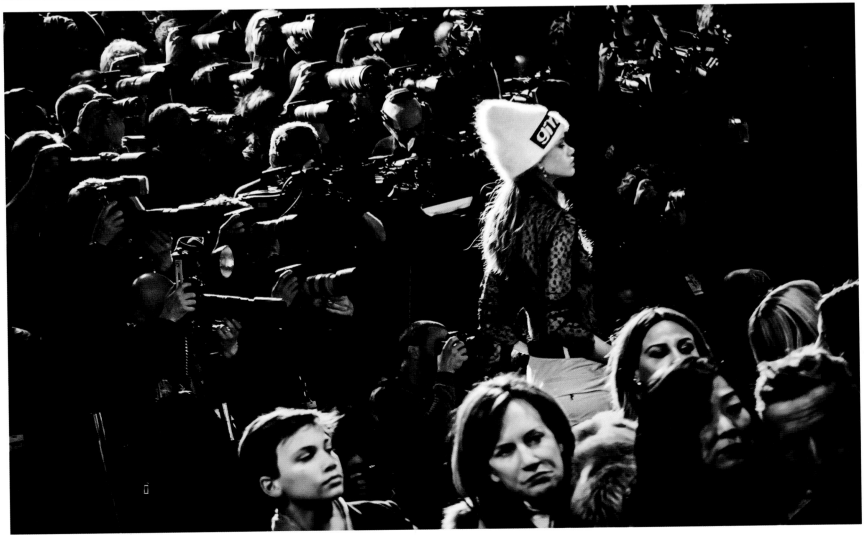

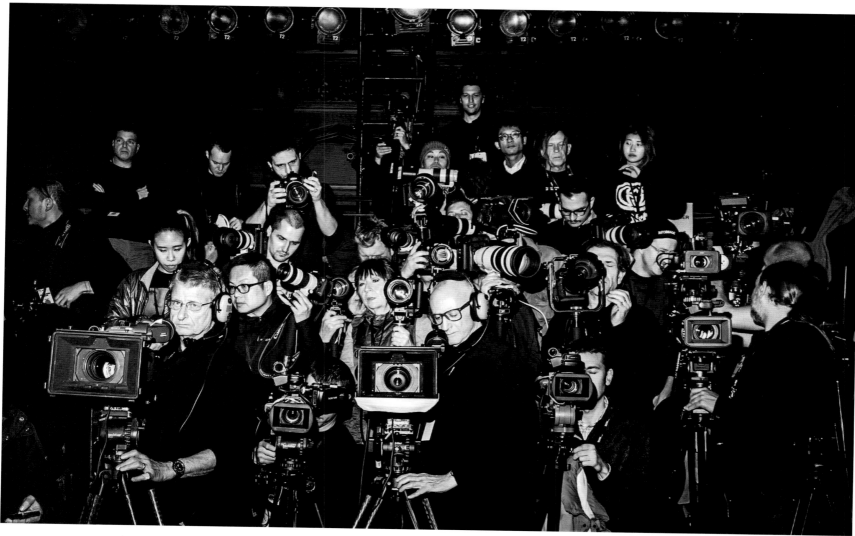

the right, and go away on the right. So you don't want to be on the wrong side.

When the shows were at Bryant Park, thousands of empty film canisters would be left on the podium. My wife and I were shooting easily fifty to sixty rolls per show as house photographers for designers, and if we shot ten shows a day, [it would be] hundreds of canisters. We did not empty the canisters on site; we came prepared with all the film already out of the canisters, because it was just so time consuming to do otherwise, and of course, we were also concerned with the amount of garbage that we would leave behind. There was a lab four or five blocks away, and we had a runner so it would be developed as we shot.

The transition to digital happened gradually, even for me. I was sure that I would die shooting film. My wife changed to digital only because some of our clients needed digital, but they also wanted film. They didn't trust that media yet. So for about five years we shot digital and film. Then everyone wanted only digital in 2004 or 2005, and I had no choice.

The cameras changed, but the lenses stayed the same because they worked on a film body or a digital body. We carried less stuff around—we didn't have the six hundred to one thousand rolls of film, but we carried a computer and downloader. The flash cards at the time were super expensive, and the amount of images you could put on a card was small compared to today, but we had to use them because there was nothing else. Eventually all that changed, and it became better.

Inside the venue, if we are lucky enough to get in early, we can see the rehearsal and read the light then, and see the color balance and know when we are going to shoot during the show. But if we arrive late, sometimes I'll speak to the lighting designer, or ask video who is shooting for the house. Sometimes I have to use my logic though. Within a second or two you can adjust, but if you happen to shoot something the wrong way, it's better to continue so you can correct the whole batch in Photoshop. We use Photoshop on every image we use, we have to put images at 300 dpi, color correct them,

sometimes lighten them. Nothing comes out of camera and is used as is.

On the podium, there can be one hundred photographers or more in a very small space. The only people who disrupt the peace are the youngest ones; [they can] move too much and don't know that one inch makes a lot of difference. Still, it can be unpleasant in a huge show if we're packed and waiting for it to start. Sometimes we have to be in position for an hour ahead of time. You don't have room to sit down. You are either standing on the floor if you're in the front, or on a box if you're behind, or even two boxes if you are behind that. It takes a toll on the legs and the knees.

It depends on the show how many photos I will take. The longest show I ever shot was a Giorgio Armani show. There were 330 looks on the runway. I shot all the film I brought with me, which was 110 rolls, and I'm sure I missed some outfits because I had to reload . . . [and] change the battery pack twice. There was a Gucci show in Milan in 2017 that was men's and women's, with 110 looks, and we shot 6,000 digital images.

It does hurt, especially if the tempo of the show is such that you have no time to relax your arm between shooting. If you continue pushing down on the trigger and aiming, it hurts your arm.

At the beginning, both my wife and I would edit everything we shot at the end of the day, but eventually we realized we needed an editor to look at slides, and later on look at the digital images. That simplified life and allowed us to sleep more. The editor was the one working all night to send the images.

Obviously, I must like something about what I do. When the show happens and the clothes look amazing, the choice of models is great, the lighting is magnificent, and the music is to die for, all of that together gives me such a high, it's just like listening to an amazing piece of concert by Handel or Beethoven or Bach or Mozart. Sometimes by the end of a show, it overwhelms me and I have tears in my eyes.

Opposite, from top: New York Fashion Week, February 2005; Photographers at the Alexander Wang Fall 2016 show, February 2016.

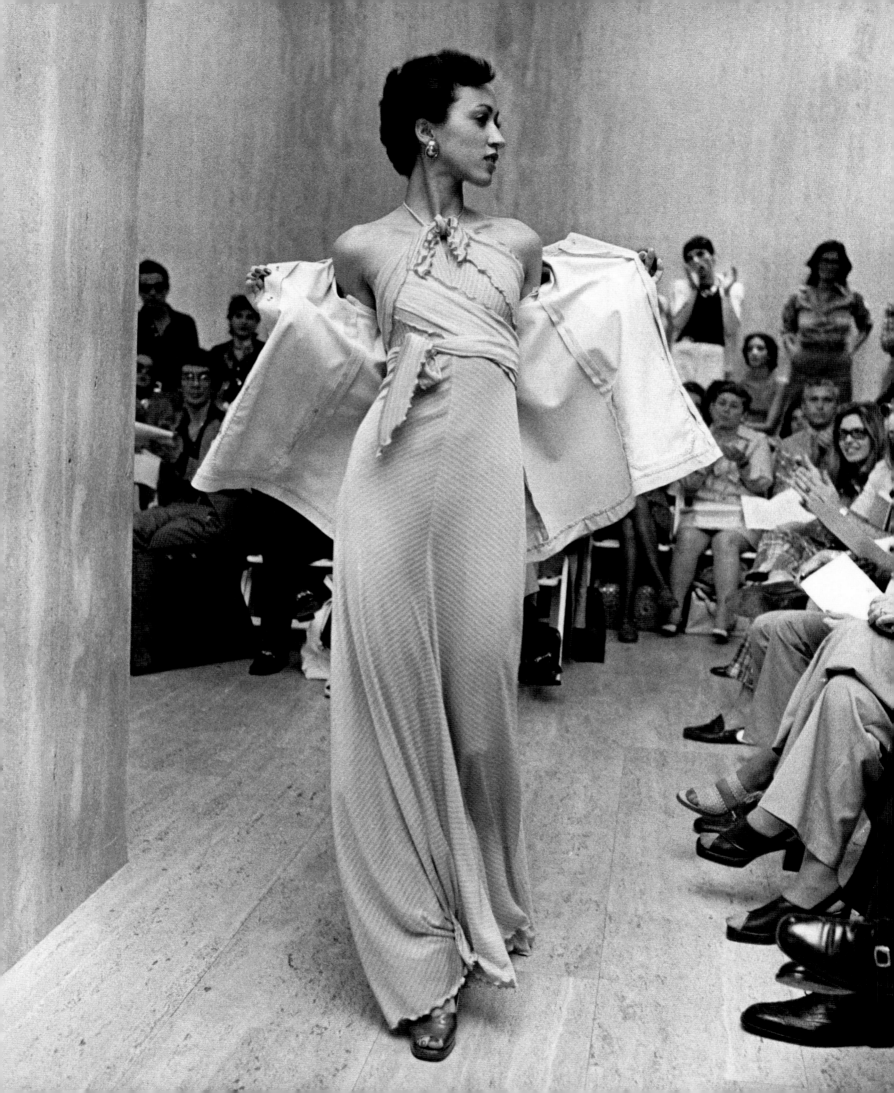

IN THEIR SHOES

Modeling is hard work, especially during hectic New York Fashion Weeks, when "girls," as they are still referred to in the industry, have to juggle castings, fittings, and early call times, all leading up to a grand performance of just eight to twelve minutes on the runway. They travel from show to show by cab, subway, or motorcycle, and spend hours waiting backstage for hair and makeup, all while being photographed for social media and press who have as much of an interest in what goes on behind the scenes as out front.

On clothing racks, each outfit, or look, as it's called, is neatly organized along with a model's photograph. Models usually get into their first looks about ten minutes before a show. Nowadays, most walk the runway only once, wearing a single look, although in the past, some were required to walk multiple times with different looks, which meant employing a team of dressers and stylists to ensure a quick change.

After walking the finale, they say their goodbyes to the designer and rush to the next venue, where their hair and face metamorphose to suit another vision. During Fashion Week, days can be twelve to eighteen hours long by the time after-hours events and parties wrap up. And now that models have become their own brands, with their own social media channels, they have followers to communicate with, keeping them up to date with their glittery Fashion Week comings and goings.

Here's a look at what it's like to walk a runway show through the eyes of four models.

Pat Cleveland

Coming up in the 1960s and '70s, Cleveland was one of the first African American models to achieve success in both print and runway. Born and raised in Harlem, she got her start in the Ebony Fashion Fair national runway tour, then was discovered on a subway platform in 1967 by Carrie Donovan, an assistant fashion editor at Vogue *at the time. At age eighteen, she was signed to Ford Models, and she had success both in New York, where she was a model and muse to Stephen Burrows, and in Europe, where she modeled for Karl Lagerfeld and Yves Saint Laurent, among others. The pinnacle of her success was her participation in the ground-breaking Versailles 1973 runway show. Now her daughter, Anna Cleveland, is carrying on the family tradition as a model herself.*

Before I started [modeling], it wasn't called *runway*, because people weren't jet-setting. It started in a salon with designers inviting women over for a tea, and they'd have some pretty girls come out very casually without a word spoken, no music or anything, just for clients to see what clothes they were going to order.

I started modeling in 1964, and it was "bring your bras, your girdle, your stockings, your gloves, and your own shoes!" I had one of those model cases that was black patent leather and round, like something Barbie would carry, and I had it packed with every undergarment. Even Halston's shows were very intimate, and the salon was just a room with little chairs

Opposite: Pat Cleveland during the Stephen Burrows Fall 1973 show, June 1973.

and a space to walk between the ladies. Sometimes you'd walk past their legs and the fabric would touch their shins, and they'd reach out and touch your dress. It was very tactile, not like it is now.

When I met Stephen Burrows, it was no undergarments, just tights, taking after dancers, so you could be free in your body. That was his approach. Stephen had this friend who made cassette tapes of music for his shows, and everyone wanted that music because it livened things up. It was soul and R&B and Barry White. It made you feel good walking, like it was more of a party than a show.

Stephen allowed me to enter his world and made me feel like a butterfly. I developed these rainbow wings because of him; he saw something in me I didn't see in myself. Of course, he was a good dancer, and he had a certain way of carrying himself, as all designers do, and you look at them and have to represent some of how they are. It's not like you are yourself; when you're working for a designer doing shows, you really are them.

The Versailles 1973 show changed things for Americans, because everyone was so young and spirited. We were hired to express happiness, joy, and vitality. In America, the shows were simple, with music and girls who walked really well. It wasn't designers putting on performances in circus tents like in Europe. Those old houses influenced America, but we had freedom feelings we wanted to express, like, "We're not going to wear undergarments because they're old-fashioned." And, "Hey we're coming to get our reward because America is always standing up for everyone, and we deserve some hugs back because we kicked ass for you guys."

People didn't know about fashion like they do today. I used to do thirty-three shows in Italy, twenty-five in Paris, ten in London, and then some in New York, because in those days, New York was last. I did the Bill Blass, Halston, and Stephen Burrows shows; I think I've done every one available. They all blended into one big family. After the shows were over, everyone would hang out at Studio 54 and just be together.

They weren't competing with each other; they were competing with themselves.

In the 1970s, modeling was more about personalities. Now it's about "two black, one white, and two yellow"; it's a formula. There could be more diversity in fashion now for sure, but there are also more opportunities and outlets than ever before. My daughter likes working with designers and photographers where she can express her energy and be a bit of an actress. That's what a model is, an interpreter.

At the same time, today, it's all about numbers and how many Instagram followers you have. Models are on Instagram all day trying to impress people. Today, communication is so instantaneous, you don't even have to go to the show. But that also makes you lose the experience of having it enter your senses; you can't get that on a flat screen.

Cindy Crawford

An iconic American beauty of the twentieth century, Crawford was one of the original supermodels in the 1980s and '90s, when her face smiled back from thousands of magazine covers and runway photos. She starred in a Pepsi Super Bowl commercial and had a part in George Michael's "Freedom" music video. Her curves brought a more athletic body type into vogue, and her role hosting the MTV series House of Style *helped move fashion into the realm of pop culture. She did it all while maintaining a down-to-earth persona true to her Midwestern roots in DeKalb, Illinois. And now her daughter, Kaia Gerber, is setting out on a modeling career of her own.*

Back then, New York was about Seventh Avenue and big American designers. I used to love doing Ralph Lauren's shows because he was so meticulous. Sometimes you'd be waiting in your outfit to be seen for hours until he decided he hated it on you. But it was so specific, his look—it's even an adjective now. I really loved working with Calvin Klein, too, because of the cleanness and how modern it was. It felt like he celebrated natural beauty. Instead of trying to fit you into his mold, he was trying to celebrate your simple, beautiful self. Donna Karan, the way her clothes fit women's bodies, it made

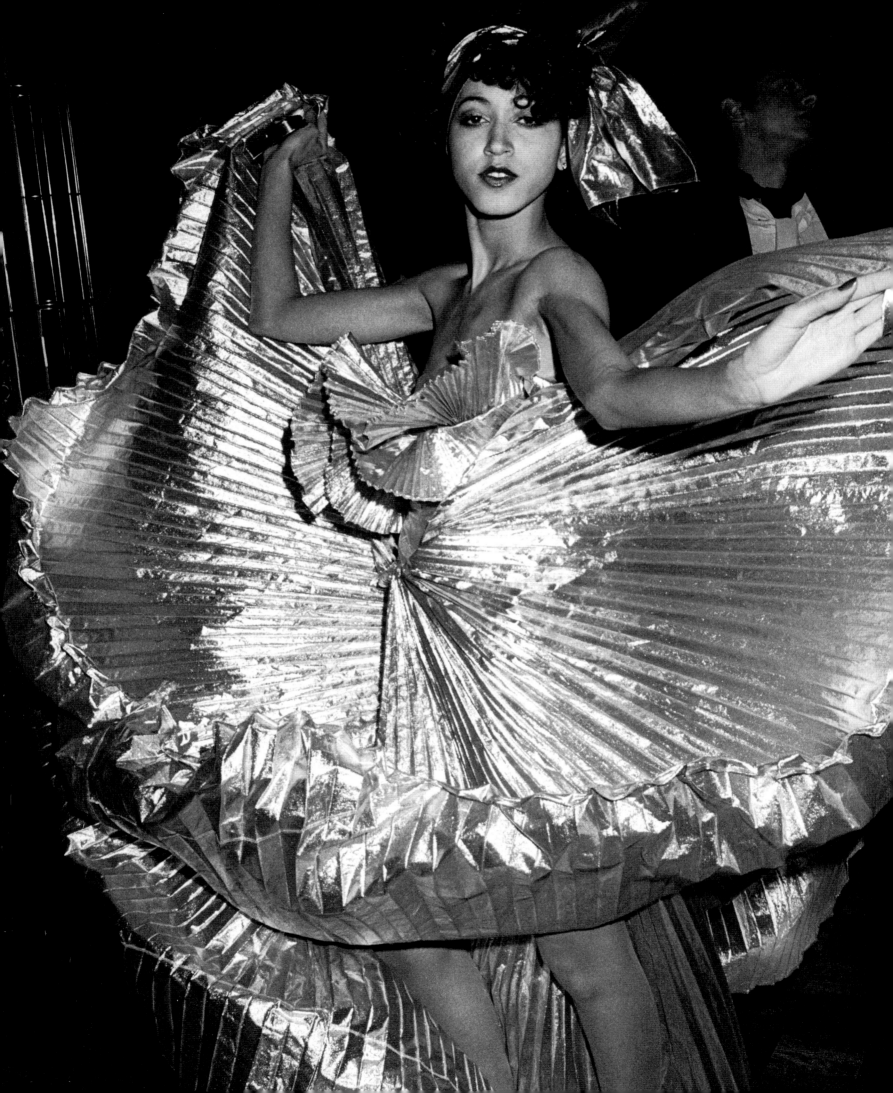

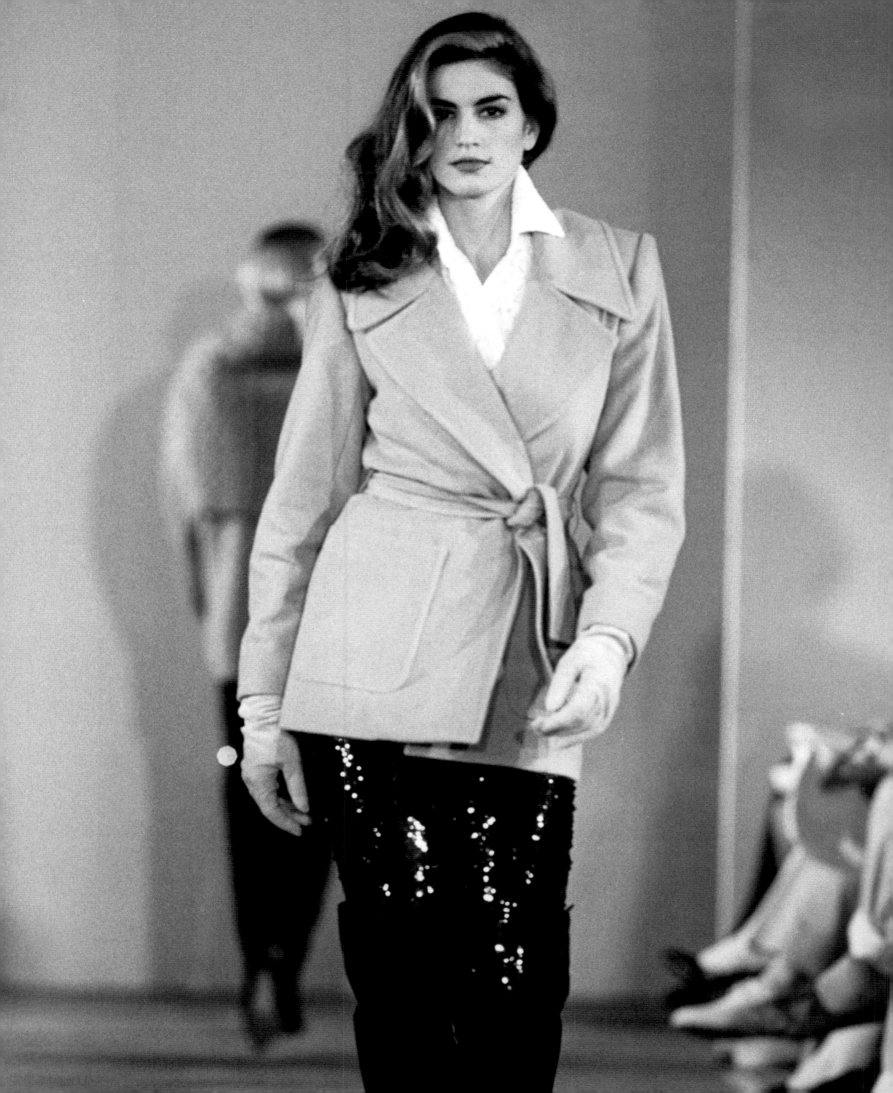

you feel strong and feminine. And I loved Todd Oldham and his sense of fun. Sometimes you're like, "Where is anyone going in this outfit?" But that was his quirkiness.

By the time we got to New York, which was at the end of the show cycle then, we were very tired. The models took cabs or maybe one of us had a car. We were working models; we weren't celebrities in the way it's evolved into now. You'd have to be at a fitting or starting your makeup by 7 a.m., and then you'd go until 11 p.m. or 12 a.m., going from show to show, maybe grabbing lunch or half a sandwich backstage, hoping the first show you weren't in a greasy ponytail because then you'd have to deal with that the rest of the day. I always thought that was so selfish of a designer to put greasy pomade in the models' hair first thing, knowing that you could screw up the other designers along with way.

I would always try to arrive a little early for a show because I wanted the A team, the lead hair and makeup, and then I could make sure to get in their line. I'd bring a book—probably something by John Grisham—I'd do what they told me to do; I wasn't a diva. We all had our own brown-and-white striped Henri Bendel toiletry bags so we could do our own makeup if we had to. Linda Evangelista was great at doing her own eyebrows.

Once you were dressed in your look, you lined up when it was five minutes to the show. You had a few excited butterflies; at a lot of shows, there would be a glass of Champagne to lend a celebratory mood. You had to time it right, and drink it twenty minutes before the show. It couldn't be an hour before the show because then you'd get tired.

Our generation was the first time the designers took the print girls and put them on the runway. And the style of runway modeling was changing a bit, too. The old-school girls could execute the perfect turn while taking their suit jacket off. Then there was us, who maybe tried to walk like them but it wasn't as studied. It was more casual, and we'd smile.

I like seeing the model's personality come through on the runway. I like a smile. I don't like it when they look like emotionless robots. Some designers like that, but it wasn't what was in vogue when I was on the runway. It was more about connecting. If I saw [fashion editor] André Leon Talley in the seats, I'd smile at him. If you tripped, you'd have your "oops" move. To me, that's what made us approachable and human.

Right before you walk out, they just say, "Now," then they push you a little bit, and whoever was doing hair would still have their hands in your hair. You are literally being manhandled until the second they push you out on the runway. That's what made it exciting and fun, because it's a live performance. So much of modeling is done in a studio in a controlled environment. Especially now, you're looking at the digital playback and thinking, "Maybe it will look better if I do this or that." When you're on the runway, it's just, "Go."

Another thing that's strange about shows today is a lot of girls only have one look. We used to have five changes, so in your mind, you had to decide how you'd get through your changes. It was strategic, so if you were taking off this shoe, you could be putting on the next one at the same time. You worked with your dresser. Your changes were choreographed. Now when I see shows, the models only have one or two looks; that wasn't my experience.

What did I think about on the runway? I remember when I was shooting covers with Avedon, he'd always say, "Have a thought in your head." I tried to do the same thing so that my face was registering some emotion. The thought I don't remember, and it doesn't matter. It could just be, "Hey, look at my dress." But whatever it was, you had an intention. Once you step out, if the shoe is precarious or the runway is slippery, you are praying, "Don't let me wipe out." It also depends on what you are wearing; if you feel good, it's like performing. If not, I couldn't wait to get out of there.

To me, the elevated runway added an element of being on stage. The lights were bright, you couldn't really see faces—I liked that. You were performing. And when we walked down the runway, Anna Wintour was looking at you, Polly Mellen

Opposite: Cindy Crawford during the Michael Kors Fall 1991 show, April 1991.
Following spread: Crawford reclines on the runway at the Donna Karan Fall 1992 show, April 1992.

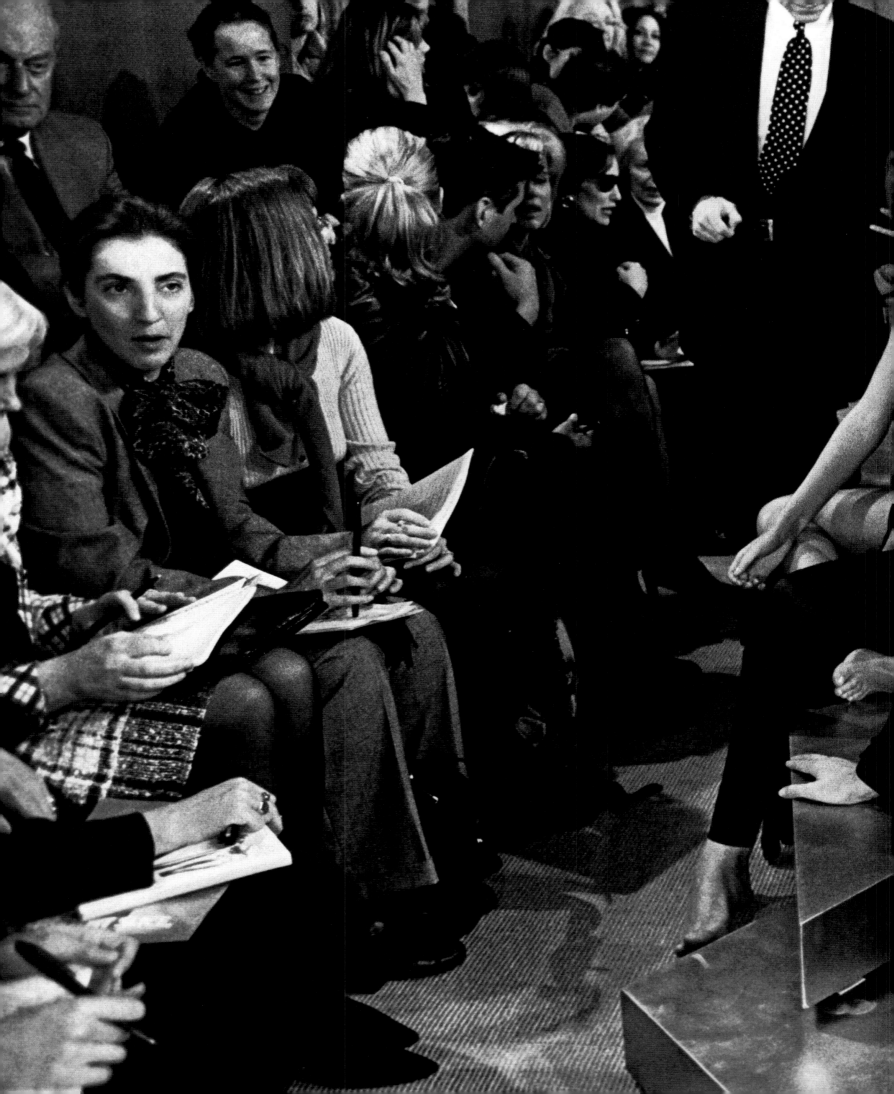

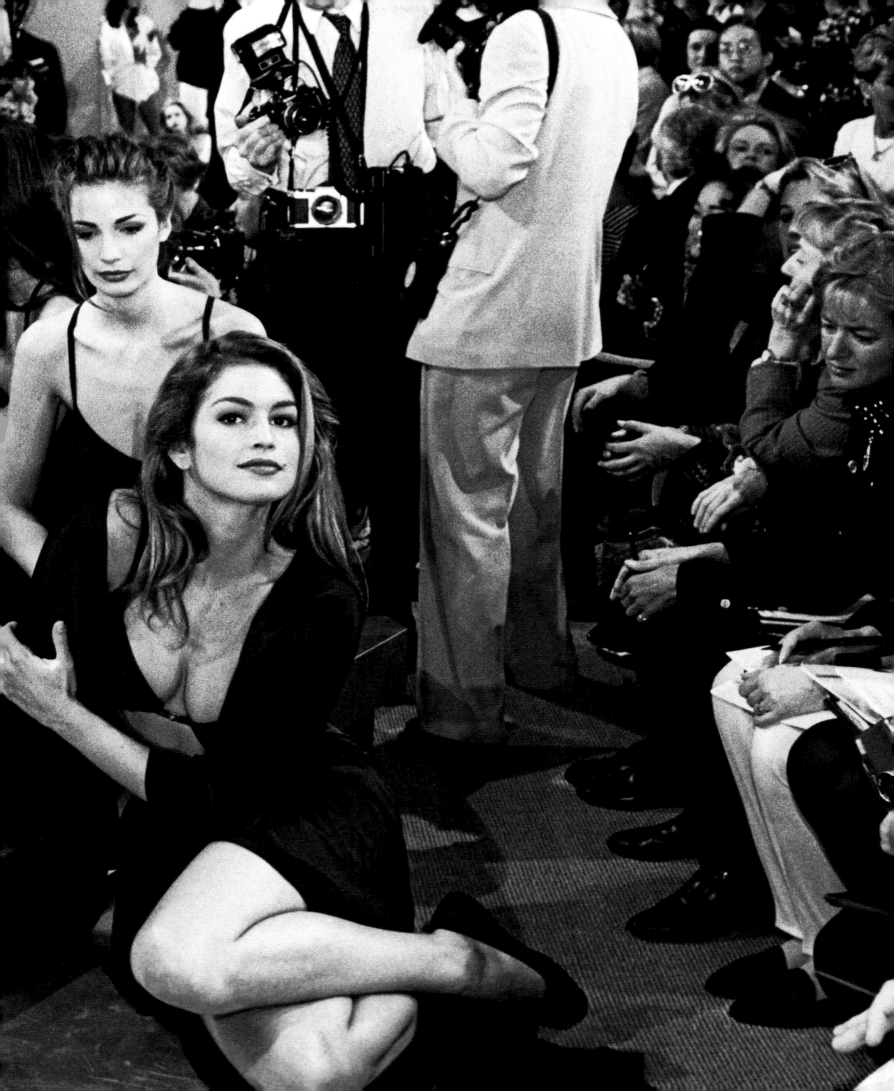

and Franca Sozzani were there, and you were looking them in the eye. They weren't looking at their phones or looking at you through their phones. Also, the set wasn't designed for how it's going to photograph for someone to Instagram; it was how to best photograph the clothes.

I never felt self-conscious about people looking at me. I think if you're a model, you hopefully get off on that. That's part of it. If you hate your hair and makeup, and you don't like what you're wearing, it's harder. But if you're wearing some amazing outfit, and your boobs are pushed up and your hair is flowing and the music is great, because good music propels you down the runway, hopefully, you enjoy it. I wouldn't want to be out of my body, I'd want to be in it.

Karlie Kloss

The runway made Karlie Kloss one of the top models of the 2000s, with exclusive contracts with Calvin Klein, Donna Karan, Christian Dior, and John Galliano, among others, thanks to her distinctive, balletic walk and powerful persona. She's used her celebrity status and her social media channels to advocate for social causes and to empower young girls who, like her, are interested in computer science and software engineering. In 2015, she partnered with the Flatiron School and Code.org to offer a scholarship named Kode with Klossy, which has since become a coding summer camp for teen girls.

The focus for the first four or five years of my career was on the runway, where I was very lucky to be well-received by designers and editors who would see that I stuck out a little bit and had a distinct weird little walk. There was no calculated plan to do that; it was just me trying to walk with the same confidence that the supermodels had in videos I'd seen.

My first Fashion Week was September 2007. It doesn't matter if you're fifteen or you're twenty-five, if it's your first season, it's your first season. You're a freshman, and you build these relationships with the people who are in your class.

The first four years of my experience were still before social media and before the instantaneousness, real-time access you can have to these runway shows now. There was something so special and sacred about being a part of backstage and running around the city with six shows the same day and three fittings in between. It was like being on *The Amazing Race.*

I wasn't Snapchatting or Instagramming any of it. I was just living my life and experiencing these moments for myself and with my family. I would have my mom or dad or aunt or teacher or sister, any one of the above, chaperone me. And they would tag-team; one person would do New York, one person would do London or Paris, because it is really intense those first few seasons.

I was fifteen when I started, so forget trying to find time to exercise, I was trying to find time to do my homework between shows or on airplanes. So my waiting time and late nights were spent writing papers and reading just to keep up with my classmates back home.

I'd wake up at 6 a.m. for a 9 a.m. show, bolting out the door with breakfast in hand for a 7 a.m. call time. This was long before I drank coffee, too. You can't show up a half hour before because you have to do all the preparation of hair and makeup and see the runway and where you need to walk or stop or turn. Not that it's such a big deal, but you are walking six or seven shows in a day and you don't want to be the person who messes the whole show up.

I was lucky to be so successful on the runway early on, and I didn't realize how intense it was having my nails done six times in one day, and having a crazy hairdo that was immediately taken out at the next show and put into another crazy hairdo. I was just surviving at the time. Now, looking back, I don't know how I did it.

Partially because of my ballet background, I always approached being on the runway as a performance. It was not necessarily me that people were looking at, it was me in this character, behind this shield of hair and makeup and these beautiful designs.

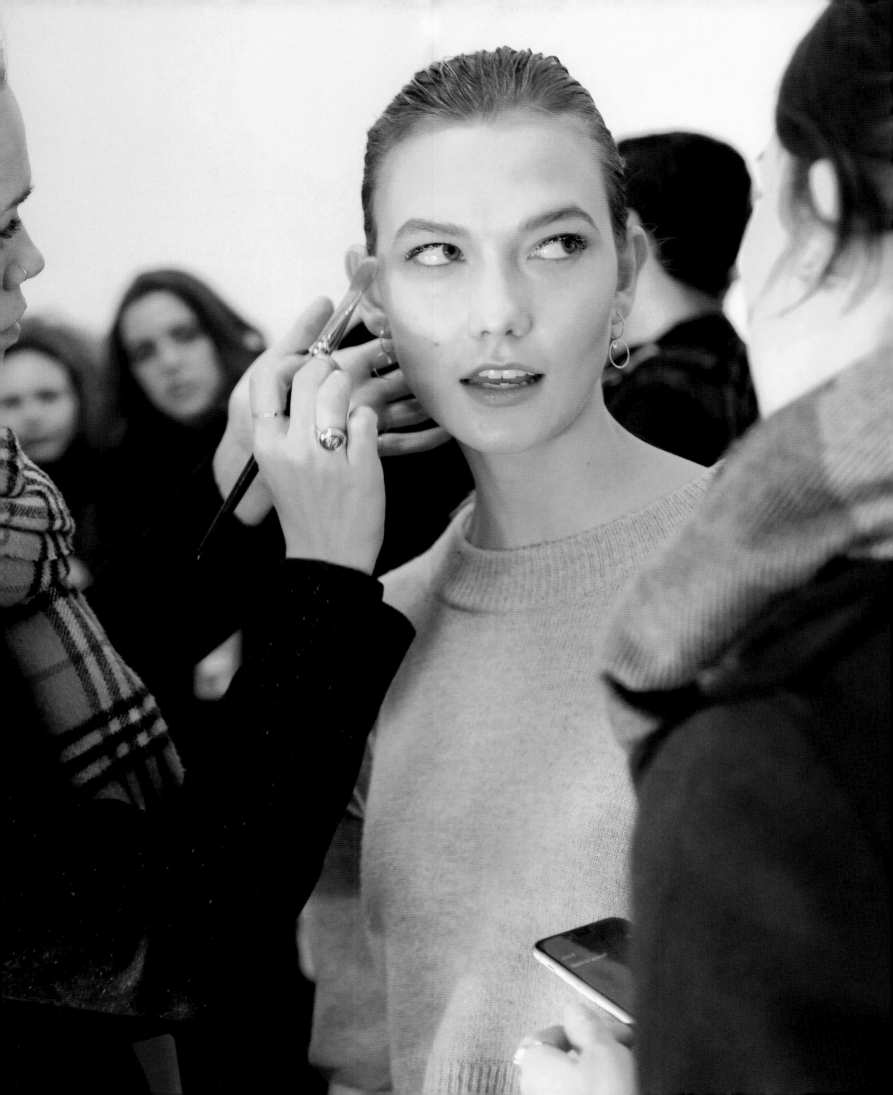

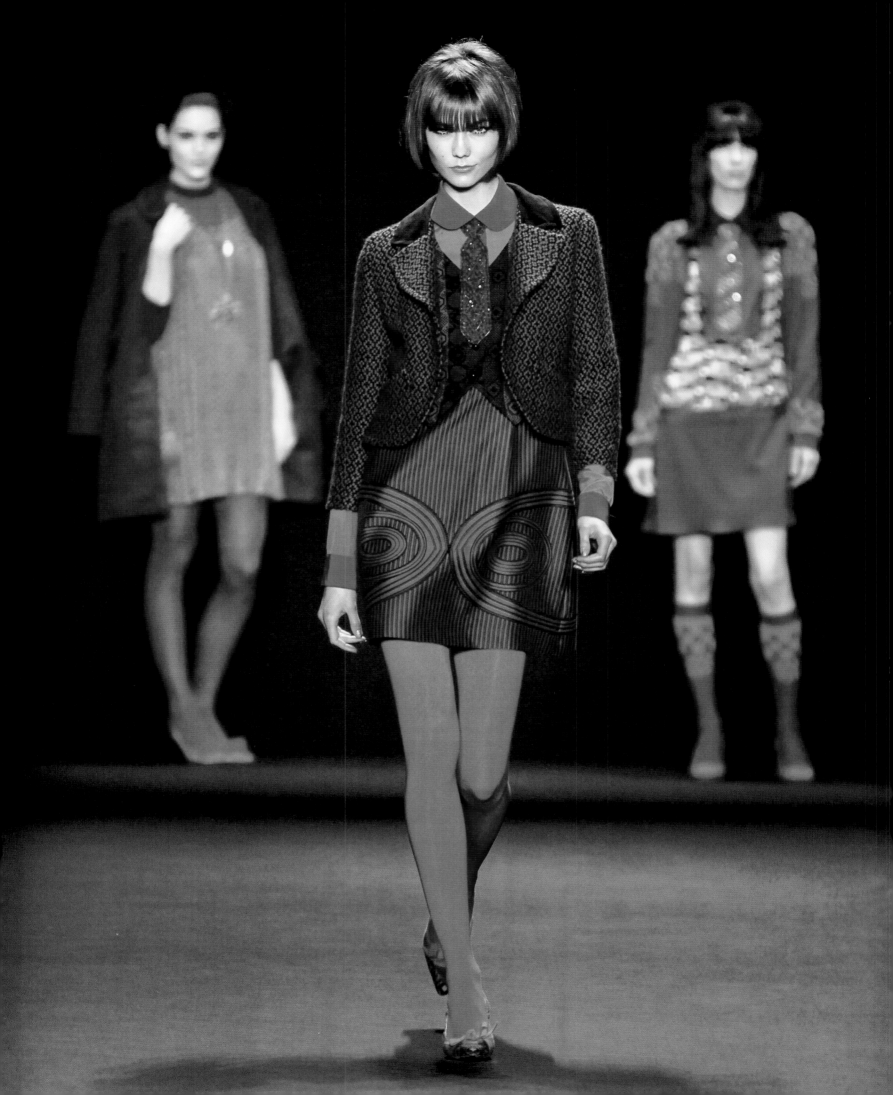

Nobody stays in one lane anymore, and that's been a seismic change in the industry. You can be—and I was—a Victoria's Secret mainstream girl, but also a high-fashion girl on the cover of *Italian Vogue*, with bleached eyebrows where you don't even recognize that it's me. There are shows that are walking catalogues but don't have real passion or purpose or theatrical elements. Runway shows at their best can be part of a designer's artistic expression, not just the designs on the runway, but the overall experience should be valued even in this digital day and age.

There were a few shifts for me from age fifteen to twenty. I was a teenage girl growing into myself, my body, my confidence, and learning who I am in every sense. I just happened to be doing it while on the runway and in front of many other people. But this shift also happened in my head, of realizing the runway and my career as a model could be a platform in an inverse way, not just me being on the stage to perform for others and embody and reflect messages for designers and houses. I could actually use that same stage of a fashion and modeling career and project what I care about and who I am.

About age twenty or twenty-one, I started my cookie project, which was a total passion project, a culmination of a lot of people who wanted to help and the right opportunity. For *Vogue*'s Fashion's Night Out, I was connected to Momofuku Milk Bar to collaborate on a "Perfect 10" cookie. I was opening Donna Karan's show around the same time, and she allowed me to put a cookie on each seat. That was instant access to all the top editors in the industry. It was an a-ha moment— I realized my role as a model doesn't mean I can't also have my own opportunity to create what I'm passionate about as an individual, whether it's building a business or making a meaningful impact.

After high school, I took some coding classes and got excited about this skill of being able to build a business using code. I wanted to use my voice on social media to make young women aware that there is a lot of opportunity in the STEM fields. It was important for me to connect dots—to not only advocate for it, but also create opportunities for girls to learn how to code. With social media, I as a model, who at times have the job of embodying somebody else's message, can use the same resources of time, energy, and voice to champion the things I care about to those women.

Adwoa Aboah

With her close-cropped hair and signature freckles, model Adwoa Aboah is one of today's most distinctive-looking beauties. Her honesty about her battles with addiction, depression, and the unreal imagery of the Instagram age, as well as her decision to create Gurls Talk, also makes her one of the industry's most compelling voices. She uses her Gurls Talk Instagram account and website to post stories about female empowerment and mental health, leading the charge for other models to use their social media exposure for good.

New York is the first Fashion Week, so it's far more exciting than Paris, where you are exhausted because you've seen everyone every single day. I used to stay up quite late, but I've learned now to get a good night's rest during Fashion Week. Still, balance goes out the window, especially with all the evening events on top of daytime shows.

I don't have any hair so I get a later call time, but I still wait around a lot backstage. I try to eat healthy, I try to be a nice person to be around and talk to everyone. But there's not much time to chill out and have a conversation or read a magazine because of all the press photos we have to do. I find them quite boring, so I do a lot of hiding to try to avoid them; I have more cigarettes, and I pretend to be on my phone. Luckily, I've never been self-conscious about being naked backstage because I'm around all these amazing women. Sometimes models are more insecure when they are younger, but not me.

I've done theater before, and to me, the catwalk has a massive element of performance to it. You have five seconds on the runway where everyone sees you and your outfit; it's your chance to make an impression. I pay attention to the designers' notes and try to get into that character. I've never tried to walk a specific way. My walk can change if they want a more boyish walk, or something else.

Opposite: Adwoa Aboah at the Brandon Maxwell Fall 2017 show, February 2017. Following spread, from left: Aboah backstage at the Marc Jacobs Fall 2017 show, February 2017; Aboah on the runway for the Coach Fall 2017 show, February 2017.

Brandon Maxwell, he's a special one, he lets us be sexy and ourselves, and he does these amazing handwritten notes and gives a pep talk to models before the show. Marc Jacobs is another one of my favorite shows to walk because he does performances. For Fall 2017, it was really cool having the role reversal—with the models having the phones instead of the audience.

I don't really think about anything specific when I'm walking; sometimes for certain shows, I've caught a friend's eye in the audience and they try to make me laugh. The end of the runway is scary though, because you only have that one moment and with all the photographers and social media posting, you don't want to be making a weird face.

My organization, Gurls Talk, is mentally something I work on every day. It's the first thing I think about and the last thing. During Fashion Week it's a lot more difficult; that's the one time where I'm not as focused on my emails as I could be. But I have an amazing team, and I did fit in a panel discussion during a recent Fashion Week. The industry is really celebrating activism right now, which is amazing.

The positive of being a model in the age of social media is that we do all have a voice and a platform, and the negative is not everyone uses it in a way they should. Everyone has an opinion and everyone can pick out a flaw. But everyone can be an activist, too, or choose to say something constructive. I think a lot about what I post to Instagram during Fashion Week; I'm very grateful, so I want to thank the designer, the hair and makeup people. That comes from an honest place.

Something that definitely plays in my mind is how I'm adding to the way in which girls look at themselves, and this confusion about who they should be and look up to. I just try to be authentic and honest. There are some not-so-great people in the fashion industry, but there are some amazing people, too, especially models. I love meeting them, getting dressed up, and being able to be someone different for an hour or a day.

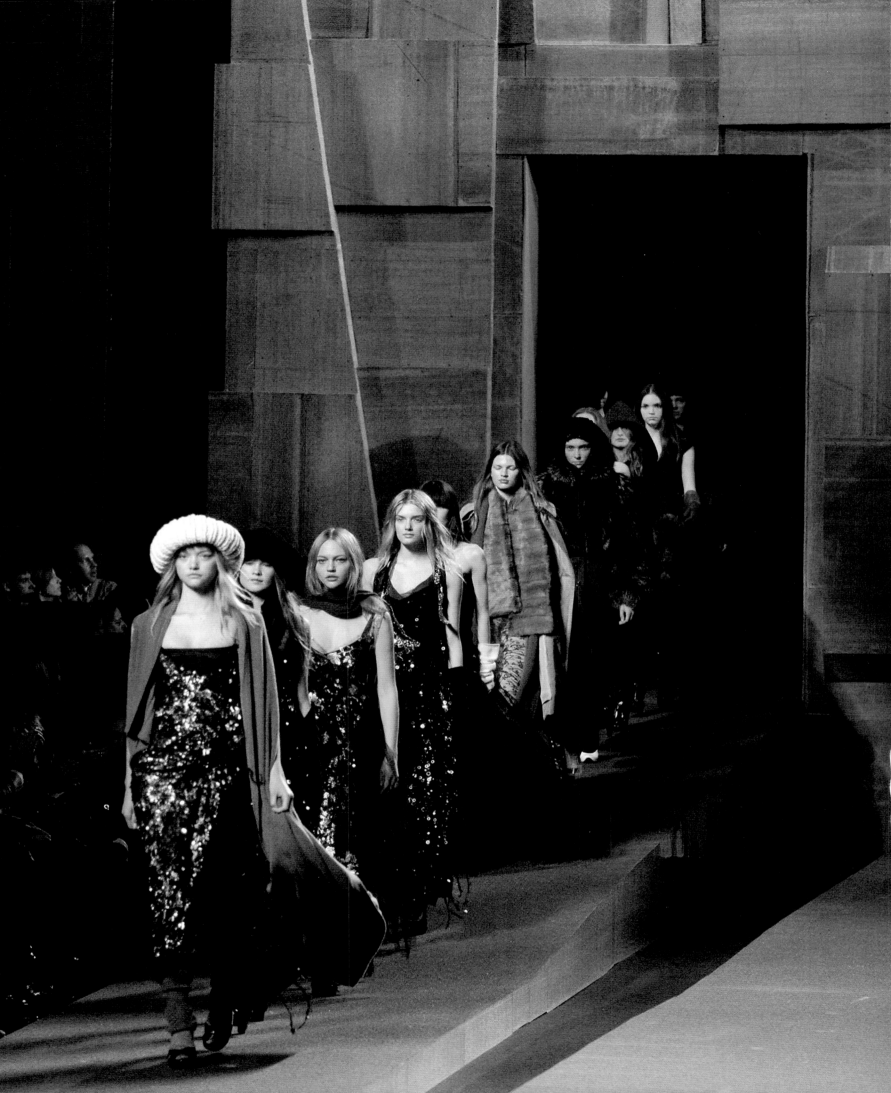

8

THE RISE OF THE SHOW SPECTACULAR

Marc Jacobs has elevated the runway show to its own kind of art form. Over the past decade, he has proved to be the consummate fashion showman, creating runway spectacles that draw inspiration from high and low, avant-garde cinema and hip-hop, Philip Glass and Sonic Youth, Bob Fosse and Burning Man. Whether he is staging a show at the Ziegfeld Theatre, complete with popcorn, candy, and Marc Jacobs–branded *Playbills*, or a "non-show" at the Park Avenue Armory, where the absence of a set, music, and lights is an equally calculated creative choice, he always manages to tap into the zeitgeist. Jacobs's runway shows transcend fashion to tell a story about the times, providing commentary on the loneliness of modern, urban life or the loss of true engagement in the social-media age.

A New Yorker through and through, Jacobs was first exposed to fashion as a teenager working at the Upper West Side boutique Charivari. While a student at Parsons School of Art and Design, he started his first fashion business, a knitwear label. In 1986, he launched Marc Jacobs, and by 1987 he had become the youngest designer at the time—just twenty-four years old—to win the CFDA Perry Ellis Award for New Fashion Talent. The Perry Ellis brand hired him the next year, and in 1992, he showed his controversial grunge collection.

In the fall of 1993, he and business partner Robert Duffy established Marc Jacobs International, and in 1997, he added the role of creative director of Louis Vuitton to his responsibilities. From the mid-2000s on, Jacobs's runway shows became ever more theatrical, starting with Spring 2006, when he nodded to both Ellis and his own 1992 grunge collection by having the Penn State Blue Band open the show with a rendition of Nirvana's "Smells Like Teen Spirit."

"I don't know if I ever consciously made a decision to start thinking of the show as a piece of theater," says Jacobs. "But over the course of years . . . the idea of presenting clothes felt like an opportunity to transmit a feeling and a spirit and to move people in some way and make them feel involved in an experience that was more than just seeing clothes."

In 2006, he commissioned his first runway show set from Stefan Beckman—a fractured wood cityscape with a grand façade from which models emerged and an elevated ramp for a runway. Set to Philip Glass's symphony *Heroes*, the show cast models as heroic urban nomads in everyday luxe layers, including jersey tops embroidered with crystals, low-slung jeans, strapless plaid flannel dresses, distressed sequin gowns, skirts over pants, and legwarmers over snub-toed pumps.

It was the beginning of a creative partnership between Jacobs and Beckman that would usher in the rise of the show spectacular. Over many seasons, the two would transform the interior of Jacobs's preferred show venues, the 69th Regiment and Park Avenue Armories, time and time again, creating immersive experiences blending fashion, live theater, music, and fine art.

"Social media definitely upped the pressure on sets," says Beckman, who started out in Hollywood set decorating

Opposite: Fall 2006 show, February 2006.

before moving to New York in the early '90s. "There's pressure to have that Instagrammable moment, which is great for the house."

Beckman had never built a runway show set when he got a call in 2006 from Jacobs, shortly after working on the designer's first Louis Vuitton campaign. "We had an initial meeting. He talked about the city and his references, and I came back with ideas about [the artist and sculptor] Louise Nevelson and layering and collage." After a few easy sketches and a discussion about materials, Beckman and his team went to work, completing the set in five days, which included several all-nighters. "I got lucky," he says. "The feedback was good."

The next season saw Jacobs's runway transformed into a rolling green walkway over a "river" of 500,000 peppermint candies, and in the distance, silver leaf "mountains" made of antique wallpaper from Gracie, a New York City–based showroom that specializes in Asian antiques and hand-painted wallpaper and furniture.

"The beginning of the [design] process could be a thought about clothes or about hair or about shoes or about the atmosphere; it could be about anything," says Jacobs. "It doesn't come together until a few weeks before the show, and then the environment, set, or the lack of set becomes clearer."

First, a creative dialogue ensues between Jacobs, his long-time stylist Katie Grand, and Beckman. "Sometimes I'll see something, sometimes she'll see something, sometimes neither of us sees anything that we're particularly interested in saying or doing with the set or the environment, so Stefan will come up with a bunch of visuals," Jacobs says. "We either react against them or respond to them or both, and it goes back and forth until we get to what it is that we want to say."

"The hardest thing is [that] you don't have a lot of time—but it's also the best thing," notes Beckman. "It's one thing to say, 'Let's do it two months before,' but then the shoes aren't back from Italy, or the collection is still in process, and how are you supposed to do a show that's just based on a set?"

As it gets closer, Beckman starts sourcing materials, both high-end and low-end, and contracts out the building work depending on what's needed. He gets a week inside the venue to build the set, and a day or so to strike it afterward.

For Spring 2009, he created a hall of mirrors on the runway to reflect Jacobs's mashup of prairie skirts, grunge plaids, and crushed straw hats set to Gershwin's "An American in Paris." For Spring 2012, he strung lightbulbs on wooden beams to evoke an old-fashioned dance hall setting, and models draped themselves over chairs, "Chorus Line" style, wearing Jacobs' flapper-inspired dresses.

A giant sun was suspended from The Lexington Armory ceiling for Fall 2013, when Jacobs used a low-frequency lighting trick from an art show he had seen in London, Olafur Eliasson's "The Weather Project," to strip the color from his clothing during the show, giving the whole environment the look of a sepia photograph. The Fall 2014 show set included five hundred extra-large, cloud-shaped pillows suspended from the Armory's 110-foot ceiling. The clouds were made over a single weekend in a factory in Greenpoint, Brooklyn, sewn from Spandex, then spray-filled with so much foam that it had to be sourced up and down the entire Eastern seaboard.

The set for Jacobs' Spring 2014 Victoriana surf-themed collection was even more elaborate, with a black sand beach that turned the Armory into a post-apocalyptic wasteland littered with burned-out cars, discarded liquor bottles, cigarette butts, beach chairs, and even the moored mast of a ship.

"I had seen a Paul McCarthy exhibition at the Armory with all these oriental carpets, then we were talking about some kind of nightmarish experience, and we were looking at sculptures by Robert Tyrion, and it was just one thing abstractly leading to another," says Jacobs. "It was, 'How can we create a beach or festival scene but indoors,' and then it got trippy and weird and dark and Victorian with all kinds of strangeness going on."

"That one literally made me cry," says Beckman. "It was challenging because of all the layers. It was a lot for the audience,

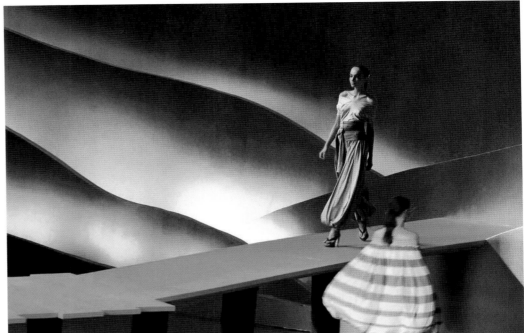

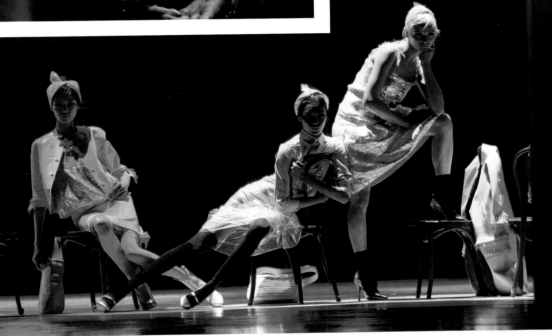

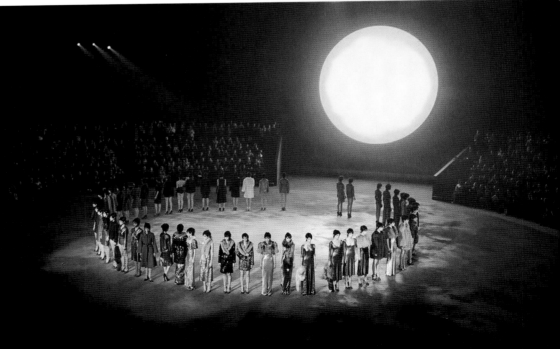

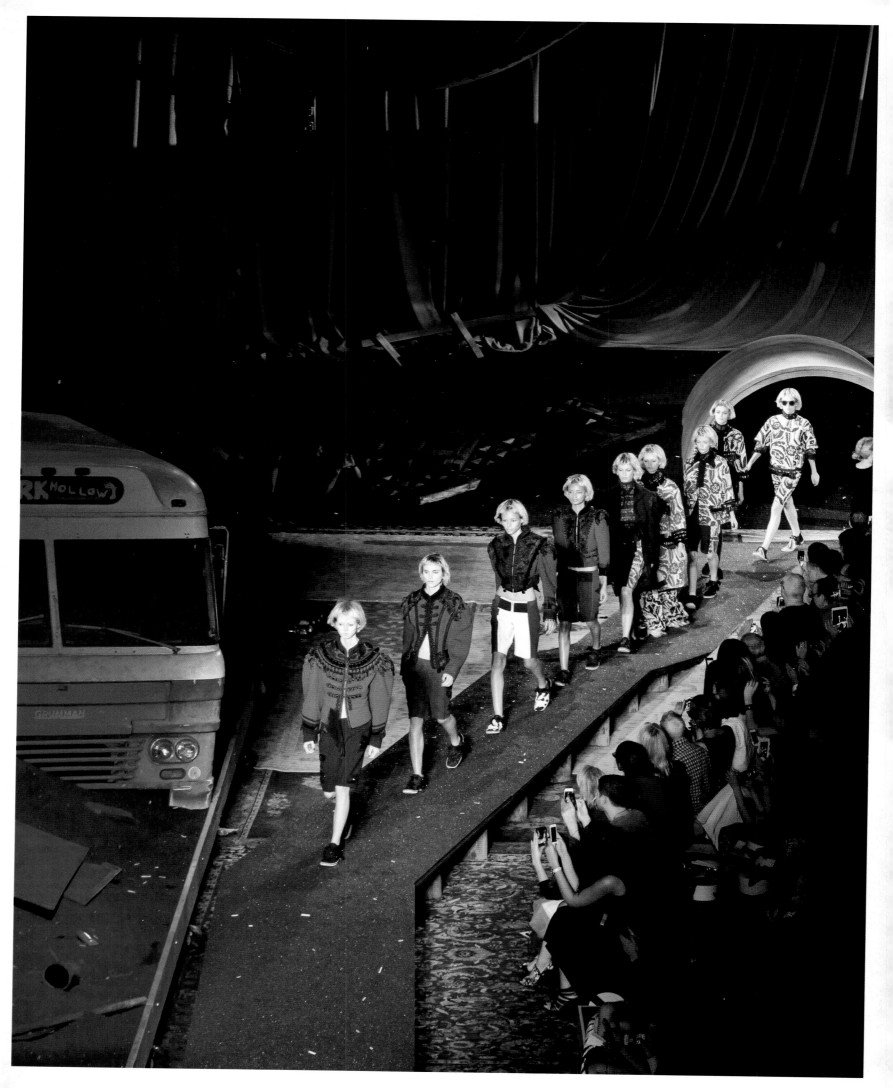

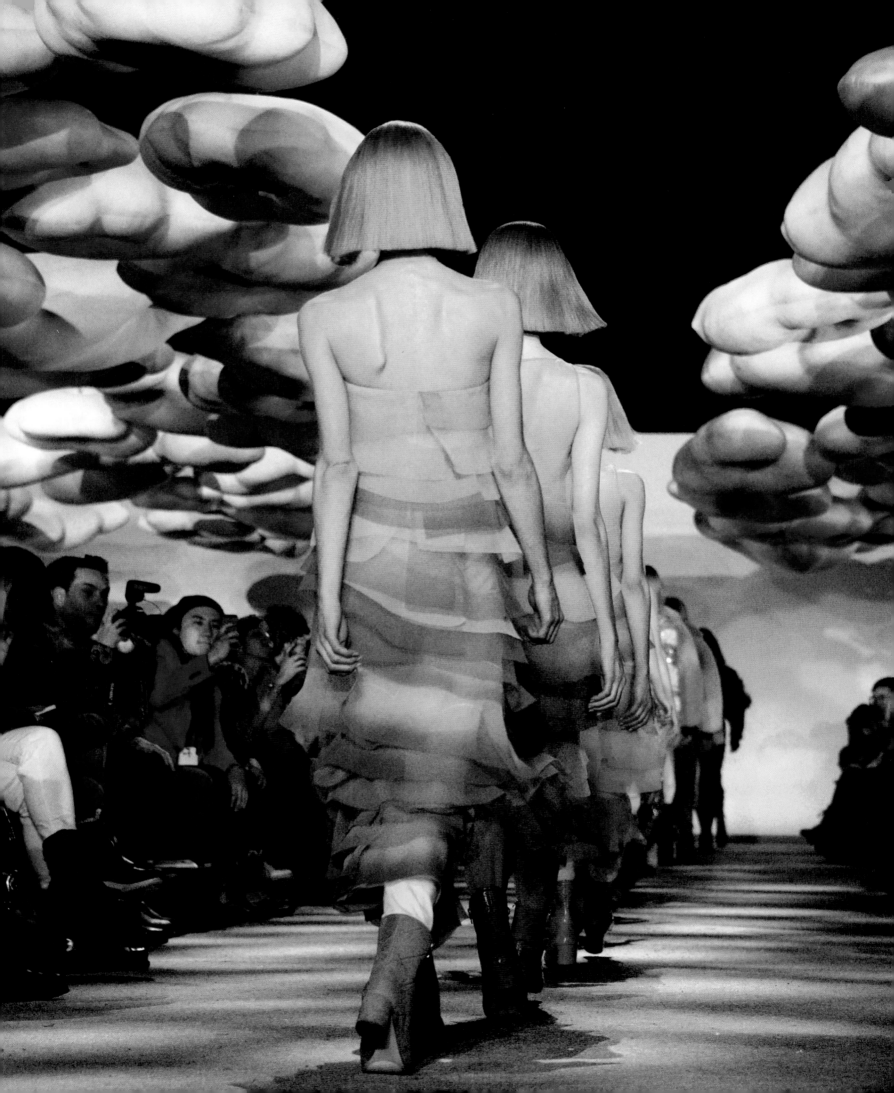

and it was also super hot in there on the day of the show. But it's good to push people and make them uncomfortable or challenge them in some way."

For Spring 2015, Jacobs dropped a perfectly suburban-looking Barbie-pink house in the middle of the Park Avenue Armory, surrounded by pink gravel. He partnered with Beats by Dre, who provided headphones for guests at their seats to listen to the vocal narrative conceived by music producer Steven Mackey. During the show, a voice spoke into attendees' ears, cluing them into the choreography for the runway. "Tell this model to go here, and the one with the tattoo on her foot to go there." This element was inspired by *The Girl Chewing Gum*, a 1976 short film by John Smith that blurs the line between art and reality, and the effect was chilling. Showgoers were taking part in a group activity indi-vidually, like guests at a silent dance party, and on the runway was a fashion army, wearing Jacobs's riffs on the humble olive-drab military uniform of the everyman (and everywoman) with candy-like jeweled cabochon buttons, overgrown cargo pockets, and lace details.

You could make of it what you wanted in your own head. It was a party of one. And that's how Jacobs likes it. "Me explaining a show is just my side of it. With anybody who sees theater or looks at a painting or listens to a piece of music, what they hear and see and feel is equally important," he says. "When something really resonates, it's because many people feel the same thing. Even if it's not exactly what I was trying to transmit, it strikes a popular chord."

By Fall 2015, Jacobs was back to a more lush set that was inspired by Jeremiah Goodman's painting of iconic *Vogue* editor Diana Vreeland's red living room—a room she likened to "a garden in hell." This translated into a backdrop of red walls and sketchy paintings of an interior. "That was all hand-painted, and it was all done in a week," Beckman says. "The first idea was to project sketches against the wall, but it didn't work with the scale of the space."

The Spring 2016 show was held at the Ziegfeld Theatre, where Jacobs had attended movie premieres as a child, and featured his own branded *Playbills*, popcorn, and a runway that started

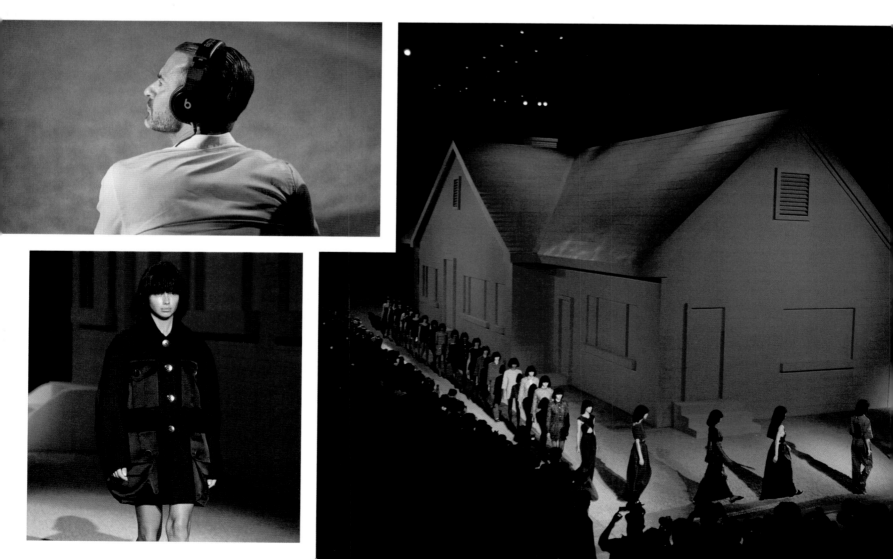

on a public sidewalk. Then, for Fall 2016, he switched gears again, moving back to the Park Avenue Armory with a sparse, white lacquer set. Inside the show notes was a concise, creative statement about singer-songwriter Keiji Haino, the Japanese concept of *ma* (which translates as "pause"), and defying the notion that that you can't create something out of nothing. To the sounds of Haino's repetitive, meditative chimes, the first model stepped out on the runway, casting an enormous, dramatic shadow on the back wall, followed by the next and the next. Oversized silhouettes with richly textured embellishment produced even bigger images on the blank white wall. The shadow play loomed large over the runway, showing the outlines of the over-the-top Goth elegance of the collection. Jacobs cast pop icon Lady Gaga, who was starring in *American Horror Story: Hotel* at the time, as one of his models, though she was practically unrecognizable in 1920s pin curls and glam-rock makeup.

"The girls were so extreme, we kept simplifying and simplifying the set," Jacobs explains, adding that he wanted to create an intimate, haunting space within the large armory. "That was the beginning of trying to use the show in a new way to focus on the clothes. But the set, or the absence of a decorative set, was still a creative choice."

"He has the most incredible intuition about what's important, when to pull back, when to make it more of a spectacle," says Beckman. "People look to him for that."

For Fall 2017, the designer pulled back even more, and the resulting statement was as effective as any of his blockbusters. Jacobs borrowed an idea from Prince, of all people. He had seen an intimate concert of his in December 2015 while on vacation in St. Barts, one of the pop singer's last shows before he died in April 2016. Jacobs had been struck by the fact that Prince asked everyone to put their phones away before the performance. So as guests lined up outside the Park Avenue Armory, organizers requested there be no camera phones used, "so you can enjoy the show."

Inside, there was no set except for two single rows of folding chairs that created a runway spanning the entire length of the armory, from Lexington to Park Avenues. There was no music either, and as the models walked, all you could hear was the swish of flared pants and the clip-clop of platform shoes. The clothes were their own lyrical mash-up of nostalgic, old-school streetwear inspired by the polished 1980s hip-hop style of Jacobs's youth—shaggy furs, patchwork coats, cable knits, track pants, gilded mini-dresses, chunky gold-chain jewelry, and pumped-up hats. And, per Jacobs's request, you couldn't help but pay attention to them.

"It started by me saying to Stefan, 'I don't think we should do anything this season. . . . Why don't you just bring me some pictures of chairs?'" Jacobs laughs. Beckman brought in a variety, but what the designer seized on was an image of a humble metal folding chair. "I said, I think that's all we need to do—folding chairs—and no lights, no music, no nothing. It became about stripping every single thing away."

It appeared as if the designer was taking the showmanship out of the show and rebelling against the monster he had helped create. When he took his bow, he led guests out the opposite side from where they had entered on Lexington Avenue. But he wasn't done yet. Outside on the sidewalk, there was music blaring from enormous banks of speakers set up on Park Avenue, and the models were all there sitting on folding chairs—the original source of inspiration—set up along the sidewalk. Each girl, including Instagram-sensation Kendall Jenner, had a camera phone in her hand to capture and share images of the fashion show crowd filing out. Jacobs had staged the ultimate surprise finale, proving that you never can underestimate a showman.

"It never feels fun when you're doing it," he says, "but it does once it comes together, because in the process of making all those choices, as abstract as they are and as random as they seem, you do end up making a complete story that somehow feels very logical and viable." (And fun.)

And the shows, for all the hate and pain, are worth it. "It's creatively fulfilling having a moment to work toward," says Jacobs. "We want to say something with the collection each season, but without that presentation, it wouldn't be complete."

Opposite: Spring 2015 show, September 2014. Following spread, from left: Fall 2016 show, February 2016; Fall 2017 show, February 2017. Pages 178–79: Fall 2015 show, February 2015.

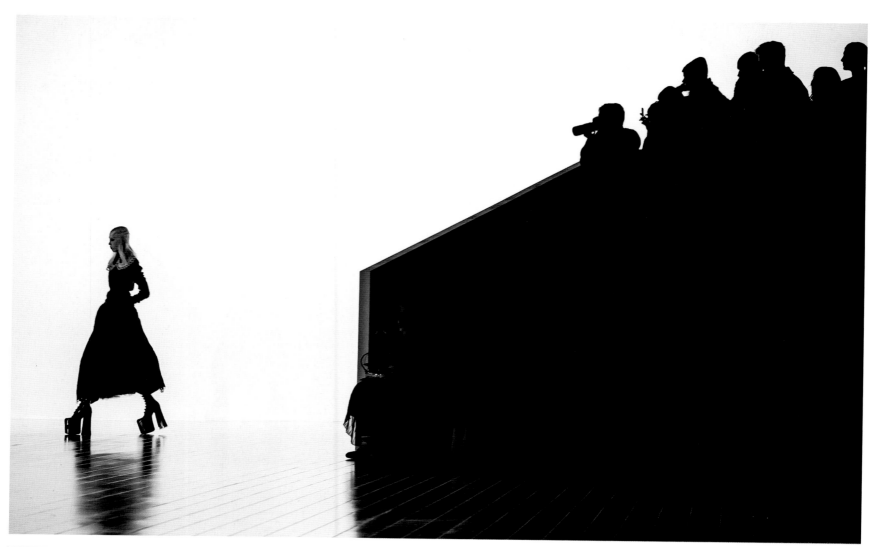

9

MOST MEMORABLE MOMENTS

What makes a memorable runway show? It could be an interesting venue, a grand set or special effect, a live music or dance performance, surprising runway antics, a stirring tribute or protest, a cast of stunning models, unexpected guests on the catwalk, or a star-studded front row. And sometimes, it's just the pure theater of the clothes themselves, which, when they're good, have actually had the power to move people to tears. Throughout the 1990s, as fashion shows became more accessible through television and online media, and more important to designers as global-branding tools, the stakes for the presentations got higher, and so did the showmanship.

Here are some of the most memorable New York Fashion Week moments from the last twenty-five years.

Location, Location

Over the years, shows have been held on piers and subway platforms, at parks and churches, in ice rinks and swimming pools, even on a boat in the Hudson River, and showgoers have logged tens of thousands of miles traveling to see them, exploring the nooks and crannies of New York City along the way—from the sublime (on the 71st floor of 4 World Trade Center, with sweeping views of the New York skyline and Lady Liberty at designer Brandon Maxwell's show in February 2017), to the more mundane (in the Department of Sanitation's Spring Street Salt Shed, where in September 2016, designer Heron Preston showed his collection of reworked uniforms against a unique backdrop—massive piles of salt).

Imitation of Christ, the buzzy label started by art students Tara Subkoff and Matt Damhave with Chloë Sevigny as creative director, staged its first show in 2000 at the Peter Jarema Funeral Home in the East Village, with a collection made from Goodwill clothing that had been resurrected and reconstructed. Subkoff described the line as "a tribute to an uncle who passed away." (It wasn't the last time "death would become them" at a show: In February 2012, Thom Browne had his models rise from coffins, reanimated by their love of fashion.)

The season following their funeral home show, Imitation of Christ moved to Clearview Cinemas, a movie theater that was on the Upper East Side, and guests inside watched a video of models arriving by limo on the sidewalk. "The first to arrive was creative director Chloë Sevigny, in a vintage lingerie dress over pants. You could argue if this was fashion or styling, but there was no doubt that for a short time Imitation of Christ defined downtown cool in spades,"[96] said *Vogue* archive editor Laird Borrelli-Persson.

New York Fashion Week has had several stops on the transit system, most notably Yeohlee Teng's Spring 2005 show held in the 42nd Street subway station underneath Bryant Park, which featured a Metrocard for an invitation and "real people" as models, including Farrah Fawcett and Elsa Klensch.

"We dressed the models in my loft on 35th Street and hired the coldest bus we could find, because it was so hot that day,"

Opposite: The finale at the Alexander Wang Spring 2013 show with glow-in-the-dark clothing, September 2012.

181

says Teng. "They entered the station on 40th Street and Sixth Avenue, swiped their cards, and walked onto the platform, and that was the show. Nothing was closed off, so the trains ran and the people came and saw, too. And when we finished the show, sweaty and all, Farrah Fawcett said, 'Do you want to get a six-pack and go back to your loft?' It was quite a moment, a true New York moment."

In February 2011, outerwear brand Moncler orchestrated a flash mob at Grand Central Terminal, where 363 "chic aliens" wearing goggles and vividly colored skiwear confronted unsuspecting commuters. The models were recruited on Craigslist, paid $150 each, and gifted a Moncler jacket. On cue, they "came together in eight minutes of jazz dance and ballet and tap dancing and vogueing and organized pandemonium," Guy Trebay wrote in the *New York Times*.[97]

Four years later, in September 2015, Maxwell Osborne and Dao-Yi Chow made a strong statement by showing their first DKNY collection in an arm of the World Trade Center Transportation Hub's Oculus, the underground mall and food court built over what was Ground Zero. The *New York Times* wrote that the show was "a direct bid for the soul of the city."[98] The city that had been Donna Karan's muse when she launched DKNY in 1989 had changed, as evidenced by the bustling construction sites and altered skyline at the southern tip of Manhattan. The venue was a symbol of the new New York.

In September 2007, Scott Sternberg took his show seaside, presenting his nautically inspired "Band of Outsiders" collection on an eighty-foot yacht docked at Chelsea Piers, with editors sipping Salty Dogs on the dock as they waited to board. On the subject of boats, in February 2014, Alexander Wang chartered a 149-seat New York Water Taxi to ferry showgoers to the Brooklyn Navy Yard to see his collection, including a finale of thermoreactive, color-changing coats at the Duggal Greenhouse. Ever the urban explorer, Wang brought the fashion flock to Hamilton Heights in northern Manhattan in February 2016, where he showed his collection at the crumbling RKO Hamilton Theater, originally opened in 1913. The format was a standing-room-only kegger!

Cynthia Rowley scored a rooftop with a swimming pool for her menswear show in July 1999, which opened with synchronized swimmers and ended with all the models diving into the pool. "I could hear them whispering right before the show started, and at the end, within one split second, the entire collection was floating in the pool—leather pants, tailored jackets, and all!" Rowley remembers. Rosie Assoulin took it one step further and placed her models in a drained public pool for her Spring 2016 show. Another leisure activity was center stage for Elise Overland's Fall 2011 presentation, when she took over the ice rink at the Standard hotel and had Olympic skating star Johnny Weir, dressed in plenty of glitter and fur, leading models on the ice.

New York City's myriad museums have also been popular venues, especially for designers who are inspired by contemporary art, such as Proenza Schouler's Lazaro Hernandez and Jack McCollough. In February 2015, they staged their collection at the Whitney Museum of American Art's Marcel Breuer–designed building uptown, after the museum had closed its doors to the public and before it had opened its new location. The empty, raw space put the designers' slashed sweater dresses, needle-punched tweeds, and assemblages-as-dresses in the context of the art that inspired them, in this case, abstract expressionism. Then, in September 2016, the designers pulled off another venue coup, showing inside the new Renzo Piano–designed Whitney Museum on Gansevoort Street in the Meatpacking District, with the lights of the skyline as well as the Hudson River in the distance. For Carolina Herrera's thirty-fifth anniversary in September 2015, she chose the classically designed Garden Court at the Frick Collection on the Upper East Side. Beneath the garden skylight, flowers and palms framed her feminine, pretty-in-pink collection.

Designers also found parks—other than Bryant Park—to be ideal locations. Coach's debut runway show was held on the High Line in September 2015. The abundant grasses and fig trees that dot the urban, aerial park running along Manhattan's west side were the perfect backdrop for designer Stuart Vevers's ode to the heartland of America, his fourth collection

Opposite, clockwise from top left: The Moncler Fall 2011 show at Grand Central, February 2011; Models on the boat *The Manhattan*, docked at Chelsea Piers for the presentation of the Band of Outsiders and Sperry Top-Sider Spring 2008 collection, September 2007; Rosie Assoulin Spring 2016 show, September 2015; Yeohlee Teng and models on the runway after her Spring 2005 show at the 42nd Street and 6th Avenue subway station, September 2004; Imitation of Christ Fall 2002 show, February 2002; Elise Overland Fall 2011 show, February 2011. Following spread, from left: Carolina Herrera Fall 2016 show at The Frick Museum, February 2016; Cynthia Rowley Spring 2016 show in Montauk, September 2015 (top); Coach Spring 2016 show at the High Line, September 2015 (bottom).

182

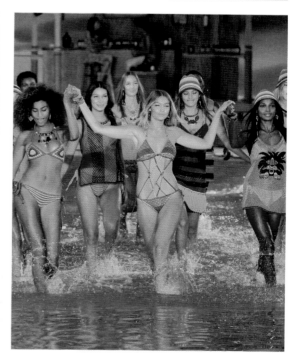

for the brand. "That runway was my biggest opportunity to say, 'Look, this is a new day, and things have changed,'" says Vevers.

After two years of planning, Ralph Lauren celebrated his fortieth anniversary in 2007 with a show and dinner in the lush gardens of the Central Park Conservatory. Guests, including Mayor Michael Bloomberg, Sarah Jessica Parker, Matthew Broderick, Dustin Hoffman, and Robert De Niro, walked through the magnificent Vanderbilt Gate and into a wonderland of perfectly pitched tents, white-gloved waiters, and Champagne that managed to stay chilled even on a late summer's night.

"It was a beautiful collection, like a movie, that came to life in the most magical environment," says Lauren of his favorite show ever. After the tuxedo-clad designer took his bow to Sinatra's "The Best Is Yet to Come," the back wall of the tent opened onto a twinkling terraced garden where more tents were hung with chandeliers. No one wanted to leave.

Many people *did* want to leave Roosevelt Island, when in September 2016, Kanye West held his Yeezy Season 4 fashion show at Four Freedoms Park there. Only they couldn't. The designer shuttled guests from Manhattan in buses to the location, then made them stand nearly an hour waiting to get in, without providing water or shade. Editors took to social media to vent their anger, and Gerald Flores, the editor-in-chief of *Sole Collector*, live tweeted something he heard on the bus. "It feels like we're being kidnapped." By the time the show started, the models, dressed in form-fitting body suits, were literally wilting, with one passing out from the heat and others struggling to walk in crippling heels.

Special Effects and Grand Sets

Not only have designers have gone 3-D—Escada's first US show in April 1994 featured a video that required showgoers to don 3-D glasses—but they have also explored holograms, such as in September 2014, when Ralph Lauren created a high-tech runway event to showcase his contemporary Polo collection, once again using the glittering New York skyline as a backdrop. He projected a holographic runway show onto a sixty-foot water screen in the Central Park Lake, with images of virtual models walking among familiar New York sites, including on the Brooklyn Bridge and the High Line. As guests watched, they enjoyed gimlets, "Ralph Burgers," and lobster rolls, for the ultimate fashiontainment experience. "That technology contrasted with the natural beauty of the environment said everything about the modern spirit of the Polo woman," Lauren says.

Designers have also experimented with light effects: Alexander Wang's Spring 2013 glow-in-the-dark finale dresses were revealed under black light, and Marc Jacobs's fall 2015 show used a low-frequency light trick to create a desaturation effect on the clothes. And they've built more elaborate sets than ever before, as social media has demanded the perfect sharable moment.

In 2008, Cynthia Rowley built a life-size pop-up book on her runway in Gotham Hall that fell open when the show started, blowing everyone's hair to one side. "All these wooden cutouts of trees popped up, the first girl walked out as if she'd been in a storybook for years, patted dust from her clothes, and that was the first look," says the designer.

To celebrate his tenth anniversary in 2015, Phillip Lim installed mounds of dirt around his catwalk, an arrangement designed by architect Maya Lin using compost the designer and his team had been making from their own food waste for months. "I was thinking about where things start. They start from a seed. They start from dirt," Lim said.[99] In 2016, Kate Spade used 30,000 flowers as a backdrop for its presentation.

Tommy Hilfiger has constructed some of the most impressive sets, from turning the Park Avenue Armory into an actual football field in February 2015, for his old-school, collegiate-inspired looks, to building an ocean liner named the *TH Atlantic* at the same location in February 2016. Between these shows, in September 2015, Hilfiger constructed a beach lagoon on Pier 94 for models like bikini-clad Gigi and Bella Hadid to splash in. "It was incredibly hard because we had to build the pool in the place," says Tommy Hilfiger chief brand

Opposite, clockwise from top left: Tommy Hilfiger Fall 2015 show, February 2015; Yeezy Season 4 at the Franklin D. Roosevelt Four Freedoms Park on Roosevelt Island, September 2016; Tommy Pier for the Tommy Hilfiger Fall 2016 show, September 2016; Gigi Hadid leads models out at the Tommy Hilfiger Spring 2016 show, September 2015; 3.1 Phillip Lim Spring 2016 show, September 2015; Cynthia Rowley after her Fall 2008 show, February 2008. Following spread, from left: Ralph Spring 2008 show, celebrating the brand's 40th collection, September 2007; Ralph Lauren's Polo for Women holographic show in Central Park, September 2014.

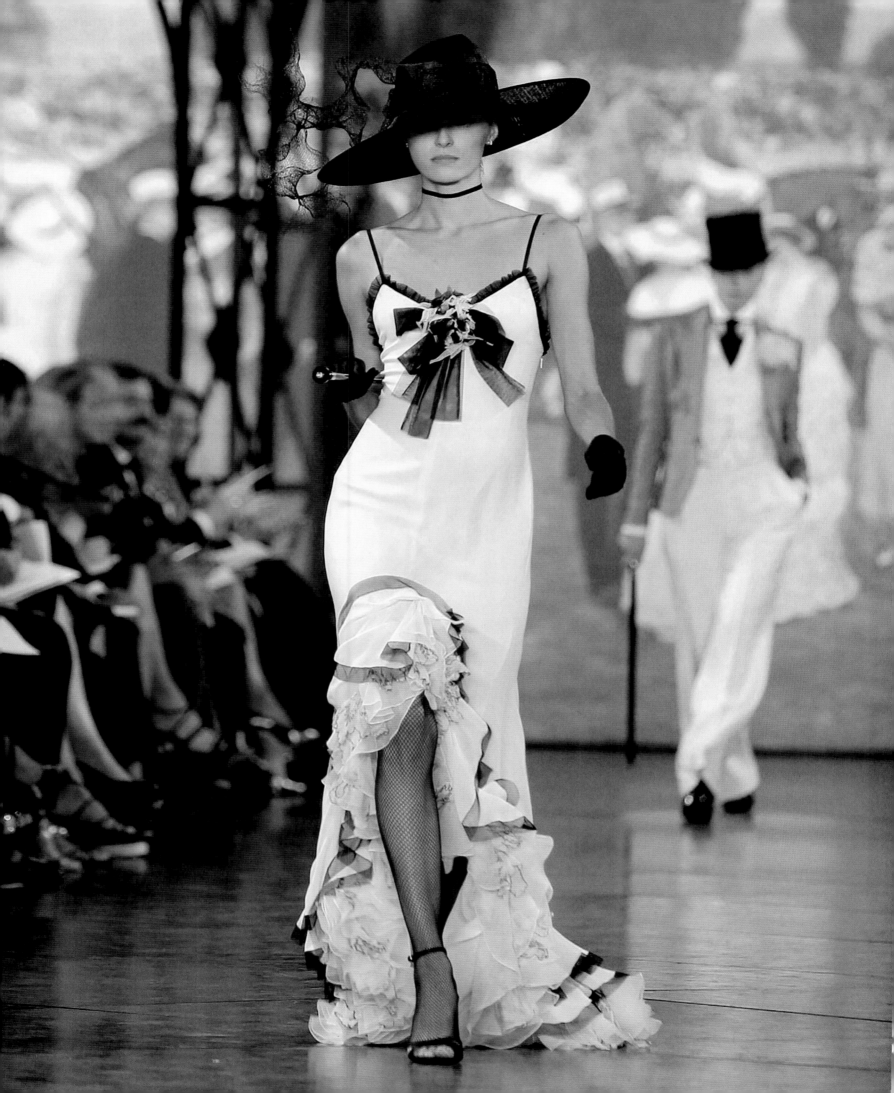

officer Avery Baker. "We only had half an hour to run through it ahead of time, and not all of the girls were there. But that was the great thing about Gigi, she was totally up for it, because she has such positive energy. She just grabbed other girls' hands, smiling and laughing."

But perhaps no other set in New York Fashion Week history can top Hilfiger's carnival in September 2016, staged on Pier 16 at South Street Seaport in front of one thousand invited guests and the public, and rumored to have cost $4 million. Complete with a Ferris wheel and popsicle carts, the show featured Gigi Hadid leading the charge down the runway, and her pal Taylor Swift singing along from the front row. Alongside the Tommy-themed rides and games there was a tattoo parlor, a nail art station, and a photo booth. Several merch shops sold pieces from the see-now, buy-now collection fresh off the runway.

"The helicopter shot over the pier is a hard thing to top," Baker says, calling out one of the more choice camera angles in the event's live streaming coverage online at Tommy.com. But it's more than just watching, she says. "It's experiencing and interacting."

Star Players

With the rise of celebrity-designed fashion lines, the designers themselves became part of the fashion show experience, too. Sean "Diddy" Combs was one of the first to really make an impression at Fashion Week, when he staged his first star-studded spectacular in February 2000. Combs recruited many of his famous friends to sit in the audience, including Missy Elliott, Lil' Kim, John Singleton, Patrick Ewing, and music mogul Russell Simmons. He knew that the crowd had turned out not just to look at clothes but also to be entertained. And he did not disappoint, sending models in fur coats of linebacker dimensions down the runway to music from *2001: A Space Odyssey*, *The Godfather*, the Doors, and Sinatra.

In February 2005, Jennifer Lopez closed New York Fashion Week with the debut of her Sweetface label at Bryant Park. Titled "The J.Lo Show," it was an extravaganza in three acts loosely corresponding to phases of the superstar's life, with accompanying lights and music. Bernadette Peters, Lil' Kim, Foxy Brown, and Simmons were in the audience for the "Jenny from the Block" act, the "J.Lo as Chart-Topping Pop Star" act, and, finally, the "J.Lo as Red Carpet Icon" act. Lopez also used the show to debut her Miami Glow fragrance and her new album, *Rebirth*. And in a spectacular use of synergy, the whole gig was filmed for a documentary on MTV. (In striking contrast, in the tent next door on the very same day, American master Ralph Rucci's runway was an oasis of calm, complete with tinkling spa music. For him, the clothes were the theater, including a white double-faced wool "suspension suit" with orange slits and triangles that brought to mind an Alexander Calder mobile and a black wool dress scored with tiny knots and tears that evoked constellations in the night sky.)

The runway debut of Gwen Stefani's L.A.M.B. clothing line in September 2005 was also like a music video. There was even a product tie-in from Sony, her record label, which bankrolled the million-dollar event. The show opened with a fog of dry ice rolling onto the runway and canvas tarps magically lifting to reveal models in the drivers' seats of cherry-red lowrider cars that were hopping up and down to the music beat. Instead of their typical blank expressions, the models were all attitude, strutting to Stefani's newest song, "Orange County Girl," even as they stopped on the runway to play with Sony's latest gaming gizmo, the PlayStation Portable. Stefani's husband at the time, musician Gavin Rossdale, snapped photos, while Nicky Hilton, Ashanti, Combs, and Faith Hill watched from the front row.

More recently, celebrity designers have been able to transcend their Hollywood status and achieve more legitimacy in the fashion hierarchy, most notably former Spice Girl Victoria Beckham, who started out doing very intimate, old-school salon shows. "She always made everyone feel so special because she greeted everyone in each group of fifteen or so by name, and she showed off her knowledge about fashion history and garment construction by narrating it more like it was a show from the 1960s," remembers former AP fashion editor Samantha Critchell. "One year she told everyone that the look on her mini runway was what she'd be wearing to the Oscars that year."

Opposite, clockwise from top left: Jennifer Lopez and a model backstage at her Sweetface by Jennifer Lopez Fall 2005 show, February 2005; Naomi Campbell leads the models at the Sweetface by Jennifer Lopez Fall 2005 show, February 2005; Gwen Stefani at her L.A.M.B. by Gwen Stefani Spring 2006 show, September 2005; Victoria Beckham at her Fall 2017 show, February 2017; Victoria Beckham Spring 2017 show, September 2016; L.A.M.B. by Gwen Stefani Spring 2006 show, September 2005.

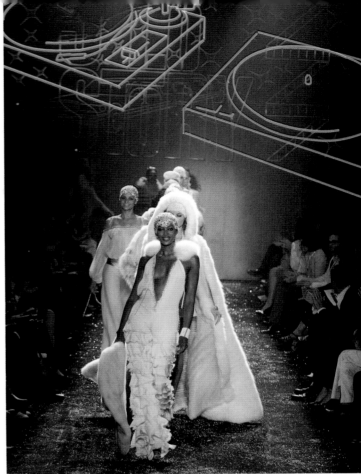
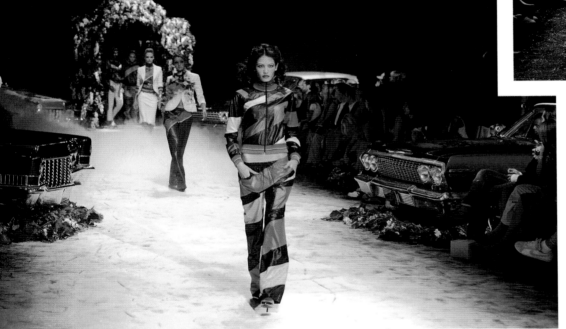

Beckham, who now shows at Cipriani on Wall Street, still doesn't do fashion spectacles at all, save from the star wattage of her husband David Beckham and their children in the front row. Likewise, Mary-Kate and Ashley Olsen have been in the spotlight since they were child actors on the TV show *Full House*, but they have since gained a positive reputation as designers of their high-end collection, The Row. They prefer to show in the quietest way possible, often in a private townhouse with just fashion insiders in attendance.

Notable Models

Over the years, a number of big stars have made cameos on the catwalk—Sofia Coppola walking for Donna Karan in 1994; Claire Danes and Scarlett Johansson for Cynthia Rowley in 1996 and 2003, respectively; Kim Kardashian for Christian Audigier in 2007; Rita Ora for DKNY in 2014; and Lady Gaga at Marc Jacobs in 2016. But Rowley was one of the first to put celebrities on her runway, starting with Molly Ringwald in 1995.

"I have been lucky enough to become friends with a lot of actresses through dressing them over the years, and I hope we inspire each other," Rowley says. In 2015, Miley Cyrus designed a collection of neon beaded accessories for pal Jeremy Scott's runway, and she walked with him during his runway bow. "I went to her house for a Fourth of July party," the designer told Elle.com. "She asked about my upcoming show, and I was throwing out inspirations, and we started literally completing each other's sentences. She said, 'I want to design something for the show!' And I said, 'Absolutely!' "[100]

But perhaps the most star-studded runway ever was the debut of Tom Ford's namesake women's collection in September 2010, when he held a private showing at his Madison Avenue store and cast "the world's most inspirational women" to walk his runway, including Beyoncé, Julianne Moore, Daphne Guinness, Lauren Hutton, and Rita Wilson.

Some models themselves have risen to the level of celebrities, from the '90s supes to today's Insta-famous. "The '90s was the height of the supermodel period, where you had such strong personalities that they dominated and radiated on the runway,

so that they were spectacles themselves," says Anna Sui, a stylist-turned-designer who wowed with her very first show in 1993 by enlisting her supermodel friends Naomi Campbell, Christy Turlington, and Linda Evangelista to appear.

"We went through the supermodel period, the waif period, then it was the Brazilians—who were super sexy—then the Eastern Europeans. What type of model is in at the moment reflects what shows look like," says Sui. "Now, it's all about the sensation of being able to see the girls in person that you see so much on social media." Sisters Gigi and Bella Hadid are the models of the moment, and they shared the runway for Sui's Fall 2017 show, walking in clothes inspired by Elsa Schiaparelli, Elsie de Wolfe, and the 1945 film *Blithe Spirit*.

Other runway shows have been memorable for casting models that challenge fashion's conventional and often narrow definition of beauty. Long before diversity became a buzzword in fashion, designer Sophie Theallet was making it a part of her runway narrative. Her Spring 2009 debut, inspired by Barack Obama's election, featured a cast of exclusively black models. For Fall 2016, she was inspired by globalization, tailoring each one of her looks based on the model's background. "Invariably, fashion expresses the zeitgeist of our time, so in a sense, fashion and runways are political and social platforms, whether a designer uses it with intention or not," said Theallet.[101]

Betsey Johnson used non-models in her show in September 1999, including her daughter and her yoga instructor, and the next season, she featured *Playboy* bunnies on the runway. For the DKNY twenty-fifth anniversary show in 2014, Donna Karan cast regular folks from New York, including artists, nightlife hostesses, tattoo artists, skateboarders, and personalities Hannah Bronfman and Chelsea Leyland, rapper Angel Haze, and even self-described DJ/writer/cyborg Juliana Huxtable.[102]

In September 2016, designer and *Project Runway* winner Christian Siriano made headlines for challenging the notion that only sample-size girls can walk the runway by casting five plus-size models in his show. The same season, Rachel Comey and Tracy Reese cast a wide range of ages to help high-

light the versatility of their clothes, and Tom Ford, Ralph Lauren, and Michael Kors embraced '90s and '00s supermodels, highlighting the theme of diversity and social media's demand for Instagrammable personalities that consumers connect to and identify with around Fashion Week.

The February 2017 collections had the most plus-size models in history. Out of the one hundred-plus major runway shows featuring nearly three thousand model appearances, twenty-seven models on six runways were plus-sized, according to TheFashionSpot.com, with Ashley Graham becoming the first plus-size model to walk for Michael Kors. The same season, Kanye West introduced hijab-wearing model Halima Aden on his Yeezy Season 5 runway, and eighty-seven-year-old astronaut Buzz Aldrin walked for menswear designer Nick Graham while wearing a silver bomber jacket and a T-shirt that read, "Get Your Ass to Mars."

"The shows are not just for the industry anymore. There is a much broader audience," says Kors. "Some people are watching because they like the theater, some are watching because they want tips, some are watching to buy clothes, and the editors are watching for a story. So when I design a collection I'm trying to think in a multilayered way. The idea of a bunch of mannequins out of a Robert Palmer "Addicted to Love" video seems very old fashioned. My show is going out to different countries and women of all sizes and ages, so that influences the variety of clothes you show, and the variety of people on the catwalk."

Live Performances

Along the way, Hilfiger, Kors, Ford, Reese, Nanette Lepore, Rebecca Minkoff, and others have incorporated live performances by singers such as Bush, Rufus Wainwright, and Leon Bridges into their runway shows. Designers have also employed dancers and actors to spectacular effect.

Of Kors's Spring 2017 show, *Vogue* fashion news director Mark Holgate said, "How could anyone who was there forget this? Not just the terrific, upbeat clothes and great casting—only at Michael's shows do Taylor Hill, Marjan Jonkman, Romee Strijd, and Bella Hadid all somehow effortlessly

coexist in the same universe—but Rufus Wainwright's swing through the standards, set to a live orchestra."[103]

In September 1999, DKNY enlisted Boy George to spin for its tenth anniversary, and in extravagant fashion, Kanye West rented out Madison Square Garden in February 2016 to show his Yeezy Season 3 collection and simultaneously stage a listening party for his album, *Life of Pablo,* for the ticket-buying public. His wife, Kim Kardashian, and her sisters and mother, Kris Jenner, attended, creating a show of their own—which was even filmed for their own reality TV show.

Others have made their runways into performance pieces using theater and film. Humberto Leon and Carol Lim, the designers behind Opening Ceremony, a retail store founded in 2002 that has since grown into a full-fledged, branded collection, are known for throwing a good party and upping the ante at New York Fashion Week.

Their Spring 2015 show cast Elle Fanning, Rashida Jones, Bobby Cannavale, Karlie Kloss, and others (wearing the collection, naturally) in a forty-five-minute, one-act play, cowritten by Jonah Hill and Spike Jonze, that lovingly skewered the fashion industry. For their Fall 2015 show, they collaborated with New York City Ballet choreographer Justin Peck to have dancers executing fake falls on the runway. "One fell right in front of me, and I felt so bad for her," remembers fashion writer Christina Binkley. "Then another fell in the same spot, and I thought there was something wrong with the floor. By the time the third one fell, I realized the joke was on us. Honestly, Opening Ceremony has thrown so many curveballs at us."

"A runway show is everything you ever wanted to say in total 3-D form," says Donna Karan, who cites her thirtieth anniversary show in February 2014 as her favorite. The show featured the unveiling of her *Woman in Motion* film, a motion study of Karlie Kloss shot in a geodesic dome by Steven Sebring. "Forget about the show, I just love the film," Karan says.

Meanwhile, Shayne Oliver, founder of New York label Hood

by Air, has staged shows that are almost like performance art, capturing a mashup of DJ and club culture and upending traditional concepts of race and gender, including his Fall 2014 show, which "made the fashion world sit up and pay attention," said *Vogue*'s fashion news director Chioma Nnadi. "It was billed as a menswear collection, but, of course, Oliver has never been one for gender conformity. A woman opened the show and all of the models—male/female/trans—had hair extensions trailing down the back of their Hood by Air leather trench coats and logo tees. It was just the right way to build up to the show's terrific finale, when a troupe of dancers stormed out dressed in the brand's bondage denim, whipping their colored wigs back and forth."[104]

The Sideshow

The runway has played host to plenty of eyebrow-raising antics, too, both inside and outside the shows. "New York Fashion Week attracts more crazies than the other weeks, but that's part of its charm," says Binkley. "The guy in the Superman costume seated at a bunch of Lincoln Center shows—including front row at Monique Lhuillier. The topless woman posing outside all day."

"There are always groupies because it's the place to be seen," says photographer Jonas Gustavsson. In 2009, an unwanted guest created a stir at the Yigal Azrouël show: Ashley Dupré, the prostitute who had been linked to New York Governor Elliot Spitzer, caused such a scandal just by showing up that the designer fired his publicist.

Getting into shows can be such a scrum that occasionally it turns to pushing and shoving. And once inside, seating can be fraught with drama, too. In 2012, things became so heated at the Zac Posen show that a French fashion editor slapped a publicist across the face when she was denied a front-row seat, resulting in a $1 million lawsuit that was later settled.

Sometimes crashers do make it inside. "I'll never forget the streaker at Prabal Gurung!" exclaims *Newsday*'s Anne Bratskeir, referring to the gent dressed in nothing but a crown,

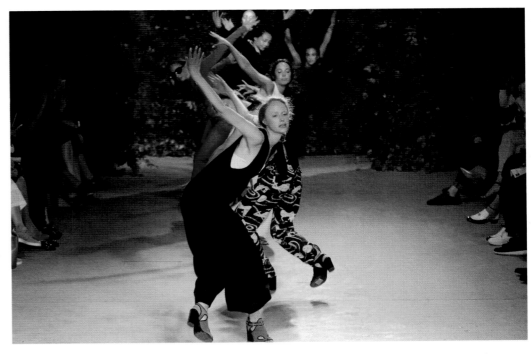

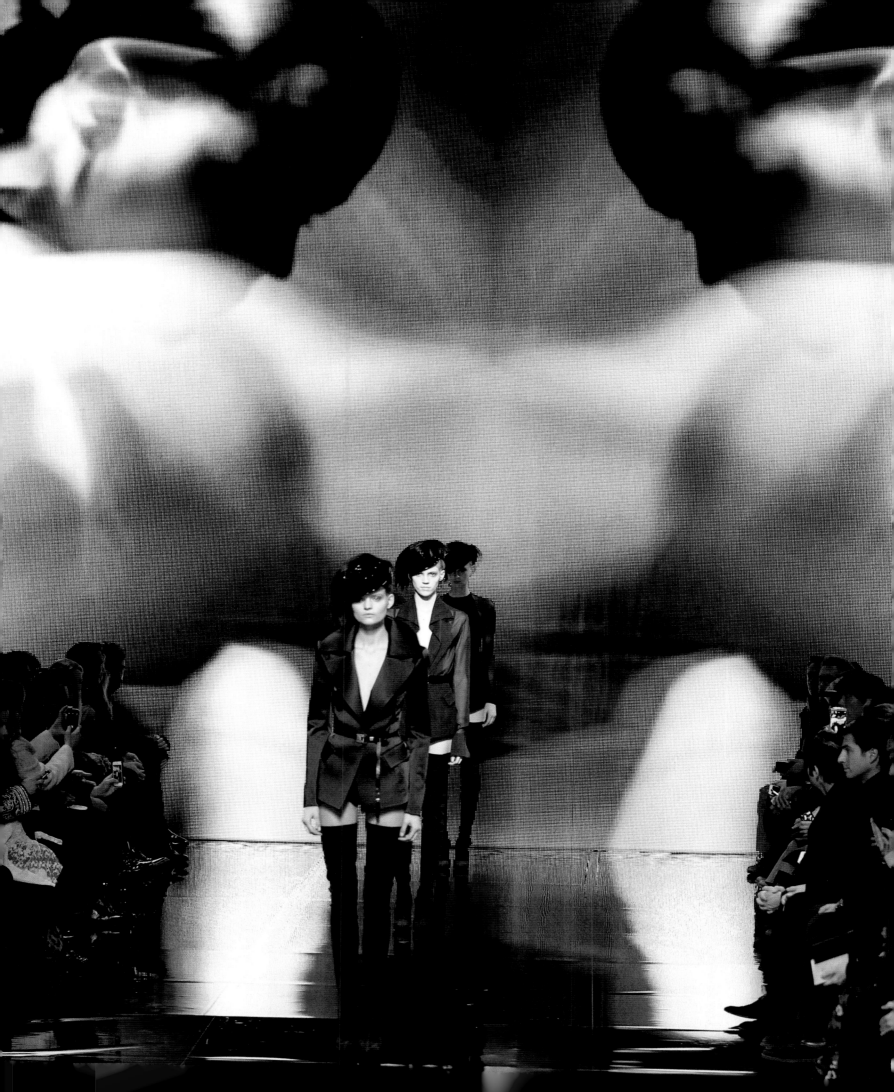

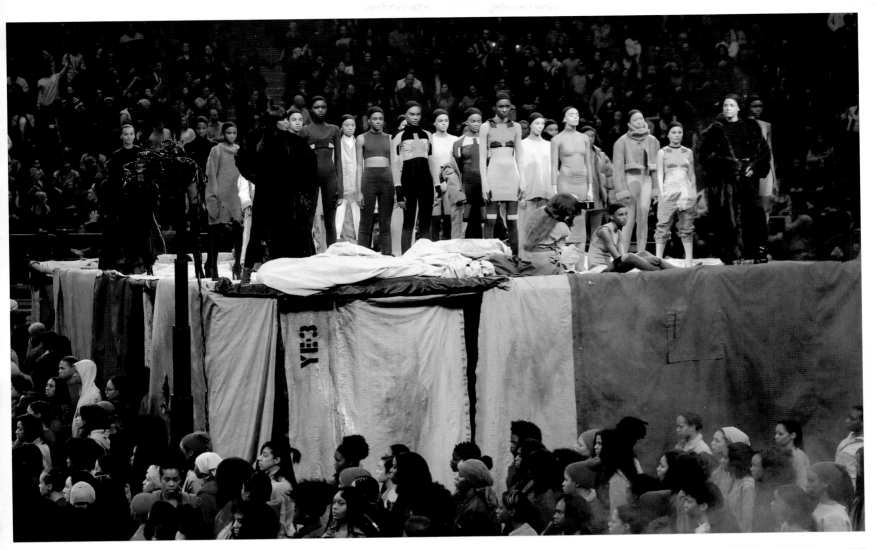

trench coat, and jockstrap who jumped onto the designer's runway in 2014 and kneeled in front of a model who, like *Vogue* editor-in-chief Anna Wintour, remained unfazed. (It was Vitalii Sediuk, the Ukrainian media personality who has also disrupted the Grammys and Met Gala red carpets and harassed model Gigi Hadid.)

Models don't always perform as planned, and thanks to ill-fitting shoes and slippery runways, trip and falls are all too common. "I'll never forget my show where the water leaked onto the white patent runway, turning it into a skating rink," remembers designer Steven Stolman. "Nightmare . . . models skidding off the edge." Former *InStyle* editor Hal Rubenstein remembers, "One time, I had to get up and help a model walk down the runway because her shoes were so awful."

To lend an extra air of authenticity to his Fall 2001 Middle Eastern–inspired collection, held at a Lower East Side market turned souk with billowy tent cloth on the ceiling, designer Miguel Adrover sent out a few models carrying packages on their heads, some dressed as colonial-style officers, and one as a shepherdess with a live goat.

"It was a dicey neighborhood back then, and the entry was essentially a black sheet of canvas with a very small opening," remembers former *Palm Beach Daily News* fashion editor Robert Janjigian. "I didn't bother to take a seat because the place was so packed. The clothes were OK, but the animals accompanying the models were the most memorable. A young woman was struggling with a goat that lost its footing and stepped into the crowd. Apologies came later, along with a less dangerous venue."

Isaac Mizrahi had better luck with animal husbandry in February 2011, when he sent out pastel-colored poodles alongside his models, who had matching bouffant hairdos. "He dyed the dogs to match the clothes!" says *Newsday* style writer Anne Bratskeir.

Accidents do happen. "My funniest memory involves me falling into Anna Wintour's lap, no joke," says one publicist.

Journalist Elycia Rubin says, "I'll never forget when a protestor from PETA ran onto the runway, splashing paint on the model and all over me. [It] made the evening news." Considering how many people are packed into the shows, and how many shows there are, it's remarkable that there have only been a few more serious incidents. A bank of hot show lights fell from the ceiling at Diane von Furstenberg's show in 2005, injuring several editors, including Hilary Alexander of the UK's *Daily Telegraph*. "I went to the hospital with her," remembers Suzy Menkes. "We thought it was great, because she survived with a couple of bruises and DVF lent us her fancy car—I think it was a Bentley—for the rest of the shows."

In 2012, ninety-five-year-old Zelda Kaplan, a beloved New York style icon and fashion show lover, collapsed front row at Joanna Mastroianni's fashion show. After being rushed to the hospital, she was pronounced dead. "She went to the great front row in the sky," says Adam Tschorn of the *Los Angeles Times*. "It was quite a shock," Mastroianni told *New York* magazine's *The Cut* blog. "But I have to tell you, if a fashion girl ever decides to go, this is the way to go."[105]

In one of the most tender runway moments, Alice Roi was shocked at her September 2003 show when her boyfriend, Marc Beckman, arranged for models to hold up signs that read, "Will You Marry Me?" She said yes. Another poignant turn? "The Vera Wang show the day after her dad died," says Bratskeir. "A sheet of paper with his name on it lay on each seat and at the end, we watched her heart-wrenching long finale walk with tears streaming down her face."

Sometimes, what's memorable is a familiar designer bow, like Ralph Lauren's walk-wave down the runway, always stopping to kiss his doting family in the front row. Or von Furstenberg's long, slow, gracious diva spin and greeting of all of the New York power brokers in her front row, which has included Anderson Cooper, Charlie Rose, and more.

Then there's Betsey Johnson's cartwheel and split, the cherry on top of every one of her high-energy shows, which over the years have taken the form of tea parties, high school proms,

and backyard follies. "I moved to New York to be a Rockette," she says by way of explaining her signature move. "The first time I did it, it was a Viking-inspired show, and when it was over, I did a cartwheel and split as a way of celebrating. The audience really loved it, so I stuck with it. It's my trademark, people recognize me by the hair and by the cartwheel. Put that together with my turn on *Dancing with the Stars* and I feel extremely successful! I made my mark."

Taking a Stand

Designers have also used the runway as a platform for social activism, none more so than Kenneth Cole, who in 1985 started to promote awareness of HIV/AIDS through his advertising, and beginning in 1998, used his shows for messages about homelessness, gun control, abortion, the environment, and same-sex marriage. "It enabled our fashion stories to have some context and relevance," Cole says. He used his shows as a forum to collect shoes for the homeless, get out the vote, and, in the aftermath of Hurricane Katrina, to collect funds for the Red Cross. That same year, Naomi

Campbell organized the Fashion for Relief charity show, starring Beyoncé and Tyson Beckford, among others. On September 10, 2001, Cole held his show in a clear tent in Rockefeller Center, making an alliance with the Brady Campaign to Prevent Gun Violence, to bring attention to the cause of gun control. There were toy guns on the seats, along with anti-gun literature, and on the screen above the runway, an animated film satirizing then-president George W. Bush.

But no runway season was as political as Fall 2017, following the election of President Donald Trump, when designers made their opposition heard with statement-making soundtracks and directly inspired collections, slogan T-shirts, and personal accessories, including the CFDA's own Stand with Planned Parenthood buttons. Prabal Gurung sent models down his runway in tees bearing feminist phrases such as "The Future Is Female," "Voices for Choices," and "We Will Not Be Silenced."

"More than ever, I feel like fashion and politics should mix," says Gurung. "We have the platform, we have the audience. . . .

I went to the Women's March [in New York]] and wanted to capture what I saw in the finale."

"I got teary-eyed, and other people were outright crying," says Binkley. "Not that slogan tees are great fashion, but it felt like it was time for fashion to take a stand, and Prabal was one of the loudest voices doing that."

The national cochairs of the 2017 Women's March on Washington kicked off Mara Hoffman's presentation and performance with opening remarks about feminism in the age of Trump, and at Tracy Reese there was a live reading by Aja Monet of her poetry about female strength. And for Raf Simons's debut show at Calvin Klein, the music (David Bowie's "This Is Not America"), the art installation acting as a set piece (featuring American flags and swatches of denim by Sterling Ruby), and, of course, the clothes (remixed band uniforms and sharp power-broker tailoring) made a stirring statement about the state of America.

The Front-Row Show
The Calvin Klein show also featured an all-star front row that included Naomie Harris, Millie Bobby Brown, Sarah Jessica Parker, A$AP Rocky, Kate Bosworth, Sofia Coppola, Julianne Moore, and Gwyneth Paltrow. It was a salient example of how the front row has changed over the years from inside-industry media and buyers to include Hollywood power brokers such as *Sex and the City*'s Patricia Field; stylist-turned-designer Rachel Zoe (who filmed episodes for *The Rachel Zoe Project*, her reality show, in and around the Bryant Park tents); red carpet stylist Cristina Ehrlich, who works with Priyanka Chopra, Brie Larson, and Margot Robbie among others; red carpet stylist Kate Young, who works with Selena Gomez, Dakota Johnson, and Michelle Williams among others; as well as celebrities themselves, who either have a connection to the designer, are working with the designer on a campaign, or are simply paid to sit front row and draw media attention.

The celebrity presence at fashion shows has ebbed and flowed, from the socialites of the '60s, '70s, and '80s to the reality-TV stars and paid-for paparazzi bait of the '90s and '00s, to the social media stars of today. At Kanye West's Yeezy Season 2 show, the Kardashians attracted so much paparazzi, they literally stopped traffic on West 27th Street.

Some celebrities fly more under the radar than others. "I remember a Diane von Furstenberg show where the photographers were stalking where J.Lo was going to sit and all the commotion when she emerged from backstage, while Uma Thurman walked in with all the editors and went unnoticed and took her seat in the middle of Barry Diller and J.Lo. It was like night and day!" says Critchell. "I sat right behind them."

Musicians have dotted the front rows at Todd Oldham, Marc Jacobs, Alexander Wang, John Varvatos, and Jeremy Scott. Mick Jagger was a regular attendee at the intimate shows of his late girlfriend L'Wren Scott, even composing and recording two songs for her Spring 2009 season.

"At Badgley Mischka in 2003, I got there a little early to see a very young Beyoncé Knowles and Jay Z seemingly before they were totally recognizable to the fashion flock," says Janjigian. "I just went up to them and said 'Hey.' " Another time, he was surprised to see Justin Timberlake sitting among Barbara Walters and the other Old Guard socialite clients at an Oscar de la Renta show. "I politely asked him why he was at the show and he replied, 'Oscar invited me.' "

Athletes have taken up their share of real estate, too, particularly at menswear shows such as Rag & Bone and Robert Geller. The association reached a climax in February 2015, when New York Fashion Week shared time with the NBA's All-Star Weekend, and players, including Russell Westbrook, James Harden, and Nick Young, flooded the fashion zone, lending their global exposure to the runways (and racking up some designer collaboration deals along the way).

"There were enough NBA players in the front row to break into a fashion-forward pick-up game," says the *L.A. Times*'s Tschorn.

It's all part of the intoxicating swirl that makes a runway show worth watching in real life. You just have to be there.

Opposite, clockwise from top left: Keren Craig and Georgina Chapman of Marchesa with Planned Parenthood buttons at their Fall 2017 show, February 2017; An activist T-shirt at the Fall 2017 Prabal Gurung show, February 2017; Leaders of the Women's March at the Mara Hoffman Fall 2017 show, February 2017; Calvin Klein Fall 2017 show, February 2017; Betsey Johnson does her signature cartwheel at the end of her Spring 2014 show, September 2013. Following page, from top: New York Fashion Week, February 2005; Y3 Spring 2011 show, September 2011. Page 203: Adam Selman Fall 2016, February 2016. Pages 204–05: Calvin Klein Fall 2007, February 2007.

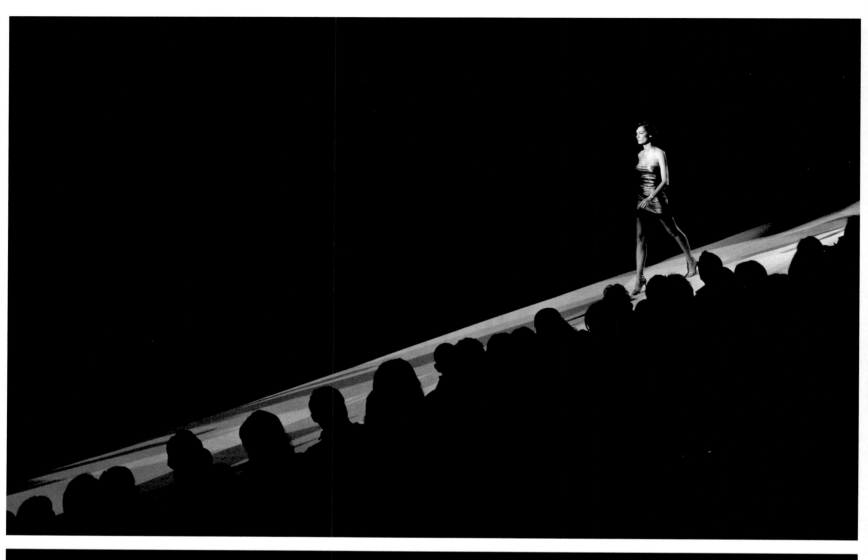

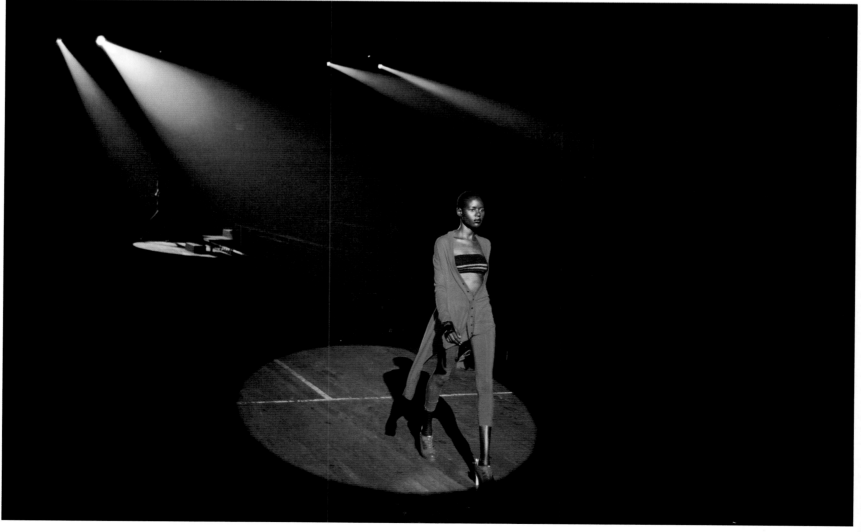

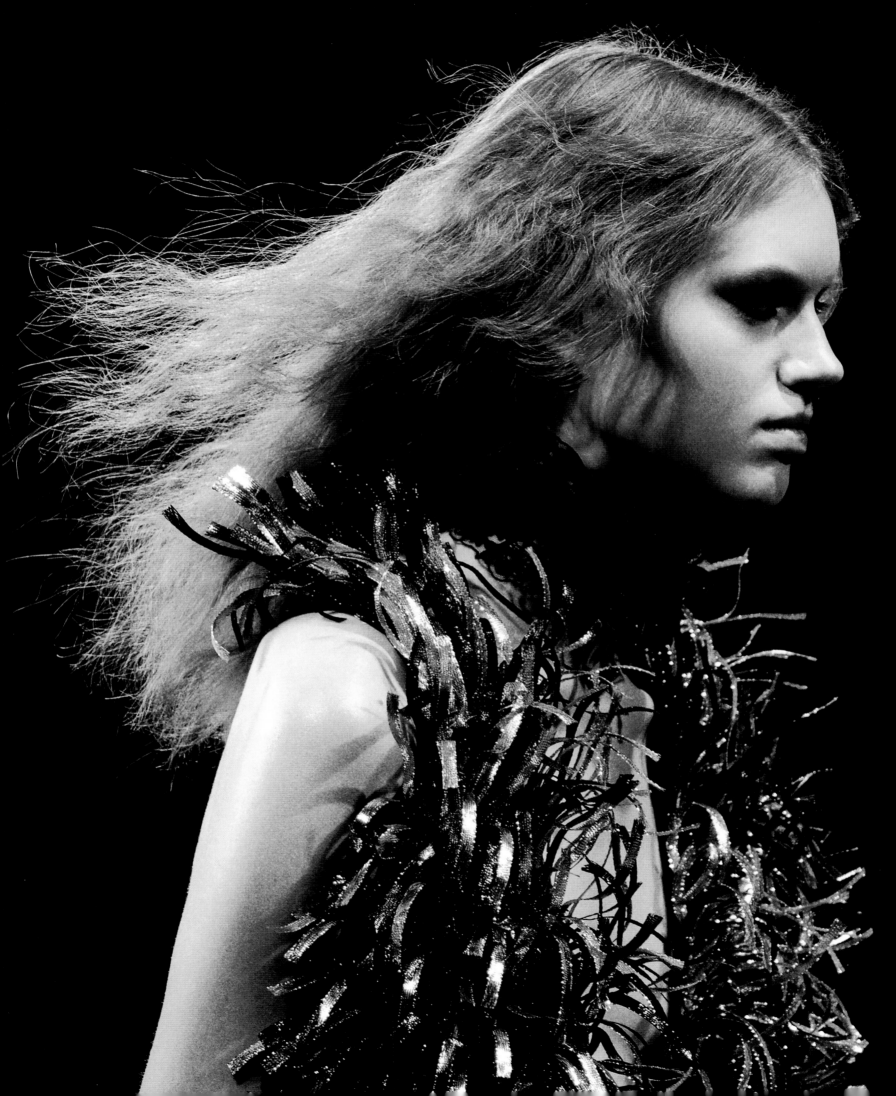

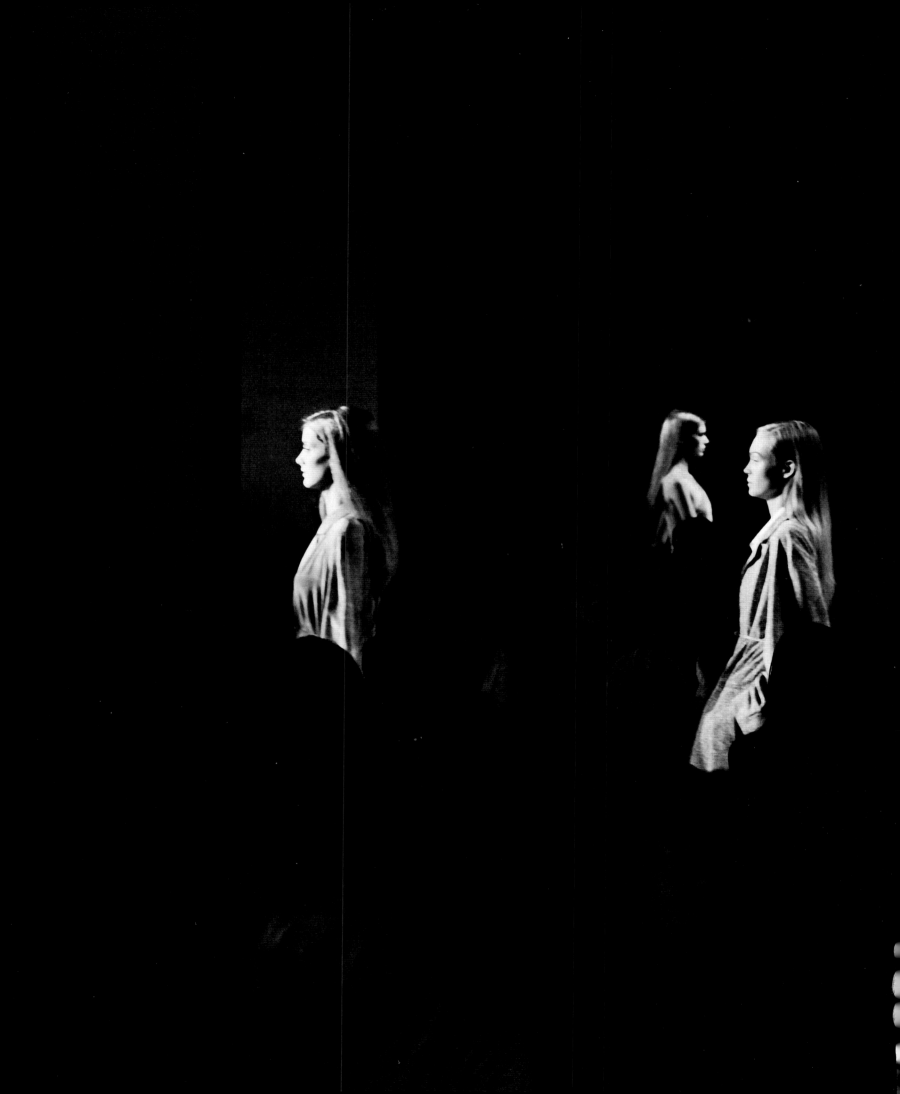

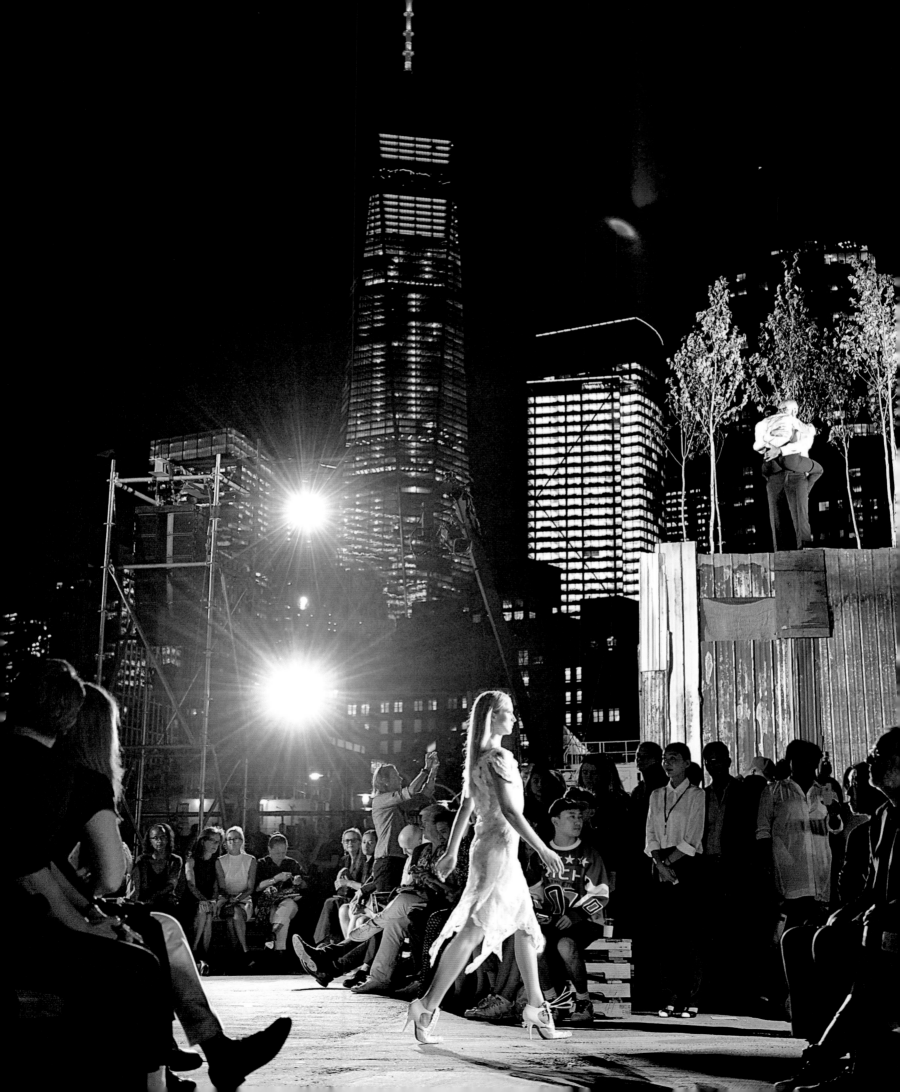

10

THE SHOW MUST GO ON

Through natural disasters, hurricanes, and snowstorms, New York Fashion Week has gone on, creating collective memories for the thousands of attendees, store buyers, print and online media, photographers, models, and backstage crew, who travel together, sit crammed up against one another—basically, live, breathe, and eat fashion together—over the course of nine days.

Runway shows are held on the hour, every hour from 9 a.m. to 9 p.m., but typically start twenty minutes to a half hour late (unless you are bad boy Marc Jacobs in the old days, when an hour late was a good day), and not all of them were at Bryant Park, or any other central venue for that matter, as locations are scattered all over New York City—uptown, downtown, across town, even across the river. It's not uncommon for attendees to zigzag the map, logging five to six miles by foot and more by car or subway on a single day.

Getting to a show on time can be a challenge in the best of circumstances, and showgoers often go to great lengths to make it to their seats, even seconds before the show starts, when the protective plastic is peeled off the runway and the photographers in the pit yell in booming voices a reminder to the front row to make a clear path for clean photographs and "uncross your legs!"

"One season, I was on a mission to get into the Heatherette show," says *Paper* magazine editorial director Mickey Boardman. "It was so crowded that the fire department had come and shut down the front, so I snuck in the backstage.

Tinsley Mortimer was already lined up with the rest of the models in her tennis outfit, and the guard put his hand out, letting me know they had already peeled back the plastic to start the show. But I just went for it and bounded on out. Coming from backstage, people thought I was the first look. But my adrenaline was going, and I just went for it. . . . There's nothing worse than being stressed and getting there and the door is closed. So it felt like a triumph, a triumph for fashion."

"I can never forget Marc Jacobs's Spring 2008 show, which was scheduled for 9 p.m. but didn't start until 11 p.m. Natalie Massenet was just starting Net-a-Porter and a group of us headed over to the roof of the Gramercy Park Hotel and Natalie bought Champagne. So we were not nearly as pissed off about the lateness as Suzy Menkes, who wrote the next day that the show represented everything that was wrong with fashion," says fashion writer Christina Binkley. "That was the last year that Marc Jacobs was late with his show. After that, he went the other direction, and everyone had to get there early. I also will never forget stepping out of Marc Jacobs's first on-time show, which he literally started at the moment people were supposed to arrive, so it ended at about twelve minutes after the hour. As I exited the Lexington Avenue Armory, a guest was just pulling up in a chauffeured SUV, and when she realized the show was already over, she stood in the door of her car and shrieked."

Showgoers are a hearty and determined bunch—though attending the runway presentations may look like a vacation, it's not. The schedule is grueling, it involves putting your

Opposite: On the anniversary of September 11th, Richardo Tisci presented his Givenchy Spring 2016 collection on the Hudson Pier. The show was staged against the backdrop of 1 World Trade Center, and included a performance by artist Marina Abramović and a moving rendition of "Ave Maria," September 11, 2015.

personal life on hold, long hours, little sleep, skipping meals, schlepping all over town, and inevitably, frayed nerves and blistered feet. "I was eight months pregnant for Francisco Costa's first season designing for Calvin Klein," remembers former AP reporter Samantha Critchell. "I asked if I could go in early and sit in the venue, back when it was the tiny space at Milk Studios, and the only person in there other than the photographers setting up was Calvin. He stayed by the photo pit to watch the show."

Through Storms

When designers decided to shift their shows ahead of the Europeans, they moved them into September and February, prime hurricane and winter snowstorm months, respectively, in New York City.

In September 1999, just the second season after America's schedule change, Fashion Week coincided with Hurricane Floyd, a powerful storm that struck the East Coast and led to more than fifty fatalities.

The weather became so bad that 7th on Sixth canceled its shows on September 16, 1999, but not before Bill Blass could have his swan song at the Bryant Park tents. A gentleman designer who had the power "to charm the clothes onto" a woman's back, as the *New York Times* put it,[106] he made sportswear elegant over his sixty years in business, mingling with the society set he dressed, including socialites Pat Buckley, Happy Rockefeller, Nan Kempner, Nancy Kissinger, and Brooke Astor. It was to be the seventy-seven-year-old designer's official farewell, but on the morning of his show, hurricane-force winds were raging, rain was pounding, and the New York City public schools had been closed.

Fern Mallis, then executive director of the CFDA, recalls the show fondly, at least now. "Bill's loyal clients were all there dressed to nines, umbrellas blowing to kingdom come, heading up those stairs to Bryant Park," she says. "There was no way we were not going to get water in those tents. When they leak and the spotlights are on, every drop is magnified. We were in the control room, it was late, Bill was pacing with

his cigarette, waiting for more people to keep coming in, and finally, he said, 'You know what, I've done it, let's cancel.' "

But Mallis wasn't having it. "I said, 'Hold on, please!' I didn't want to let him leave without having this special moment. I made an announcement, saying that the show would go on. And it was worth it. When it started, the music was Lerner and Loewe, everything was red, white, and blue; it was spectacular. There was a standing ovation, and there wasn't a dry eye in the house. It was such an emotionally beautiful moment."

Everyone forgot about the leaks in the tent as they watched Blass's easygoing American glamour parade down the runway—cropped sweaters over floral beaded skirts or sequin pants, loose jackets with soft hoods, and dresses trailing asymmetrical ruffles.

The Jill Stuart collection was shown that morning as well, but then 7th on Sixth canceled the rest of the shows for the day, for fear of what the gale-force winds could do to the tents.

Downtown, however, the off-site shows continued, and the fashion crowd soldiered on, trading their stilettos for rain boots. Helmut Lang presented his collection at his store on Greene Street, despite the fact that the floor just past the front door had to be mopped up continuously because water was blowing in. And that night, when the storm was at its worst, Alexander McQueen showed on a West Side pier—that's right, a pier in a hurricane. "They had closed down all of the West Side Highway," remembers show producer Julie Mannion. "But through connections in the mayor's office, we were able to get the highway reopened an hour before our show."

Ironically, the show's set included a water effect—models splish-splashing through a wading pool that had been installed just for the occasion. "How many Manolos were ruined?" jokes former *Palm Beach Daily News* reporter Robert Janjigian.

For the finale, a bed of three-foot nails mechanically rose from the water, and ghostly-looking aerialists soared and danced over the terrifying spikes. "[The pier] is not a place you

Opposite: New York Fashion Week models and attendees brave the harsh weather conditions. Clockwise from top left: Fall 2017 season, February 2017; Outside the Imitation of Christ Spring 2005 show, September 2004; A model departs the Proenza Schouler Spring 2009 show on her bike, September 2008; Crowds leave the main tent on Sixth Avenue as Hurricane Floyd hits the city during the Spring 2000 season, September 1999; Fall 2017 season, February 2017.

want to go when the hurricane is coming; it was at night, you could hear the wind howling," remembers *Flaunt* magazine editor Long Nguyen. "There was no Uber yet, and there were very few cabs because people had gone home and locked themselves in." But the seats were full; everyone showed up. For his part, McQueen was so happy the show had gone off he dropped trou during his runway bow, showing the audience his stars-and-stripes boxer shorts.

February snowstorms have also wreaked havoc. "One season, we had twenty-two inches of snow at the Park Avenue Armory. Because of the weight loads, they said if we didn't get a scaffolding system up by 6 p.m., we [would] have to shut down the Tommy Hilfiger show," says Mannion. "We had to find one, track it down, and get it in up a matter of hours."

In February 2013, a blizzard dumped eleven inches of snow on the tents at Lincoln Center. "Before the *Project Runway* show, I sat in that upstairs lounge with Zac Posen and Michael Kors as they were making fun of all the fashionistas in their

heels in the storm!" says Critchell. "It was so fun. Michael said he had worn Uggs that day—and joked that he looked like Pam Anderson."

"I will never forget the cold of February 2015, when it was so frigid that we had to stop at a diner for a hot toddy just to walk three blocks from one show to another in Chelsea," says Binkley. "It was so cold and icy that season that even the bloggers were bundling up."

When the Shows Stopped
The one time in history that New York Fashion Week stopped was on September 11, 2001. Following the attacks on the World Trade Center and the Pentagon, the shows, already in progress, were canceled in their entirety.

The night before had been one of American fashion's highest moments. Marc Jacobs presented his collection on the Hudson Pier, a runway spectacle with a cast of front-row characters that included Donald Trump, Monica Lewinsky,

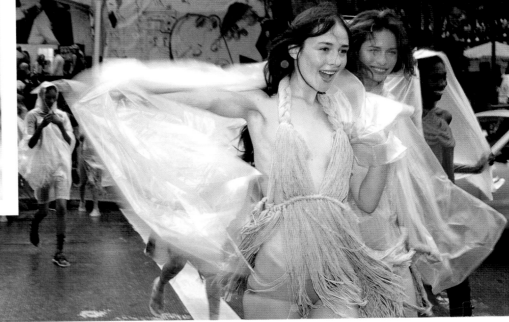

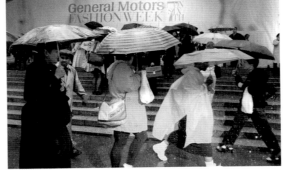

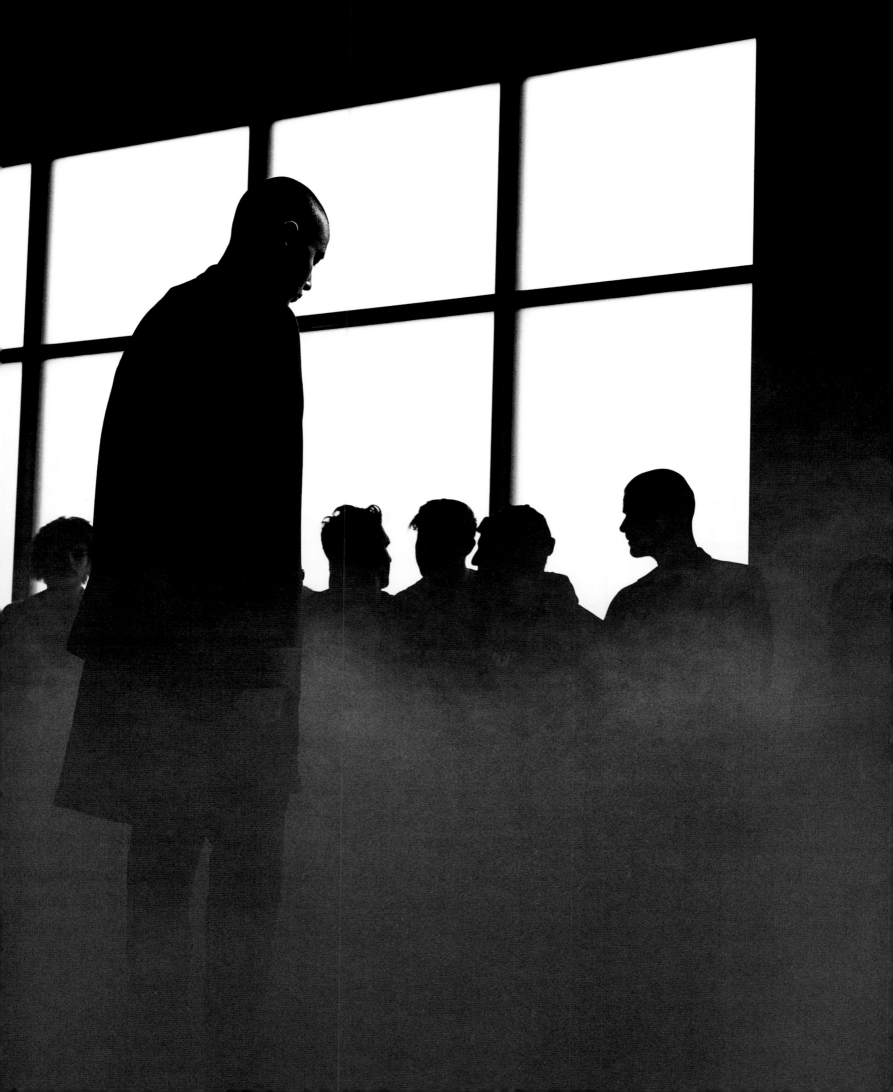

Hilary Swank, and Lisa Marie Presley. "That was when Marc Jacobs shows started an hour or more late, but it didn't matter because that was *the* place to be, and there was endless great people-watching to be done," remembers *Wall Street Journal* off duty fashion director Meenal Mistry. "The collection of shrunken band-leader jackets and denim made every model look like the coolest girl downtown. Marc came out to take his bow and then as he waved one arm, the runway backdrop slid aside to reveal a sea of white lanterns, inviting everyone there to the party for his first fragrance. It was one of those magical nights where everyone seemed to be having fun. It had rained so hard that day, but by then, it was crystal clear and you could see all the way downtown to those looming Twin Towers." It's an image that's stuck with the thousand or so attendees to this day. "Who knew what was coming?" says the *Washington Post*'s fashion editor Robin Givhan. The next morning at 9 a.m. at the Bryant Park tents, designer Liz Lange was set to stage her first runway show ever. It was to be the high point in the trajectory for her brand, founded in 1998 with the goal of making maternity wear fashionable.

"I wanted maternity clothing to be treated like other clothing in every way and not segregated to the baby aisle," Lange says. "I had the date, September 11, circled on my calendar, and I had been working toward it for so long. A New York Fashion Week show meant you had arrived; for someone who cares about fashion there could be no greater stamp of approval." She was also planning on unveiling an exciting new licensing project during the final act of her show, the Liz Lange for Nike line of maternity athletic wear.

Lange had spent a lot of time securing pregnant models, Nike executives had flown in, and the tennis player Mary Jo Fernández was going to lead that part of the show. Because it was maternity wear, and there was new public fascination with celebrity baby bumps and pregnancy style, there was a lot of media interest, including from CNN, *Today*, and *Good Morning America*. It was mayhem that morning at the tents, with Billy Baldwin, Chynna Phillips, Ali Wentworth, Marina Rust, Aerin Lauder, and more turning out for the show. The music started, and the models began to march. Then, ten minutes in, Lange, who was watching backstage, noticed the

cameramen had started bolting for the doors. She didn't know what she'd done wrong.

"I'm yelling at my publicist, 'What the hell is going on?' I was hysterical because it was hundreds of thousands of dollars down the drain. People started whispering that a small plane hit the World Trade Center, but my head was in my show. I was confused and angry," says Lange. "It wasn't until I walked outside that I started to understand a world-changing event had taken place."

"Word started to trickle through the front row about the attacks on the World Trade Center—all by word of mouth," says Critchell. "By the time the show was over . . . everyone walked out in silence."

"It was the first season of the shows after IMG bought us, so pressure was on to prove we were going to protect the franchise," says Fern Mallis. "When I got to the tents, designer Douglas Hannant was setting up, Oscar de la Renta's group was at his venue. . . . I remember standing on a chair, and I said, 'Please stop, there's been a terrorist attack on New York City, the World Trade Center has been hit, please go home and be with your loved ones.' "

There were rumors of attacks on Grand Central Terminal and in Times Square, just blocks away from Bryant Park, which is in a high-traffic, vulnerable area of the city. "I was on the phone, trying to get a press release out, and a security guard found an American flag and hung it up immediately," Mallis says. The seventy-three remaining shows of New York Fashion Week were scrapped. The world had changed, and no one was sure how, or if, fashion would even have a place in it anymore. Many of the journalists who had been in town to cover the collections took off their stilettos and put on their sneakers. There was a story to report at Ground Zero.

"The night before September 11, a colleague and I sipped wine and dined at a long Romanesque table setting at a lavish party hosted by designer Marc Jacobs, attended by Hilary Swank, Christy Turlington, and Debbie Harry," said Michael Quintanilla, then a fashion reporter at the *Los Angeles Times*.

"Hours later, we wandered the city on foot, headed for the World Trade Center. I stopped people in the street, their faces, hands, clothes coated in dust, concrete bits in their hair. I slipped into hospital emergency rooms and witnessed other survivors inhaling oxygen from tanks. . . . By midnight, we were on Church Street, amid the ruin. Soon, I was in front of a vast spiked section of one of the towers. It plowed into the ground, but looked like sculpture emerging from an angry Earth."[107]

In the following weeks, the bigger-name designers who had the resources, such as Ralph Lauren and Donna Karan, showed their collections in intimate presentations, opening up their studios to a small selection of press and buyers. Business had to go on. But up-and-coming designers were already stretched financially, especially after paying for shows that never happened. They faced a grim reality: With the economic uncertainty after the attacks, their fledgling labels were unlikely to survive.

So on September 21, 2001, in the Carolina Herrera showroom, *Vogue* and Style.com arranged An American View, a group show for eleven of those labels—Rebecca Taylor, Peter Som, and Behnaz Sarafpour among them—with the models and hair and makeup artists donating their services. It was the first time the industry had come together to support new talent, and it became a forerunner for similar efforts coordinated by the CFDA to support young designers in future years, including the annual CFDA/*Vogue* Fashion Fund Award under the leadership of Anna Wintour.

"I'm a great believer in new talent, and there were all these designers who had worked really hard on their collections and then this terrible thing happened to us and they had no place to go," says Herrera. "So I offered my showroom because I had the space and wanted to help them show somewhere where they didn't have to pay or reorganize anything."

The next season, in February 2002, Mayor Michael Bloomberg cut the ribbon to kick off New York Fashion Week at Bryant Park as a way of both honoring those who were lost in the terrorist attacks and helping the industry to move forward. Flags dotting the park were decorated with a drawing of a woman in red, striking a Lady Liberty pose. That season, some designers staged smaller, more intimate presentations, cutting back their guest lists; many touched on patriotic themes. Ralph Lauren and Calvin Klein showed all-black collections.

Over the years, designers and fashion show attendees struggled with how to commemorate the anniversary when fashion and tragedy continue to intersect on the September 11 date. On the tenth anniversary, Diane von Furstenberg handed out tiny American flags at her show, and on September 11, 2015, Paris-based designer Riccardo Tisci staged a particularly moving tribute when he brought his Givenchy show to the Hudson Pier, with Kim Kardashian, Kanye West, Nicki Minaj, Ciara, Julia Roberts, and many more stars in the seats. Against the backdrop of the new 1 World Trade Center, he showed a collection in black and white. The set, designed by Marina Abramović, was made of recycled wood and aluminum, and the show featured performance artists moving in slow motion and doused by ritualistic water, with meditative chants from multiple cultures and religions echoed in the background. The finale was set to the strains of "Ave Maria" as the Tribute in Light beams stretched into the skyline commemorating where the Twin Towers once stood.

On September 11, 2016, the CFDA blocked out the 9 a.m. time slot on the Fashion Calendar to mark the fifteenth anniversary of the attacks and made a $15,000 donation to the National September 11 Memorial & Museum. In commemoration of the anniversary, at the Victoria Beckham show, the city's moments of silence at 9:59 a.m. and 10:28 a.m. were observed, roughly marking the times each of the towers collapsed. Timo Weiland's presentation at 11 a.m. had first responders in attendance and started with a saxophone tribute to 9/11.

CFDA chairwoman Diane von Furstenberg wrote in an email to CFDA members at the time, "We lived it, saw it, smelled it, and refused to be defeated. We are not victims. We build a better building, an entire neighborhood. We are proud, but we do not forget. Living fully is the only way to honor those who perished on that terrible day fifteen years ago."

Opposite: Givenchy Spring 2016 show, September 11, 2015.

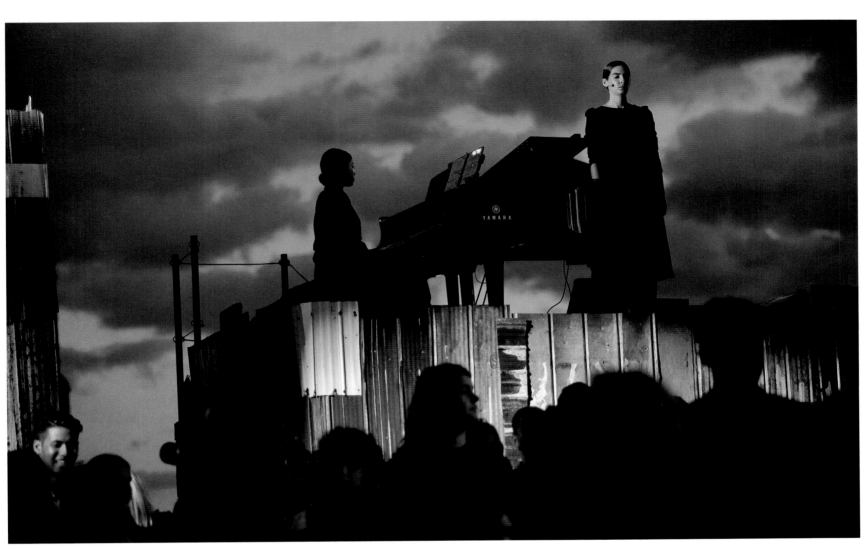

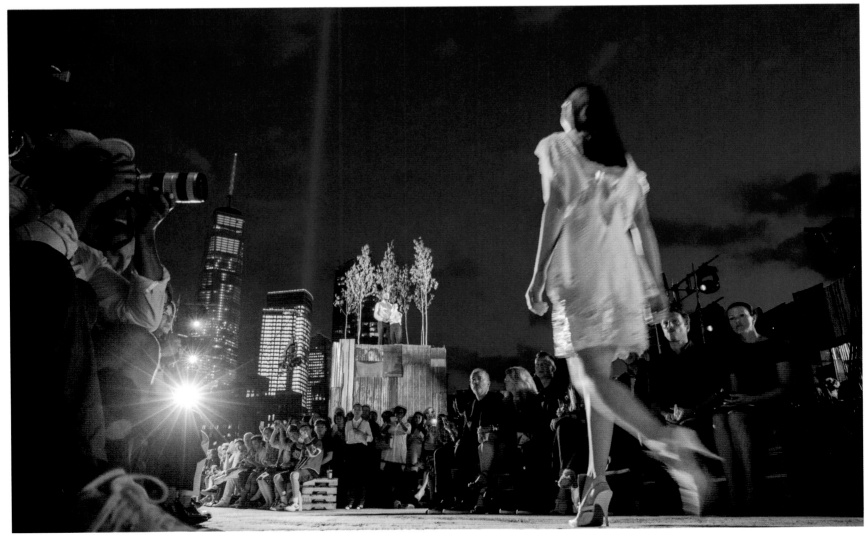

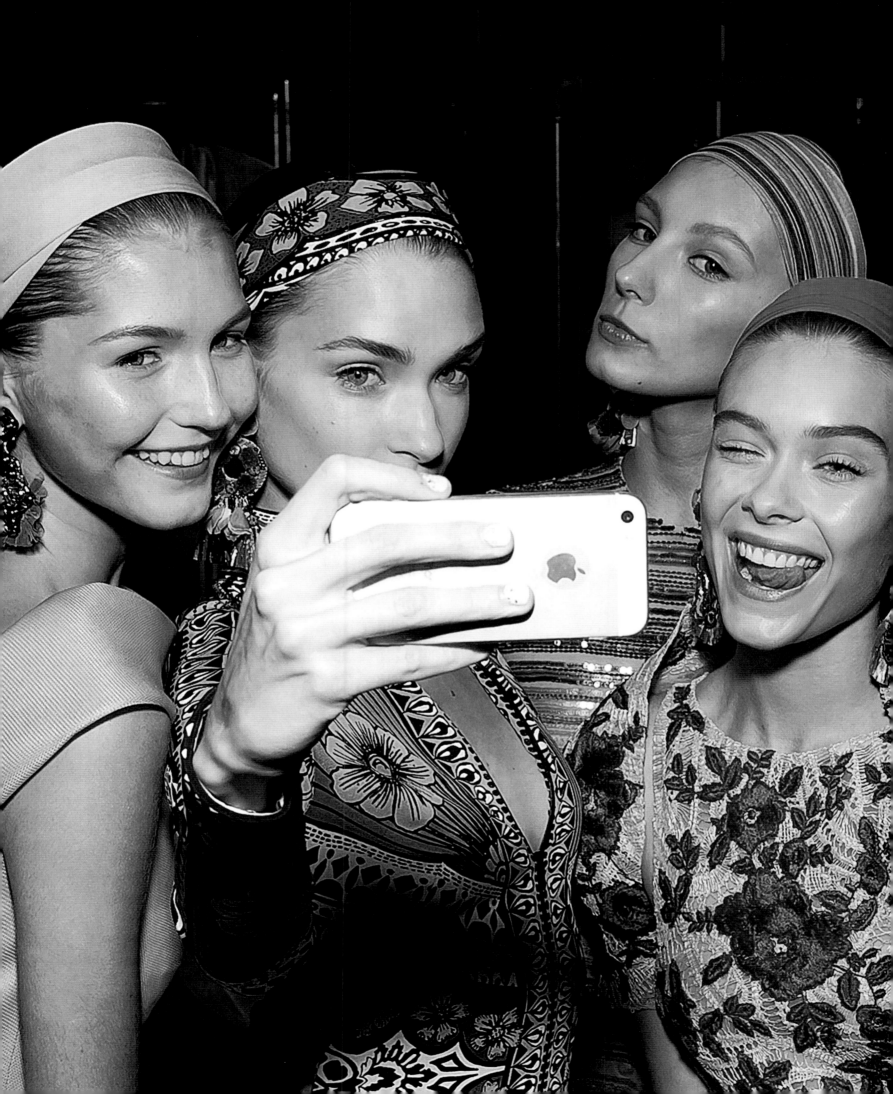

11

GETTING SOCIAL

If the rise of youth culture, globalism, and celebrity were a few of the defining factors in shaping the runways at New York Fashion Week during the first millennium, the digital revolution has been the most powerful force for change in recent years, as the rise of online and social media have democratized fashion and made the shows a participatory sport. In 2000, Condé Nast launched Style.com as an online site for *Vogue* and *W* magazines, as well as Internet-only material including entire runway collections. The site brought the runway to people's fingertips and let them click through every single look within twenty-four hours of a designer showing it. About the same time, designers themselves started webcasting their shows live, giving the world a front-row seat to what once was the purview of industry insiders.

But it wasn't until the advent of social media that we truly saw the birth of the armchair fashion critic. As recently as 2008, camera phones in the front row of fashion shows were still relatively rare. But now, many in the audience watch through their phone screens and post real-time coverage on Twitter, Facebook, Periscope, Instagram, Tumblr, Snapchat, and other social-media platforms.

The coverage is not only encouraged by designers, who also post on their own social-media channels, sometimes it's paid for; a whole new class of digital tastemakers has emerged, and they are celebrities in their own right, curating the runway for their followers who watch alongside them engaging, sharing, and commenting as the experience unfolds.

"When Instagram came out, I remember every editor was on it, with the snap of a finger," says Eva Chen, former *Lucky* magazine editor and now director of fashion partnerships for Instagram. "Designers understood how to use it, too. All of a sudden, you could make people feel like they were at the shows with you." The rise of online and social media at New York Fashion Week has made the runway even more accessible, popular, and immediate "for everyone from six-year-olds to sixty-year-olds," says Chen. But it's also disrupted the way the industry does business, changing the way fashion is delivered and consumed.

Street-Style Stars and Snaps

Up until the early 2000s, the only photographs of the runway that mattered were head-to-toe shots of models walking in the clothes. Now, it's not only professional photographers documenting the experience, it's every single person in the audience, too. And the action isn't limited to the runway; it's backstage and out front, too, where hundreds of street-style photographers look for that unscripted moment.

Street-style photography has a long history, from Robert Frank's portraits of ordinary Americans to Jacques-Henri Lartigue capturing fashionable French women at the end of the twentieth century. In New York, beginning in the 1970s, Bill Cunningham of the *New York Times* was the genre's most visible practitioner. Though Fashion Week was by no means his only inspiration, for his "On the Street" columns, he did capture on film well-dressed guests climbing the staircase to the shows at Bryant Park. Eventually, he had company. By

Opposite: Models take a selfie after the Naeem Khan Spring 2016 show, September 2015.

2005, digital cameras had become mainstream consumer devices, and with them came the rise of amateur street-style photo bloggers such as *The Sartorialist*'s Scott Schuman, Garance Doré, and *Jak&Jil*'s Tommy Ton. Each of them lent their own vision to interpreting the street-style scene.

"What I liked in the beginning was shooting glamorous people going to work in a glamorous industry," says Doré, a fashion illustrator by trade who then started to shoot street-style photography outside of the shows and feature it on her blog in 2007. She was eventually embraced by designers and invited inside to sit in the front row. (Street-style photography became so well-respected in the industry that in 2012, she and Schuman received the prestigious CFDA Media Award.)

To differentiate his photographs from those of other style bloggers, Ton took more candid, documentary-style shots, often horizontals with his subject in motion. He focused on the details of the outfit (such as the detail of the heels, for example) rather than the whole ensemble. Street style "is a lot more accessible and relatable, and people tend to respond better to clothes put together [in a] way [different than] a designer or stylist does it. They can see themselves wearing it," says Ton, who has been shooting street style during Fashion Week since 2009.

"I try to go to every show I can. If the first show is Michael Kors at 10 a.m., I get there by at least 9:30, and I will keep shooting shows until the sun goes down because it's important for me to feel like I capture every important outfit," he says. That means taking 3,000 to 5,000 street-style photos in a day and editing them down to fifteen to twenty shots. What does he look for? "An example I like to use is [*Editorialist* co-founder] Kate Davidson Hudson; she has a very beautiful, glamorous Upper East Side look. One day, I saw her wearing a Supreme T-shirt with a bomber jacket. It's about documenting how people have changed the way they dress based on what's going on in the industry. That spoke to the influence of Demna Gvasalia and streetwear," Ton says.

These documentarians redefined the paths outside show venues, turning them into sidewalk runways for trickle-up trendsetting that's in some ways as influential as what designers show on the runway. When New York Fashion Week moved from Bryant Park to Lincoln Center in 2010, it opened the space up for more photographers and more posing. Before and after shows, the walkway to the tents from Columbus Avenue, as well as the Revson Fountain in the plaza square, was street-style central, with hundreds turning out dressed to impress. And inside, the venues were made for the digital age, with video walls to accommodate multimedia presentations and an updated registration system allowing for barcode ticketing and check-in.

The New Tastemakers

Alongside the rise of street-style photographers, a new class of bloggers and Instagram stars grew up around the runway shows. They didn't wait for anyone to discover or hire them; they created their own sites online, bridging the gap between fashion house and shopper. Bloggers covered the runway as the ultimate fanboys and fangirls, delivering commentary at break-neck speed to a global audience and on a more personalized level. Their approach turned the traditional industry media hierarchy on its head, and even influenced the designers themselves. In 2008, Marc Jacobs named a green ostrich handbag the BB, after the Filipino blogger Bryanboy, who is considered the godfather of fashion social influencers. Jacobs had seen a video Bryanboy made about him, and a post in which he raved about the bag in the designer's Fall 2008 runway show. Jacobs later sent him the runway sample, a gift the blogger called "the best thing that has ever happened to me." At every Marc Jacobs show since, Bryanboy has been seated in the front row.[108]

Tastemakers began arriving at New York Fashion Week from every corner of the world: from the United States, Tavi Gevinson, just twelve years old when she started *Style Rookie*, Leandra Medine of *Man Repeller*, and Rumi Neely of *Fashion-Toast*; from Italy, Chiara Ferragni of *The Blonde Salad*; from Britain Susie Lau of *Style Bubble*; from Sweden, Elin Kling of *Style by Kling* (now designer of the brand Toteme NYC); Hanneli Mustaparta of *Hanneli* from Norway; and Gala Gonzalez of *Amlul* from Spain. These influencers were invited and sometimes paid to come to the shows and be dressed by

Opposite, from top, left to right: Garance Dore, 2015; Leandra Medine (second from left) and Bergdorf Goodman fashion director Linda Fargo at the Sally LaPointe Fall 2014 show, February 2014 (top); Rumi Neely at the Yigal Azrouel Fall 2014 show, February 2014 (bottom); Bryanboy and Neely outside the 3.1 Phillip Lim Fall 2015 show, February 2015; Steven Kolb (left) and photographer Bill Cunningham at the Carolina Herrera Fall 2013 show, February 2013; Eva Chen outside the Proenza Schouler Fall 2017 show, February 2017 (top); Tommy Ton with Anna Dello Russo and Giovanna Battaglia, September 2013 (bottom left); *The Sartorialist*'s Scott Schuman (bottom right); Tavi Gevinson arrives at the Coach Fall 2017 show, February 2017; Backstage at the Brandon Maxwell Spring 2016 show, September 2015.

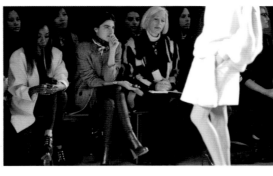

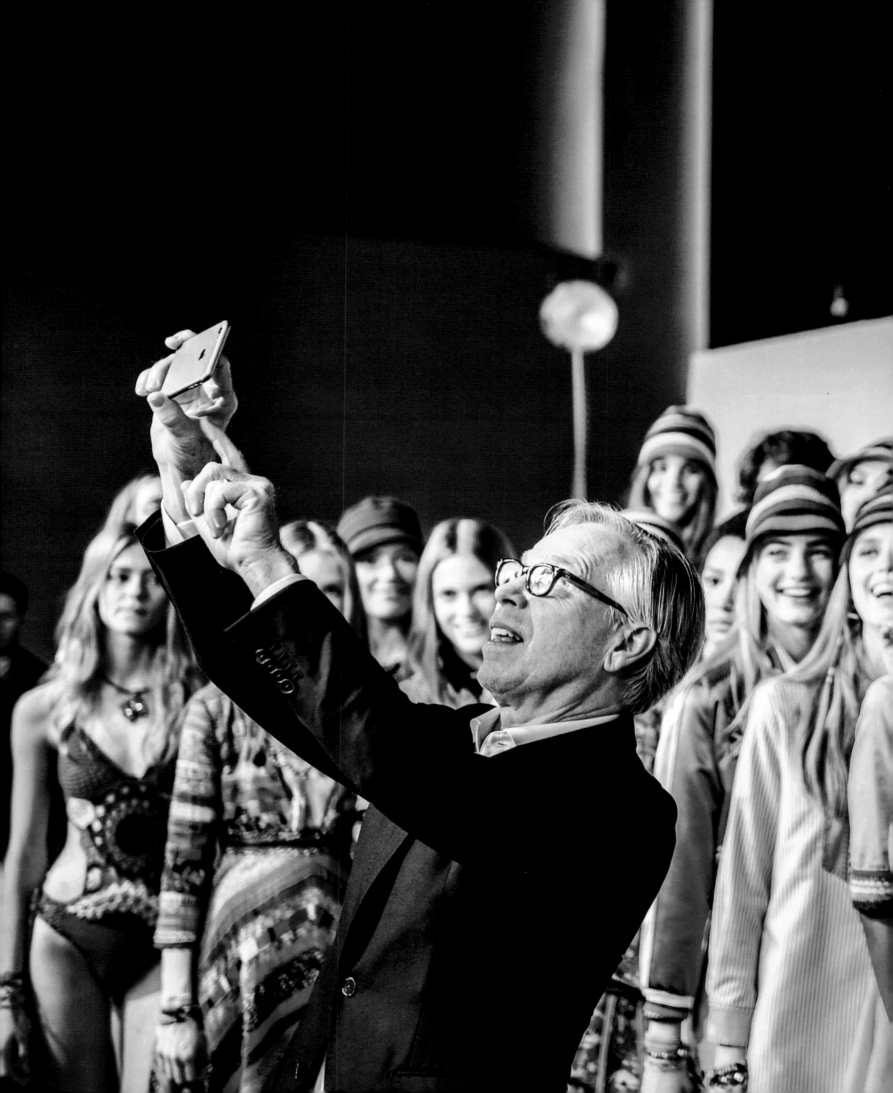

designers for optimal photo ops on the sidewalk runway outside. They were playing multiple roles, as model, stylist, critic, and publisher of their site—a one-person walking, talking fashion magazine.

It wasn't long before blogging became its own seven-figure industry with top talents raking in money from affiliate deals, appearance fees, modeling gigs, and design collaborations.[109] In 2009, Coach enlisted several bloggers to design handbags, including Mustaparta and Emily Schuman of *Cupcakes & Cashmere*; in 2011, *Bag Snob*'s Tina Craig designed handbags for DKNY; in 2012, Doré was tapped to design a capsule for Kate Spade using her illustrations while Bryanboy and several others marked the launch of the Galaxy Note smartphone tablet during New York Fashion Week; and in 2014, Medine helped launch #MyCalvins on Instagram. Some bloggers have also become brands themselves: In 2015, Ferragni launched her own eponymous footwear collection, putting herself in the same category of the designers whose runway shows she attends, and in 2017, Neely created her own collection of slinky, undone clothing, Are You Am I.

With the rise in popularity of Instagram around 2012, digital influencers began to focus as much on posting to that site as to their own blogs, sometimes charging designers per post. Social media followings became the new metric in the fashion industry, determining who sat in the front row and what models were booked on the runways.

"Seeing Aimee Song of *Song of Style* wearing a boho top walking down the street tickles your fashion fancy in a different way than seeing a fashion magazine shoot styled by [well-known fashion editors] Tonne Goodman or Grace Coddington," says Instagram's Chen.

YouTube star and blogger Chriselle Lim of *The Chriselle Factor* went to New York Fashion Week for the first time in 2010. "I was not getting paid or doing any sponsorships; I just had a silent curiosity and motivation," she says. "It was difficult to get into shows. The only brands back then that invited bloggers were BCBG and Herve Leger, so I went to those two shows and got dressed by the brands. It was really motivating

to see the majority of people sitting front row and attending from traditional media. I was familiar with them, but no one knew me. I saw an opportunity to rise, and I made it a goal to get into more shows. It took me two to three years."

Now, Lim travels with a team of three to four people to New York Fashion Week, including an in-house photographer, videographer, and an assistant to manage the schedule and operations. She'll often change clothes several times a day to make sure she has different outfits to post online and to represent the designers whose shows she's attending.

"Content is one of the biggest goals, because a lot of my followers are engaged online during that week, seeing what I'm wearing, where I'm going, what I'm doing. We dish it out within a twenty-four-hour time frame. We hire a driver and a big car, and we're pushing out content constantly," she says. "For me, the goal is to support designers who are advertising or who are personal friends. Prabal Gurung is a good friend, and we've never had any monetary deal. I believe in his work, so that's a show I will never miss."

Lim sees her greatest asset being her relationships both with designers and her followers. "We as digital influencers have immediate access not just to incredible people but also personal relationships with our followers. They relate to my personal taste. When I'm talking about a runway collection, or something I love, it's helping my followers navigate how to shop. Instead of going to a website that has all the runway collections, I'm curating for them on whatever platform I'm on."

Bloggers, who have become style celebrities in their own way, and the street-style photographers who chase them, have become such a fixture outside of the shows that they sometimes make the sidewalks feel like an obstacle course where you have to avoid scurrying cameras and peacocking posers. The see-and-be-seen atmosphere has faced its fair share of critics, and it reached a boiling point in September 2016, when several *Vogue* editors weighed in on the scene in an online write-up that ignited an industry debate with shades of old versus new media: "Please stop. Find another business. You are heralding the death of style," wrote one. "The profes-

sional blogger bit, with the added aggression of the street photographer swarm who attend them, is horrible, but most of all, pathetic for these girls, when you watch how many times the desperate troll up and down outside shows, in traffic, risking accidents even, in hopes of being snapped," another chimed in. Meanwhile, *Vogue* Runway's director, Nicole Phelps, pointed out how many bloggers borrowed clothes from brands. "It's not just sad," she explained, "it's distressing."[110] Bryanboy fired back a response: "Why would they knock a certain subset of people who found an alternative platform to make a livelihood doing something essentially similar? It really feels like flat-out bullying!"[111]

During the shows, editors and influencers use digital platforms such as Snapchat, Facebook Live, and Instagram Live to take their followers along with them in real time as the models walk the runway. The rush to capture live what's happening means many people are actually watching the shows through their phones, rather than experiencing them, to the irritation of some in the industry.

"If you would never go out on a date with someone who is on their phone all the time, then why, when someone is putting $1 million of their life on the line, are you distracted [at shows]?" asks model-casting director James Scully. "Someone builds a million-dollar set and all anyone cares about is taking pictures of it rather than enjoying the context and theater? It's taken some of the joy and emotion out of fashion."

The New Media

At the same time, online publishers have also changed the dynamics of the runway. In the 2000s, online-only fashion magazines and news sites such as Style.com, Who What Wear, Fashionista, Refinery29, and Business of Fashion started to challenge the age-old supremacy of print glossies and newspapers and the hierarchy of editors-in-chief and critics, changing the look and feel of the front row.

Hillary Kerr, a former *Elle* magazine editor who cofounded the popular fashion site Who What Wear with Katherine Power in 2006, started going to New York Fashion Week in 2007. "People were quite kind to us from the get-go, I think because we had a stamp of approval coming from an *Elle* background," she says. "Because our site was dedicated to fashion and shopping and not about our own outfits or ourselves, we were just seen as a new form of media."

"I remember getting invited to the Oscar de la Renta show and feeling like I'd made it. I started to tear up in my seat. I was in the third or fourth row, but I was there, and I had made my seat. I kept thinking of it that way; my seat didn't exist before we started the site. There was no history or longstanding brand. I remember sitting next to Britt [Aboutaleb], who was the editor-in-chief of Fashionista at the time, and thinking 'we're in the digital ghetto but we're here.' It felt like magic to be in that room and look at those clothes and be a part of that history. It felt like something had shifted."

The new media transformed the way runway shows were covered. Within one day of a runway show finale, Who What Wear reports on the best looks and key trends, with links to the designer's website. "It was the immediacy," Kerr says. "The magazines we loved wouldn't cover a show for three or four months. We were pulling back the curtain a bit. The fashion world as a whole had always been so exclusive, and we were giving people an elevated peek into what it was like. And at the time that felt fresh."

Designers Go Digital

Of course, designers don't have to rely on third parties to carry their message for the season to the public; they can speak to them directly on their online and social-media channels, too, which has made the runway a key source of brand content, from who wears the clothes in the front row to what models are walking the runway (large social followings put a premium on talent) to what the runway looks like and the scene going on backstage. Digital pioneer Tory Burch started selling online the same year she launched her brand, in 2004, and in 2009, she launched her online magazine *Tory Daily* not only to celebrate her own style, but also other stylish people, places, and things. "We launched with e-commerce, which, at the time, was unusual (many people told me that no one would buy online)—but we wanted to connect directly with our customers from day one," says Burch. "We also hired

Opposite, clockwise from top left: **Who What Wear cofounder Hillary Kerr, September 2015; Bryanboy, Tina Craig, Irene Kim, Aimee Song, and Chriselle Lim outside the 3.1 Phillip Lim Fall 2017 show, February 2017; Michelle Harper outside the Givenchy Spring 2016 show, September 2015; Bryanboy outside the Tommy Hilfiger Fall 2016 show, February 2016; Leandra Medine outside the Calvin Klein Spring 2014 show, September 2013; Chriselle Lim outside the Coach Spring 2017 show, September 2016.**

Honor Brodie, a former editor at *InStyle*, to create an online magazine—and to infuse our site and social-media channels with an editorial point of view and original content."

For designers, the runway is a stage for storytelling, and the web and social media an endless repository for spinning off different chapters. One of Burch's favorite runway shows was for Spring 2014. "It was inspired by Romy Schneider's character in *La Piscine* and the easy elegance of the French Riviera in the late sixties. I love how we extended that concept to our set—our runway resembled a pool lined with incredible cypress trees—and there was beautiful natural light streaming through the windows." To coincide with her shows, Burch features multiple pieces of content on her blog, Snapchat, and Instagram; she shares her runway playlist, day-of-show diary, and after-show lunch menu; there are step-by-step guides to the runway beauty and hair looks, features on exclusive runway accessories, and downloadable wallpaper designs.

"Fashion for so long was this behind-the-curtain *Wizard of Oz* experience where you didn't know what was happening, and clothes would just kind of show up in stores," says Chen. "Instagram has empowered designers to show some of the process."

Michael Kors also sees his website and social channels working hand in hand with his runway show to reach not only the front row but the end consumer around the world.

"I started my career being on the road, doing a million trunk shows and personal appearances everywhere from Toledo, Ohio, to Jacksonville, Florida," says Kors. "I loved the interaction and was always amazed how vocal and upfront the customer would be. . . . When I'm in a dressing room with a stranger, and they are telling me, 'I need a jacket but I want to show my waist, or I want a color that's not a color.' As my business grew and as American fashion became global, it became impossible for me to go to Dubai, Sydney, and Tokyo, and I had the a-ha moment when I realized, 'If we handle social media properly, and bring the customer into the fashion show, it's like a global trunk show.' And that's how we've approached it from the beginning. People get very excited, and they don't

even have to live in a large city. They can live in Saskatchewan, and they are still part of the fashion story and part of a voice; there is a conversation back and forth. It's just like me in the fitting room."

When Rebecca Minkoff launched her business as an accessories collection in 2005, she focused immediately on using the Internet as a tool to talk directly to customers, reserving an hour each day to answer their emails. "Technology is what allowed us to be," she says. "Prior to the Internet, there were a few editors and buyers who determined your future, and if you were in with them, great. And I didn't come up that route. I came up the route of the people, because the customer embraced me, and I can have a direct connection to her; that's why we're here."

For her first runway show in 2010, she used digital influencer Rumi Neely of the blog *Fashion Toast* as a model. "I remember people said, 'Ew, why are you using a blogger in your show? That's disgusting, it's so C-list.' We definitely got heat for it," Minkoff says.

But the strategy proved to be so successful, it set a new standard. And when Minkoff staged her Spring 2017 show in Los Angeles, she had nine influencers walking the runway. "They were broadcasting to their followers at least a couple of times, and all of a sudden, you're capturing twenty million followers' attention, which translates into something like $120 billion of press."

Another pioneer in using the power of digital innovation on the runway is Tommy Hilfiger. The toughest ticket at his Fall 2016 show was a seat in the "InstaPit." A New York Fashion Week first, it was a separate influencer-only section, located on risers of the Park Avenue Armory for maximum visibility. "There was a realization that influencers have a larger media following than some of the more respected and well-known media," Tommy Hilfiger chief brand manager Avery Baker says of the InstaPit. It wasn't the first time the designer had deployed unique digital strategies at his shows (in previous seasons, he'd engaged models and influencers to use a backstage Vine Booth and share selfies using Twitter Halo and Twitter Mirror), and it wouldn't be the last.[112]

Opposite, clockwise from top left: Tory Burch Spring 2014 show, September 2013; Model Romee Strijd backstage at the Jeremy Scott Fall 2016 show, February 2016; Model Coco Rocha at the Rebecca Minkoff Spring 2017 show at The Grove in Los Angeles, September 2016; Models take selfies backstage at Kenneth Cole Fall 2013 show, February 2013. Following spread: Alexander Wang Fall 2017 show, February 2017.

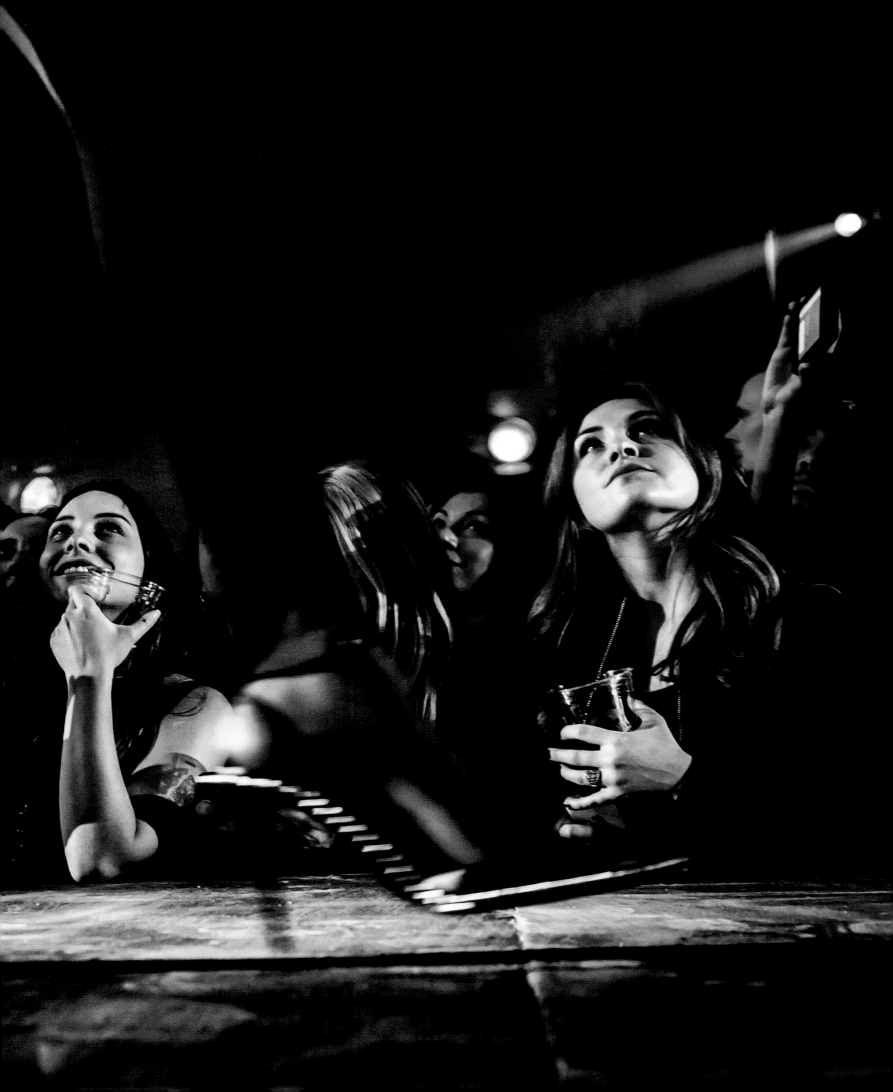

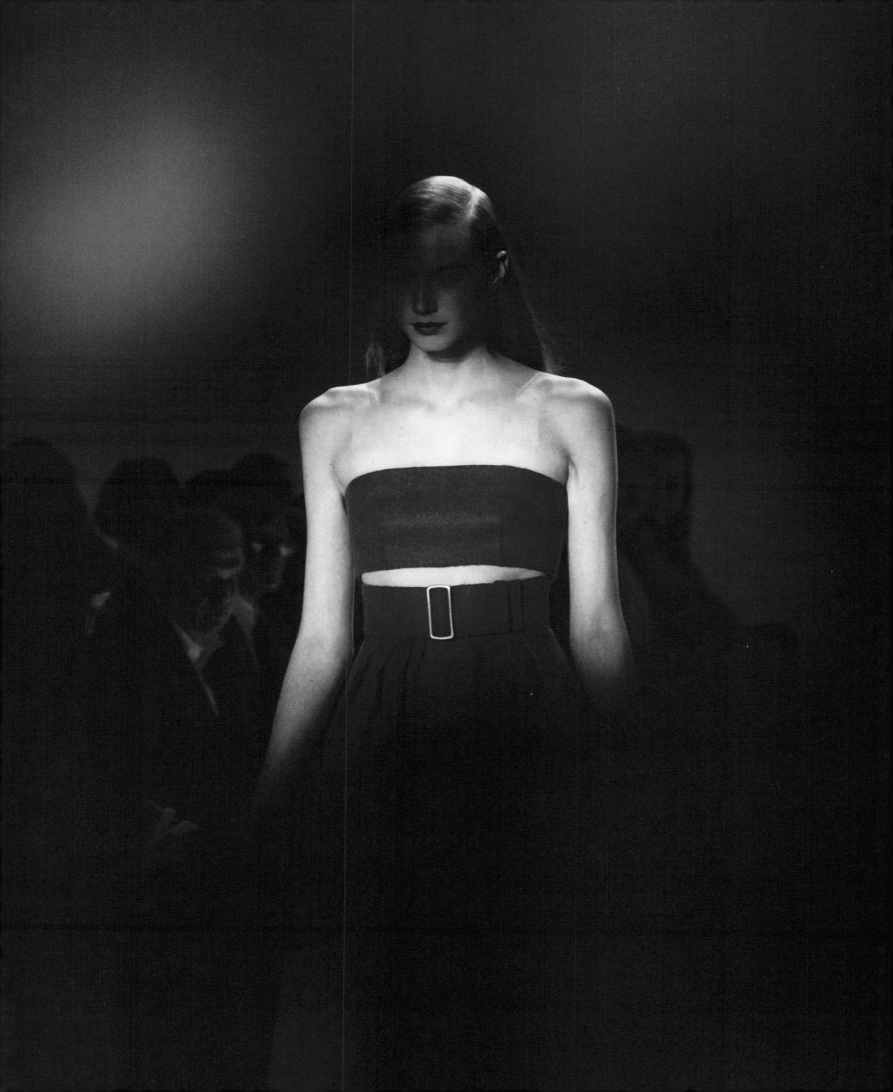

12

THE FUTURE OF THE RUNWAY

The original objective of Eleanor Lambert's first Press Week in 1943 was to make noise for American fashion. But now there's so much noise, even Lambert's grandson Moses Berkson admits that his grandmother might likely find it all "a bit vulgar." "She kind of turned up her nose at the shows in later years, almost like, 'What have I created?' " he says of Lambert, who died in 2003. "She was into sophistication, and she thought it should be taken seriously. When it became more about celebrity and spectacle, it diverged a bit from her vision."

The exclusive, invitation-only Fashion Week that Lambert knew, and the one depicted in the book and film *The Devil Wears Prada,* is over. The Digital Age has made the runways more inclusive and democratic than ever before. Live webcasts of the shows and instantaneous social-media postings have given the public a front-row seat to the designer runways. But all of this connectivity and accessibility has also disrupted the traditional top-down structure of how fashion does business; this has made some question whether the model of Fashion Week is out of sync with the twenty-first century's high-speed culture and demand for instant gratification.

Consequently, the future of the runway is a topic that's dominated the fashion conversation for nearly a decade, as designers debate the pros and cons of so much exposure. During New York Fashion Week today, the public is inundated with images of clothing designs straight from the runway, months before the clothes themselves will land in stores,

which gives fast-fashion copyists a leg up. Consumers no longer have to wait for the designer collections; they can purchase a version of what they see on the runway from H&M or Zara before the original has even had a chance to make it into stores. And when the original does land in stores, sometimes consumers have already moved on.

Now, there's so much noise around the runway, it's about figuring out how to channel and leverage it for business success. Some designers have tested alternatives to traditional runway shows, pulling back from the spectacle and inviting fewer guests, in the hopes that bringing back exclusivity and anticipatory desire will drive sales, while others have pushed forward, staging ever-more-entertaining runway extravaganzas as a way of reaching consumers directly, and even inviting them to attend and shop in-season clothing as it comes down the runway. Some designers have even given the public literal access to front-row seats. In September 2015, Givenchy allowed people to enter an online lottery for seats at its Hudson Pier show, while Rag & Bone opened up its runway show to the public, offering free tickets via the Uber app. And some have pulled up stakes and decided to show collections elsewhere—in LA, Paris, and beyond.

In the middle of it all has been the CFDA, the governing body of American fashion, which has sought to reshape the calendar and fashion week events to better work for designers. To help chart the future of the runways, in 2016, the organization commissioned a Boston Consulting Group study "to talk

Opposite: Calvin Klein Fall 2013, February 2013.

to designers, editors, and buyers both international and American about the changing face of Fashion Week," says CFDA President and Chief Executive Officer Steven Kolb. "That's the irony about Fashion Week; it's an event our industry has twice a year, an industry that changes quite frequently in terms of trend and seasonal clothing, and yet the model of Fashion Week and what it is, and how we all work within Fashion Week hasn't changed. It's basically the same business model for decades, but everything around it has changed—the way it's covered, who attends it."

The study determined that "in-season relevancy" should be addressed on the runway. So, starting in September 2016, New York Fashion Week had twenty-three designers out of the hundred or so participating in the runway shows doing some version of showing and offering merchandise for sale at the same time. Other designers took their shows on the road to Los Angeles, for example, breaking out of the proverbial Fashion Week tent. Kolb says, "What we saw out of the study is it's not a one-size-fits-all approach."

Runway Shake-Up

Tom Ford is one designer who has never been afraid to experiment with his runway format. After twenty years at the helm of two of the biggest global luxury brands in the world, Gucci and Yves Saint Laurent, Ford wanted to start small when he launched his namesake women's collection at New York Fashion Week in 2010. Rather than staging a global media event, he held his show in his intimate Madison Avenue store and allowed only one photographer, his own.

Top editors sat in the front row watching one of the most star-studded runway casts in history (Beyoncé, Julianne Moore, Daphne Guinness, Lauren Hutton, and Rita Wilson), but they couldn't post a thing about it online. Ford embargoed all coverage until a few months later, to coincide with the seasonal magazine publishing schedule, and the time when the clothes would actually be in stores.

At the time, he believed that many women felt divorced from what the fashion world had become (in no small part thanks

to his showmanship and celebrity persona at Gucci)—a place that provided entertaining content to be blogged and tweeted about, but that wasn't necessarily a place to find something beautiful to wear. So he shifted his focus to what he called "personal luxury," with the customer in mind, not the media or even his show attendees. "I'm not an artist with an opening; this is not a film. I'm just trying to make pretty clothes. And beautiful clothes make beautiful women, but sometimes they don't make fashion news. I don't want to be pushed to think about what we have that's new when we don't need anything new except another version of what we did last year that still looks good to me."[113] It was a novel approach, but within a year, Ford was changing his tune. And he's changed it again since then, proving what may be the only knowable fact about the future of the runway—you have to keep 'em guessing.

"That's what fashion is about; it's all change," says Ford.[114]

Other designers, including Derek Lam, have followed Ford's lead, hosting smaller, more intimate presentations for long-lead editors with the intent of generating interest around a collection, but not releasing too much to customers before they can buy it. Some have questioned the usefulness and expense of mounting a live runway show altogether. In 2009, Marc Bouwer hosted the first virtual fashion show, and in 2015, Misha Nonoo held an "Insta-show," unspooling her entire collection on the photo-sharing platform.

Donna Karan, who left her namesake brand in 2015, doesn't show her new niche line of luxe, seasonless layers, Urban Zen, on the runway at all. "The shows have gotten so big that you don't really see the clothes; it's about the exhibition—a fantasy—and that's not what New York stands for. People put all this money into a runway show that's ego-gratifying, but it's not good business. Maybe it is if you want to sell fragrance, but not if you want to sell clothes. The runway has overshadowed the clothing and the customer, and fashion is a victim of its success."

Fernando Garcia—who with Laura Kim designs Monse and Oscar de la Renta, worn by the likes of Zoë Kravitz, Sarah Jessica Parker, and Selena Gomez—is still evaluating the usefulness of the runway in today's world. "Honestly, it's not completely necessary nowadays," he says. "You can tell what our brand is about through the girls who wear our clothes on the red carpet and on Instagram. You get so much more exposure and visibility throughout the year rather than a runway, which just happens twice a year."

"But there's something to be said for people in the industry—editors and buyers—seeing the clothes in real life," Kim adds. "I don't think you can dismiss it yet."

Bigger Is Better

Then there are those, Ford included in 2016, who have gone in the opposite direction, committing to the idea that the runway show has morphed into something bigger than the industry. These designers have taken the stance that the runway is for the online consumer, and they appealed to her by showing in-season merchandise that could be purchased right away.

"The fashion shows used to be such an elite situation, only for editors and very special buyers," Norma Kamali said in 2009, when she showed her first in-season collection at New York Fashion Week, available for purchase simultaneously online. "Then it opened up and became more of a celebrity-type event. Now there is no elite anymore. You don't have to be in the same country to see a runway show. Everybody can see it as soon as it's over, on the Internet."

This approach has become known as "see now, buy now," and some designers have invested big bucks into making their shows consumer friendly by turning them into multimedia experiences and upping the entertainment factor. In September 2016, two days after the premiere of his film *Nocturnal Animals* at the Venice Film Festival, designer-turned-film-director Ford used his moment in the spotlight to hold a premiere of another sort, his first see-now, buy-now show at New York Fashion Week.

Held in the glittery former Four Seasons Restaurant in midtown Manhattan, the event was produced to resemble

Opposite: Tom Ford shows his Spring 2011 collection at his Madison Avenue store, September 2010.

an awards show, complete with red carpet. He enlisted his Hollywood pals as his supporting cast—forty celebrities in all, wearing Tom Ford—including Tom Hanks, Rita Wilson, Neil Patrick Harris, Cindy Crawford, Zayn Malik, Jon Hamm, and Rita Ora. Seasoned Golden Globes director Louis Horvitz worked twenty-two cameras to film what was happening on and off the runway—from the models to reaction shots from the crowd—for a live stream at TomFord.com. To cap off the evening, Leon Bridges performed three songs. "It only makes sense that you spend millions of dollars promoting a collection when the things are actually in the store," Ford said at the time.[115] To make it so that anyone could buy something from the show—not just clothes like Ford's $12,450 blouson midi-dress—the designer also launched a special lipstick to coincide with the event, Lip Contour Duo Runway for $53.

For Ford, see-now, buy-now was not a success, so he abandoned it and returned to the regular show format in 2017. "The store-shipping schedule doesn't align with the fashion-show schedule," he said, noting that his Fall 2016 collection shipped in August but didn't show until September, so he lost a whole month of selling.[116] For Thakoon Panichgul, another early adopter, and one with a relatively small business, it wasn't enough to buoy sales and keep him from having to put his brand on pause. "We have recognized that the business model is ahead of the current retail environment," read a statement from the designer's backer, Bright Fame.[117]

But the format is working for some.

It's the Experience

Hilfiger has made see-now, buy-now the new cornerstone of his business. He first tried it in September 2016, leveraging his ability to harness the powers of celebrity and social media by hosting a fashion carnival on Pier 16 at South Street Seaport. At the event, he debuted a runway show featuring a collection designed in collaboration with Gigi Hadid, and it was live streamed on more than three hundred fashion and lifestyle sites and sold in real time. The show was presented to one thousand industry guests, including Hadid's friend

Taylor Swift, and one thousand members of the public. A Ferris wheel, popsicle carts, and booths where customers could buy the collection rounded out the 360-degree experience. The Tommy Pier was open to the public for free the following day, and Hadid was spotted taking selfies with the crowd. According to insiders, the extravaganza cost between $5 and $7 million.

The Tommy x Gigi event generated more than two billion impressions online (the previous season's show generated 984 million impressions), including Hadid's dozen Instagrams to her twenty-two million followers, which garnered up to three million likes each. There was a 900 percent increase in traffic to Tommy.com in the two days the carnival was open to the public, and a 154 percent increase in sales from September 9 to 12 year-over-year.[118]

The same season, Ralph Lauren closed down part of Madison Avenue to bring his show to the sidewalk in front of his store, closing the gap almost completely between runway and cash register. Though the front row may have been filled with stars (Julianne Moore, Jessica Alba, and Rosie Huntington-Whiteley), the focus was on the customer beyond the specially constructed tent. There was a letter from Ralph on every seat, which was also printed online, where the show was live streamed. "From the very beginning, I've always designed with you in mind. You are changing the way you live and the way you want to shop, and we are changing with you and for you," he wrote. When Lauren took his bow, he danced a little jig, and then, thumbs in the air, directed the crowd into his store for a Champagne reception and shopping.

"I see it like a multimedia extravaganza that touches social media, TV, live performance, music, fashion, and pop culture," says Hilfiger of the runway today. For him, his March 2017 show, held far from New York City on the Venice Pier, in Venice Beach, California, is the future. "I will always have a snapshot of Venice Beach and the fog rolling in, the lights on the runway, Gigi and Bella Hadid opening the show with Joan Smalls to a crowd of three-thousand-plus people

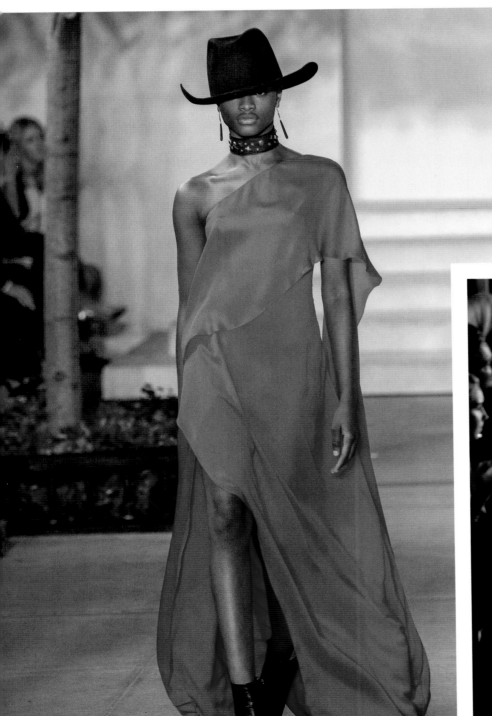

and incredible music from Fergie. It almost gives me chills to think about it; it was a moment we never saw before, a real breakthrough for who we are as a brand. We've established how to move into the future and bring the youthful audience with us."

"We believe strongly having the product for sale during the show or right after is more important than ever because of the need for immediate gratification," he says. "That changes the paradigm, and the runway has to be viewed through the lens of entertainment and experience."

Sales of Rebecca Minkoff's Spring 2017 collection were up 227 percent from the previous year following her in-season see now, buy now runway show in February 2017 at The Grove shopping mall in Los Angeles. "We know, for us, these shows are driving our customer to buy in a big way in all categories," she says. "We go into the show already knowing what editors have shot for magazines because they have seen it in private before; so instead of putting a bunch of stuff on the runway that you don't know if people are going to like, and you don't know is going to be bought, we're going in smarter.... [It] drives consumers to shop from you and not from the people who will knock you off."

Making a Difference

The popularity of fashion has also opened up opportunities for the industry to utilize the runway to make a difference. The CFDA has used New York Fashion Week as a platform for crowd-pleasing shows with corporate partners (Barbie's 50th Anniversary; 30 Years of Snoopy & Belle), as well as philanthropic causes. It's also used its membership to fundraise for various causes, including AIDS, which claimed the lives of so many fashion designers in the '80s and '90s, including Perry Ellis and Halston.

In 2007, the CFDA spearheaded a health initiative to address the global concern that models were unhealthily thin, partnering with doctors and nutritionists to create guidelines to educate the industry. The initiative has raised awareness around model casting, and designers showed their support by

not hiring models under the age of sixteen to walk in the shows, which has since become law.

The CFDA has also worked with model-turned-activist Bethann Hardison on increasing racial diversity on the runways and honored her with its top award, the Founder's Award in honor of Eleanor Lambert, at the 2014 CFDA Fashion Awards. In 2013, Hardison sent open letters to the governing bodies of Fashion Weeks in New York, London, Milan, and Paris "to put under one umbrella all of the designers who were guilty of only using one model of color or none consistently for three to four seasons. Because no matter the intension, the result is racism," she says. "That pushed back on casting directors, and they never said again 'no blacks, no ethnics.' Some may still not book as many as they could or should, but they never say it, and our industry has improved."

At the Fall 2017 New York Fashion Week shows, for the first time in history, every runway featured a model of color. Size, gender, and age diversity were also prevalent, with twenty-six plus-size models on nine runways and eight transgender or nonconforming models walking in the shows, out of nearly 2,500 runway appearances.[119] "Now our outreach is not just about health, but diversity as well," says Kolb. "It's a reminder of the power of fashion in terms of people's perceptions, which has become a big part of what we do."

Nurturing young designers is another cornerstone of the organization's work on the runway. Through the CFDA/*Vogue* Fashion Fund Award and CFDA {Fashion Incubator}, two young talent programs, "we've helped create a new generation of talent," says Kolb, noting that Prabal Gurung, Alexander Wang, Proenza Schouler, and Rag & Bone all came out of the programs. "That investment into young talent has injected a new youthfulness into New York Fashion Week."

In 2014, the CFDA acquired the Fashion Calendar from Ruth Finley and became the official scheduler of New York Fashion Week. As such, it is considered the umbrella organization for

all of Fashion Week, which left Lincoln Center in 2015 to spread out once again, with IMG- and MADE-produced events, shows at Skylight and Spring Studios, in lofts and at off-site venues.

The same year, New York Fashion Week: Men's kicked off with a slate of shows and presentations designed to draw attention to the burgeoning American menswear design pool, including Todd Snyder, Billy Reid, Michael Bastian, John Elliott, and David Hart. It is the CFDA's second try at making menswear the focus of its own Fashion Week; the first ran from 1995 to 2001.

The industry and its various events may no longer be unified under one tent, but they are unified under one blue-and-orange logo, says Kolb, who in 2015 worked with Mayor Bill de Blasio to introduce a New York Fashion Week branding campaign. "The real official venue for Fashion Week is the city of New York," Kolb says.

New Horizons

As American fashion has expanded globally, the runway has become a tool for designers to reach new audiences far and wide, both digitally and physically. "I don't think Fashion Week will ever go away, but we're starting to see fewer borders. People are taking advantage of different markets," says Kolb. "We're also seeing designers stepping out of Fashion Week, as brands are realizing that they can take their shows on the road but always come back to the core."

For Fall 2017, Cynthia Rowley swapped her usual New York runway show for one in Shenzhen, China, where she also manufactures, as part of a Fashion Week organized and funded by the Shenzhen People's Government with WME-IMG (IMG merged with Hollywood talent agency WME in 2013), the entertainment, sports, and fashion juggernaut that produces many of the runway shows at New York Fashion Week, as well as at thirty other fashion events around the world. "It's exciting and good for the industry to create a spectacle, but there are a lot of ways and places to do that," she says. "For me, I've enjoyed taking my show to other countries, because it's a combination of bringing an American brand someplace new and thinking about my brand in a more global way."

Anna Sui, an American designer who does most of her business outside of the United States—in Asia—sees her New York runway as a global tool to send a message to customers and licensees. "I don't have the budget to do a strong advertising campaign, so my New York runway is what gives my company image for the season." And yet, she acknowledges the challenges of holding public attention for six months. "The amount of exposure and audience you get right away is so different than when we first started, and you had your review the next day if you were lucky, then magazine editorials three months later. The Internet has sped up the process, and I don't know that people can absorb things that quickly.... [W]hat's so great about fashion is having time to absorb something and get enthusiastic about owning it or wearing it. We need to allow for that. Otherwise, you're onto the next. If you don't dream about it, what does it all mean?"

The runway is still the best way to stir up excitement for fashion, whether it's in the moment or later, for an audience near or far, says Michael Kors. "I am a real theater fan. I go all the time, and I don't think anything can match what it's like to see something live," he adds. "We can all take beautiful photos and make wonderful films, but there's nothing that can come close to seeing clothes move. The right girl wearing the right clothes at the right time—it is a magic that won't disappear."

For all the varying opinions on the future of the runway, most people agree that it will always exist, at least in some form, whether it's for in-season or a-season-ahead clothing, open to insiders only or open to everyone, experienced in virtual reality or actual reality.

"I still think the runway is very important," says Minkoff. "Maybe to an editor who has gone to every Fashion Week for ten years, it's 'Oh my god, I have to do this trek again?' But to the consumer, it's just starting."

Former CFDA president Stan Herman is more philosophical: "As long as people love to strut, there will be runway shows."

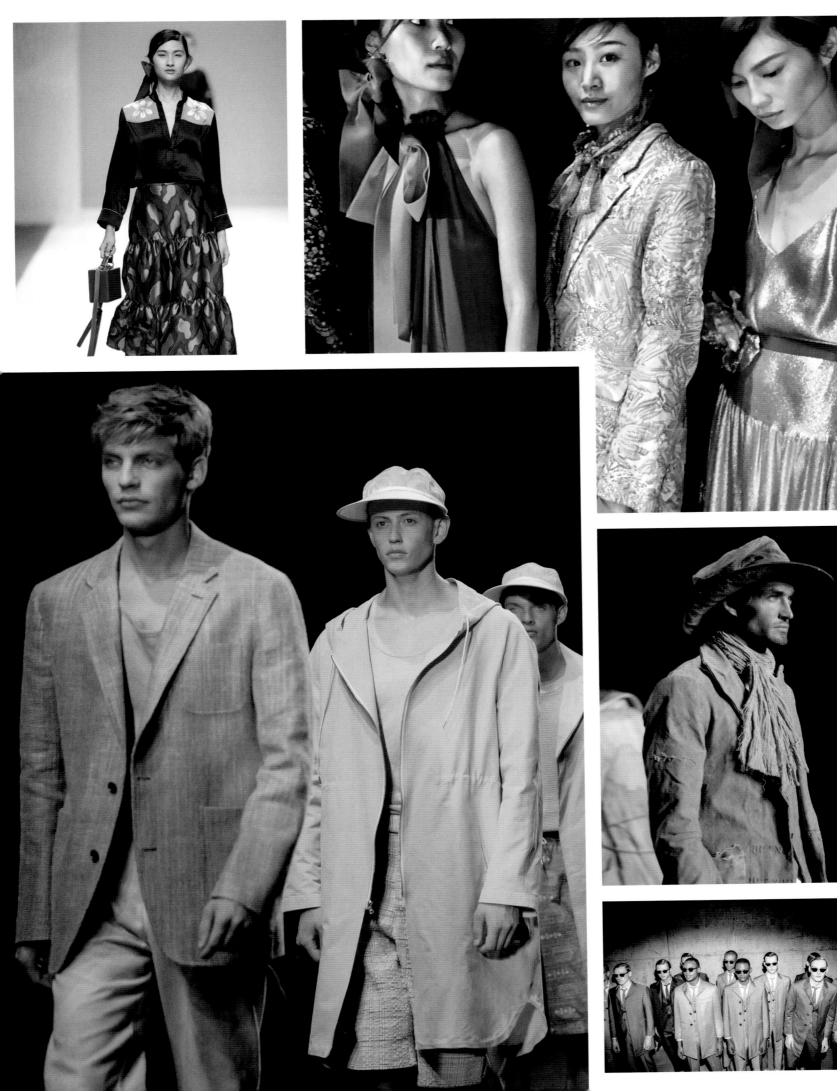

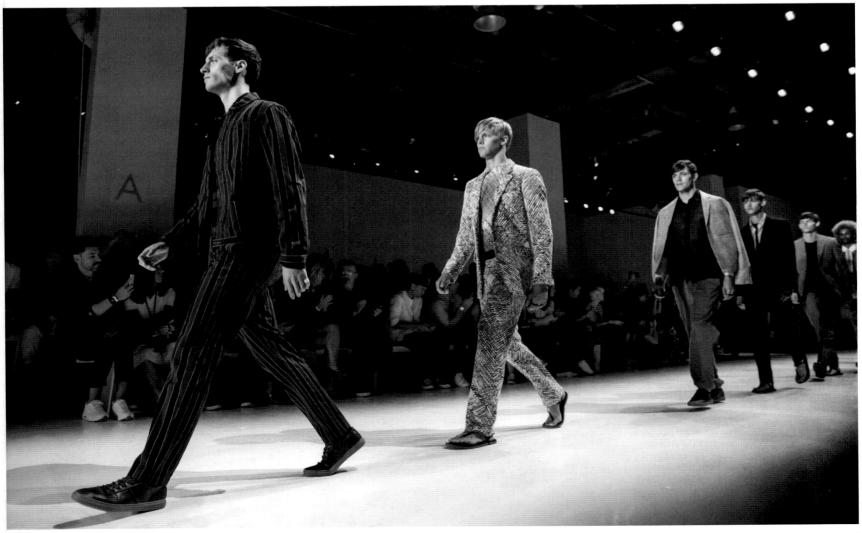

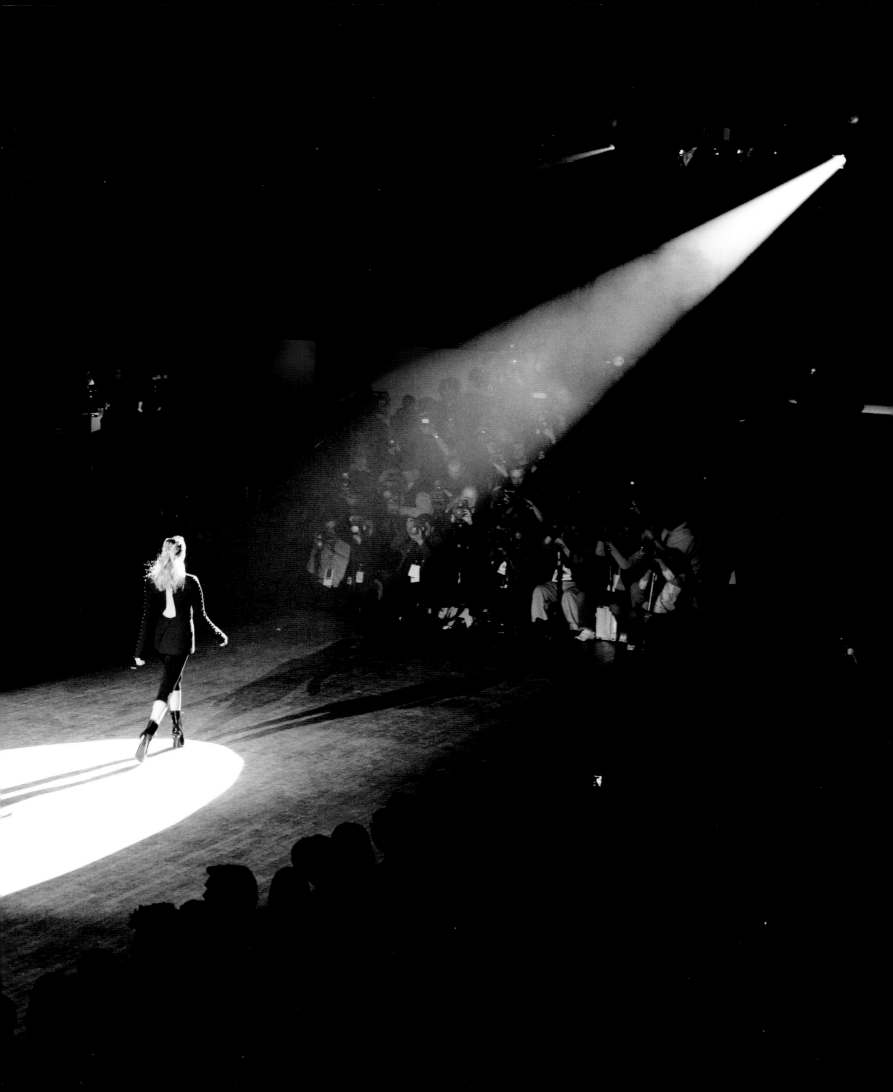

I would like to thank the Council of Fashion Designers of America,
including Steven Kolb and Marc Karimzadeh; my incredible researcher Stephanie Sporn;
my level-headed editors Sarah Massey and Rebecca Kaplan; our designer Dan Lori
and photo guru Liane Radel; my patient and ever-supportive husband, Adam Tschorn;
and all of those who have worked in print fashion journalism past and present,
because without you there would be no American runway. —**Booth Moore**

The CFDA would like to give a huge thank you to *WWD* and Penske Media for their generosity with this project;
Sean Finnegan and Ashley Dumazer at Getty Images; Inga Oganyan at Shutterstock; Michael Shulman at Magnum Photos;
Marcel Saba and Lori Reese at Redux Pictures; Leslie Simitch and Escarlen Baque at Trunk Archive; Brooke Bond at FGI;
Dan Terry at The Licensing Group; Caroline Sturgess at the Everett Collection; Kathryn Leigh Scott, Fern Mallis, Ivan Shaw,
and Becky Michel at the Conde Nast Archives; Ayanna Quint, Ruth Finley, Natalie Nudell, Stacy Fischer, April Calahan, Danyra
Chavez, Michael Ariano, Nanette Lepore, Nina Santisi, Daisy von Furth, and Kavya Kolli for all of their patience and support.

Also a special thanks to the following photographers for going above and beyond the call of duty to allow us to use their
imagery: Eric Ray Davidson, Matthew Sprout, Christopher Sturman, Michael Lavine, Robbie Fimmano, Anna Moller,
Elfie Semotan, Eli Schmidt, Monika Kratochvil, Dina Litovsky, and Katie Thompson.

Opposite: Zac Posen Fall 2008 show, February 2008.

TIMELINE

1860s: Charles Frederick Worth founds his eponymous fashion line and pioneers the role of the modern fashion designer.

1868: Worth establishes the Chambre Syndicale de la Couture Parisienne, designed to regulate the industry in France, promote its designers, and protect their designs from copying.

1900s: The garment industry becomes New York's biggest business.

1918: Couture fashion houses in Paris start to show their collections on fixed dates, twice a year.

1920s: American designers, like Valentina and Elizabeth Hawes, begin to sell original designs under their names.

1928: The Fashion Group is founded by *Vogue* editor-in-chief Edna Woolman Chase, with the purpose of promoting and dignifying American fashion.

1932: Dorothy Shaver, vice president of Lord & Taylor, launches "The American Look," which features clothing by new American designers.

1940: The Nazis invade France; Paris couture houses shut down, cutting off clothing and design ideas from Europe.

1941: The New York Dress Institute is created to promote locally made dresses and establish New York as a fashion center; Eleanor Lambert is named the publicist. Clothing labels with "New York Creation" are now sewn into every dress.

Dec. 1941: The United States enters WWII.

1942: War Production Board order L-85 is issued, restricting the use of certain fabrics and materials by clothing manufacturers.

1942: *New York Times* hosts first Fashions of the Times fashion show; Lambert creates Coty American Fashion Critics' Awards.

Jul. 19, 1943: The First Annual Fashion Press Week is held.

1945: Ruth Finley creates the Fashion Calendar.

1950s: Press Week continues, showing the collections of Bill Blass, Oscar de la Renta, and Pauline Trigère.

1960s: The decade ushers in the Youthquake, and New York becomes a hotspot for art, music, and fashion.

1961: The new first lady, Jacqueline Kennedy, popularizes styles by Halston, Givenchy, and Oleg Cassini.

1962: Lambert founds the Council of Fashion Designers of America.

1965: Andy Warhol hosts the opening of the New York boutique Paraphernalia.

Jun. 28, 1966: Halston holds first runway show for his in-house ready-to-wear line at Bergdorf Goodman.

May 1968: Calvin Klein launches his label.

May 5, 1968: Lambert hosts the first fashion show at the White House, "Discover America," with Lady Bird Johnson.

Aug. 1970: Stephen Burrows holds his first show at Henri Bendel.

1970s: American sportswear gains popularity as new designers, like Calvin Klein, Ralph Lauren, and Perry Ellis, emerge.

Fall 1972: Ralph Lauren shows his first womenwear's collection to press.

1973: The first recognized Paris Fashion Week is held, organized under the umbrella of Fédération Française de la Couture.

Nov. 28, 1973: The Battle of Versailles Fashion Show is held.

1975: Perry Ellis founds his eponymous label.

Fall 1978: Perry Ellis stages "pep rally" fashion show.

1980: Style with Elsa Klensch debuts on CNN.

1985: Donna Karan leaves Anne Klein and starts her own line, launching her Seven Easy Pieces collection of separates.

1988:	Isaac Mizrahi holds his first show at a SoHo loft.
1989:	House of Style launches on MTV, with supermodel Cindy Crawford as the host.
1991:	Plaster falls on the runway at Michael Kors show, and brings attention to the need for a professional New York Fashion Week in one venue.
Nov. 3, 1992:	Marc Jacobs presents his controversial grunge collection for Perry Ellis.
1993:	The CFDA creates 7th on Sixth, a separate production company for the shows,
Oct. 31, 1993:	The official—centralized and organized—New York Fashion Week begins, with forty-two shows held in the tents at Bryant Park,
Nov. 1994:	The first Alternative Fashion Week is held at Webster Hall,
Aug. 1995:	Unzipped, the documentary on Isaac Mizrahi's fall 1994 collection, premieres,
Dec. 1995:	VH1 airs the first VH1/*Vogue* Fashion Awards.
Jan. 1996:	Gianni and Donatella Versace show their Versus collection to a star-studded audience at Bryant Park.
1997:	7th on Sixth moves New York Fashion Week to Chelsea Piers in September. The new location was not popular, and the shows return to Bryant Park the following season.
1998:	E! launches the Style channel, a twenty-four-hour home for fashion programming.
Apr. 1998:	Austrian designer Helmut Lang, the first international designer to move his headquarters to New York, cancels his runway presentation and hosts a virtual show instead, uploading his collection to the Internet.
Sept. 1998:	Lang holds his show before the European collections, forever altering the global Fashion Week schedule.
1999:	New York Fashion Week officially moves ahead of European shows.
Feb. 1999:	Victoria's Secret webcasts its fashion show to one million online viewers.
Sept. 1999:	Mayor Rudy Giuliani hosts millennium-themed NYC2000 fashion show, which attracts more than 18,000 spectators.
2000:	Condé Nast launches Style.com, a site that posts entire runway collections and reviews within twenty-four hours of the show.
Feb. 2001:	The CFDA sells 7th on Sixth to IMG.
Fall 2001:	Sean "Diddy" Combs shows his menswear collection, a $1 million production, at New York Fashion Week.
Dec. 2004:	Project Runway launches on Bravo.
Sept. 2005:	The Penn State Blue Band opens the Marc Jacobs show with Nirvana's "Smells Like Teen Spirit," a nod to both Perry Ellis and Jacobs's own 1992 grunge collection.
Jan. 2007:	CFDA launches Health Initiative.
Late 2000s:	Street-style photographers and fashion bloggers gain prominence at New York Fashion Week.
Sept. 2010:	IMG/Mercedes-Benz Fashion Week New York relocates to Lincoln Center; Tom Ford launches his namesake women's collection.
2014:	CFDA acquires the Fashion Calendar from Ruth Finley and becomes the official scheduler of New York Fashion Week.
Sept. 2014:	Ralph Lauren projects a holographic runway show over Central Park Lake.
2015:	New York Fashion Week leaves Lincoln Center, and show locations continue to expand across the city; New York Fashion Week: Men's launches.
Sept. 2015:	Marc Jacobs: One Night Only show is held at Ziegfeld Theatre.
Sept. 2016:	Tommy Hilfiger hosts a fashion carnival at South Street Seaport, his first venture into the "see-now, buy-now" format.
Feb. 2017:	Marc Jacobs requests that attendees of his Fall 2017 show refrain from using camera phones and social media during the presentation.

ENDNOTES

1 Caroline Evans, *The Mechanical Smile* (New Haven: Yale University Press, 2013), 30.

2 Elizabeth Hawes, *Fashion Is Spinach* (Mineola, New York: Dover Publications, 2015), 113.

3 Ibid, 115.

4 Elizabeth Hawes, "Paris Cold to Show of American Designer," *The New York Times* (July 25, 1931).

5 National Museum of American History Archives, "Dorothy Shaver: The First Lady of Retailing." http://amhistory.si.edu/archives/WIB-tour/dorothy_shaver.pdf

6 Printed in a brochure published by the National Retail Drygoods Association, 1935.

7 Virginia Pope, "Behind the Easter Parade of Fashion," *The New York Times* (April 21, 1935).

8 Eleanor Lambert interview, The Oral History Project of the Fashion Industries, 1977.

9 "City Hall Style Show Introduces New Label for New York Creations," *The New York Times* (July 8, 1941).

10 "Mrs. Roosevelt Helps Launch N.Y. Dress Label," *Women's Wear Daily* (July 7, 1941).

11 "Dresses: Pictures Tell Launching of Dress Label," *Women's Wear Daily* (July 8, 1941).

12 Virginia Pope, "WPB Order Means No Radical Change," *The New York Times* (April 9, 1942).

13 Virginia Pope, "Wartime Changes in Fashion Shown," *The New York Times* (October 7, 1942).

14 Amy Fine Collins, "The Lady, the List, the Legacy," *Vanity Fair* (April 2004).

15 Eleanor Lambert interview, The Oral History Project of the Fashion Industries, 1977.

16 Ibid.

17 "Nation's Fashion Press Coming to View Couture Dress Collections In N.Y.," *Women's Wear Daily* (July 1, 1943).

18 "Dress Creators Show Readiness to Retain N.Y. Style Leadership," *Women's Wear Daily* (July 26, 1943).

19 "What Did the Visiting Editors Tell Their Home-Towns About N.Y. Fashions?" *Women's Wear Daily* (July 28, 1943).

20 "Institute Missed Boat with Press Showings, but It's Not Too Late, Says Fashion Writer" *Women's Wear Daily* (July 28, 1943).

21 "CFDA: A Snapshot of History," *Women's Wear Daily* (Sept. 9, 2012).

22 Eugenia Sheppard, "Inside Fashion," *Women's Wear Daily* (March 1, 1968).

23 Marylin Bender Altschul, *The Beautiful People* (New York: Coward McCann, Inc., 1967), 46.

24 Abigail Franzen-Sheehan, ed., *Halston and Warhol: Silver and Suede* (New York: Abrams, 2014), 36–37.

25 Daniela Morera, ed., *Stephen Burrows: When Fashion Danced* (New York: Skira Rizzoli, 2013), 29–30.

26 Steven Gaines, *Simply Halston* (New York: G.P. Putnam's Sons, 1991), 99.

27 Carol Bjorkman, "Carol Says," *Women's Wear Daily* (June 29, 1966).

28 Ibid.

29 Laird Borelli-Persson, "Pat Cleveland on Working with Halston and Irving Penn for Vogue," Vogue.com (January 1, 2015).

30 *Stephen Burrows: When Fashion Danced*, 10.

31 Pat Cleveland, *Walking with the Muses* (New York: Atria, 2016), 160.

32 Bernadine Morris, "Halston, Symbol of Fashion in America in '70s, Dies at 57," *The New York Times* (March 29, 1990).

33 *Halston and Warhol: Silver and Suede*, 36.

34 *Simply Halston*, 147.

35 Enid Nemy, "Fashion at Versailles: French Were Good, Americans Were Great," *The New York Times* (November 30, 1973).

36 Bernadine Morris, "Perry Ellis, Fashion Designer, Dead," *The New York Times* (May 31, 1986).

37 Lisa Marsh, *The House of Klein* (Hoboken, NJ: John Wiley & Sons, 2003), 38.

38 Carrie Donovan, "Fashion View: Designers Come of Age," *The New York Times* (May 6, 1979).

39 Bernadine Morris, "Paris Fashion Unveiled in Super Bowl Style," *The New York Times* (April 9, 1979).

40 Carrie Donovan, "Paris Shows Open in Chaotic Fashion," *The New York Times* (March 31, 1980).

41 John Duka, "Gaultier's U.S. Debut a Three-Ring Affair," *The New York Times* (September 18, 1984).

42 Michael Gross, "Alaia Show Mixes Fashion and Flash," *The New York Times* (September 6, 1985).

43 Bernadine Morris, "For Halston, Challenge of the Mass Market," *The New York Times* (June 9, 1983).

44 Hal Rubenstein, "Fashion, Behind the Scene," *The New York Times* (December 13, 1992).

45 Bernadine Morris, "Fall Fashion: Serious about Sportswear," *The New York Times* (April 27, 1983

46 Beverly Garrison, "Ivana Trump, Grande Dame of the Plaza," Gannett News Service (June 11, 1989).

47 "Fashion; The Big Surprise on Seventh Ave.," *The New York Times* (May 14, 1989).

48 Woody Hochswender, "Patterns," *The New York Times* (April 10, 1990).

49 Woody Hochswender, "Patterns," *The New York Times* (November 1, 1989).

50 Hal Rubenstein, "Fashion, Behind the Scene."

51 Tracy Achor Hayes, "Johnson," *The Dallas Morning News* (November 25, 1987).

52 Loretta Grantham, "Real Clothes Shine on Show's Dark Day," *The Palm Beach Post* (November 13, 1991).

53 "SA's Changing Show Scene," *Women's Wear Daily* (October 28, 1991).

54 Linda Gildan Griffin, "Bob's Living Legends," *The Houston Chronicle* (November 21, 1991).

55 Chris Bynum, "Showtime: Beene's New Bag," *The Times Picayune* (November 19, 1992).

56 Bernadine Morris, "Fashion Openings Without the Fanfare," *The New York Times* (April 13, 1993).

57 Amy Spindler, "Carefree Confidence at DKNY, Street Savvy at CK," *The New York Times* (November 1, 1993).

58 Ibid.

59 Ibid.

60 Mary Rourke, "Spring Collections/New York: Untucked, Unbuttoned, Uninspired," *Los Angeles Times* (November 3, 1993).

61 "Designers Save Best for Last in Showing of '94 Collections," World Wire Services (November 11, 1993).

62 Janet McCue, "The Sins of an Omission," *The Cleveland Plain Dealer* (November 11, 1993).

63 Bernadine Morris, "After a Show Gone Awry, Karan Makes Her Points," *The New York Times* (November 9, 1993).

64 Trip Gabriel, "Hyperbole Takes to the Runway; The Sirens of Fashion Beckon for a Week—and Then Some," *The New York Times* (October 30, 1994).

65 Linda Gillan Griffin, "From the New York Runways: Attention Goes Wild, Designs Appear Tame," *Houston Chronicle* (October 30, 1995).

66 Jennifer Steinhaeuer, "Crowding the Runway: Art, Money and Egos Collide During Fashion Week," *The New York Times* (March 27, 1998.

67 Alice Walsh, "Getting a Jumpstart on Fashion Week," *Women's Wear Daily* (October 21, 1994).

68 Debra Gendel, "New York's Runaways from the Runways," *Los Angeles Times* (October 27, 1994).

69 Ibid.

70 Daniel Feinstein, "This Fashion Show Is Styled for the Public," *Newsday* (October 25, 1995).

71 Dan Shaw, "Don't Tent Them In: Beyond Bryant Park," *The New York Times* (October 30, 1994).

72 Ibid.

73 "New York Spring '95," *Dallas Morning News* (November 16, 1994).

74 Amy Spindler, "Review/Fashion; The Strident and the Serene," *The New York Times* (April 11, 1994).

75 Debra Gendel, "By Design: New York's Runaways from the Runways," *Los Angeles Times* (October 27, 1994).

76 "Ralph, Donna Pull up Their Stakes on Tents, at Least for a Season," *Women's Wear Daily* (March 18, 1996).

77 Janet McCue, "Wild Child Must Heed Bottom Line," *The Cleveland Plain Dealer* (April 18, 1996).

78 Jessica Kerwin, "The McQueen of England," *Women's Wear Daily* (March 28, 1996).

79 Maureen Callahan, *Champagne Supernovas: Kate Moss, Marc Jacobs, Alexander McQueen and the '90s Renegades Who Remade Fashion* (New York: Touchstone, 2014), 62.

80 Lisa Lockwood, "The Grunge Stampeed," *Women's Wear Daily* (November 20, 1992).

81 Barbara De Witt, "New Film Has Designs On Bringing Isaac Mizrahi's World to Mass Audience," *Daily News of Los Angeles* (July 23, 1995).

82 Ann Geracimos, "An Expertly Sewn Look Inside Fashion Industry," *The Washington Times* (August 18, 1995).

83 Barbara De Witt, "New Film Has Designs On Bringing Isaac Mizrahi's World to Mass Audience."

84 Miles Socha, "Lang Moving His Fall Women's to New York," *Women's Wear Daily* (February 4, 1998).

85 Bridget Foley, "Lang Sets Early Date for His New York Show," *Women's Wear Daily* (July 7, 1998).

86 "125 Most Unforgettable Fashion Shows Ever," Vogue.com (May 5, 2017).

87 Lisa Schwartzbaum, "CNN's Elsa Klensch," *Entertainment Weekly* (March 5, 1993).

88 Eric Wilson, "Rudy's Fashion Moment," *Women's Wear Daily* (September 15, 1999).

89 Ibid.

90 Merle Ginsberg and Lisa Lockwood, "You Outta be in Pictures," *Women's Wear Daily* (April 26, 1996).

91 Miles Socha, "Star Power," *Women's Wear Daily*, suppl. WWD Century (September 1, 1992), 250, 252, 254, 256.

92 Booth Moore, "Fashion's Front Row Show," *Los Angeles Times* (February 9, 2001).

93 Ibid.

94 Marc Karimzadeh, "Fashion's New Pecking Order: It's All About the Photo Op," *Women's Wear Daily* (September 14, 2005).

95 Cathy Horyn, "Designers Council Sells Sponsorship of New York Fashion Week to IMG, the Sports Management and Marketing Company," *The New York Times* (February 6, 2001).

96 "The 125 Most Unforgettable Fashion Shows Ever," Vogue.com (May 5, 2017).

97 Guy Trebay, "Moncler Grenoble Show Takes Over Grand Central," *The New York Times* (February 14, 2011).

98 Vanessa Friedman, "At DKNY, Calvin Klein and Ralph Lauren, Coming Full Circle," *The New York Times* (September 17, 2015).

99 Maya Singer, "Philip Lim Spring 2016 Review," Vogue.com (September 14, 2015).

100 Faran Krentcil, "Miley Cyrus Says She's the Chillest Person at Fashion Week," Elle.com (September 11, 2014).

101 Katharine K. Zarrella, "For Sophie Theallet, the Runways Still Matter," Fashion Unfiltered (April 13, 2016).

102 Allison P. Davis, "Donna Karan Models Were Just Regular People," *The Cut* (February 9, 2014).

103 "The 125 Most Unforgettable Fashion Shows Ever."

104 Ibid.

105 Bennett Marcus, "Designer Joanna Mastroianni on Zelda Kaplan's Death," *The Cut* (February 23, 2012).

106 Woody Hochswender, "On the Fashion Road with Bill Blass," *The New York Times* (June 22, 1988).

107 Michael Quintanilla, "A Fashion Week Assignment Led to Coverage of Attacks," *San Antonio Express* (September 11, 2011).

108 Jenna Sauers, "How Fashion Blogger BryanBoy Became a Front-Row Fixture," *Observer* (February 8, 2012).

109 Rachel Strugatz and Karen Robinovitz, "To Pay or Not to Pay: A Closer Look at the Business of Blogging," *Women's Wear Daily* (June 5, 2012).

110 "Ciao Milano! *Vogue* Editors Discuss the Week That Was," Vogue.com (September 25, 2016).

111 "2009 Called: It Wants Its Vogue vs. Bloggers Fight Back," *The Cut* (September 26, 2016).

112 Dena Silver, "Tommy Hilfiger's NYFW Show Will Have a Photo Pit Just for Instagrammers" *Observer* (January 29, 2016).

113 Booth Moore, "Tom Ford Gets Personal," *Los Angeles Times* (February 20, 2011).

114 Booth Moore, "Tom Ford In L.A.? It Fits," *Los Angeles Times* (February 20, 2015).

115 Booth Moore, "Tom Ford Talks NYFW Show, Plans to Bring Golden Globe Cameraman and Actual Red Carpet," *The Hollywood Reporter* (September 6, 2016).

116 Bridget Foley, "Tom Ford, Coming Home," *Women's Wear Daily* (March 17, 2017).

117 Lauren Sherman, "Silas Chou Halts Thakoon Venture," *Business of Fashion* (March 13, 2017).

118 Booth Moore, "What Instant Gratification Retail Means for Hollywood," *The Hollywood Reporter* (September 22, 2016).

119 Cordelia Tai, "Diversity Report: Landmark Gains at New York Fashion Week Fall 2017, But Is It Enough?" TheFashionSpot.com (February 23, 2017).

INDEX

PHOTO CREDITS

Frontmatter

Front endpaper spread: Photograph by Dina Litovsky/Redux Pictures. **Endpaper opposite page 1**: Photograph by Paolo Pellegrin/Magnum Photos. **Pages 2–5**: Photograph by Gueorgui Pinkhassov/Magnum Photos. **Page 6**: Photograph by Alex Majoli/Magnum Photos. **Pages 8–9**: Photograph by Christopher Anderson/Magnum Photos. **Page 10**: Photograph by Elliot Erwitt/Magnum Photos. **Page 12**: Courtesy of Marc Jacobs International, LLC. **Page 15**: Photograph by Arthur Brower/The New York Times/Redux Pictures. **Pages 16–17**: Photograph by Eliot Elisofon/The LIFE Picture Collection/Getty Images.

Chapter 1

Page 18: Photograph by Bob Landry/The LIFE Picture Collection/Getty Images. **Page 21**, from top row, left to right: Erich Lessing/Art Resource, NY; Private Collection/Archives Charmet/Bridgeman Images; National Museum of American History, Behring Archives Center, Smithsonian Institution; The Fashion Group Foundation; Photograph by George Karger/Pix Inc./The LIFE Images Collection/Getty Images; National Museum of American History, Behring Archives Center, Smithsonian Institution; National Museum of American History, Behring Archives Center, Smithsonian Institution; Photograph by Lusha Nelson/Condé Nast via Getty Images; Bettmann/Getty Images; Wurts Bros. (New York, N.Y.)/Museum of the City of New York. X2010.7.1.7932; Bettmann/Getty Images; Sketch by Hugo Gellert, 1934/National Portrait Gallery, Smithsonian Institution © Condé Nast. **Pages 22–23**: Photograph by Slim Aarons/Getty Images. **Page 24**: Photograph by Bob Landry/The LIFE Picture Collection/Getty Images. **Page 25**: Photograph by Frank Scherschel/The LIFE Picture Collection/Getty Images. **Page 26**, from top row, left to right: The Fashion Group Foundation; Kheel Center for Labor-Management Documentation and Archives Martin P. Catherwood Library; Kheel Center for Labor-Management Documentation and Archives Martin P. Catherwood Library; Photograph by Morris Huberland © Photography Collection, The New York Public Library; Worsinger Photo/Museum of the City of New York.X2010.11.4558. **Page 28**: Photograph by Alfred Eisenstaedt/The LIFE Picture Collection/Getty Images. **Page 29**, from top: Photograph by Ernest Haas/Ernest Haas/Getty Images; Photograph by Bob Landry/The LIFE Picture Collection/Getty Images. **Pages 30–31**: Photograph by Martha Holmes/The LIFE Images Collection/Getty Images. **Page 33**, clockwise from top left: AP Photos; Anonymous/AP/REX/Shutterstock; Cover by René Bouét-Williaumex, *Vogue*, January 15, 1942, © Condé Nast; Photograph by Eileen Darby/The LIFE Images Collection/Getty Images; Photograph by Eileen Darby/The LIFE Images Collection/Getty Images; Fashion Institute of Technology/SUNY, FIT Library Special Collections and College Archive. **Pages 34–35**: Photographs by Eileen Darby/The LIFE Images Collection/Getty Images. **Page 36**, clockwise from top left: Photograph by Tony Palmieri/REX/Shutterstock; Wurt Bros. (New York, N.Y.)/Museum of the City of New York.X2010.7.1.15319; Fashion Institute of Technology/SUNY, FIT Library Special Collections and College Archive; Courtesy of Light Cone Pictures © Ruth Finley; AP/REX/Shutterstock; 20th Century Fox/Kobal/REX/Shutterstock; Courtesy of Anne Klein. **Pages 38–40**: Bettmann/Getty Images. **Page 41**: The New York Times/Redux.

Chapter 2

Page 42: Photograph by Santi Visalli/Getty Images. **Page 45**, clockwise from top left: Photograph by Michael Stroud/Express/Getty Images; Ben Martin Estate; Nick Machalaba/Penske Media/REX/Shutterstock; Time Life Picture Collection; Time Life Picture Collection; Photograph by Jack Manning/The New York Times/Redux. **Pages 46–47**: Photograph by Arthur Brower/The New York Times/Redux Pictures. **Pages 48–49**: Photograph by Pierre Schermann/Penske Media/REX/Shutterstock. **Page 50**, clockwise from top left: John Bright/Penske Media/REX/Shutterstock; Pierre Schermann/Penske Media/REX/Shutterstock; Bettmann/Getty Images; Allan Tannenbaum/Getty Images; Dustin Pittman/Penske Media/REX/Shutterstock. **Page 52**: Peter Simins/Penske Media/REX/Shutterstock. **Page 53**: Harry Morrison/Penske Media/REX/Shutterstock. **Page 55**, clockwise from top left: Reginald Gray/Penske Media/REX/Shutterstock; Reginald Gray/Penske Media/REX/Shutterstock (top and bottom); Reginald Gray/Penske Media/REX/Shutterstock; Photograph by Daniel Simon/Gamma-Rapho/Getty Images; Reginald Gray/Penske Media/REX/Shutterstock; Reginald Gray/Penske Media/REX/Shutterstock; Reginald Gray/Penske Media/REX/Shutterstock. **Pages 56–57**: Reginald Gray/Penske Media/REX/Shutterstock. **Page 58**, clockwise from top left: Pierre Venant/Penske Media/REX/Shutterstock; Tony Palmieri/Penske Media/REX/Shutterstock; Courtesy of Erica Lennard; Nick Machalaba/Penske Media/REX/Shutterstock; John McDonnell/The Washington Post via Getty Images. **Page 60**: Peter Simins/Penske Media/REX/Shutterstock. **Page 61**: Bettmann/Getty Images. **Pages 62–63**: Photograph by Anthony Suau/The Denver Post via Getty Images. **Page 65**, clockwise from top left: Peter Simins/Penske Media/REX/Shutterstock; Swift Richard/Penske Media/REX/Shutterstock; Photograph by Berry Berenson/Condé Nast via Getty Images; Photograph by Ron Galella/WireImage/Getty Images; Nick Machalaba/Penske Media/REX/Shutterstock.

Chapter 3

Page 66: Photograph by Ron Galella/WireImage/Getty Images. **Page 69**, clockwise from top left: Photograph by Ron Galella/WireImage/Getty Images; Photograph by Ron Galella, Ltd./WireImage/Getty Images; Photograph by Erin Combs/Toronto Star via Getty Images; Photograph by PL Gould/IMAGES/Getty Images; George Chinsee/Penske Media/REX/Shutterstock; George Chinsee/Penske Media/REX/Shutterstock; Photograph by Catherine McGann/Getty Images. **Page 70**: Dustin Pittman/Penske Media/REX/Shutterstock. **Page 71**: George Chinsee/Penske Media/REX/Shutterstock. **Page 72**, clockwise from far left: George Chinsee/Penske Media/REX/Shutterstock; Photograph by Ron Galella, Ltd./WireImage/Getty Images; Photograph by Ron Galella, Ltd./WireImage/Getty Images; Photograph by The LIFE Picture Collection/Getty Images; Photograph by Ron Galella/WireImage/Getty Images. **Pages 74–75**: Photograph by Neil Schneider/New York Post Archives/© NYP Holdings, Inc. via Getty Images. **Page 77**, clockwise from top left: Kyle Ericksen/Penske Media/REX/Shutterstock; Photograph by Ron Galella/WireImage/Getty Images; Courtesy of Fern Mallis; Fashion Anthology; Courtesy of Fern Mallis; Courtesy of Fern Mallis; Kyle Ericksen/Penske Media/REX/Shutterstock. **Page 78**: Photograph by Ron Galella, Ltd./WireImage/Getty Images. **Page 79**: Photograph by Barry King/WireImage/Getty Images. **Page 80**, clockwise from top left: G. Paul Burnett/The New York Times/Redux Pictures; Kyle Ericksen/Penske Media/REX/Shutterstock; Photograph by Alex Webb/Magnum Photos; Thomas Iannaccone/Penske Media/REX/Shutterstock; Image Collection. **Page 82**: Thomas Iannaccone/Penske Media/REX/Shutterstock. **Page 83**, clockwise from top left: Photograph by Barbara Rosen/IMAGES/Getty Images; Photograph by Catherine McGann/Getty Images; Photograph by Rose Hartman/Getty Images. **Pages 84–85**: Photograph by Martine Franck/Magnum Photos.

Chapter 4

Page 86: Thomas Iannaccone/Penske Media/REX/Shutterstock. **Page 89**, clockwise from top left: Photograph by Catherine McGann/Getty Images; Photograph by Patti Ouderkirk/WireImage/Getty Images; Photograph by Catherine McGann/Getty Images; Photograph by Michael Lavine; Photograph by Michael Lavine; Photograph by Catherine McGann/Getty Images. **Page 90**: Courtesy of Calvin Klein. **Page 91**: Kyle Ericksen/Penske Media/REX/Shutterstock. **Page 92**, clockwise from top left: Steve Eichner/Penske Media/REX/Shutterstock; Photograph by Rose Hartman/WireImage/Getty Images; Photograph by Evan Agostini/Getty Images; Photograph by Christopher Anderson/Magnum Photos; Photograph by Rose Hartman/WireImage/Getty Images; Photograph by Mitchell Gerber/Corbis/VCG via Getty Images; Photograph by Catherine McGann/Getty Images. **Page 94**, clockwise from top: Richard Mildenhall/REX/Shutterstock; John Aquino/Penske Media/REX/Shutterstock; Richard Mildenhall/REX/Shutterstock. **Page 95**: Fashion Anthology. **Page 97**, clockwise from top left: Courtesy of Perry Ellis; Kyle Ericksen/Penske Media/REX/Shutterstock; Kyle Ericksen/Penske Media/REX/Shutterstock; Kyle Ericksen/Penske Media/REX/Shutterstock. **Page 98**: Courtesy of Anna Sui. **Page 99**: George Chinsee/Penske/REX/Shutterstock. **Page 100**, clockwise from top left: Everett Collection; Everett Collection; Hachette Filipacchi/Kobal/REX/Shutterstock; John Aquino/Penske Media/REX/Shutterstock; Photograph by Evan Agostini/Liaison; Alamay; Kyle Ericksen/Penske Media/REX/Shutterstock. **Pages 102–103**: Everett Collection. **Page 104**: Rose Hartman/WireImage/Getty Images. **Page 105**, from top: Photograph by Elfie Semotan; Photograph by Alex Webb/Magnum Photos.

Chapter 5

Page 106: Photograph by Gary Gershoff/WireImage/Getty Images. **Page 109**, clockwise from left: Everett Collection; AP Photo/Stephen Chernin; Everett Collection; Nancy Siesel/The New York Times/Redux. **Pages 110–111**: Photograph by Larry Busacca/Getty Images for Mercedes-Benz Fashion Week. **Page 112**, clockwise from top left: Steve Wood/REX/Shutterstock; Photograph by Ron Galella/WireImage/Getty Images; Photograph by Rabbani and Solimene Photography/WireImage/Getty Images; Photograph by Dimitrios Kambouris/Getty Images; Photograph by Ron Galella, Ltd./WireImage/Getty Images; Photograph by Sonia Moskowitz/IMAGES/Getty Images. **Pages 114–115**: Billy Farrell/BFA/REX/Shutterstock. **Page 117**, clockwise from top left: IPOL/Globe Photos, INC.; Doug Kanter/AFP/Getty Images; Photograph by Djamilla Rosa Cochran/WireImage/Getty Images; Photograph by Evan Agostini/Getty Images; Photograph by Arnaldo Magnani/Liaison/Getty Images; Photograph by Scott Gries/Getty Images for IMG. **Pages 118–119**: Photograph by Trevor Gillespie/Getty Images. **Page 120**, clockwise from top left: Photograph by Larry Busacca/Getty Images North America; Photograph by Kevin Mazur/Getty Images for Condé Nast; Photograph by Spencer Platt/Getty Images for Condé Nast; Photograph by Spencer Platt/Getty Images for Condé Nast; Photograph by Jemal Countess/Getty Images for Condé Nast; Photograph by Kevin Mazur/Getty Images North America. **Pages 122–123**: Photograph by Karl Walter/Getty Images for Mercedes-Benz Fashion Week.

Chapter 6

Page 124: Kathy Willens/AP/REX/Shutterstock. **Page 127**, clockwise from top left: REX/Shutterstock; Robert Mitra/Penske Media/REX/Shutterstock; Julien Boudet/BFA/REX/Shutterstock; Seth Wenig/AP/REX/Shutterstock; Estrop/Getty Images; Photograph by

Astrid Stawiarz/Getty Images for TRESemmé; Photograph by Neilson Barnard/Getty Images for Mercedes-Benz Fashion Week; Rodin Banica/Penske Media/REX/Shutterstock. **Pages 128–129:** Photograph by Christopher Anderson/Magnum Photos. **Pages 130–131:** Photograph by Alex Majoli/Magnum Photos. **Page 132,** from top: Photograph by Alba Vigaray/EPA/Redux; Photograph by Anna Moller. **Page 133,** from top: Photograph by Gueorgui Pinkhassov/Magnum Photos; Photograph by Eric Ray Davidson/Trunk Archive. **Pages 134–135:** Photograph by Kevin Tachman/Trunk Archive. **Page 136,** clockwise from top left: Courtesy of Nanette Lepore; Photograph by Monika Kratochvil; Photograph by Evan Sung for The New York Times/Redux Pictures; Photograph by Christopher Sturman/Trunk Archive; Firstview. **Pages 138–139:** Photograph by Eric Ray Davidson/Trunk Archive. **Page 141,** clockwise from left: Photograph by Karl Prouse/Catwalking/Getty Images; Billy Farrell/BFA/REX/Shutterstock; Jason Szenes/EPA/REX/Shutterstock; DAVID X PRUTTING/Patrick McMullan via Getty Images. **Page 142,** from top: Photograph by Paolo Pellegrin/Magnum Photos; Photograph by Thomas Concordia/WireImage/Getty Images. **Page 143:** Photograph by Christopher Anderson/Magnum Photos. **Page 144,** clockwise from left: Photograph by Mark Leibowitz/Trunk Archive; Photograph by Robbie Fimmano/Trunk Archive; Photograph by Alba Vigaray/EPA/Redux. **Page 147,** from top: Photograph by Patrick McMullen/Patrick McMullen via Getty Images; Photograph by Dina Litovsky/Redux Photos. **Pages 148–149:** Photograph by Evan Sung/The New York Times/Redux Pictures. **Page 150,** from top: Photograph by Thomas Dworzak/Magnum Photos; Photograph by Dina Litovsky/Redux Pictures.

Chapter 7
Page 152: Peter Simins/Penske Media/REX/Shutterstock. **Page 155:** Guy Marineau/REX/Shutterstock. **Page 156:** George Chinsee/Penske Media/REX/Shutterstock. **Pages 158–159:** George Chinsee/Penske Media/REX/Shutterstock. **Page 161:** Photograph by Monica Schipper/Getty Images for Mercedes-Benz Fashion Week. **Page 162:** Photograph by Peter Michael Dills/Getty Images for Mercedes-Benz Fashion Week. **Page 163:** JP Yim/FilmMagic/Getty Images. **Page 165:** Photograph by Nina Westervelt/Courtesy of Karla Otto. **Page 166:** David X Prutting/BFA/REX/Shutterstock. **Page 167:** Photograph by Peter White/WireImage/Getty Images.

Chapter 8
Page 168: Stan Honda/AFP/Getty Images. **Page 171,** clockwise from top left: Will Ragozzino/BFA/REX/Shutterstock; Courtesy of Marc Jacobs International, LLC; Photograph by Dave Kotinsky/Getty Images for the Daily Front Row; Courtesy of Marc Jacobs International, LLC; Steve Eichner/Penske Media/REX/Shutterstock; Courtesy of Marc Jacobs International, LLC. **Pages 172–174:** Courtesy of Marc Jacobs International, LLC. **Page 176:** Photographs by Dina Litovsky/Redux Pictures. **Page 177–179:** Courtesy of Marc Jacobs International, LLC.

Chapter 9
Page 180: Photograph by Monica Feudi Ngowera. **Page 183,** clockwise from top left: Courtesy of Montcler; Photograph by Joe Kohen/WireImage/Getty Images; Photograph by Andrew Toth/Getty Images; Photograph by Mark Mainz/Getty Images; Steve Wood/REX/Shutterstock; Courtesy of Elise Overland. **Page 184:** Courtesy of Carolina Herrera. **Page 185,** from top: Courtesy of DJI at Cynthia Rowley; Giovanni Giannoni/WWD/REX/Shutterstock. **Page 186,** clockwise from top left: Matteo Pradoni/BFA.com; Leanne Italie/AP/Rex/Shutterstock; Getty Images; Photograph by Victor VIRGILE/Gamma-Rapho via Getty Images; Photograph by Catwalking/Getty Images; Talaya Centeno/Penske Media/REX/Shutterstock. **Page 188:** EPA/Peter Foley/Shutterstock. **Page 189,** from top: Paul Porter/BFA/REX/Shutterstock; Photograph by Catwalking/Getty Images. **Page 191,** clockwise from top: Photograph by K. Mazur/WireImage/Getty Images; Photograph by Mark Mainz/Getty Images; Photograph by Mark Mainz/Getty Images; Seth Wenig/AP Images; Andreas Kudacki/AP/REX/Shutterstock; Everett Collection Inc./Alamy Stock Photo. **Page 192,** clockwise from top left: Courtesy of Yeezy; Photograph by Slaven Vlasic/Getty Images; Photograph by JP Yim/Getty Images; Photograph by Cathy Horyn/New York Times/Redux Pictures; Photograph by JP Yim/Getty Images for Michael Kors; Photograph by Randy Brooke/WireImage; Photograph by Mark Sullivan/WireImage; Photograph by Jamie McCarthy/Getty Images for Marc Jacobs; Photograph by Peter Michael Dills/Getty Images. **Page 195,** clockwise from left: Photograph by Dimitrios Kambouris/Getty Images for Yeezy Season 3; Photograph by Arun Nevader/Getty Images; Photograph by Peter White/WireImage/Getty Images; Photograph by Dimitrios Kambouris/Getty Images for Yeezy Season 3. **Page 196:** Photograph by Thomas Concordia/WireImage/Getty Images. **Page 197,** from top: Photograph by Dimitrios Kambouris/Getty Images for Yeezy Season 3; Photograph by Joe Kohen/Getty Images. **Page 198,** clockwise from top left: Photograph by Karl Walter/Getty Images for IMG; Photograph by Frazer Harrison/Getty Images; Firstview; Photograph by Brad Barket/Getty Images; Matt Baron/REX/Shutterstock. **Page 200,** clockwise from top left: Photograph Aria Isadora/BFA.com; Alba Vigaray/EPA/REX/Shutterstock; Photograph by Victor Virgile/Gamma-Rapho via Getty Images; Photograph by Jonas Gustavsson/MCV Photo for The Washington Post via Getty Images; REX/Shutterstock. **Page 202,** from top: Photograph by Alex Majoli/Magnum Photos; Photograph by Anna Moller. **Page 203:** Photograph by Katie Thompson. **Pages 204–205:** Photograph by Paolo Pellegrin/Magnum Photos.

Chapter 10
Page 206: Photograph by Catwalking/Getty Images. **Page 209,** clockwise from top left: PIXELFORMULA/SIPA/REX/Shutterstock; Photograph by Bryan Bedder/Getty Images; Photograph by Eric Ray Davidson/Trunk Archive; STAN HONDA/AFP/Getty Images; PIXEL-FORMULA/SIPA/REX/Shutterstock. **Page 210:** Photograph by Katie Thompson. **Page 213,** from top: Joshua LOTT/AFP/Getty Images; Lucas Jackson/Reuters.

Chapter 11
Page 214: Photograph by Michael Stewart/WireImage/Getty Images. **Page 217,** from top, left to right: Photograph by Matthew Sprout; Photograph by Stephen Lovekin/Getty Images for Sally LaPointe (top); Photograph by Chelsea Lauren/Getty Images (bottom); Photograph by Daniel Zuchnik/Getty Images; Photograph by Cindy Ord/Getty Images for Mercedes-Benz Fashion Week; Photograph by Christian Vierig/Getty Images (top); Photograph by Timur Emek/Getty Images (bottom left); Photograph by The Sartorialist (bottom right); Photograph by Gilbert Carrasquillo/GC Images; Angela Pham/BFA.com. **Pages 218–219:** Photograph by Grant Lamos IV/Getty Images for Tommy Hilfiger. **Page 220,** from top: Photograph by Christian Vierig/Getty Images; Swan Gallet/WWD/REX/Shutterstock. **Page 223,** clockwise from top left: Photograph by Jason Kempin/Getty Images for Nordstrom; Photograph by Daniel Zuchnik/Getty Images; Photograph by Daniel Zuchnik/Getty Images; Benjamin Lozovsky/BFA/REX/Shutterstock; David X Prutting/BFA.com; Photograph by Christian Vierig/Getty Images. **Page 224,** clockwise from top left: Courtesy of Tory Burch; Photograph by Dina Litovsky/Redux Pictures; Katie Jones/WWD/REX/Shutterstock; Kathy Willens/AP/REX/Shutterstock. **Pages 226–227:** Photograph by Dina Litvosky/Redux Pictures.

Chapter 12
Page 228: Photograph by Christopher Anderson/Magnum Photos. **Page 230:** Photograph by Cathy Horyn/The New York Times/Redux Pictures. **Page 233,** clockwise from top left: Carmen Chan/WWD/REX/Shutterstock; Photograph by Zach Hetrick for Starr Media/Sprint Step; David X Prutting/BFA.com; David X Prutting/BFA/REX/Shutterstock; Photograph by Peter White/Getty Images. **Page 234,** clockwise from top left: Photograph by Angela Pham/BFA.com; Photograph by Slaven Vlasic/Getty Images for New York Fashion Week: The Shows; Photograph by Angela Pham/BFA.com; Photograph by Slaven Vlasic/Getty Images for New York Fashion Week: The Shows; Courtesy of Rebecca Minkoff. **Page 237,** clockwise from top left: Courtesy of WWD; Photograph courtesy of Jessica Farrugia at Cynthia Rowley; David X Prutting/BFA/REX/Shutterstock; Photograph by Eli Schmidt; Matteo Prandoni/BFA/REX/Shutterstock. **Page 238:** Kelly Taub/BFA/REX/Shutterstock. **Page 239,** from top: David X Prutting/BFA/REX/Shutterstock; Kelly Taub/BFA/REX/Shutterstock. **Pages 240-241:** Photograph by Eric Ray Davidson/Trunk Archive.

Backmatter
Page 242: Photograph by Christopher Anderson/Magnum Photos. **Endpaper opposite page 252:** Photograph by Ferdinando Scianna/Magnum Photos. **Back endpaper spread:** Photograph by Spencer Platt/Getty Images.

Designed by Dan Lori / The Lori Group

Editor: Sarah Massey

Photography Editor: Liane Radel

Production Manager: Denise LaCongo

Library of Congress Control Number: 2016960256

ISBN: 978-1-4197-2648-4

eISBN: 978-1-68335-098-9

Printed and bound in the United States of America

10 9 8 7 6 5 4 3 2 1

Abrams books are available at special discounts when purchased in quantity for premiums and promotions as well as fundraising or educational use. Special editions can also be created to specification. For details, contact specialsales@abramsbooks.com or the address below.

Front endpapers: Marc Jacobs Fall 2016 show at the Park Avenue Armory, February 2016. Endpaper opposite page 1: New York Fashion Week, September 2004. Endpaper opposite this page: New York Fashion Week, 1997. Back endpaper spread: Photographers at the Betsey Johnson Fall 2014 show, February 2014.

ABRAMS The Art of Books
195 Broadway, New York, NY 10007
abramsbooks.com